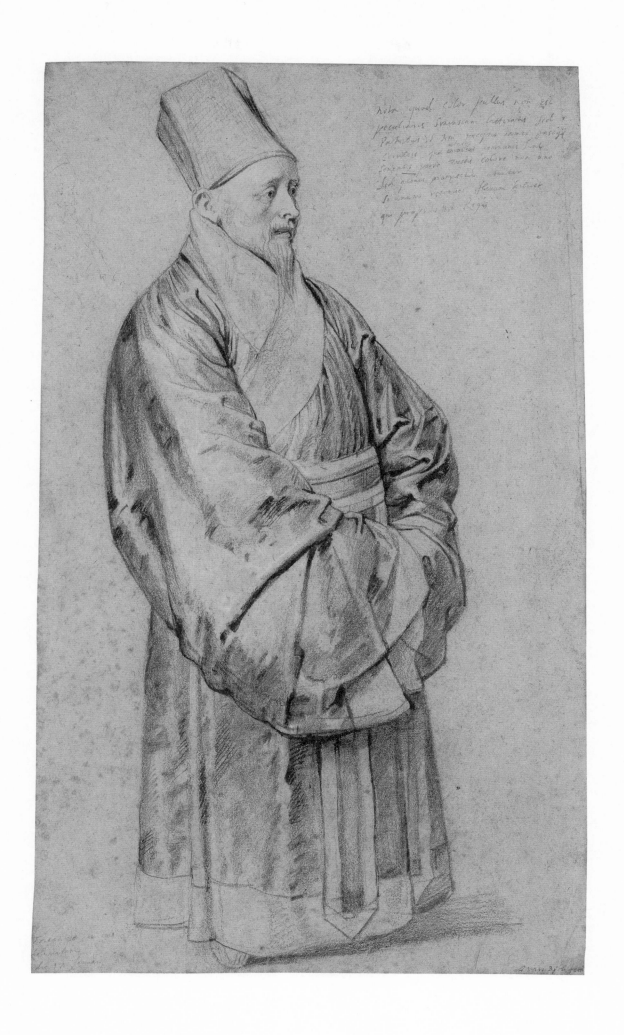

ANNE-MARIE LOGAN

FLEMISH DRAWINGS IN THE AGE OF RUBENS

SELECTED WORKS FROM AMERICAN COLLECTIONS

Distributed by

University of Washington Press, Seattle and London

DAVIS MUSEUM AND CULTURAL CENTER

Wellesley College

Wellesley, Massachusetts

This catalogue accompanies an exhibition
held at the Davis Museum and Cultural Center,
Wellesley College, Wellesley, Massachusetts,
October 15 – November 28, 1993, and at
The Cleveland Museum of Art, Cleveland, Ohio,
January 4 – February 20, 1994.

Frontispiece
Peter Paul Rubens
MAN IN CHINESE COSTUME (NICOLAS TRIGAULT?)
Private Collection, catalogue number 48

This project was supported in part by a grant
from the National Endowment for the Arts,
a Federal agency, the Margaret Mull Art Museum
Fund, the Susan H. Bradley (Class of 1979)
Memorial Gift through the estate of Emma H.
Bradley, and Bekaert Corporation.

ISBN 0-295-97316-1
Library of Congress Catalog Card Number 93-071493

CONTENTS

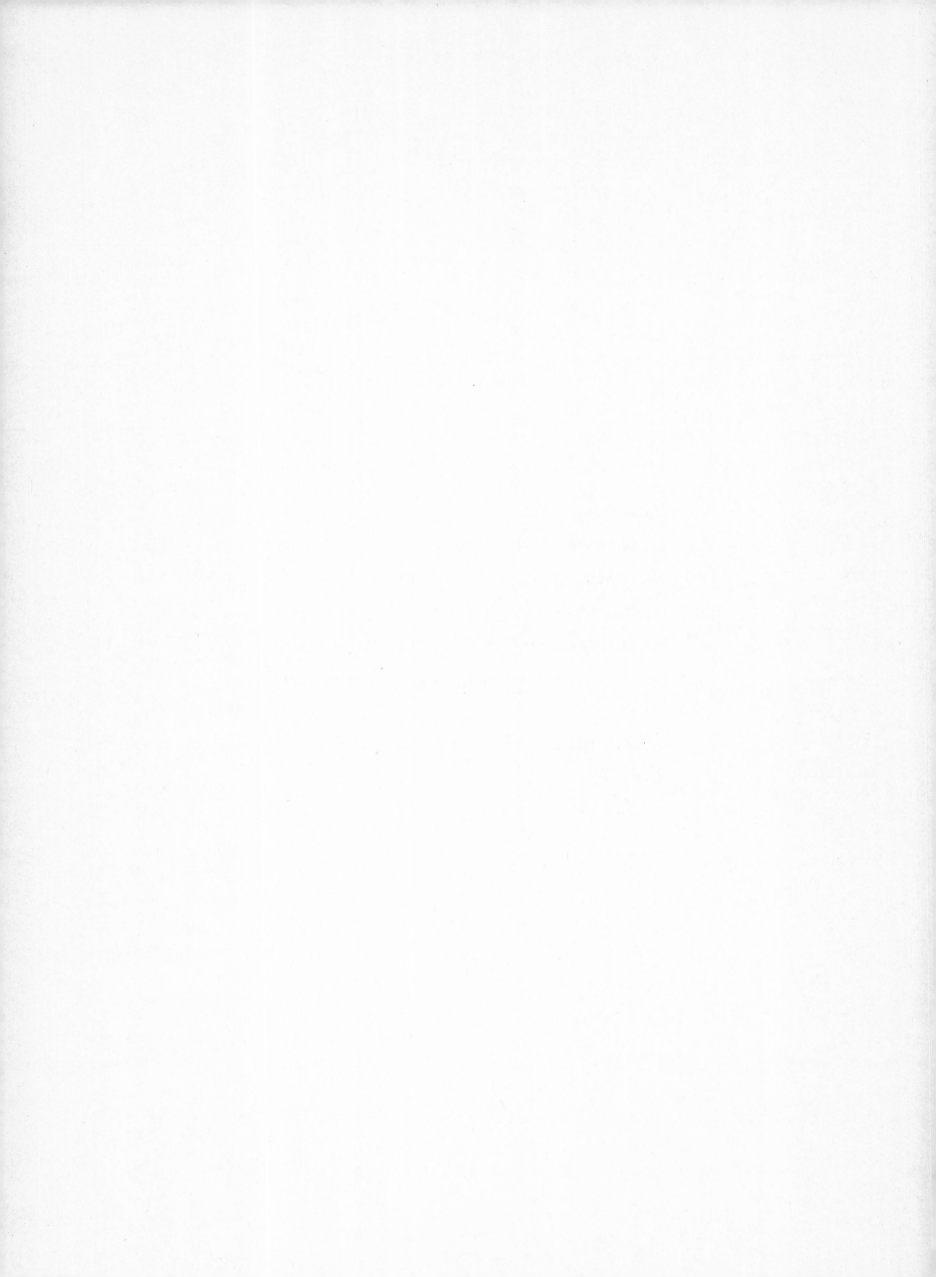

Gary and Millicent Adamson, Saint Louis, Missouri
(via The Saint Louis Art Museum)

The Art Institute of Chicago, Chicago, Illinois

Bowdoin College Museum of Art, Brunswick, Maine

The Chrysler Museum, Norfolk, Virginia

The Cleveland Museum of Art, Cleveland, Ohio

Department of Printing and Graphic Arts, The Houghton Library,
Harvard University, Cambridge, Massachusetts

Fogg Art Museum, Harvard University Art Museums,
Cambridge, Massachusetts

Hart Collection

The J. Paul Getty Museum, Malibu, California

The Metropolitan Museum of Art, New York, New York

The Minneapolis Institute of Arts, Minneapolis, Minnesota

Museum of Art, Rhode Island School of Design, Providence, Rhode Island

Museum of Fine Arts, Boston, Massachusetts

National Gallery of Art, Washington, D.C.

Peck Collection, Boston, Massachusetts

Philadelphia Museum of Art, Philadelphia, Pennsylvania

The Pierpont Morgan Library, New York, New York

The Saint Louis Art Museum, Saint Louis, Missouri

Sterling and Francine Clark Art Institute, Williamstown, Massachusetts

Mr. & Mrs. Eugene Victor Thaw

Wadsworth Atheneum, Hartford, Connecticut

Yale University Art Gallery, New Haven, Connecticut

Private Collections

FOREWORD

The Davis Museum and Cultural Center is pleased to present FLEMISH DRAWINGS IN THE AGE OF RUBENS, the first comprehensive survey of seventeenth-century Flemish draftsmanship in this country. Organized by distinguished guest curator Dr. Anne-Marie Logan, the exhibition affords a rare opportunity to examine the work of the masters Rubens, Van Dyck and Jordaens along with the drawings of almost thirty lesser-known yet highly respected artists working in and around Antwerp at the same time. The Wellesley presentation complements the concurrent exhibition, *The Age of Rubens*, at the Museum of Fine Arts, Boston.

The exhibition includes a range of works, from the preliminary sketch to the presentation drawing, affording insights into the creative process of the artist and allowing the viewer to reconstruct the genesis of a work of art. In addition it provides a more complete understanding of the artistic activity and patronage in Antwerp at the time of the Counter-Reformation. Through examination of the drawings, specific and complex aspects of an artist's development can be identified. It is possible to examine how Rubens used drawings to educate himself when studying ancient works of art in Italy. He is also seen engaged in studies of the figure in his Antwerp studio. In other preliminary drawings, the artist has worked out the concept and composition of a commissioned painting. In several cases, the viewer can also compare a preliminary drawing with a finished picture on view at the Museum of Fine Arts. By comparing the drawings of other Flemish masters included in this exhibition, viewers can gain an appreciation of local Flemish style and the nuances of differentiation between personal styles of different masters.

The first exhibition in Wellesley's new arts facility, FLEMISH DRAWINGS IN THE AGE OF RUBENS continues the museum's long commitment to education and visual enrichment. For students, there are numerous advantages to first-hand access to such a rich selection of important drawings. Not only are they are able to closely examine original works of art, they are introduced to the challenges of installation and interpretation. Questions of attribution, iconography, style and purpose can be addressed by both scholars and students by bringing these important works together. The analysis of such issues, when combined with seminar and class discussions of current critical and interpretative theories, provide an incomparable introduction for any student to the range of opinions and approaches in the field of art history today.

FLEMISH DRAWINGS IN THE AGE OF RUBENS represents both continuity and change in the Museum's efforts to coordinate the exhibition offerings with the curriculum. Often in the past, exhibitions resulted from a seminar or individual research. This year, Associate Professor Margaret Carroll created a seminar based on the contents of this exhibition and the Boston presentation. By inverting the Museum's traditional relationship between scholarship and exhibitions, we hope to show that exhibitions can not only reflect the curriculum but can also expand its scope and direction. These resources are also available to the public and it is with great pride that we share an exhibition of such distinction with our diverse constituency.

The organization of an exhibition of this complexity requires the talents and participation of many people. First and foremost, we are grateful to our guest curator, Dr. Anne-Marie Logan. Dr. Logan has been an ideal collaborator and we have the greatest respect for her as a scholar, curator and colleague. Our gratitude and appreciation extend to Associate Professor Margaret Carroll who initially brought the Museum and Anne-Marie Logan together with the assistance of Peter Sutton, Mrs. Russell W. Baker Curator of European Paintings, Museum of Fine Arts, Boston. We are most fortunate to have colleagues who support our efforts to present a stimulating exhibition program at the Davis Museum and Cultural Center.

I would like to thank the Museum staff, particularly Curator Judith Hoos Fox and Curatorial Coordinator Joseph Giuffre, who have worked with enthusiasm and dedication on all aspects of this project. Registrar Melissa Saalfield ably handled the arrangements for the loans of the drawings and all aspects of the exhibition tour. Curator of Education Corinne Fryhle designed and coordinated the educational programming that accompanied the exhibition and with Joseph Giuffre worked to develop related curricular programming. Sarah Bancroft, Wellesley Class of 1995, ably attended to numerous details related to the production of this catalogue. Graphic designer Anita Meyer gave the book its visual distinction. The talents of Museum Technician John Rossetti greatly assisted the work of architect Rafael Moneo in the design for the installation of the exhibition.

The Museum would also like to thank Vice President for Resources Peter Ramsey and his staff, Monica Mackey, Christine Atwood, and Rodger Crowe, for their help in securing critical support for the exhibition. Assistant Director for Museum Development Nancy Gunn also gave important assistance. Once again, the National Endowment for the Arts has provided critical support with funding for the exhibition and catalogue.

We are pleased to share this exhibition with The Cleveland Museum of Art. Director Evan Turner was instrumental in bringing the exhibition to this prominent institution. The presentation of the exhibition at Cleveland was greatly facilitated by William Talbot, Alan Chong, Michael Miller and Jane Glaubinger. No exhibition of this scope is possible without the generosity of its lenders, public and private. We are grateful for their willingness to loan their works to the exhibition, many of which have been seldom exhibited in public.

Finally, I would like to acknowledge the crucial role of former Wellesley College President Nannerl O. Keohane. Her guidance, leadership and advocacy for the arts have made possible the presentations in the new Davis Museum and Cultural Center. Her commitment to a central place for the arts in a liberal arts education has been remarkable.

SUSAN M. TAYLOR
Director
Davis Museum and Cultural Center

Exhibitions of Old Master drawings have become so frequent that we are likely to forget why they are held. Although their fascination may be linked to some extent to the often substantial value of the individual items included, the popularity of these exhibitions codifies more importantly an appeal based on other factors.

For centuries, drawings in vast numbers have been part of the holdings of great and small museums, libraries, and, above all, private collections. Their aesthetic and historical significance has been recognized since the Renaissance! There always were people who honed a special kind of connoisseurship focused on the drawings of artists, and collectors who kept an avid eye open for opportunities to acquire them. The public at large, however, even if interested in art, had little knowledge of or curiosity about works on paper. Since the beginning of our century some of the major museums (London, Paris, Vienna, and Berlin, to name the most prominent) have started to systematically study, catalogue, and publish certain sections of their extensive holdings of drawings. At the same time, professional art historians began to recognize the importance of this material in relation to a variety of problems they were studying. That did not necessarily mean that they had to work with the original drawings themselves; for a number of problems good photographs, which had become available since the turn of the century, proved to be sufficient. Thus, for a long time the number of people who felt the need to examine original drawings remained rather small. Whether the drawings were carefully mounted, or loosely kept in large folders (as were, for instance, even some of the best drawings in the Louvre), they led a cloistered and rarely disturbed life. Exhibitions limited to drawings were most uncommon. The first exhibition on record of drawings by Rubens was held in London in 1835 as a strictly commercial venture by a leading dealer. It took more than one hundred years for another one—alas a not very distinguished one—to be mounted in Brussels in 1938!

Print rooms, where the drawings were kept, were theoretically open to the public, but since as a rule it was only serious and well qualified students who came to study these works, access was

frequently easy and informal. I remember with lasting gratitude, and not without a bit of awe, that when I intended to go through the entire group of Flemish seventeenth-century drawings kept at the British Museum in London, the then Keeper of the collection, A. E. Popham, showed me where the boxes with these drawings were placed (on an estrade of the Reading Room) and then left me alone for hours, to examine them at my own pace. Such largess, still possible forty years ago, is a thing of the past.

Several factors made stricter rules of admission necessary. One, evidently, has been the astonishing growth of art history as a scholarly discipline and the number of serious students engaged in research. Being not only fragile objects but also increasingly valuable, drawings could not be handled too often and by too many students, no matter how circumspect. It was also, however, certain changes in the nature of art history that affected the policies of admission in most institutions, both here and abroad. Whereas formerly scholars of drawings concentrated on the works of artists who had always been recognized as draftsmen of the highest order,[2] they now greatly extended the areas of their curiosity, encompassing fields previously neglected, and "discovering" masters not inferior in their drawings to those of the small group of "recognized Olympians." Moreover, aspects of drawings were now examined that had been of no interest before, such as the specific materials used by the artists; investigations were carried out with new tools and techniques, such as ultraviolet light, infrared photography, and occasionally chemical analysis. With the prominence now given to studies of iconography, even drawings formerly passed over as aesthetically unrewarding often yielded valuable insights into symbolical or allegorical traditions. That process is still going on.

The intense occupation with drawings by an ever larger number of scholars, who were not slow to publish their findings in learned as well as popular studies, inevitably caught the attention of a great many people less interested in the stylistic, iconographic, and/or historical problems investigated by professionals, but willing to appreciate drawings as aesthetic objects of a unique

kind. They, too, developed an eye for the beauty of these relatively modest objects, produced by gifted hands on small pieces of paper, using such humble tools as lead pencils, chalks, pens filled with ink, and brushes dipped in watercolor.

The organization of exhibitions exclusively featuring drawings has been the natural outgrowth of this development. They serve the needs of scholars, either in the form of one-man shows, or—as in the case of the exhibition documented by the present catalogue—by assembling drawings from specific schools or periods. In recent years it has become almost mandatory that the exhibitions be accompanied by well-researched and fully-illustrated catalogues, which themselves become part of the scholarly literature. At the same time, these exhibitions provide visitors who love art with the thrill of coming face to face with originals from the hands of great artists which they previously could see, at best, only in reproductions. Only by patiently scanning the originals displayed before them could they learn to follow the hand of the artist, sketching, correcting, occasionally even canceling the shapes that had given form to his ideas. In addition, exhibitions— again like the present one—demonstrate the manifold functions drawings have been called on to fulfill. Most common are the preparatory studies for works to be realized in larger size and different materials (painting, sculpture, tapestry and, not to forget, architecture). Then there are drawings in which artists expressed their delight in, and kept a record of, what had attracted their attention, be it a picturesquely gnarled tree (catalogue number 62) or a quaintly elegant headgear worn by a pretty young woman (catalogue number 36). There are drawings executed in the most precise detail, so that an engraver could transfer them onto a copper-plate to be printed in many copies (catalogue number 47). These and still other categories, together with the endless variations reflecting the artists' training and personal temperament, are the factors that account for the ever-growing popularity of these exhibitions.

The present exhibition assembles examples of all these types of drawing. By concentrating on an area limited both geographically and chronologically, the selection allows us to draw some

conclusions about the character of the school—the Flemish seventeenth century—from which they have come. An exhibition of equal size, but chosen to represent the better-known, neighboring Dutch school would have a very different look. Landscape drawings would surely occupy a larger place and would offer many more intimate glimpses of nature. There would be fewer large scale studies of individual figures, or compositions combining such figures in dramatic actions. Drawings made as models for engravers would occur only rarely, and would not come—as they do here— from the hands of major artists. And while biblical and mythological subjects would also be seen, particularly in drawings by Rembrandt and artists of his circle, these themes admittedly occupied a more limited place in the panorama of Dutch seventeenth-century art. There are tangible historical reasons why Flemish art of that period was more involved with the human figure and dealt with subjects in which figures played a prominent role. These aspects of Flemish art are touched upon in the introduction that follows.

13

JULIUS S. HELD

1 See Julius S. Held, "The Early Appreciation of Drawings," *Studies in Western Art* III, Acts of the 20th International Congress of the History of Art, Princeton, 1963, pp. 72–95.

2 In his 1959 book *Great Draughtsmen from Pisanello to Picasso* (Cambridge), Jakob Rosenberg listed not only the eight artists (Pisanello, Leonardo, Raphael, Dürer, Rembrandt, Watteau, Degas, Picasso) whose drawings he discussed at some length, but in his Preface mentioned also some other candidates he had considered. Yet, from the perspective of the 1990s, even that extended list (Michelangelo, Rubens, Goya, and a host of French nineteenth-century artists) only shows how much richer our knowledge of outstanding draftsmen has become in the intervening years.

Many of these Flemish seventeenth-century drawings, acquired within the last ten to fifteen years, have rarely been exhibited except within their own institutions. It was therefore most fortunate that a representative number from collections within the United States could be assembled to provide a survey of drawing in Flanders in its Golden Age, and particularly in its artistic center, Antwerp. Drawings by the less familiar painters such as Justus van Egmont, Theodoor van Thulden, or Cornelis Schut, who were much in demand and praised in their own time, are included within the much larger group of drawings by Rubens, Van Dyck, and Jordaens, the artists traditionally associated with Antwerp in the first half of the seventeenth century. With the rising awareness and increased publication of seventeenth-century Flemish paintings, these less familiar drawings surely will become better known as well.

It is especially fortunate that not only museums but also many private collectors have agreed to part briefly with some of their Rubens drawings; many works have rarely been seen in public, and one is exhibited for the first time. The last Rubens exhibition in the United States took place in 1956 at the Fogg Art Museum in Cambridge, Massachusetts, as a joint effort with The Pierpont Morgan Library in New York. An effort has been made to include many of the Rubens drawings acquired or identified since then. Following the first comprehensive exhibition of drawings by Van Dyck in thirty years, shown in New York and Fort Worth in 1991, loans of Van Dyck's drawings were more difficult to secure for the present exhibition, and the selection was thus purposefully limited to examples from the artist's years in Antwerp. Institutions and collectors who have lent their Van Dyck drawings are gratefully acknowledged for their willingness to assist in making this as comprehensive a survey of Flemish draftsmanship as possible. To be able to show more or less contemporary black chalk studies by Rubens and Van Dyck side by side was a particular *desideratum*, since their drawings come uncomfortably close during the two or three years Van Dyck was Rubens's most trusted assistant, from about 1618 until 1620. Regarding the drawings by the lesser known artists, an attempt was made to select securely attributed works. Here again, loans from private collections of studies by Foucquier, Sallarts, Siberechts, Snyders, and Van Uden have greatly benefitted this exhibition.

The selection of close to eighty drawings from public and private collections in the United States complements the exhibition of paintings in *The Age of Rubens*, organized by Peter Sutton, Mrs. Russell W. Baker Curator of European Paintings at the Museum of Fine Arts, Boston. The catalogue of FLEMISH DRAWINGS IN THE AGE OF RUBENS continues earlier surveys of northern European drawings in United States collections such as *Seventeenth-Century Dutch Drawings from American Collections*, organized in 1977 by Franklin W. Robinson, *Drawings from the Holy Roman Empire 1540–1680*, organized by Thomas DaCosta Kaufmann in 1982, and Hilliard T. Goldfarb's *From Fontainebleau to the Louvre: French Drawing from the Seventeenth Century*, which originated at The Cleveland Museum of Art in 1989.

Many people have assisted in making this exhibition possible, beginning with Peter Sutton, who first suggested the project to me. The idea of holding the special exhibition in celebration of the opening of the new Davis Museum and Cultural Center at Wellesley College came from Margaret Carroll, associate professor of art history at the College; Susan M. Taylor, director of the Davis Museum, and Judith Hoos Fox, curator, were no less enthusiastic. I owe them particular thanks for their unfailing support and assistance. Judith Fox coordinated the exhibition and catalogue with patience, good humor, and efficiency, with the able assistance of Joseph Giuffre. I am grateful for Elizabeth Allen's editing, a task that was completed by Lucy Flint-Gohlke, assistant director at the Davis Museum, Nancy DuVergne Smith, Wellesley College editorial director, and Robin Hazard Ray. Melissa C. Saalfield, registrar, assisted with coordinating photography, copyrights, and loan requests as well as making the complex shipping arrangements. Museum Technician John Rossetti oversaw the installation of the exhibition.

We are especially grateful to the museum directors, curators, and private collectors who agreed to these loans, namely Clifford S. Ackley, Millicent and Gary Adamson, Anne Anninger, Jacob Bean, David S. Brooke, Barbara Butts, Jean Cadogan, Richard Campbell, Alan Chong, James Cuno, Gail Davidson, Cara Denison, Peter Dreyer, Rafael A. Fernandez, Richard S. Field, Robert H. Frankel, Jane Glaubinger, George R. Goldner, Sidney M. Goldstein, Margaret Morgan Grasselli, Jefferson C. Harrison, Mr. and Mrs. H. Rodes Hart, Lee Hendrix, Patrick McCaughey, Suzanne Folds

McCullagh, Evan M. Maurer, Michael J. Miller, Helen B. Mules, Mary Gardner Neill, Maureen O'Brien, Leena and Sheldon Peck, Sue Welsh Reed, Andrew Robison, Franklin W. Robinson, William W. Robinson, Donald A. Rosenthal, Barbara Stern Shapiro, Innis H. Shoemaker, Ann H. Sievers, Janice P. Singleton, William Talbot, Mr. and Mrs. Eugene Victor Thaw, Evan Turner, and Katherine J. Watson, as well as the lenders who wished to remain anonymous. We also wish to thank the outstanding professional staff members at the participating institutions and collections who facilitated this endeavor.

During the course of writing the catalogue, I received help from a number of colleagues who answered my many questions about subjects ranging from iconography, biography, or photography to costume, translations from Latin and Dutch, or information on drawings in their respective collections. I would like to gratefully acknowledge Arnout Balis, Piet Baudouin, Hans-Ulrich Beck, David P. Becker, Egbert Haverkamp-Begemann, Helen Braham, Anselmo Carini, Philip Conisbee, Gail Davidson, Richard Day, Barbara Eurich, Betsy Fryberger, Michael Goodison, Axel Heinrich, Julius S. Held, Robert M. Henning, R.-A. d'Hulst, Paul Huvenne, George Keyes, Susan Koslow, Sabine Kretschmar, Thomas LeClaire, Walter A. Liedtke, Michael McCarthy, Elizabeth McGrath, Ron Parkinson, Raymond Petke, Nora de Poorter, Patrick Ramade, Konrad Renger, Aileen Ribeiro, Gregory Rubinstein, Scott Schaeffer, Eleanor Silk, Joaneath Spicer, David Steadman, K. Vander Eycken, Hans Vlieghe, Roberta Waddell, Stephanie Wiles, Jacques Wilhelm, Ida Gertrude Wilmers, and Anne T. Woollett. Special thanks to Jeremy Wood for his valuable comments on the final draft of the manuscript and to Julius Held for his suggestions regarding the introductory text. Richard Caspole, finally, did some special photography for the comparative illustrations.

Last, but not least, I would like to express my gratitude to Duncan Robinson, Director of the Yale Center for British Art, New Haven, for allowing me to undertake this project, and to thank my colleagues in the Photograph Archive and Art Reference Library for bearing with me during the preparation of the catalogue.

The documentation of Ludwig Burchard at the Rubenianum in Antwerp proved especially valuable, since it contained a number of new articles,

even theses, published in periodicals that are all but unknown outside Belgium. My thanks go especially to Viviane Verbracken, who did not tire of my seemingly endless requests for photographs and catalogues.

The research at the Rijksbureau voor Kunsthistorische Documentatie (RKD) in The Hague was equally rewarding, and I would like to thank in particular Charles Dumas, the new head of the Drawings Section, Dorine van Sasse van Ysselt, and Anton van de Weel, as well as L.J. van der Klooster for facilitating my access to their photographs, among other courtesies they showed me. The Frick Art Reference Library in New York City was the most important resource in this country, now enhanced by the recent acquisition of microfiches after the photographs in the Witt Library, Courtauld Institute, London.

Some of the work on the catalogue entries was facilitated by recent exemplary catalogues of drawings collections, notably the one by Felice Stampfle, written with the assistance of Jane Shoaf Turner and Ruth S. Kraemer, *The Netherlandish Drawings of the Fifteenth and Sixteenth Centuries and Flemish Drawings of the Seventeenth and Eighteenth Centuries in The Pierpont Morgan Library* (1991) and the two volumes of *European Drawings in the J. Paul Getty Museum* by George R. Goldner and Lee Hendrix (Malibu, 1988 and 1992). No one has been working and publishing longer on Flemish seventeenth-century paintings and drawings, though, than Julius S. Held, whose books and articles on Rubens, Jordaens, Boeckhorst, and Fruytiers, as well as the catalogues of his own collection, I have consulted time and again. I am especially honored that he agreed to write a brief preface for this catalogue.

The collection at the Yale University Art Gallery in New Haven provided me with my first encounter with old master drawings. Much of my early knowledge was gained from working with Egbert Haverkamp-Begemann on the catalogue of *European Drawings and Watercolors*, published in 1970. Since then I have concentrated more specifically on Flemish seventeenth-century draftsmanship, in particular, on Rubens and his pupils and followers. As a token of gratitude, I would therefore like to dedicate this catalogue to Egbert Haverkamp-Begemann on his seventieth birthday.

ANNE-MARIE LOGAN
Guest Curator

In the age of Rubens, Antwerp was the artistic center of the southern Netherlands, an area roughly equivalent to present-day Belgium.[1] The court with the regents of the Spanish Netherlands, who were appointed by the Spanish king, the Archduke Albert of Austria (1559–1621) and Archduchess Isabella Clara Eugenia (1566–1633), daughter of Philip II, resided in Brussels.[2] The division of the Netherlands began as early as 1579, when the seven northern provinces—dominated by Holland—formed the Union of Utrecht. Their independence from the southern or Spanish Netherlands was acknowledged only in 1609, at the time of the Twelve Years' Truce, and legalized with the Peace of Münster in 1648. The northern Netherlands became the independent Dutch Republic, or the United Provinces, where Protestantism in the form of Calvinism was predominant, while the southern Netherlands (often referred to— not quite correctly—as Flanders, one of the provinces) remained loyal to the Spanish king with Catholicism as the prevalent religion. Netherlandish art separated early in the seventeenth century into the Dutch school in the north and the Flemish school in the south. During the first half of the seventeenth century, the two Netherlands still had much in common, with artists moving back and forth; by mid-century, however, the northern Netherlands had become a dominant force in world trade and Amsterdam succeeded Antwerp as the artistic center.[3]

The late sixteenth century was an economically trying time in the southern Netherlands. There was great devastation during the occupation by the Spanish army under Alessandro Farnese, ending with the fall of Antwerp in 1585. A former Calvinist stronghold, Antwerp lost about half of its citizens, who fled to neighboring

Holland and Germany, among them a fairly large number of artists. Some prosperity reemerged, in particular, during the Twelve Years' Truce from 1609 until 1621. During this temporary peace, churches, monasteries, and public buildings in the southern Netherlands that had been devastated were restored and a number of new churches were built.

In both north and south, the prosperous middle class was instrumental in commissioning works of art. Differences in artistic trends in the south were stimulated by the aims of the Counter-Reformation to propagate the Catholic faith.[4] In the northern Netherlands few paintings were found in churches, while in the south the introduction of large altarpieces was an important part of church decoration. In the Spanish Netherlands the churches became important patrons, supported by rich merchants, at times even by an entire city or town population. Guilds, as well as religious confraternities, were another rich source for commissions since both usually had their own chapels, often adorned with an altarpiece dedicated to their respective patron saint. A good example of this patronage is the guild of the Arquebusiers, which funded Rubens's DESCENT FROM THE CROSS (see under catalogue number 43). A factor contributing to the growth of the arts in the Spanish Netherlands was the religious fervor of the Jesuits (Society of Jesus) founded in 1540. The Society became a driving force in Antwerp with the building of a new church, consecrated in 1621. Rubens not only painted the ceiling decoration and the main altars for this Jesuit church, but also designed sculptural decorations and was involved in the design of the façade. The colleges of the Jesuits and of other religious orders

such as the Dominicans and Augustinians played a significant role in education. The Counter-Reformation required large altarpieces, intended to strengthen the veneration of the Virgin and the Holy Family, the Passion of Christ, and the martyrdoms of saints; the latter were intended to evoke compassion in the viewer through their portrayal of suffering and tragedy. The Jesuits were especially militant in spreading the Catholic faith, and religion much influenced everyday life in Flanders. Rubens, as the dominant figure, best embodied the religious art and themes of the Counter-Reformation. One of the first commissions Rubens received upon his return from Italy was from the city magistrates for an ADORATION OF THE MAGI to adorn the Hall of the States in the Antwerp Town Hall. Jacob Jordaens, whose art has a style markedly different from that of Rubens or Van Dyck, was one of the few painters working in Antwerp in the seventeenth century who belonged to the Protestant community but received commissions from Catholics as well.

Flemish drawings have received less attention in this country than Dutch drawings of the same period. Few artists besides Peter Paul Rubens (1577–1640), who dominated the arts during the first half of the century, Anthony van Dyck (1599–1641), and Jacob Jordaens (1593–1678) are known except to a small group of specialists. The present selection of drawings by close to thirty artists, active for the most part in Flanders during the first half of the seventeenth century, provides a more comprehensive view of the many facets of Flemish draftsmanship than has hitherto been attempted.

The majority of the drawings discussed in the catalogue date from about 1610 to around 1650,[5] or approximately from the time of Rubens's return from Italy in late 1608 until a decade after

Rubens's death. Antwerp's leading painter in the first decade of the seventeenth century was Hendrik van Balen (Antwerp 1575–1632 Antwerp).[6] Theodoor van Loon (Brussels 1581/82–1667 Louvain) was the foremost painter in Brussels at that time. Julius Held placed the latter's work, which was barely influenced by the art of Rubens, alongside that of Abraham Janssens and Jacob Jordaens.[7]

In the first half of the seventeenth century, Antwerp was one of the foremost publishing centers in Europe. Because of the intense propagandistic activity of the church during the Counter-Reformation, the publication of liturgical and devotional texts was strongly developed, which worked to the advantage of the Plantin Press. The "Officina Plantiniana" became the official printing house of the Catholic church for Europe (see under catalogue numbers 2 and 45). The export of religious books flourished and reached countries as far away as China (see under catalogue numbers 48 and 49). Rubens's close friendship and collaboration with the erudite Balthasar Moretus, who was in charge of the Plantin Press from 1610 until his death in 1641, was most fortuitous, since Moretus began illustrating some of his publications with engravings after designs by Rubens, above all title pages. Van Dyck is known to have illustrated only one small book, the *Vita S. Rosaliae*, published in 1629 by Cornelis Galle in Antwerp.[8] No book illustrations or title pages are known by Jordaens. After Rubens's death, Erasmus II Quellinus and Abraham van Diepenbeeck continued the tradition, although without ever approaching the erudition of Rubens's concepts. Van Diepenbeeck especially furnished many allegorical and mythological designs not only for book illustrations, but also to be painted by other artists.

Rubens's circle of friends included many of the preeminent humanists in seventeenth-century Antwerp, such as Jan-Gaspar Gevaerts or Gevartius, a lawyer and the official town clerk of Antwerp from 1621 until his death in 1661; Jan Brant, Rubens's father-in-law; Jan van den Wouver or Woverius; and Nicolaas Rockox. Rubens was not only one of the most cosmopolitan painters, but a *pictor doctus* or learned artist in the truest sense[9] with a thorough knowledge of ancient authors, in particular Virgil, Cicero, and Seneca.

Several of the artists whose drawings are discussed here were attracted to Antwerp because of Rubens, who soon began forming a studio to satisfy the increasing demand for paintings; some came to be his students. Already in May of 1611 Rubens wrote that he could take no more apprentices. As the official painter of the Archduke Albert and the Infanta Isabella, he was exempt from registering his pupils in the guild rolls. This accounts for the fact that only three of them are documented and known by name, among them Justus van Egmont. Other artists represented here were listed in the eighteenth century as Rubens's pupils (*discipels*), namely Theodoor van Thulden, Jan Thomas van Yperen, Lucas Franchoys, Anthoni Sallarts, Abraham van Diepenbeeck, and Lucas van Uden.[10] Anthony van Dyck, who was mentioned as well, was more likely a valued assistant of Rubens's rather than a pupil. He collaborated with Rubens until the fall of 1620, when he went to London and then to Italy in 1621. To distinguish Van Dyck's drawings from those of Rubens, especially in the years of their close collaboration between about 1618 and 1620, remains one of the most challenging problems of connoisseurship within the field

of Flemish seventeenth-century drawings, especially regarding black chalk studies from the model.

Rubens was the only artist in the southern Netherlands to be deeply involved in virtually every art form from small-size designs for book illustrations and title pages, as already mentioned, to larger-than-life altarpieces, and historical, allegorical, and mythological cycles for the major royal courts of Europe. In addition, he conceptualized and supervised the decorations for the Triumphal Entry of the new governor, Cardinal-Infante Ferdinand in 1635. This project involved much of the city of Antwerp and any resident artist who could be pressed into service; although temporary, it nevertheless was a highpoint of baroque festival architecture. Rubens also made designs for tapestries, silver basins, as well as architecture, and provided *modelli* for sculpture carved in ivory. He wrote theoretical texts, which unfortunately burned in the eighteenth century, except for the fragment *De imitatione statuarum* that Roger de Piles published in his *Cours de peinture par principes* (Paris, 1708).

Drawings by Peter Paul Rubens, Anthony van Dyck, and Jacob Jordaens are the most numerous in public and private collections in the United States. This reflects their greater availability, a greater familiarity on the part of collectors with their work, and, in many cases, the exceptional quality of the drawings themselves. Many of the artists included in this catalogue were born and trained in Antwerp, where they remained for most of their lives, and they were often related through marriage. Among the few who arrived in Antwerp from the northern Netherlands were Justus van Egmont, Theodoor van Thulden, and Abraham van Diepenbeeck;

Jan Boeckhorst came from Münster, Westphalia. David Vinckboons, on the other hand, fled to the United Provinces and died in Amsterdam.[11] Denijs van Alsloot and Anthoni Sallarts worked primarily in Brussels, Lucas Franchoys in Malines, while Gaspar de Crayer lived his last years in Ghent. Cornelis de Wael was an expatriate who spent most of his life in Genoa, and later lived in Rome. Van Dyck and, after him, Jan Siberechts worked many years in England, where they both died; Jan Thomas left Antwerp to work at the court in Vienna. Many of the artists traveled to Italy, with the notable exception of Jordaens; some worked for a time in Paris. Jordaens, the most important history painter in Antwerp at mid-century, and Theodoor van Thulden, who excelled in political allegories, were entrusted with commissions by patrons from the United Provinces as well as the Spanish Netherlands. De Crayer, on the other hand, refused to participate in the decorations for the Huis ten Bosch in the northern Netherlands.

Rubens, Van Dyck, and Jordaens were prolific draftsmen. R.-A. d'Hulst estimated the number of known Jordaens drawings at 425–450; at least that many exist by Rubens and Van Dyck. They were not the only artists who left behind sizeable graphic œuvres, however. Abraham van Diepenbeeck's drawings are estimated to number well over 750, the majority for prints, in addition to at least 74 designs for tapestries, according to David Steadman, to whom we owe a first list published in 1982.[12] This does not include some 300 copies in chalk after Rosso, Primaticcio, and Niccolò dell'Abate in France which Steadman added to Van Diepenbeeck's œuvre as well, an attribution supported more recently by Jeremy Wood.[13] David Teniers the Younger also left a large number of drawings.

By comparison, Otto Benesch catalogued nearly 1,400 authentic Rembrandt drawings in 1973, a number that has been greatly reduced in recent years.[14]

Still other artists active in Antwerp during the first half of the seventeenth century must have made drawings that are either lost or catalogued under the more familiar names. For example, no fewer than 168 painters (*schilder*) were registered as masters in the *liggeren*, or guild rolls, in the Antwerp guild of St. Luke between 1598 (when Rubens was recorded as a *vrijmeester* or master) and 1615. During 1616 and 1617 alone, a little less than half of the 574 members of the Antwerp guild were painters.[15] An additional 429 painters were admitted to the guild up until 1660.[16] Furthermore, these figures reflect only the situation in Antwerp, and do not include painters in other Flemish cities such as Brussels, Ghent, or Malines. Besides working for churches and convents and for the court in Brussels, many artists also painted for the art market and well-to-do citizens. The taste for collecting in Antwerp is evident in the renderings of so-called *constkamers* or collectors' art cabinets— paintings that were especially popular in the early seventeenth century, and that recently were interpreted as being more than mere representations of private collections.[17]

The decoration of the Oranjezaal (1648–52) in the Huis ten Bosch, the country residence of Amalia van Solms outside The Hague, was the last major collaboration in the years after Rubens's death in 1640 between artists who had worked with him, namely Theodoor van Thulden, Jacob Jordaens, Pieter Claesz. Soutman, and Thomas Willeboirts. The paintings were commissioned by Princess Amalia to commemorate her deceased husband, Prince Frederik Hendrik

of Orange (1584–1647). In accordance with the prevailing taste at the Dutch court, she preferred artists who were familiar with the decorative cycles Rubens had painted for the major European courts. No large projects of this kind originated in the southern Netherlands in the second half of the seventeenth century, and the number of painters continued to diminish, as did the appetite for paintings and sculpture in churches and convents around the country. The only steady market for art was through export, principally to Spain and Austria.

THE STUDY OF FLEMISH SEVENTEENTH-CENTURY DRAWINGS

Most of the drawings included in this catalogue are not signed and only a few are dated. Many of the attributions therefore are based on connoisseurship, often supported by documented paintings, prints, or tapestries, which in turn may assist in dating the drawings that are associated with them. Two studies bear inscriptions by Rubens. With few exceptions, the drawings selected for the exhibition are securely attributed to the artists. Only two examples show corrections, namely Jordaens's ANNUNCIATION (catalogue number 33), where the artist cut and/or enlarged part of the original sheet, and Fruytiers's DISTRIBUTION OF FRANCISCAN CORDS (catalogue number 24), where the "hellish" scene at the lower right was inserted. Copies found in the exhibition were made for study purposes, such as the ones by Rubens and Van Lint after antique sculpture (catalogue numbers 39 and 34), or Rubens's after parts of paintings by Titian in the Spanish royal collection in Madrid (catalogue number 55); finally, a design attributed to Pieter Soutman reproduces Rubens's LION HUNT in preparation for an etching (catalogue number 65).

Flemish drawings more often than not are preliminary studies for finished works of art and therefore served a specific function. In execution, these preliminary drawings vary greatly depending on whether they were for a painting, a print, a title page, a book illustration, a glass painting, a tapestry, a silver platter, or a marble relief. The extensive studios maintained by the leading painters, Rubens, Jordaens, and Van Dyck, resulted in the creation of a large number of drawings required to prepare their large-scale works. They guided pupils and assistants who quite often would work from these studies. Specialists in still lifes such as Frans Snyders, who were asked to collaborate, made their own preliminary drawings. In due course these studies evolved from first ideas jotted down as compositional sketches to more elaborate *modelli* or small oil sketches on panel, canvas, or paper, which were shown to prospective clients for approval before the commission was secured and a contract signed.

Of the various types of drawings, the early studies of entire compositions, where the artist is still experimenting with different ideas, can be rather confused and difficult to read: a "neat" version was sometimes necessary. A revealing example in this catalogue is Rubens's DESCENT FROM THE CROSS (catalogue number 50), where he appears to be searching intently for a satisfactory solution. With his vivid imagination Van Dyck often made several drawings in preparation for the same subject; his compositional sketches give evidence of an intense struggle. Two of the drawings shown here by Justus van Egmont had a somewhat different function: they were made in preparation for a print (catalogue numbers 18 and 19). The existence of more than one version of the same

composition not only complicates establishing the likely sequence of the various drawings, but also makes it difficult to separate an original from a copy. Rubens's DESCENT FROM THE CROSS in Boston is not the only example where a "neat" version of an original compositional drawing had to be rescued from being mistaken for a copy (catalogue number 51).

Compositional drawings were followed by specific detailed studies from the model, introduced during the last stages of the final work. Whereas this practice is well-documented for Rubens, at least until the early 1630s, it was not followed by many of his pupils or contemporaries, as the recent exhibitions of Jan Boeckhorst, Theodoor van Thulden, and even Anthony van Dyck have shown. Such studies from the model were far less common in their respective drawn œuvres. Instead, compositional sketches on paper that could also serve as *modelli* were preferred. With wash, watercolor, and bodycolor, for example, Jordaens produced designs on paper that were the equivalent of Rubens's *modelli* on panel. The example by Cornelis Schut (catalogue number 61) is different, since he made two compositional drawings in addition to a painted *modello* on canvas. Van Dyck also preferred drawings as *modelli* to show to patrons. He often struggled to arrive at a satisfactory composition, redrawing the same concept repeatedly and reversing the action in the process with great facility. His relatively few studies from the model show a somewhat diminished athletic build of the figures, with their limbs more relaxed and at ease. In addition to his drawings of narrative subjects, Van Dyck's many portrait drawings in black chalk, as well as his rare studies of dogs and horses, are vivid testimony to his extraordinary

abilities and reveal him as one of the most gifted draftsmen of the seventeenth century.

In contrast to Flemish drawings, Dutch drawings frequently were made as ends in themselves rather than in preparation for paintings or prints. Few studies by Rembrandt are known, for example, with this function. Rubens and the Flemish artists working during his time, on the other hand, drew much less for their own enjoyment or as an exercise. Thus drawings of everyday life, which abound in Dutch art, are less frequent in the work of Flemish artists, with the exception of Jordaens. The latter may have drawn many of his religious scenes as finished works of art and, in a number of his drawings with moralizing contents, he portrayed the bourgeois life that he knew from his own surroundings. Jordaens's spirited study of a mother and child (catalogue number 27), as well as Jan Cossiers's portrait of his young son (catalogue number 6), provide a glimpse into everyday life. The one painter with whom one associates genre scenes most readily, Adriaen Brouwer (Oudenaerde, Flanders? ca. 1605/06–1638 Antwerp), left no securely attributed drawings.[18]

The exceptions among Flemish seventeenth-century drawings were the many landscapes that apparently were made for diversion without a finished painting in mind. This greater independence and freedom of expression may explain the difficulty in attributing them. The most far-reaching contribution to the landscape tradition was Anthony van Dyck's watercolors. These works are dated to his later years in England where they became influential in the development of the English watercolor of the following century. This medium was not particular to Van Dyck alone, however, as a

number of landscapes in bodycolor show, such as the CLEARING IN THE WOODS (catalogue number 17) which bears an old annotation to Frans Wouters. Even earlier in the century, Jan Brueghel the Elder set a precedent in his outdoor scene with two large trees in the drawing of the VILLAGE MEETING PLACE (catalogue number 5). Unlike Dutch landscapes of the same period, Flemish landscape scenery of the seventeenth century includes few panoramas; instead the views often focus on rows of trees amidst meandering streams. Some of the more finished landscape drawings by Lucas van Uden must have been done as works of art in their own right, most likely to be sold.

Only a small number of drawings from the nude have been preserved. That Flemish artists did draw from the model is attested by a group of studies, formerly attributed to the young Jacob Jordaens, but more recently tentatively associated by Hans Vlieghe with the little-known Arnold Vinckenborch. The NUDE OLD MAN SEATED by Jordaens (catalogue number 28) is one of several related studies drawn from a model whom the artist used for a variety of roles in his paintings. Although Rubens made drawings from the live model, his approach was somewhat different; he first established the exact pose of the figure in his painting and then had the model assume that pose. His large chalk study of about 1610 for the figure of Christ (catalogue number 42) in the RAISING OF THE CROSS in the Antwerp cathedral, the study of a praying youth (figure I; The Pierpont Morgan Library, New York, New York) for DANIEL IN THE LIONS' DEN of around 1612, or the powerful reclining male nude (Louvre, Paris) for his PROMETHEUS BOUND at the Philadelphia Museum of Art, are among his most admired

drawings. Here, Rubens's knowledge and earlier study of antique sculpture assisted him when he drew from a live model. Most exceptional is the fact that these studies show so few corrections or hesitations in the drawn lines that capture the essence of the model's pose. Although at least two drawings after a female nude are found in Jordaens's œuvre and one in Van Dyck's, sketching after the female nude model seems to have been a rare event in Flemish art and in Rubens's studio in particular. This is in stark contrast to Rembrandt and his pupils, who drew nude male and female models from life, as we can observe in a number of extant drawings.[19]

Rubens did not correct drawings of his pupils, unlike Rembrandt, who often intervened rather drastically in their work. Rubens retouched and reworked other—primarily earlier artists'—studies to bring them more in line with his own ideas. His approach is exemplified by two drawings included here, one of a woman in an elaborate headdress (catalogue number 36), which must have caught Rubens's attention, the other a study of two arms, which would have appealed to his interest in anatomy (catalogue number 38). He therefore selected them for their motifs rather than for their artistic value; this adds to the difficulty in attributing the underlying drawings. These retouched and reworked drawings probably remained in Rubens's personal collection for further reference and inspiration, kept in a special cabinet or *cantoor*, as we may gather from the annotations by Willem Panneels on some of his drawings after Rubens's originals. Panneels was the only Rubens pupil who made extensive use of the master's drawings; during Rubens's absence in 1628–30, he made copies of

close to 300 of them, today preserved among the so-called *cantoor* drawings in Copenhagen.[20]

In contrast again to practice in the northern Netherlands, there existed in the southern Netherlands a sharp distinction between the freely created etching and the reproductive engraving. Rembrandt, for example, for whom etching was an extension of drawing, etched his own plates. Rubens experimented with three etchings at most, Jordaens perhaps with seven, while Van Dyck, by far the most accomplished etcher of the three, made at least fifteen lively portraits included in the so-called *Iconography*, primarily of artists, drawn freely with the etching needle on the plate and resembling his portrait drawings.[21]

Theodoor van Thulden, Jan Fyt, Erasmus Quellinus, and Cornelis Schut were artists also renowned as etchers; the latter was quite prolific with some 200 prints. Many of the engravings after paintings by Flemish artists were produced by specialized printmakers (listed in the guild rolls as *plaetsnyder*). They worked from drawings, such as the ones discussed here by Jan Boeckhorst, Abraham van Diepenbeeck, Lucas Franchoys, Philip Fruytiers, and Peter Paul Rubens (catalogue numbers 2, 8, 9, 10, 22, 24, 37, 45, 47). These designs may vary in technique from the heavy use of bodycolor (producing the effect of a painted *modello*) to a fine pen drawing heightened with wash, as we see in Rubens's ADORATION OF THE SHEPHERDS; the latter served as an illustration in the Roman Breviary of 1614 (catalogue number 45), a liturgical prayerbook published by the Plantin Press in Antwerp, "containing the psalms, readings and all that is required to follow...compiled in accordance with the decree of the Holy Council of Trent, published

by the order of Pope Pius V and certified by the authority of Pope Clement VII," as its title page explains.[22] Van Dyck used a slightly different procedure, for he not only made a portrait drawing in black chalk, but would also furnish a preliminary sketch in oil to guide the engraver in those cases where the preceding drawing concentrated primarily on the face, as in the likeness of Carlos Coloma (catalogue number 14); Van Dyck's grisaille that assisted Pontius for his engraving (in the same sense) is preserved at Boughton House (figure VI, see catalogue number 14).[23]

The reproductive engraving was elevated to a very high standard under Rubens, who had some of the best printmakers copying and reproducing certain of his paintings in print. Rubens supervised their work closely and at times corrected proof impressions with a fine pen, brown ink, and wash. He protected his copyright through official privileges. One example of such a preparatory design for a reproductive print from the Rubens school is the LION HUNT in Washington, D.C. (catalogue number 65), which Soutman published in an etching. Only for the woodcuts by Christoffel Jegher (Antwerp 1596–1652/53 Antwerp) did Rubens himself draw the preliminary designs; Jegher clearly added *P.P. Rub[ens] delin. & ex.* ("Rubens drew and published it") to the final impressions. Rubens's two outstanding, exceptionally large designs based on his painting of THE GARDEN OF LOVE in the Prado, Madrid, for Jegher's two woodcuts, which he partly reworked in brush and greenish bodycolor, are preserved in The Metropolitan Museum of Art, New York (figure II).[24] This was by far the most complicated and ambitious of the woodcuts Jegher made in collaboration with Rubens in the early 1630s.

The only overview of Flemish artists in Rubens's entourage is Marie-Louise Hairs's DANS LE SILLAGE DE RUBENS ("In Rubens's Wake"), in which she surveyed the work of Rubens's pupils and followers with a discussion of their drawings as well.[25] With regard to the three foremost Antwerp artists—Rubens, Van Dyck, and Jordaens—a catalogue raisonné exists only for the drawings of the latter by R.-A. d'Hulst, which appeared in 1974, followed by two supplements in 1980 and 1990.[26] Julius S. Held's RUBENS. SELECTED DRAWINGS (1959), with a revised edition in 1986,[27] as well as Horst Vey's catalogue of Van Dyck drawings of 1962, publish representative selections only. Vey's work was updated and expanded by Christopher Brown in his exhibition catalogue of Van Dyck's drawings in 1991.[28]

Fortunately, publications on drawings by the lesser known artists are increasing in number.[29] In 1989 Katlijne van der Stighelen attempted to reconstruct the drawn œuvre of Cornelis de Vos (1584–1651), consisting primarily of about a dozen studies of heads and hands.[30] Together with Rubens and Van Dyck, De Vos was one of the foremost portrait painters of the time, excelling especially in family portraits. Julius Held was able to relate the black chalk study of ST. JEROME (still in his own collection) to Lucas Franchoys's signed etching in reverse (figures IIIa and IIIb), thus confirming the earlier attributions to the artist of similar studies—above all of heads—drawn with an oily black chalk.[31] The drawings by Jan Fyt that Edith Greindl discussed in her catalogue of 1956 (reprinted in 1983) present such a varied picture of his draftsmanship that more work on the artist is required.[32] There are certain divergences as well between Greindl's

catalogue of Frans Snyders's drawings, published thirty-five years ago, and the œuvre assembled more recently by Hella Robels. Held drew attention to yet another neglected aspect of Flemish drawings, the studies of heads that are now classified among a number of artists, which he tentatively associated with artists such as Gaspar de Crayer and Jan Boeckhorst.[33]

Our knowledge of Flemish drawings has become more focused as well due to recent exhibitions of the work of Jan Boeckhorst, Anthony van Dyck, David Teniers, and Theodoor van Thulden, which have sharpened our knowledge of these artists' œuvres. Further research is needed, though; a monographic exhibition does not necessarily lead to a clarification of an artist's drawings, as the recent Van Thulden exhibition has shown. If the roughly 300 copies in black chalk, after the lost frescoes by Primaticcio and others at Fontainebleau and elsewhere in France, are attributed to Abraham van Diepenbeeck instead, as mentioned earlier, Van Thulden's black chalk studies practically disappear from his œuvre.[34] Van Thulden's large study of the ALLEGORY OF ANTWERP WITH THE RETURN OF MERCURY in the National Gallery of Art, Washington, D.C. (catalogue number 70), drawn extensively with red and black chalk for his painting now in Malta, may assist in establishing his authorship for other chalk studies associated with him whose authorship is disputed.[35] Another significant link was established several years back when Held recognized in the STUDY FOR SAINTS DISTRIBUTING ALMS at the École des Beaux-Arts, Paris, Abraham van Diepenbeeck's preliminary drawing for his oil sketch in the Johnson Collection in Philadelphia,[36] thus eliminating the drawing from Rubens's œuvre. This identification serves as a vivid

reminder that Van Diepenbeeck's studies can be mistaken for Rubens's. Separating drawings out of Rubens's and Van Dyck's œuvres has proven to be especially difficult; their drawings have been found even among the Italian or French schools. Similarly, Cornelis Schut's MASSACRE OF THE INNOCENTS at the Yale University Art Gallery led to the identification of three more works of his, previously classified as far afield as Mattia Preti and Nicolas Poussin (catalogue number 61).

Corresponding preliminary drawings for painted compositions unfortunately are rare. As the examples discussed here clearly show, the sorting out of hands among seventeenth-century drawings continues. One aim of the present catalogue is to draw attention to lesser known draftsmen, since some drawings traditionally attributed to Rubens, Van Dyck, or Jordaens have recently been associated with artists like Jan Boeckhorst, Arnout Vinckenborch, or Artus Wolffort, who—with the exception of Boeckhorst—are virtually unknown. Thus the EXPULSION FROM PARADISE at the National Gallery of Canada, Ottawa, exhibited in Washington, D.C. in 1990–91 among the oil sketches by Anthony van Dyck, has tentatively been given to Jan Boeckhorst.[37] Attributions of late have often been proposed on the basis of figural types rather than execution. As alluded to earlier, Vlieghe thus associated the two series of some thirteen studies of male nudes in the Hessisches Landesmuseum, Darmstadt, and the Kunstmuseum, Düsseldorf, increased by an additional sheet in the Wallraf-Richartz-Museum, Cologne, with the work of Arnout Vinckenborch (Alkmaar ca. 1590–1620 Antwerp), a painter who moved to Antwerp shortly before 1614. Vlieghe related these

academy studies from life to similar figural types in Vinckenborch's paintings. Vinckenborch, entirely unknown as a draftsman, became a master in the Antwerp guild of St. Luke in 1615.[38] Vlieghe even supposed that the artist might possibly have worked in the studio of Rubens, where he could have familiarized himself with Rubens's drawings. Since R.-A. d'Hulst published these same drawings as youthful studies by Jacob Jordaens,[39] the reattribution greatly affects our idea of the young Jordaens as a draftsman. If accepted, it eliminates all but one of the academy studies from Jordaens's œuvre, namely the SEATED MALE NUDE in The British Museum, London.

Earlier Vlieghe had suggested Artus Wolffort (Antwerp 1581–1641 Antwerp) as the author of a drawing representing the HEAD OF AN OLD WOMAN in the Louvre, Paris, which D'Hulst had included among the doubtful Jordaens attributions. Wolffort was another artist trained in the northern Netherlands who, in 1603, became a master in the painters' guild in Dordrecht before moving to Antwerp. In addition, Vlieghe found a DECAPITATION OF ST. JOHN THE BAPTIST with a cut-off signature, *[..]lffordt ft.*, in the Berlin Kupferstichkabinett, which is entirely different in execution from the head study mentioned above.[40]

Just how difficult connoisseurship of drawings can be is exemplified, finally, by what was believed to be an early ENTOMBMENT by Jacob Jordaens, first shown as a newly discovered study in the Jordaens exhibition in Ottawa in 1968 (now in the Santa Barbara Museum of Art). D'Hulst subsequently included it in his catalogue raisonné as a version closely related to the ENTOMBMENT in the Antwerp Print Room.[41] Recently, the contemporary artist/copyist Eric Hebborn

has reclaimed it as a work of his own, drawn in 1967 in the style of the old masters.[42]

We have lately witnessed an increasing interest in Flemish paintings and drawings, beginning with exhibitions of Flemish seventeenth-century paintings in Tokyo, Taiwan, and Padua,[43] not to mention the lavish volumes on Flemish art published by the Mercatorfonds in Antwerp.[44] The municipal Print Room in Antwerp has most actively exhibited selections from its Flemish drawings, beginning in 1986–87 with exhibitions in Florence and Genoa and, during 1988 and 1991, on its own premises in the Museum Plantin-Moretus and the Stedelijk Prentenkabinet, Antwerp.[45]

Of Fruytiers's drawing at the Yale University Art Gallery (catalogue number 24), one of only three studies known by the artist, Julius Held wrote in 1964 that it remained a "creditable performance." He continued that the study "helps to demonstrate the truth of the fact, never enough stressed, that in past ages even minor figures had at their command a skill and proficiency which we mistakenly grant only to the few great masters." As he pointed out, Cornelis de Bie devoted more lines in praise of Philip Fruytiers than to Rembrandt in his *Het gulden Cabinet*... ("The Golden Cabinet of the Noble Art of Painting") in 1661. Today, Fruytiers is little known and rarely included in surveys of Flemish seventeenth-century painting or drawing. Another forgotten artist, whose drawings are seldom mentioned, is Justus van Egmont, once a trusted collaborator of Rubens and one of the founders of the French Academy.[46] Thus we may recall Held's warning, still viable, especially with regard to drawings, that whoever "sees Flemish seventeenth-century painting only in terms

of a few big names not only underrates the vigor and creative vitality of this school, but fails to do full justice to the great masters themselves, who too often are credited—and hence burdened—with the products of their less famous contemporaries."[47] With the present publication, we hope to draw renewed attention to the many artists who were well respected in their own time but have fallen into virtual obscurity.

THE COLLECTING OF FLEMISH DRAWINGS IN THE UNITED STATES

Flemish seventeenth-century drawings have been far less popular among American collectors than Dutch drawings of the same period. The two largest holdings of Flemish drawings in the United States—in The Pierpont Morgan Library, New York, and in the Yale University Art Gallery, New Haven, assembled by an Englishman and an Irishman respectively—vary widely in quality. In 1910, the wealthy banker J. Pierpont Morgan bought from the English artist Charles Fairfax Murray (1849–1919) the collection of old master drawings that today forms the core of the collection of European drawings in the Morgan Library. These sheets reflect the taste of an English connoisseur and *marchand-amateur* of the later nineteenth century who bought judiciously—searching selectively for the finest and most representative examples rather than buying in quantity—in London in the 1880s and 1890s, when the collections of Lord Palmerston, the Earl of Aylesford, Robert Stayner Holford, Sir John Charles Robinson, and Pitcairn Knowles were dispersed (see catalogue numbers 6, 8, 13, 15, 29, 49, 67).

Rubens's masterful drawing from the model of a SEATED NUDE YOUTH for Daniel in DANIEL IN THE LIONS' DEN (figure I) is one of

the treasures among the approximately 100 Flemish drawings of the seventeenth century in the Morgan Library. Lesser known draftsmen such as Jan Cossiers (catalogue number 6), Abraham van Diepenbeeck (catalogue number 8), Pieter de Jode the Elder (catalogue number 26), Frans Snyders (catalogue number 64), and Jan Wildens (catalogue number 76) are represented with excellent examples, from which the present study has greatly benefitted. Felice Stampfle's impressive volume of the Netherlandish and Flemish drawings in the Library's collection, published in 1991, catalogues them in their entirety for the first time.

In contrast to the drawings brought together by Fairfax Murray, the predominantly Netherlandish drawings assembled a century earlier by the Irish peer John Percival, 1st Earl of Egmont (1683–1748) were very different. The collection does not reflect a connoisseur's taste— the attributions of more than half of the 543 drawings were incorrect or questionable—but rather that of a collector interested in drawings that originated in the northern and southern Netherlands during the sixteenth and seventeenth centuries. Since Percival claimed to be descended from the renowned counts of Egmont in Flanders, he may well have used the collection to support this supposed noble ancestry. While drawings by Rubens or Van Dyck are absent from this so-called Egmont collection, there are some fine sheets by lesser known seventeenth-century artists rarely found elsewhere in this country, such as the examples by Jan Brueghel the Elder, Frans Francken the Younger, Lucas Franchoys, and Philip Fruytiers. Presented originally to Sterling Memorial Library, they were transferred to the Yale University Art Gallery in 1961 and published fully in 1970 (see catalogue numbers 5, 17, 19, 22–24, 61).[48]

It is not surprising that one of the most memorable Flemish drawings in the United States came originally from the collection of Paul J. Sachs (1878–1965), the powerful study for CHRIST ON THE CROSS, acquired as early as 1922 and subsequently bequeathed to the Fogg Art Museum, Harvard University, Cambridge, Massachusetts (catalogue number 42). Another drawing once owned by Paul Sachs, the sixteenth-century Italian study of an OLD MAN which Rubens retouched, is now at Oberlin, acquired in 1943. From the handful of Flemish seventeenth-century drawings in the Allen Memorial Art Museum at Oberlin College, which Wolfgang Stechow catalogued in 1976, the OLD MAN and the MARRIAGE OF ST. CATHERINE, traditionally accepted as a compositional drawing by Rubens, are the most significant.[49]

Wilhelm R. Valentiner (Karlsruhe 1880–1958 New York), who organized some of the earliest exhibitions on Rubens and Van Dyck in this country (1929, 1936, 1946) when he was director of the Detroit Art Institute (1924–45), the Los Angeles County Museum (1946–54), and the North Carolina Museum of Art in Raleigh (1955–58), acquired no Flemish drawings of note for these museums.[50] John Ringling's taste for Rubens and Flemish paintings, which has benefitted the museum that bears his name in Sarasota, Florida, did not extend to drawings.[51] Interesting Flemish drawings are found in unexpected places, however, such as Frans Snyders's preliminary drawing (figure IV) in the Huntington Library and Art Gallery, San Marino, California, for his painting of the HARE AND THE TURTLE in the collection of the Vizecondes de Fefiñanes, Madrid,[52] or the series of six small pen drawings of an unknown subject (Stanford University Museum of Art, Stanford, California); which Abraham

van Diepenbeeck most likely made to illustrate a book (figure V). Until a corresponding print with an explanatory legend is found, the true identity of this column-legged lion holding court, dressed in full regalia and seated on a throne, will remain a puzzle.[53]

The J. Paul Getty Museum in Malibu, which began collecting drawings only in 1981 under the curatorship of George R. Goldner, now preserves some of the best Flemish drawings in this country, and not only by Rubens, Van Dyck, and Jordaens. The Flemish drawings from the National Gallery of Art in Washington, D.C., were acquired primarily during the curatorship of Andrew Robison. Thanks to the partial gift and acquisition of drawings collected over many years by Julius S. Held, the National Gallery now preserves some extraordinary sheets by less familiar Flemish artists such as the ALLEGORY OF ANTWERP by Van Thulden and the watercolor by Boeckhorst (catalogue numbers 70 and 4), both included here, as well as an early copy by Rubens, THE BATTLE OF NUDE MEN, after an engraving by Barthel Beham.[54] More Flemish drawings have entered the National Gallery with the recent gift from the Ian Woodner Family Collection.

With few exceptions, the Flemish drawings in the United States were collected privately and bequeathed to museums. Outstanding examples, besides those in the major collections already mentioned, were gifts to the Museum of Fine Arts, Boston; The Cleveland Museum of Art; Museum of Art, Rhode Island School of Design; The Metropolitan Museum of Art; The Art Institute of Chicago; and the Sterling and Francine Clark Art Institute, with some dating back to the early 1920s. The title page by Van Diepenbeeck (catalogue number 10) was one of the 141 old master drawings that

James Bowdoin III bequeathed in 1811 to the college that bears his name, Bowdoin College (Brunswick, Maine), the oldest collection of drawings in this country.

Some of the most interesting drawings represented here still belong to private collectors, whose generosity in lending them to FLEMISH DRAWINGS IN THE AGE OF RUBENS is gratefully acknowledged, for it made possible this remarkably varied and rich overview of the art of drawing in the southern Netherlands during the seventeenth century. May this survey stimulate further study of Flemish draftsmanship that leads beyond Rubens, Van Dyck, and Jordaens, and assist in differentiating the œuvres of their lesser known contemporaries.

43

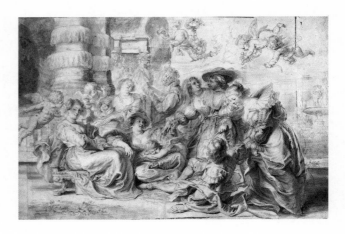

figure II

figure I
Peter Paul Rubens, SEATED NUDE YOUTH,
The Pierpont Morgan Library, New York,
New York (Inv. no. I,236; black chalk,
heightened with white chalk, on light gray
paper, 500 x 299 mm)

Peter Paul Rubens, GARDEN OF LOVE (right half),
all rights reserved, The Metropolitan Museum
of Art, New York, New York, Fletcher Fund, 1958
(Inv. no. 58.96.1; pen, brown ink, gray-green wash
over traces of black chalk, touched with indigo,
green, yellowish, and white paint, 463 x 705 mm)

44

figure IIIa
Lucas Franchoys, ST. JEROME, collection of
Julius S. Held (black chalk, 143 x 98 mm)

figure IIIb
Lucas Franchoys, ST. JEROME, collection of
Julius S. Held (etching)

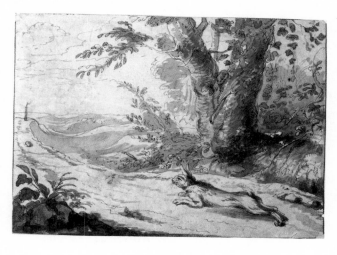

figure IV

Frans Snyders, THE HARE AND THE TURTLE,
The Huntington Library, Art Collections,
and Botanical Gardens, San Marino, California:
from the collection of Mrs. A. Bethell (Inv. no.
59.55.1008; pen and brown ink and brown wash,
260 x 197 mm)

figure V

Abraham van Diepenbeeck, LION DISPENSING
JUSTICE, Stanford University Museum of
Art, Stanford University, Stanford, California:
Given in memory of Arthur W. Hooper
by his children, Margaret H. Jameson and
John A. Hooper (Inv. no. 75.190.4E; pen and
brown ink, brown wash, heightened with white,
over sketch in black chalk, 136 x 115 mm)

1 For a history of Antwerp, see Karel van Isacker and Raymond van Uyten, eds., *Antwerpen. Twaalf eeuwen geschiedenis en cultuur*, Antwerp, 1986. After the Peace of Münster in 1648 the southern Netherlands comprised the provinces of Artois, Flanders, Hainaut, and Namur; the Duchies of Brabant, Limburg, and Luxembourg; and the Bishoprics of Liège and Cambrai. During the wars between Spain and France later in the seventeenth century, several territories along the borders with the southern Netherlands were incorporated into France under Louis XIV (among others, Lille and Douai became French). The kingdom of Belgium was created in 1830.

2 Cardinal-Infante Ferdinand, the younger brother of King Philip IV of Spain, was governor from 1634 until his death in 1641. His Triumphal Entry into Antwerp took place on 17 April 1635. The Cardinal-Infante was followed in 1647 by Archduke Leopold Wilhelm of Austria (with a Triumphal Entry into Antwerp on 27 March 1648), who remained until 1656, when he moved his court to Vienna. Don Juan d'Austria succeeded him (with an official entry into Antwerp in 1657) until 1659.

3 For an assessment of contemporary Flemish art by a seventeenth-century Dutch scholar, see Hans Vlieghe, "Constantijn Huygens en de Vlaamse schilderkunst van zijn tijd," *De zeventiende eeuw* 3, 1987, pp. 191–210. For the influence of Flemish artists on the art of the northern Netherlands, see Erik Duverger, "Bronnen voor de geschiedenis van de artistieke betrekkingen tussen Antwerpen en de noordelijke Nederlanden tussen 1632 en 1648," *Miscellanea Jozef Duverger*, I, Ghent, 1968, pp. 336–73; for cultural differences between the northern and southern Netherlands, see Frans Baudouin, "Rubens and His Social and Cultural Background," in Baudouin 1972, pp. 303–19. A good survey of Flemish art and culture is found in *Stadtbilder in Flandern. Spuren bürgerlicher Kultur 1477–1787*, exh. cat., coordinated by Jan van der Stock, Schallaburg, Renaissanceschloss, 1991.

4 For a brief survey, see David Freedberg, "Kunst und Gegenreformation in den südlichen Niederlanden, 1560–1660," in exh. cat. Cologne/Antwerp/Vienna 1992–93, pp. 55–70.

5 Uwe Westfehling surveys Flemish draftsmanship of these years in his "Zeichenkunst in Antwerpen 1600–1650," in exh. cat. Cologne/Antwerp/Vienna 1992–93, pp. 235–48.

6 Relatively few drawings by Hendrik van Balen (1575–1632) are extant, among them the BACCHUS, VENUS AND CERES in the Yale University Art Gallery, New Haven (Haverkamp-Begemann and Logan 1970, no. 517, pl. 279). For an introduction to the artist, see Ingrid Jost, "Hendrick van Balen der Aeltere," *Nederlands Kunsthistorisch Jaarboek* 14, 1963, pp. 83–128. See also Frans Baudouin, "Iconografie en stijlontwikkeling in de godsdienstige schilderkunst te Antwerpen in de zeventiende eeuw," in *Antwerpen in de XVIIde eeuw* (*Genootschap voor Antwerpse geschiedenis*), Antwerp, 1989, pp. 329–64.

7 Julius S. Held, "Notes on Flemish Seventeenth-Century Painting. Jacob van Oost and Theodor van Loon," *Art Quarterly* XVIII, 1955, pp. 150–56.

8 See Zirka Zaremba Filipczak, "Van Dyck's 'Life of St. Rosalie'," *Burlington Magazine* CXXXI, 1989, pp. 693–98.

9 Julius S. Held, "Rubens and the Book," *Harvard Library Bulletin* XXVII, 1979, p. 115.

10 Referred to in the sequence found on an anonymous insert in the album of François-Jean-Joseph Mols, *Analecta Rubeniana* II, folio 81, Brussels, Bibliothèque Royale, Ms. 5733; see Marie van der Vennet, "Le peintre bruxellois Antoine Sallaert," *Musées Royaux des Beaux-Arts de Belgique* 23–29, 1974–80, p. 188, appendix II. Philip Rubens, the artist's nephew, mentioned six pupils in 1676 in his brief biography of Rubens, namely Pieter Soutman, Justus van Egmont, Erasmus Quellinus, Jan Boeckhorst, Jan van den Hoecke, and Anthony van Dyck. See also Hans Vlieghe, "Antwerpene Historienmalerei und Rubens' Atelier. Eine Quellenstudie," in exh. cat. Cologne/Antwerp/Vienna 1992–93, pp. 133–42.

46

11 See Friso Lammertse, in *Het kunstbedrijf van de familie Vingboons, schilders, architecten en kaartmakers in de gouden eeuw*, exh. cat., Amsterdam, Royal Palace, 1989, especially pp. 13–43. See also Jan Briels, "Flämische Maler in Holland um 1600," in exh. cat. Cologne/Antwerp/Vienna 1992–93, pp. 79–91.

12 Steadman 1982, pp. 59–67, appendix 3.

13 Steadman 1982, p. 43, and Wood 1990, p. 9. This interpretation was not accepted by Alain Roy and Sylvie Béguin, in exh. cat. 's-Hertogenbosch/Strasbourg 1991–92, pp. 99–110 and nos. 3–4.

14 Otto Benesch, *The Drawings of Rembrandt*, 6 vols., London, 1954–57; enlarged and edited by Eva Benesch, London and New York, 1973. For the current state of research on Rembrandt drawings, see Egbert Haverkamp-Begemann's review, "Rembrandt. The Master and His Workshop and Drawings by Rembrandt and His Circle," *Kunstchronik* 45, 1992, pp. 456–67.

15 According to Alfons K. L. Thijs, a total of 216 artists were listed as painters (see his "De Nijverheid," in *Antwerpen in de XVIIde eeuw*, Antwerp, 1989, p. 134). For the guild rolls, see Ph. Rombouts and Th. Van Lerius, *De Liggeren en andere historische archieven der Antwerpsche Sint Lucasgilde*, Antwerp and The Hague, 1864–76; reprint Amsterdam, 1961. For the Antwerp inventories, see also Erik Duverger, *Antwerpse kunstinventarissen uit de zeventiende eeuw* (*Fontes Historiae Artis Neerlandicae*), 6 vols., Brussels, 1984 ff.

16 Van der Stighelen 1991, pp. 293–98.

17 See Jan Briels, "De Antwerpse kunstverzamelaar Peeter Stevens (1590–1668) en zijn Constkamer," *Jaarboek Koninklijk Museum voor Schone Kunsten, Antwerpen*, 1980, pp. 137–226; Justus Müller Hofstede, in *Wort und Bild in der niederländischen Kunst und Literatur des 16. und 17. Jahrhunderts*, Erfstadt, 1984, pp. 254–61; Zirka Zaremba Filipczak, *Picturing Art in Antwerp 1550–1700*, Princeton, 1987; Ekkehard Mai, "Pictura in der 'constkamer'—Antwerpens Malerei im Spiegel von Bild und Theorie," in exh. cat. Cologne/Antwerp/Vienna 1992–93, pp. 39–54; and *David Teniers, Jan Brueghel y los gabinetes de pinturas*, exh. cat. by Matías Díaz Padrón and Mercedes Royo-Villanova, Madrid, Museo del Prado, 1992.

18 In 1631/32 Brouwer registered in the Antwerp guild of St. Luke as a master. Although his drawings are listed in old inventories, only two preliminary designs for etchings have found some acceptance as originals by him. See H. Scholz, "Brouwer delineavit. Zwei Federzeichnungen Adriaen Brouwers," *Zeitschrift für Kunstgeschichte* XLV, 1982, pp. 57–65; Konrad Renger, *Adriaen Brouwer und das niederländische Bauerngenre 1600–1660*, Munich, 1986; and idem, "Der Zeichner in der Kneipe. Das Fortleben einer Brouwer-Legende," *Was getekend... tekenkunst door de eeuwen heen; liber amicorum prof.dr. E. K. J. Reznicek* (*Nederlands Kunsthistorisch Jaarboek* 38, 1987), 1988, p. 282.

19 See especially Peter Schatborn, *Drawings by Rembrandt in the Rijksmuseum*, exh. cat., Amsterdam, 1985, nos. 55, 67–69, and idem, *Rembrandt. The Master & his Workshop*, exh. cat., Berlin/Amsterdam, 1991–92, nos. 33, 38, 48–51; reviewed by Egbert Haverkamp-Begemann in *Kunstchronik* 45, 1992, pp. 456–67 (see n. 14 above).

20 See Garff and Pedersen 1988; reviewed by Held 1991.

21 For Rubens, see Hollstein XX, nos. 1–3 (as attributed to Rubens); for Jordaens, see Hollstein IX, nos. 1–3, 5–7, 9, ill., and *Jacob Jordaens. tekeningen & grafiek*, exh. cat. by R.-A. d'Hulst, Antwerp, Museum Plantin-Moretus, 1978, nos. 103–09, ill.; for Van Dyck, see Hollstein VI, nos. 1–18; Mauquoy-Hendrickx 1991, nos. 1–18; New York/Fort Worth 1991, pp. 190–93; Antwerp 1991 (A), pp. 61–117; and Spicer 1993 (see n. 23 below).

22 Quoted from Held, in exh. cat. Williamstown 1977, no. 13.

23 I would like to thank Joaneath Spicer for sharing her forthcoming article on Van Dyck's *Iconography* with me (to be published among the papers of the Van Dyck symposium, Washington, D.C., 1993). In her opinion the sketch at Boughton House (published by Larsen 1988, pp. 483–84, as not Van Dyck) is indeed by Anthony van Dyck.

24 Mary L. Myers, "Rubens and the Woodcuts of Christoffel Jegher," *The Metropolitan Museum of Art Bulletin*, summer 1966, part one, pp. 7–23, figs. 21–22, and Held 1986, nos. 210–11, pls. 203–04, dated ca. 1632–34.

25 The book consists of articles published during the 1950s and 1960s, reissued in 1977 by the University of Liège. In contrast, Werner Sumowski's *Drawings of the Rembrandt School*, begun in 1979, discusses 50 draftsmen and approximately 2,000 authentic or substantiated drawings in the ten volumes published by 1992.

26 See D'Hulst 1974; idem, "Jordaens Drawings. Supplement I," *Master Drawings* XVIII, 1980, pp. 360–70, pls. 16–35; and idem, "Jordaens Drawings. Supplement II," *Master Drawings* XXVIII, 1990, pp. 142–72.

27 In 1959, Held discussed 172 individual drawings; in the 1986 edition he increased the number to 236.

28 Vey (1962) listed 308 drawings. Brown began the exhibition in New York/Fort Worth 1991, no. 1, with a detailed discussion of the so-called Antwerp sketchbook by Van Dyck at Chatsworth, drawings that Vey had excluded.

29 In 1972 Hans Vlieghe discussed the few extant drawings by Gaspar de Crayer in his monograph on the artist (see Vlieghe 1972). For additional drawings, see idem, "Gaspar de Crayer, Addenda et Corrigenda," *Gentse Bijdragen tot de Kunstgeschiedenis* XXV, 1979–80, pp. 158–207; idem, "Drawings by Gaspar de Crayer from the Ghent Album," *Master Drawings* XXVI, 1988, pp. 119–32; and Julius S. Held, "More on Gaspar de Crayer," *Master Drawings* XXVII, 1989, pp. 53–63.

Recent monographs on Flemish painters such as Klaus Ertz's on the elder Jan Brueghel (1979), Ursula A. Härting's on Frans Francken the Younger (1989), the volume on Frans Snyders by Hella Robels (1989), and on Gerard Seghers by Dorothea Bieneck (1992), or the Ph.D. dissertation by Ida Gertrude Wilmers on Cornelis Schut (1991), take drawings into account, although only occasionally attempting a full discussion. These studies nevertheless greatly increase our knowledge of their respective graphic œuvres, thus facilitating new attributions in the future.

In 1986 Jean-Pierre De Bruyn preceded his 1988 catalogue of the paintings of Erasmus II Quellinus (Antwerp 1607–1678 Antwerp) with an article on the drawings; not one has been identified in an American collection (see De Bruyn 1986, pp. 213–71). See also Jean-Pierre De Bruyn, "Erasmus II Quellinus (1607–1678) addenda en corrigenda," *Jaarboek…Antwerpen*, 1990, pp. 325–29; and idem "Officiële opdrachten aan Erasmus II Quellinus," *Jaarboek…Antwerpen*, 1983, pp. 211–60. The latter drawings were first attributed to Quellinus by Hans Vlieghe, in *Journal of the Warburg and Courtauld Institutes* XXXIX, 1976, pp. 190–98.

Virtually unknown as well are drawings by Thomas Willeboirts, called Bosschaert (Bergen-op-Zoom 1614–1654 Antwerp), who was much favored by the Dutch court in The Hague between 1641 and 1654, possibly because he painted so much in the style of Anthony van Dyck. Axel Heinrich, who is preparing a catalogue of Willeboirts's paintings (Ph.D. diss. Göttingen), assembled some sixteen drawings, mostly of mythological subjects, among them the sheet at the Yale University Art Gallery, the DEIFICATION OF AENEAS, which he accepted based on the old annotation (letter of 22 January 1992).

No drawing has been securely attributed to Jacob van Oost the Elder (Bruges 1603–1671 Bruges), the most dominant representative of the school of Bruges in the mid-seventeenth century; his work is still found primarily in that city; see Jean Luc Meulemeester, *Jacob van Oost de Oudere en het zeventiende-eeuwse Brugge*, Bruges, 1984, pp. 187–88, fig. 157.

30 Van der Stighelen 1989, pp. 322–40.

31 143 x 98 mm; Colsoul 1989, no. 13, figs. 15–16, from the 1650s. See Carlos van Hasselt, in exh. cat. Paris 1972, no. 36, for a discussion of Franchoys's chalk drawings.

32 Greindl 1983, p. 354, nos. 288–92 (signed drawings) and nos. 293–301 (unsigned drawings). The STUDIO STILL LIFE WITH PEACOCK (her no. 288), which she considered a preliminary study for Fyt's STILL LIFE in the Kunsthistorisches Museum, Vienna (Inv. no. 1171), is now in the Robert Lehman Collection, The Metropolitan Museum of Art, New York (Inv. no. 1975.1.831; see New York 1979, no. 55, ill.). The inscription and date, *Jan fyt 1672*, are later and the drawing more likely is a copy.

33 Julius S. Held, "Some Studies of Heads by Flemish and Dutch Seventeenth-Century Artists," *Master Drawings* XXIII–XXIV, 1986, pp. 46–53, pls. 20–25.

34 Jeremy Wood has attributed a further group of black chalk copies after Primaticcio's frescoes to Theodoor van Thulden himself. They closely relate to Van Thulden's etchings of 1633, LES TRAVAUX D'ULYSSE, and are in the same (unreversed) direction as the originals; see Wood 1990, pp. 22–23 and figs. 7–12, 28–30, 33–40, for a comparison between the copies after Primaticcio in the Albertina (attributed by Wood to Van Diepenbeeck), the additional series with lengthy pen and ink inscriptions in various public and private collections (attributed to Van Thulden), and Van Thulden's reversed etchings. Wood included a list of these drawings he recently attributed to Van Thulden under his note 82. To these should be added a drawing in the Print Room, Leiden, that Sylvie Béguin published in exh. cat. 's-Hertogenbosch/Strasbourg 1991–92, pp. 105, 108. Wood returned to this problem in his review, "'s-Hertogenbosch and Strasbourg. Theodoor van Thulden," *Burlington Magazine* CXXXIV, 1992, p. 328.

35 For example, the two drawings in the British Museum, London, that Hind published as Van Thulden's preliminary designs for the two etchings in the *Pompa Introitus*, THE PASSAGE OF CARDINAL-INFANTE FERDINAND FROM BARCELONA TO GENOA and THE MEETING OF THE TWO FERDINANDS AT NÖRDLINGEN, but that Alain Roy interpreted as copies. (Martin 1972, under nos. 3 and 4, also considered them to be copies.) While the drawings are copies after Rubens's paintings in Dresden and Vienna, Hind's opinion, nevertheless, should be reconsidered. Both prints are signed on the plate *Th.a.Thulden delin.et/scalps*, indicating that Van Thulden did prepare preliminary drawings, which he then etched himself in the same sense as Rubens's compositions. (See Hind 1923, p. 141, nos. 1–2, pl. LXXIII; Roy, in exh. cat. 's-Hertogenbosch/Strasbourg 1991–92, p. 273, nos. 6–7.)

36 Held 1959, p. 8, n. 1, figs. 8–9, and idem 1986, p. 11, where he mentions a "very large number of drawings of markedly Rubenesque character...." In his opinion Van Diepenbeeck deserves a special study, as there is "good reason to suspect that the real range of his drawing style has not yet been determined."

37 Logan, in exh. cat. Antwerp/Münster 1990, p. 126, fig. 85.

38 Hans Vlieghe, "Rubens' beginnende invloed. Arnout Vinckenborch en het probleem van Jordaens' vroegste tekeningen," in *Was getekend...tekenkunst door de eeuwen heen; liber amicorum prof.dr. E. K. J. Reznicek* (*Nederlands Kunsthistorisch Jaarboek* 38, 1987), 1988, pp. 383–96. See also Erik

Duverger, "Arnout Vinckenborch, een weinig bekend schilder te Antwerpen uit het begin van de XVIIᵉ eeuw," *Jaarboek...Antwerpen*, 1973, pp. 233–46.

39 D'Hulst 1974, nos. A8–A20, figs. 8–20.

40 Hans Vlieghe, "Zwischen van Veen und Rubens. Artus Wolffort (1581–1641), ein vergessener Antwerpener Maler," *Wallraf-Richartz-Jahrbuch* XXXIX, 1977, p. 117, fig. 42 (Louvre, Paris, Inv. no. 20.019; Lugt 1949, no. 1248, pl. LXXVI); and p. 124, fig. 54 (SMPK, Berlin, Inv. no. 14643; pen and ink, 413 x 287 mm, in the "2. Garnitur"). See also idem, "Nog wat over Wolffort, zijn atelier en Van Lint," in *Kolveniershof en Rubenianum, Feestbundel*, Antwerp, 1981, pp. 85–87; and Julius S. Held, "Noch einmal Artus Wolffort," *Wallraf-Richartz-Jahrbuch* XLII, 1981, pp. 143–56, where he attributed two head studies in the Musées Royaux des Beaux-Arts in Brussels to the artist.

41 D'Hulst 1974, no. 7, fig. 7.

42 Eric Hebborn, *Drawn to Trouble. The Forging of an Artist*, Edinburgh, 1991, p. 251, fig. 58.

43 *The 17th Century. The Golden Age of Flemish Painting*, exh. cat., Tokyo, Fuji Art Museum, 1988; *The Golden Age of Flemish Painting*, exh. cat. by Arnout Balis, Taiwan Museum of Art, 1988; and *Fiamminghi*, exh. cat. by Caterina Limentani Virdis and Davide Banzato, Padua, 1990.

44 Briels 1987 and the volumes published in the series of *Flandria extra muros*, here abbreviated as Balis et al. 1987, 1989, 1992.

45 *Il tempo di Rubens*, exh. cat., Florence, Palazzo Medici-Riccardi, 1986–87; *Il tempo di Rubens*, exh. cat., Genoa, Museo di Sant'Agostino, 1987; *Meesterwerken uit het Stedelijk Prentenkabinet van Antwerpen. Tekeningen uit de XVIᵈᵉ en XVIIᵈᵉ eeuw*, exh. cat., Antwerp, Museum Plantin-Moretus and Stedelijk Prentenkabinet, 1988; *Rondom Rubens. Tekeningen en prenten uit eigen verzameling*, exh. cat., Antwerp, Museum Plantin-Moretus and Stedelijk Prentenkabinet, 1991; and Antwerp 1991 (A).

46 Jacques Wilhelm, who investigated Van Egmont's activity in France, did not refer to any drawings. See his "Le décor peint de la grand' salle du château de Balleroy," *Bulletin de la Société de l'Histoire de l'Art français, 1985*, Paris, 1987, pp. 61–84; and idem, "Portraits peints à Paris par Juste d'Egmont," *Bulletin de la Société de l'Histoire de l'Art français, 1987*, Paris, 1989, pp. 25–44. Van Egmont's signed pen-and-ink drawing, THE QUEEN OF SHEBA BEFORE SOLOMON, is entirely different in execution from the drawings exhibited here (Inv. no. GW 1602, Print Room, Leiden).

47 Julius S. Held, "Two Drawings by Philip Fruytiers," *Art Quarterly* XXVII, 1964, p. 272.

48 See Haverkamp-Begemann and Logan 1970. In their survey of "Private Collections of Old Master Drawings in America in the Twentieth Century," in *Master Drawings. The Woodner Collection*, exh. cat., London, Royal Academy of Arts, 1987, pp. 8–14, Nicholas Turner and Jane Shoaf Turner mentioned neither the drawing collection at the Yale University Art Gallery nor the more than 15,000 English drawings that Paul Mellon presented to the Yale Center for British Art between 1977 and the present.

49 Stechow 1976, no. 290, fig. 149. The corresponding painting is in the Blaffer Foundation in Houston, Texas (Vlieghe 1972, no. 76, fig. 131; Jaffé 1989, no. 117).

50 See Anne-Marie Logan, *Dutch and Flemish Drawings and Watercolors*, New York, 1988. See also *A Catalogue of Drawings and Watercolors*, exh. cat., Raleigh, North Carolina Museum of Art, 1969 and *W. R. Valentiner Memorial Exhibition. Masterpieces of Art*, exh. cat., Raleigh, North Carolina Museum of Art, 1959, an exhibition on Valentiner's achievements during fifty years of service in American museums.

51 The Ringling Museum in Sarasota does, however, preserve a drawing from the Rubens school, ST. JAMES THE ELDER, most likely a design for a print (see William H. Wilson, *Masterworks on Paper. Prints and Drawings from the Ringling Museum 1400–1900*, Sarasota, ca. 1977, no. 70, ill. in color on cover), and a STUDY OF A HOUND by Jan Fyt (no. 51, ill.).

52 Inv. no. 59.55.1008; pen and brown ink and brown wash, 260 x 197 mm (10¼ x 7¾ in.); from the collection of Mrs. A. Bethell. See Logan 1978, p. 446.

53 Inv. no. 75.190.4E; pen and brown ink, brown wash, heightened with white, over sketch in black chalk, 136 x 115 mm. Discussed in an unpublished paper by J. Eikelenboom Smits (1986). It seems doubtful that the lion is really dispensing justice, as the title of the drawing (here reproduced as figure V) states. A seventh drawing was sold at Sotheby's, London, 13 December 1973, lot 89, as ST. IVO. Jeremy Wood identified an eighth sheet that was sold at Sotheby's, London, on 30 October 1980, lot 114, depicting Athena stepping on the succumbed lion (letter of 17 September 1992). A ninth drawing, THE WEDDING, was formerly with the H. Shickman Gallery, New York; see Lorenz Eitner, B. G. Fryberger, and C. M. Osborne, *Stanford University Museum of Art/The Drawing Collection*, Stanford, California, 1993, no. 32 and fig. 23.

54 See *National Gallery of Art, 1984 Annual Report*, Washington, D.C., 1985, pp. 19, 35–43, and *National Gallery of Art, 1985 Annual Report*, Washington, D.C., 1986, pp. 49–55.

THE PLATES

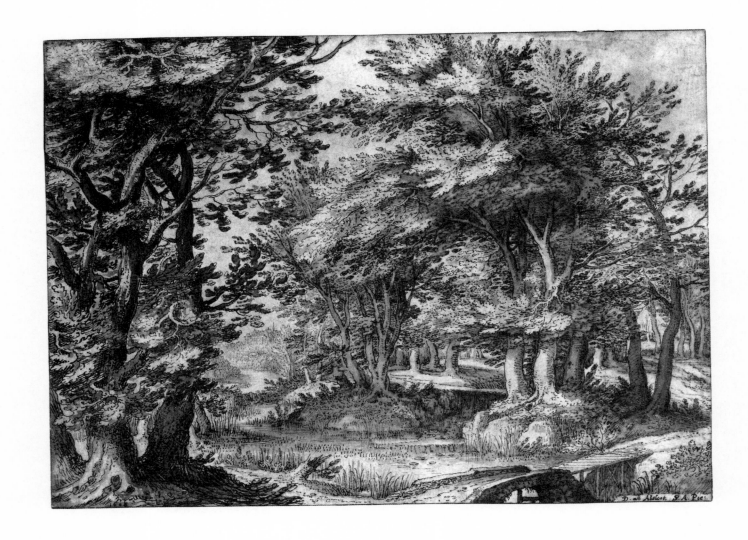

Denijs van Alsloot

FOREST LANDSCAPE WITH A DISTANT CASTLE

1

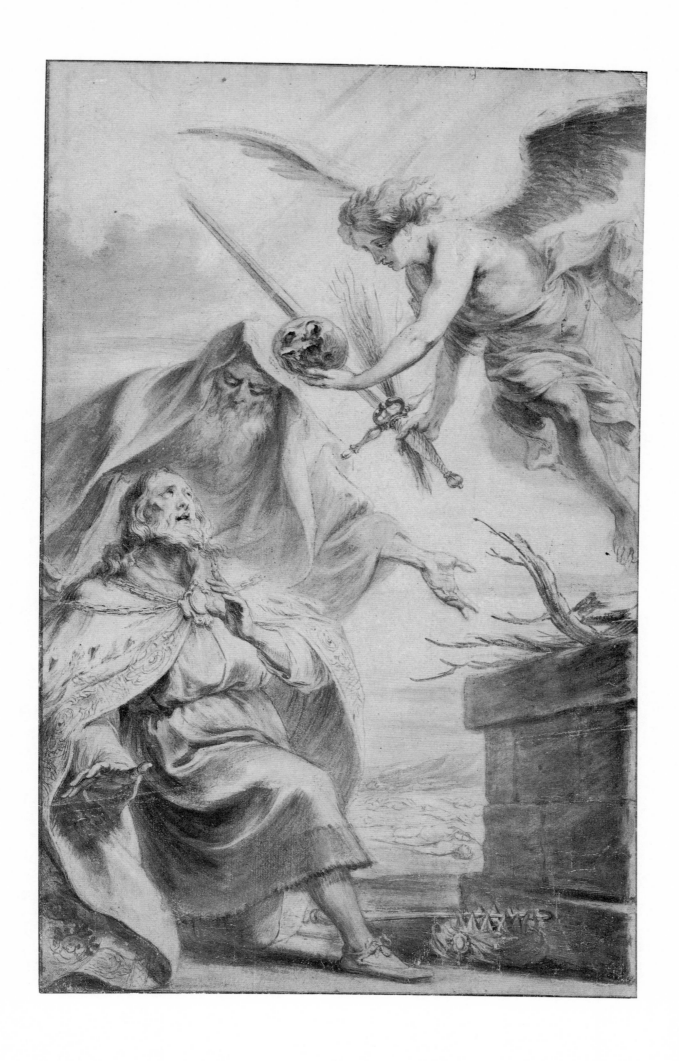

Jan Boeckhorst

DESIGN FOR "KING DAVID, THE PROPHET GAD AND THE ANGEL OF DEATH"

2

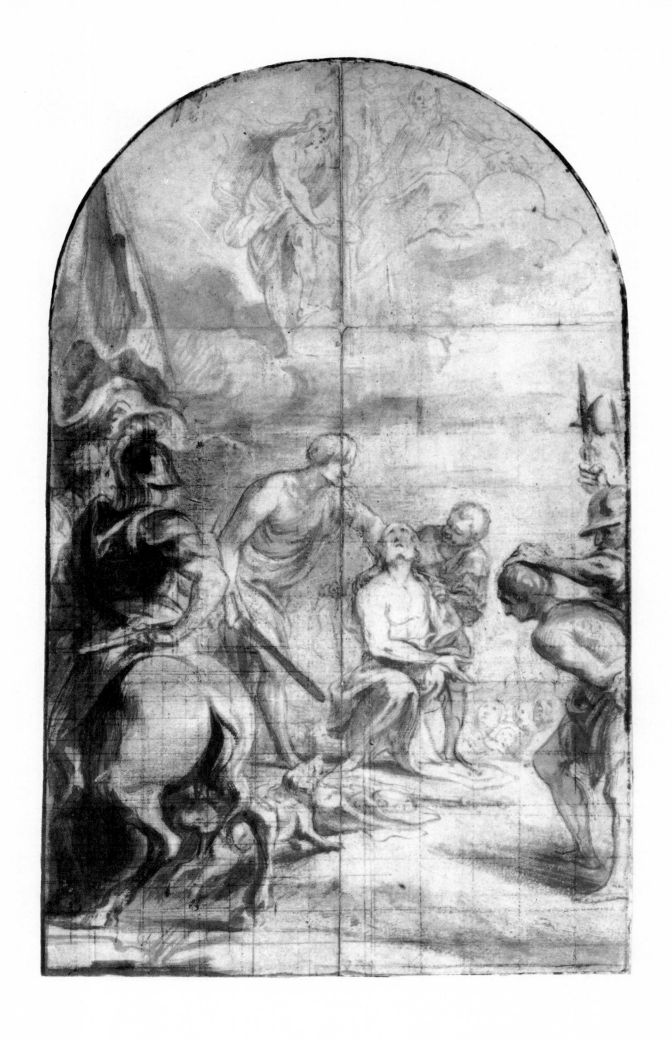

Jan Boeckhorst

THE MARTYRDOM OF ST. JAMES

3

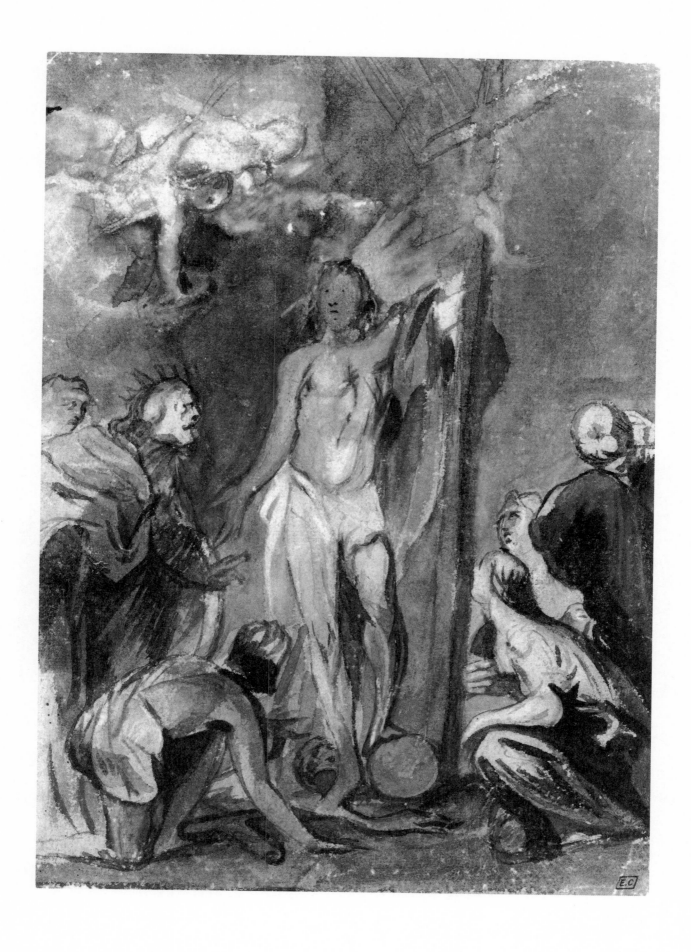

Jan Boeckhorst

THE RISEN CHRIST, SURROUNDED BY SAINTS

4

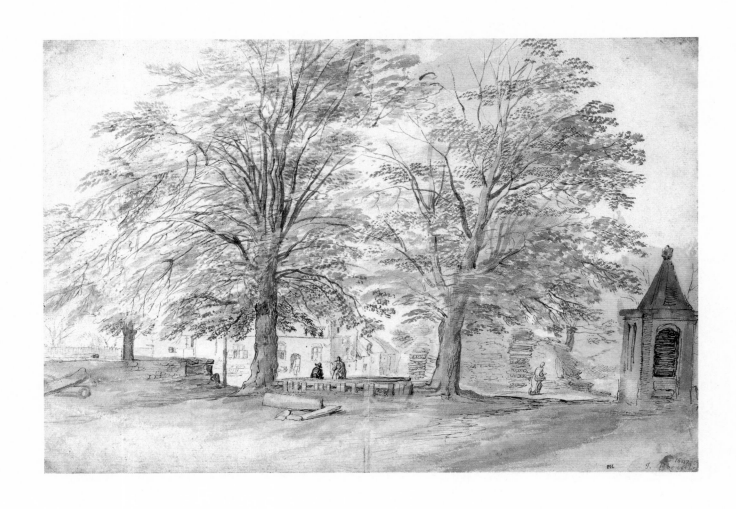

Jan Brueghel the Elder

VILLAGE MEETING PLACE UNDER TWO OLD TREES

5

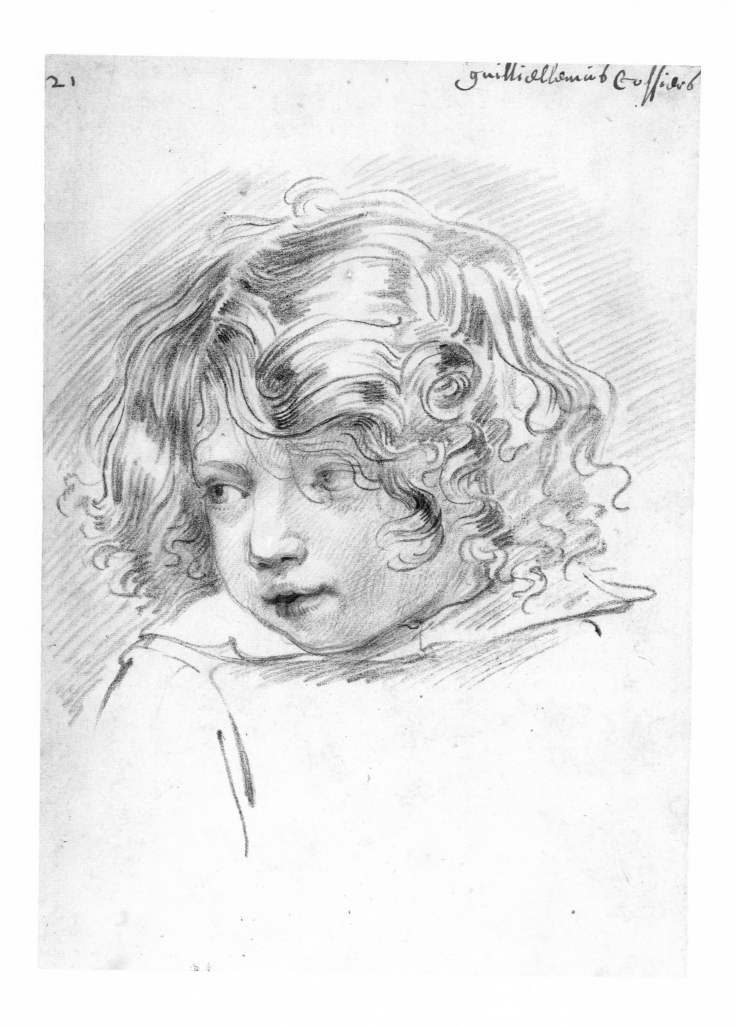

21

guilliellemus Cossiers

Jan Cossiers

PORTRAIT OF THE ARTIST'S SON GUILLIELLEMUS

6

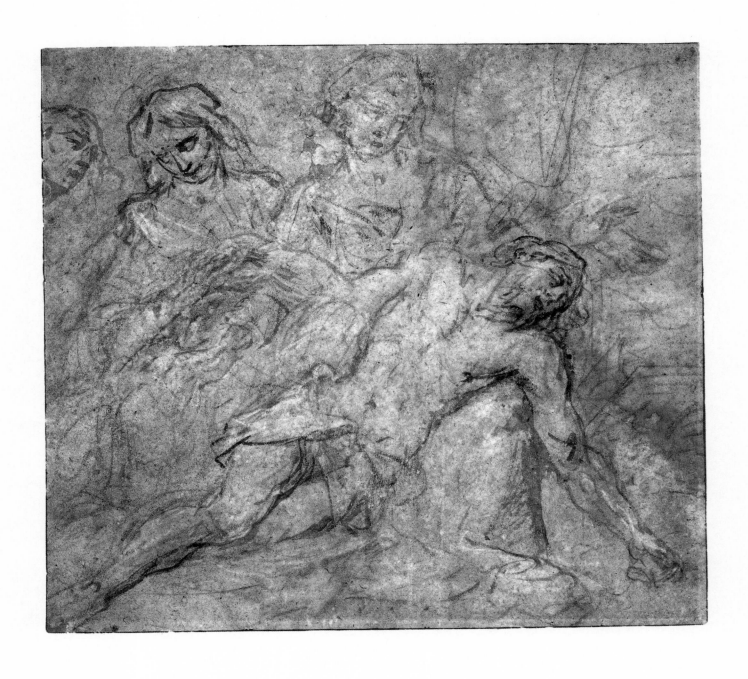

Gaspar de Crayer (*attributed to*)

THE LAMENTATION

7

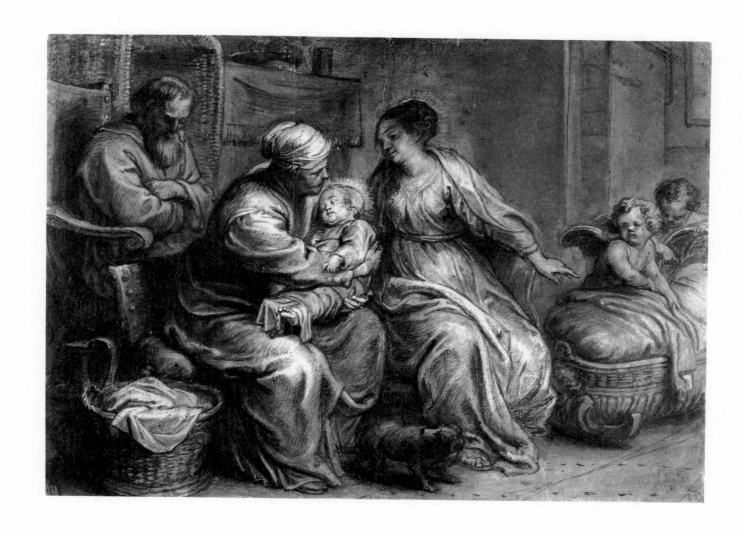

Abraham van Diepenbeeck

THE HOLY FAMILY WITH ST. ANNE HOLDING THE CHILD

8

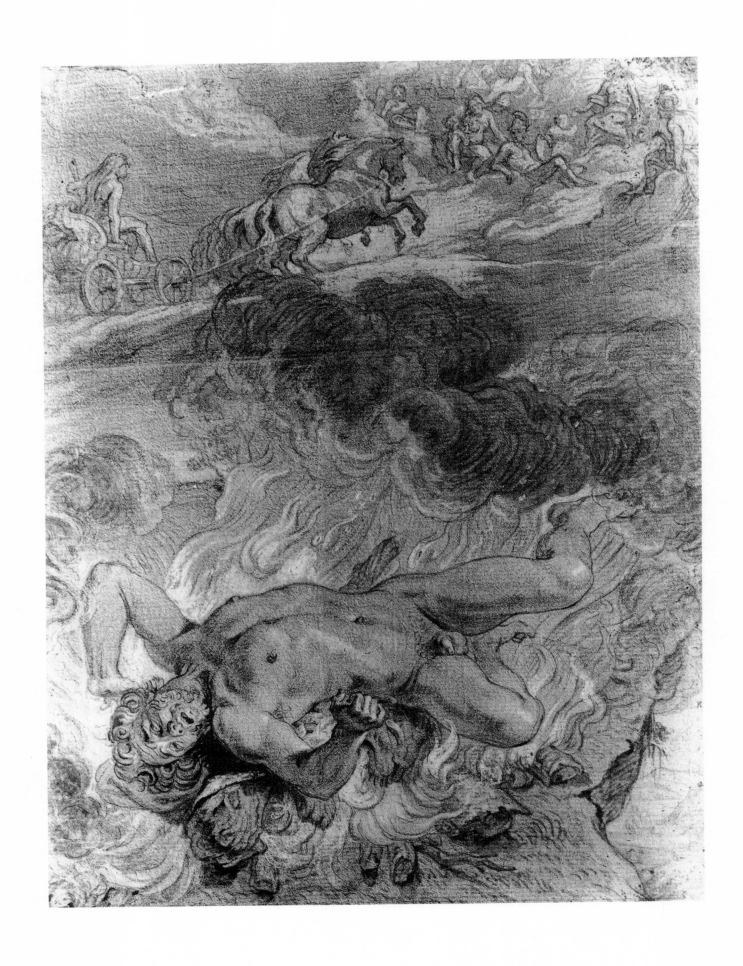

Abraham van Diepenbeeck

THE DEATH OF HERCULES

9

Abraham van Diepenbeeck

DESIGN FOR THE TITLE PAGE TO THE "COSTUMEN VAN HET GRAFSCHAP VAN VLAENDEREN"

10

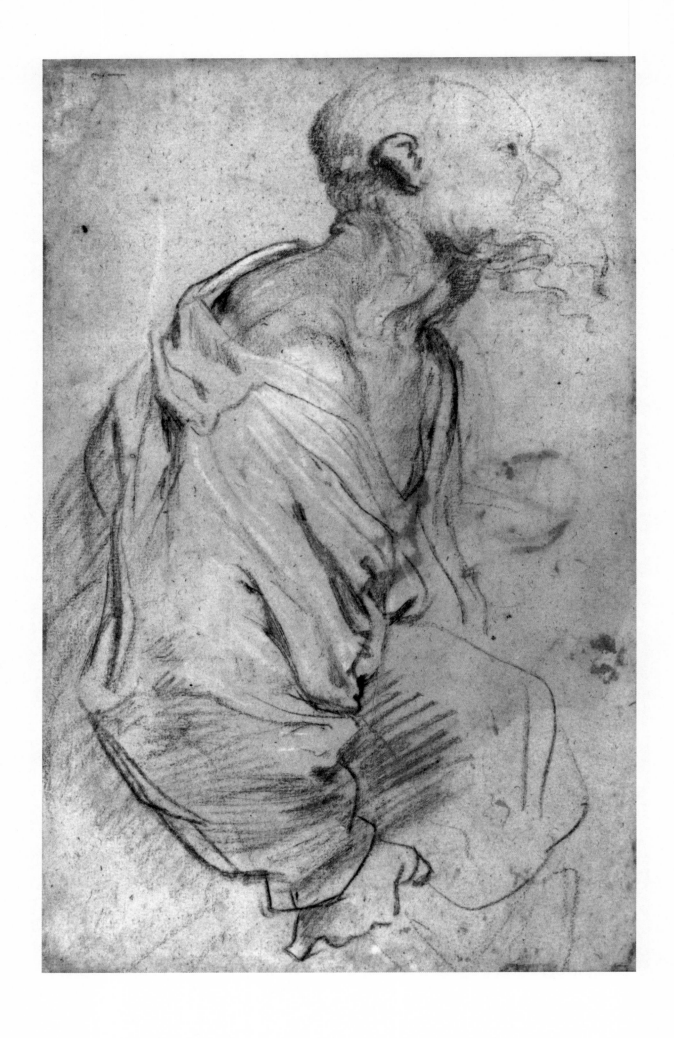

Anthony van Dyck

A BEARDED OLD MAN HOLDING A BUNDLE *recto*

11

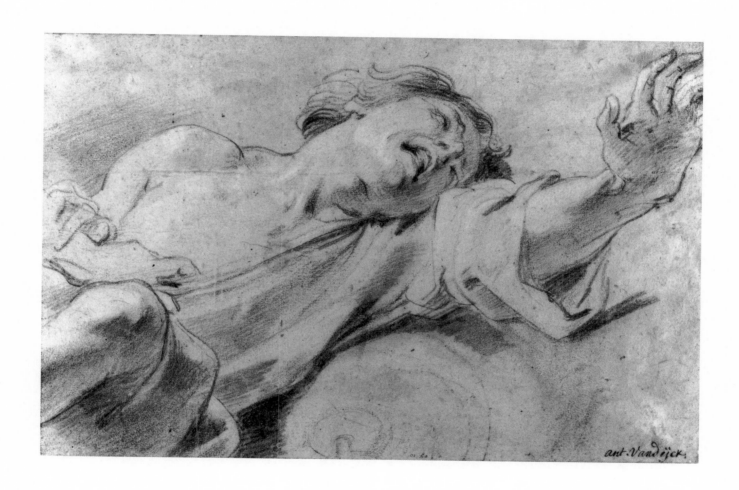

Anthony van Dyck

STUDY FOR THE FIGURE OF MALCHUS

12

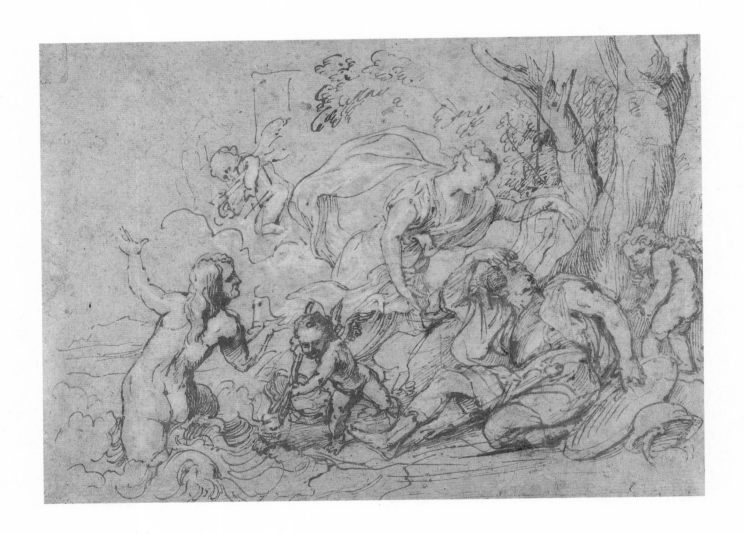

Anthony van Dyck

RINALDO AND ARMIDA

13

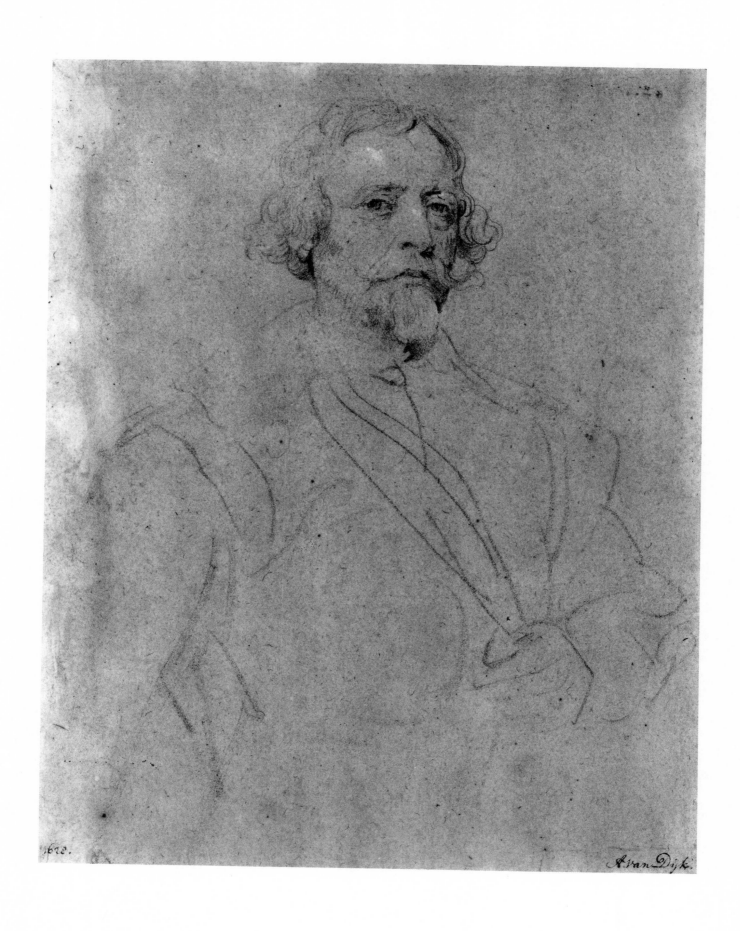

Anthony van Dyck

PORTRAIT OF CARLOS COLOMA (1573–1637)

14

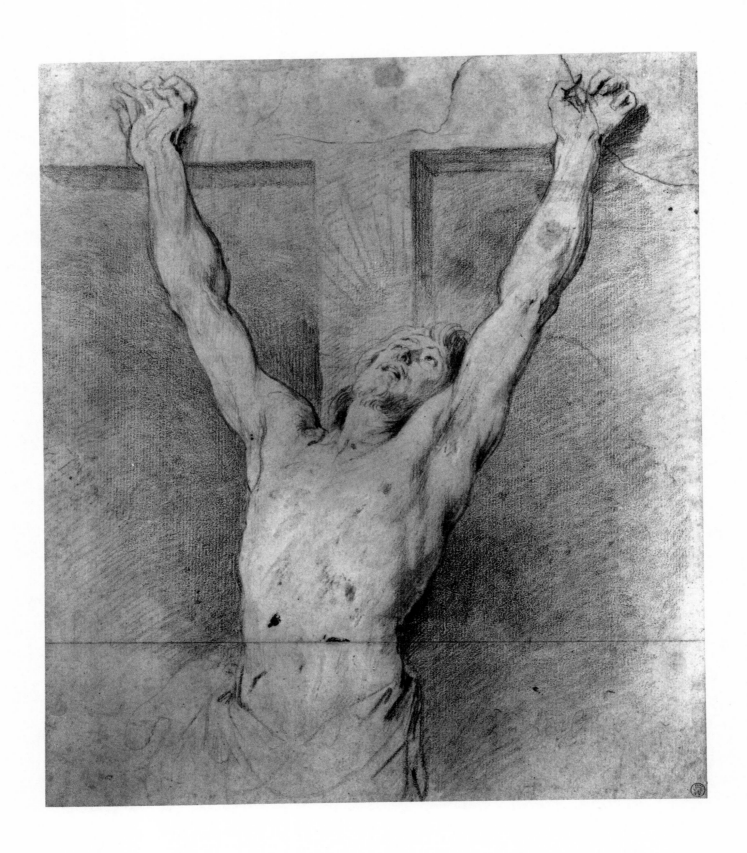

Anthony van Dyck (*attributed to*)

CHRIST ON THE CROSS

15

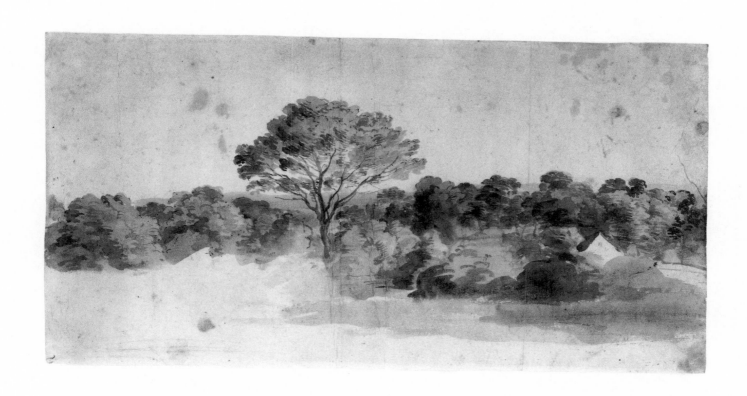

Anthony van Dyck

LANDSCAPE WITH A TALL TREE

16

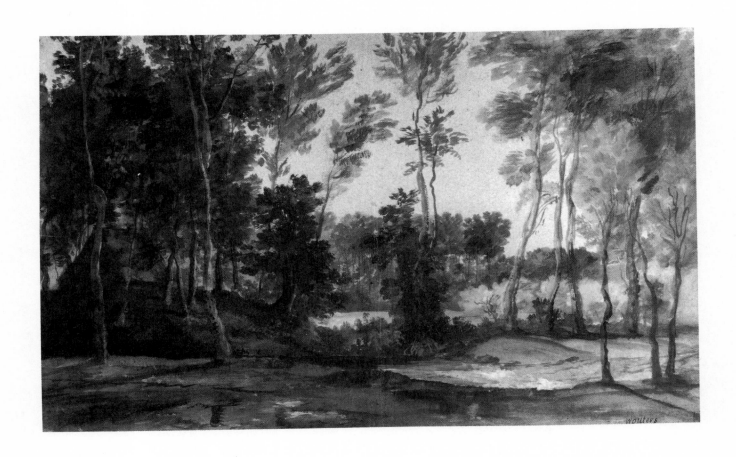

Anthony van Dyck (*school of*)

CLEARING IN THE WOODS

17

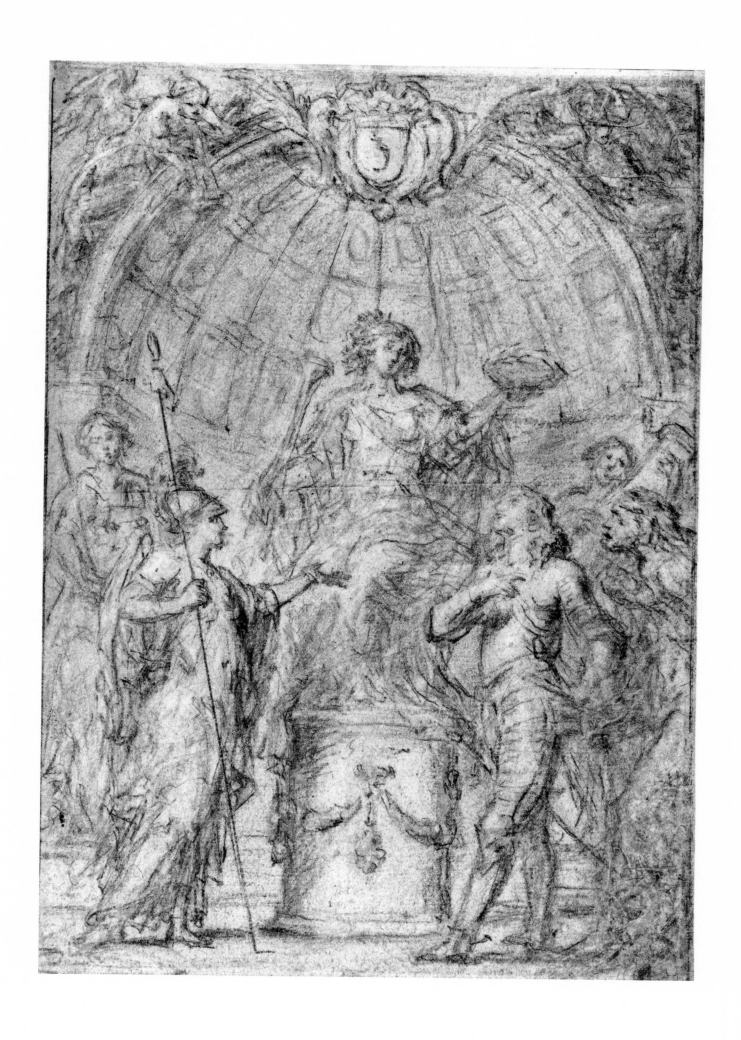

Justus van Egmont

FAME CROWNING A VICTORIOUS GENERAL, DESIGN FOR A FRONTISPIECE (?)

18

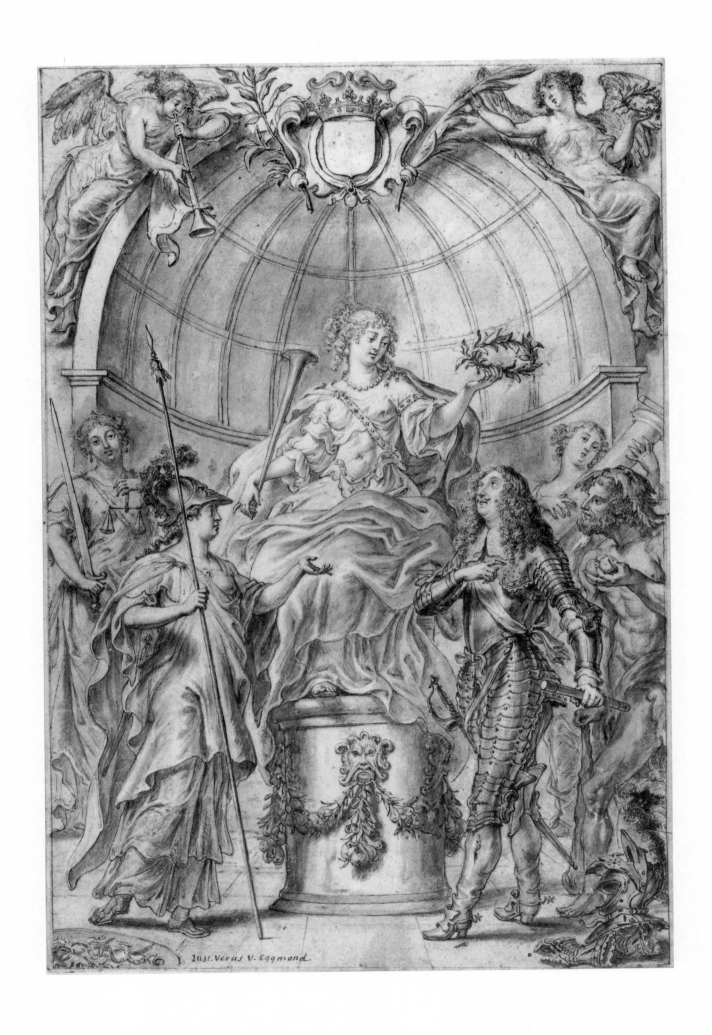

Justus van Egmont

FAME CROWNING A VICTORIOUS GENERAL, DESIGN FOR A FRONTISPIECE (?)

19

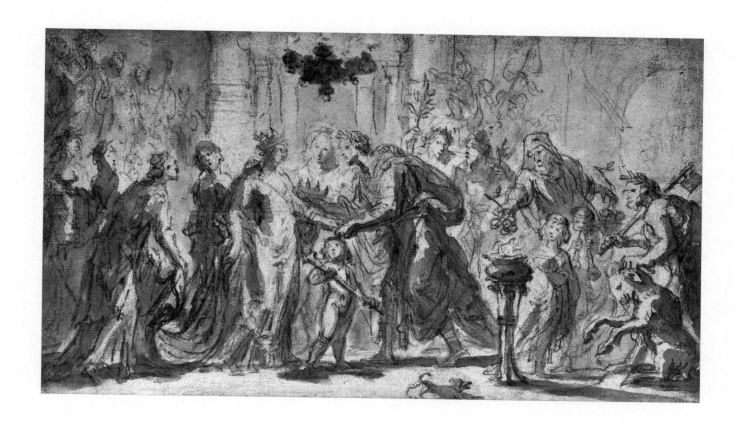

Justus van Egmont

THE MARRIAGE OF ZENOBIA AND ODENATUS

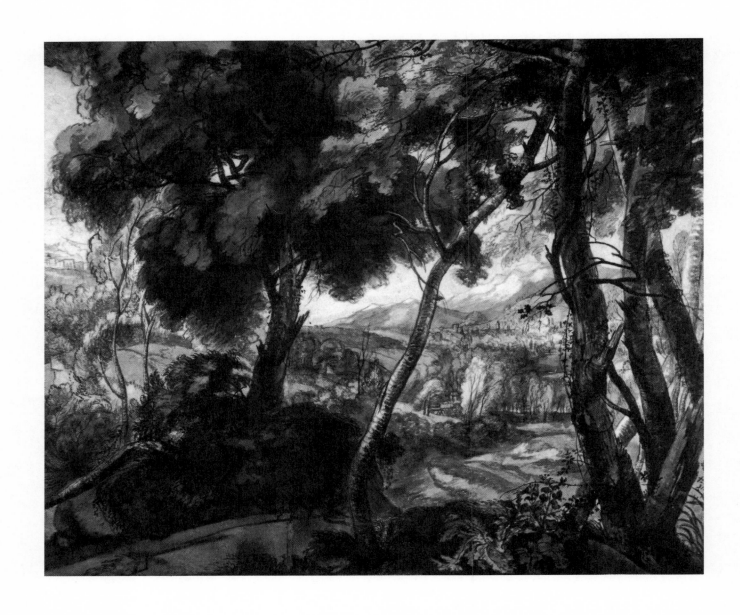

Jacques Foucquier

LANDSCAPE WITH TREES AT THE EDGE OF A FOREST

21

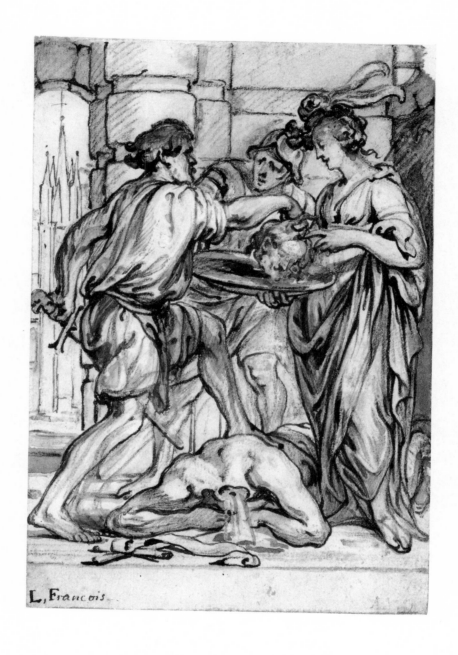

Lucas Franchoys the Younger

SALOME RECEIVING THE HEAD OF ST. JOHN THE BAPTIST

22

Frans Francken the Younger

SCENE OF A CONSECRATION

23

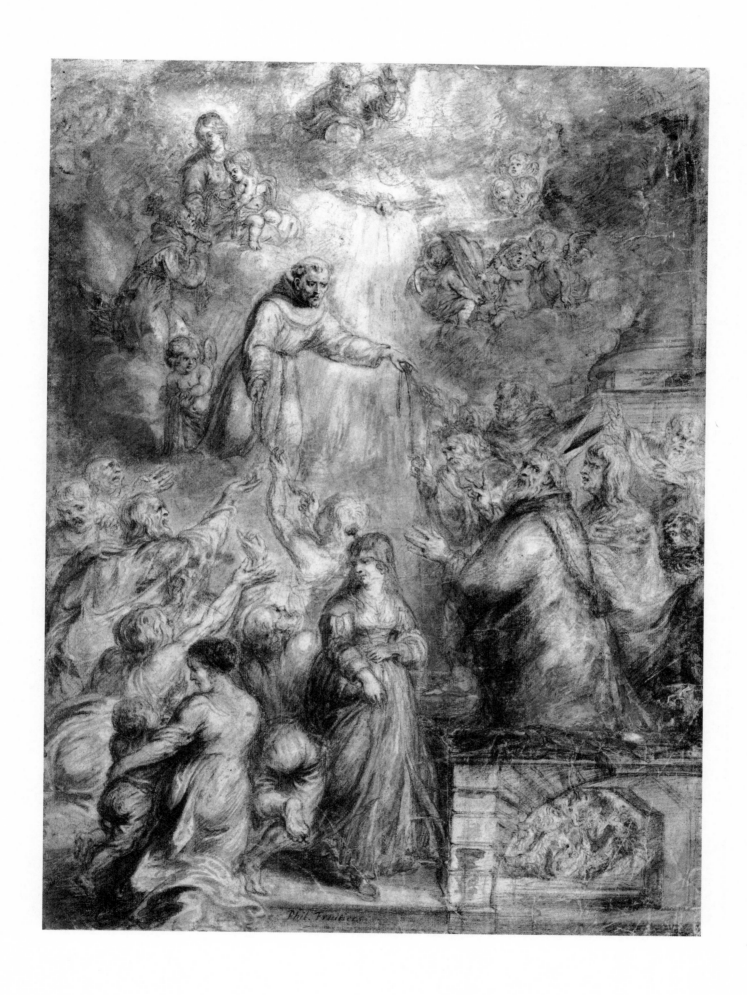

Philip Fruytiers

THE DISTRIBUTION OF FRANCISCAN CORDS

24

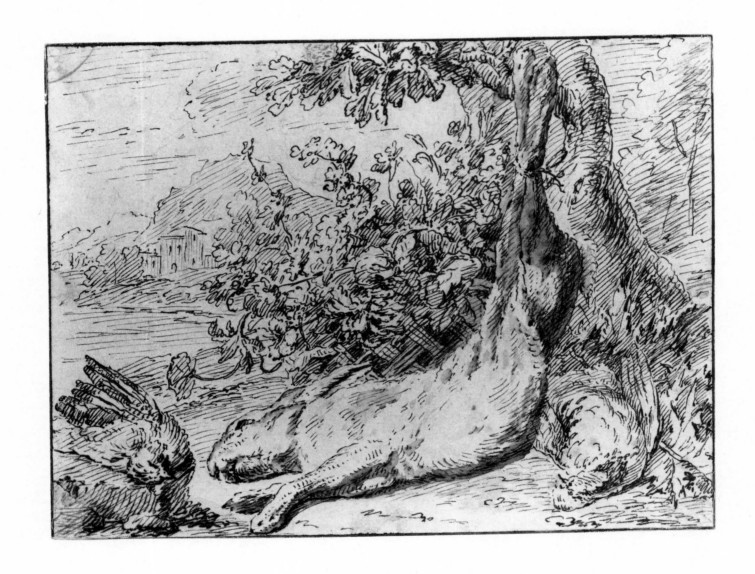

Jan Fyt

DEAD GAME IN A LANDSCAPE

25

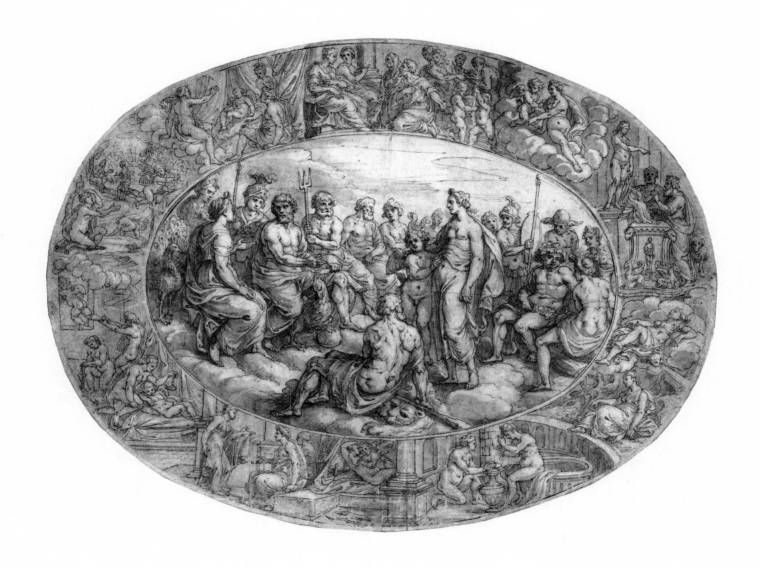

Pieter de Jode

DESIGN FOR A SALVER WITH THE STORY OF CUPID AND PSYCHE

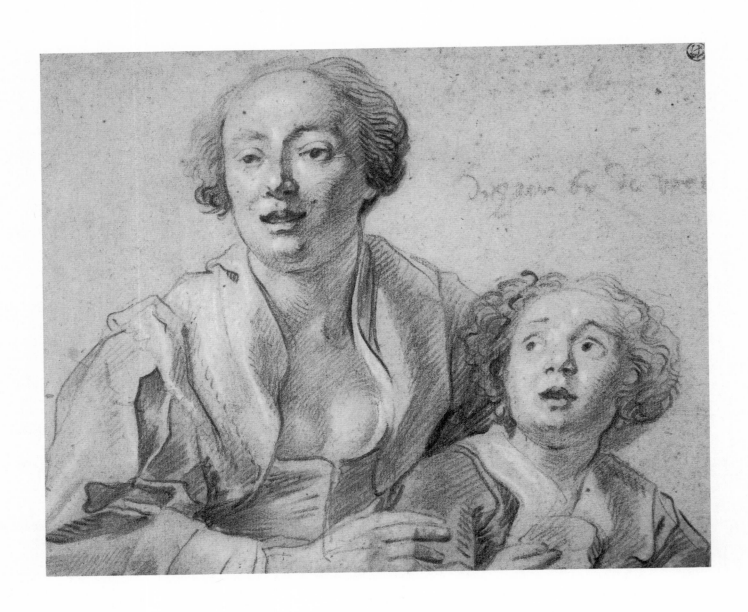

Jacob Jordaens

MOTHER AND CHILD

27

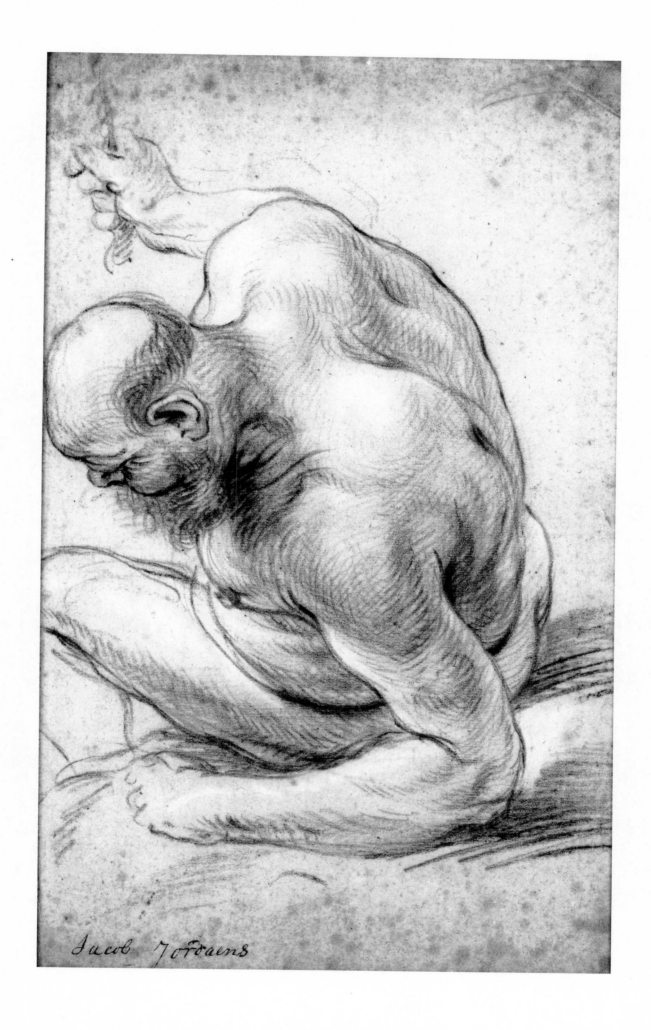

Jacob Jordaens

NUDE OLD MAN SEATED

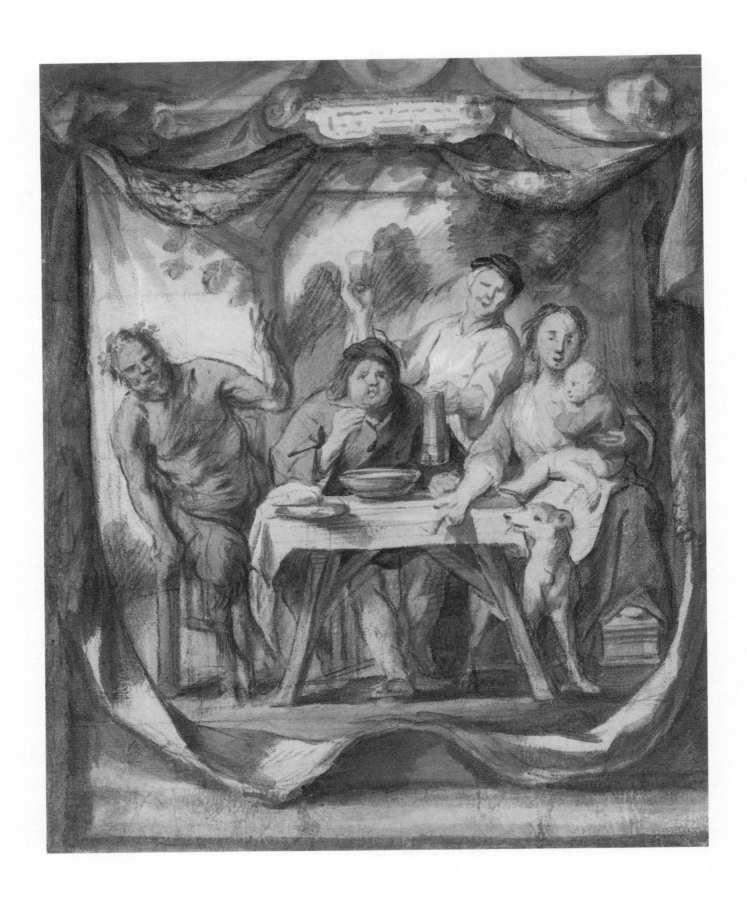

Jacob Jordaens

THE SATYR AND THE PEASANT

29

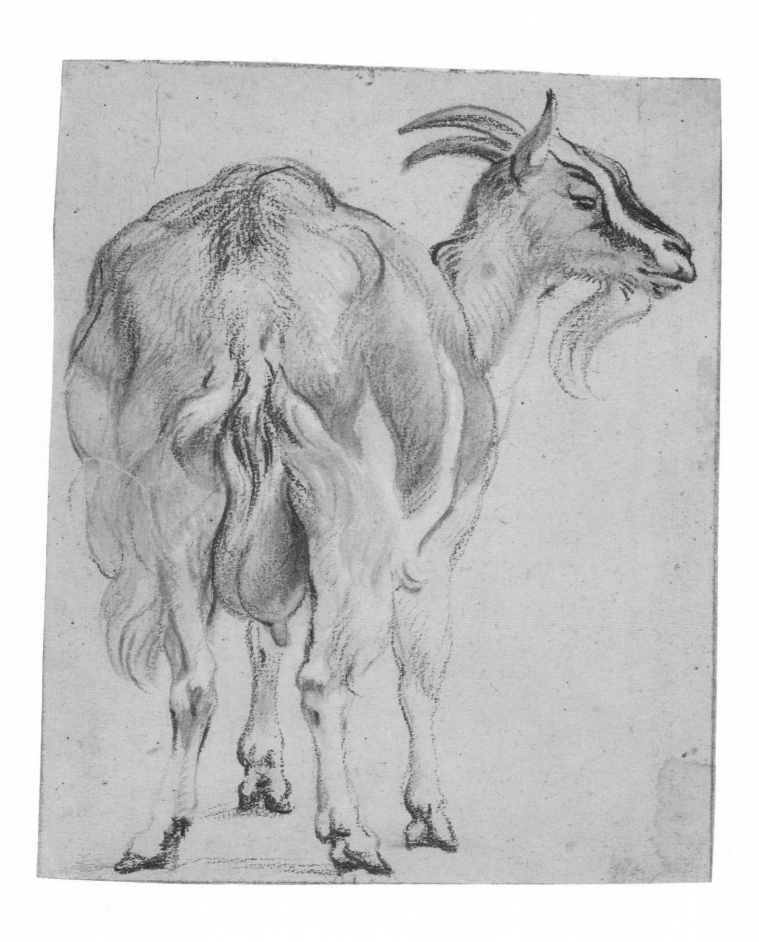

Jacob Jordaens

GOAT

30

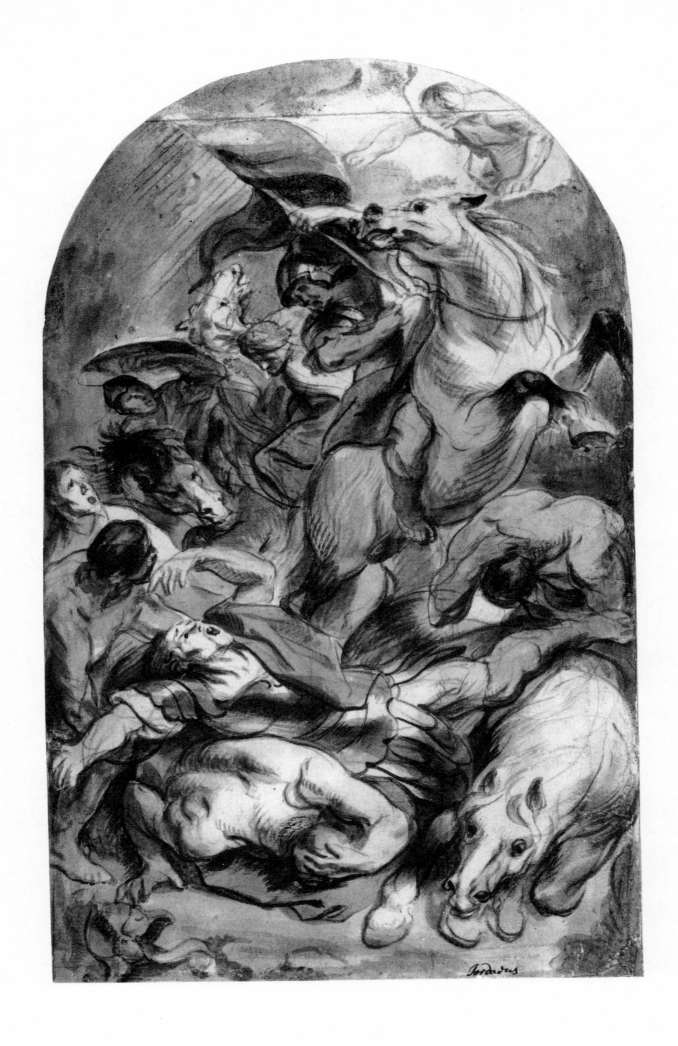

Jacob Jordaens

CONVERSION OF ST. PAUL WITH HORSEMAN AND BANNER

31

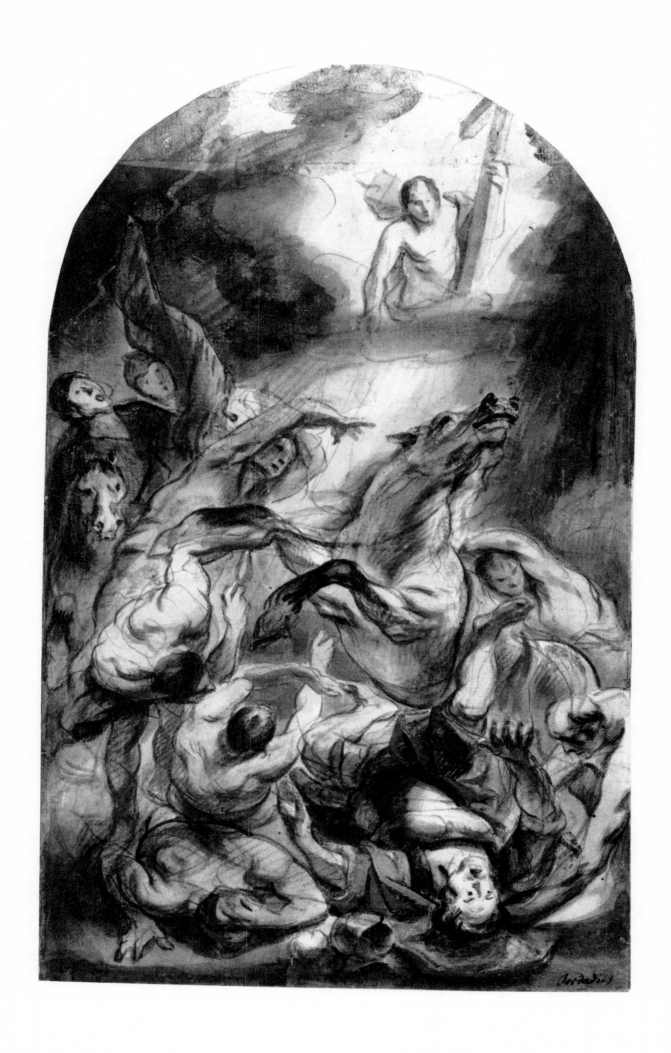

Jacob Jordaens

CONVERSION OF ST. PAUL WITH CHRIST AND THE CROSS

32

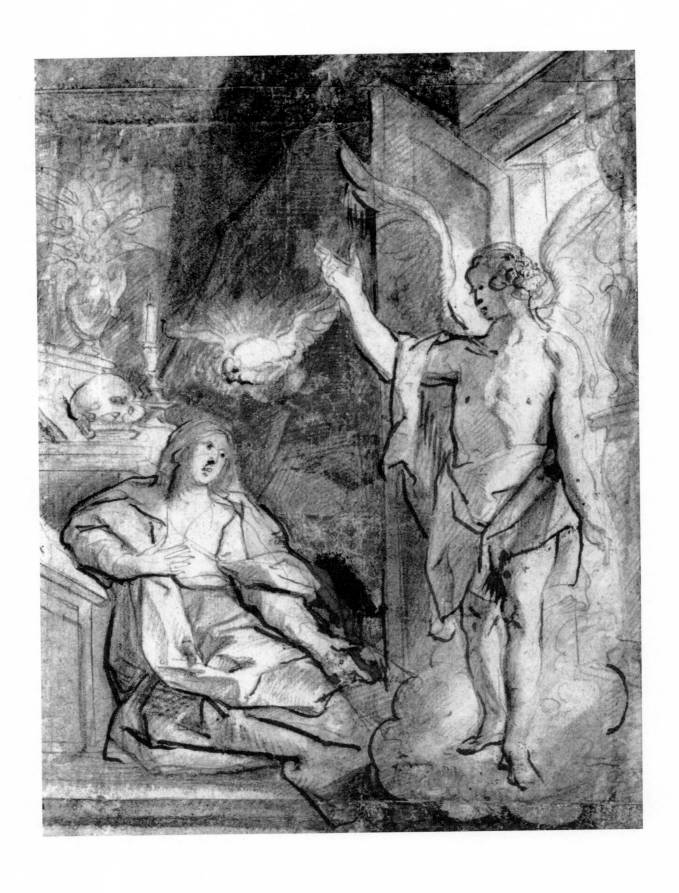

Jacob Jordaens

ANNUNCIATION TO THE VIRGIN

33

die hier te veele van my hiel
verloor gesonthijdt goed en ziel

Pieter van Lint

VENUS DE' MEDICI, SEEN FROM THE FRONT

34

Jan I Peeters

VIEW OF MECCA

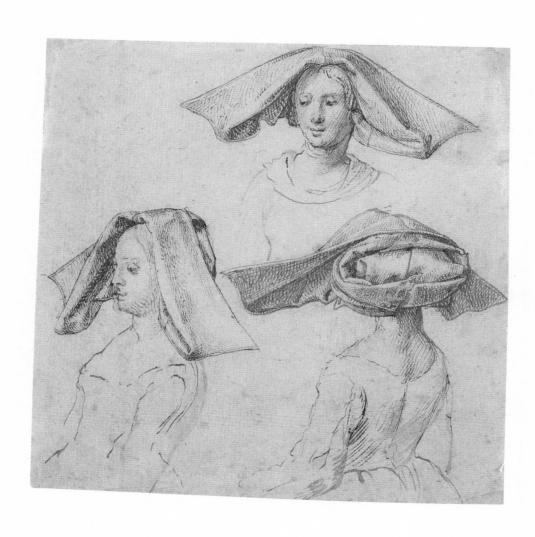

Anonymous, northern Netherlands (?), retouched by Peter Paul Rubens

THREE STUDIES OF A WOMAN WEARING AN ELABORATE HEADDRESS

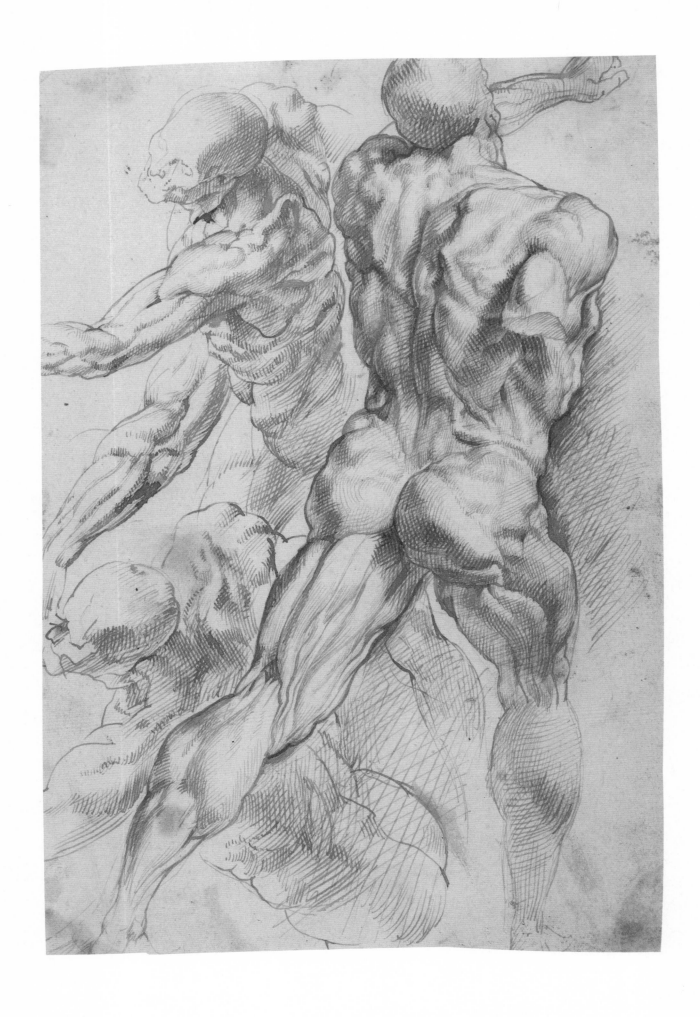

Peter Paul Rubens

ANATOMICAL STUDIES

37

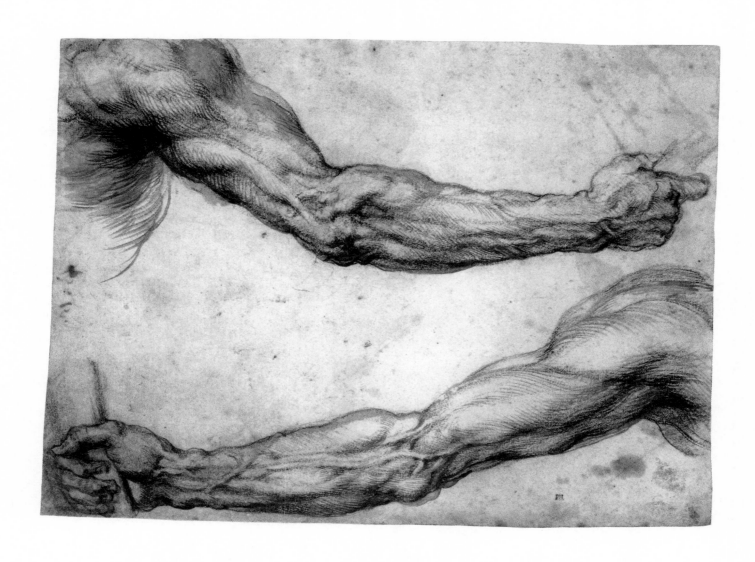

Bartolomeo Passarotti, retouched by Peter Paul Rubens

TWO STUDIES OF AN ARM

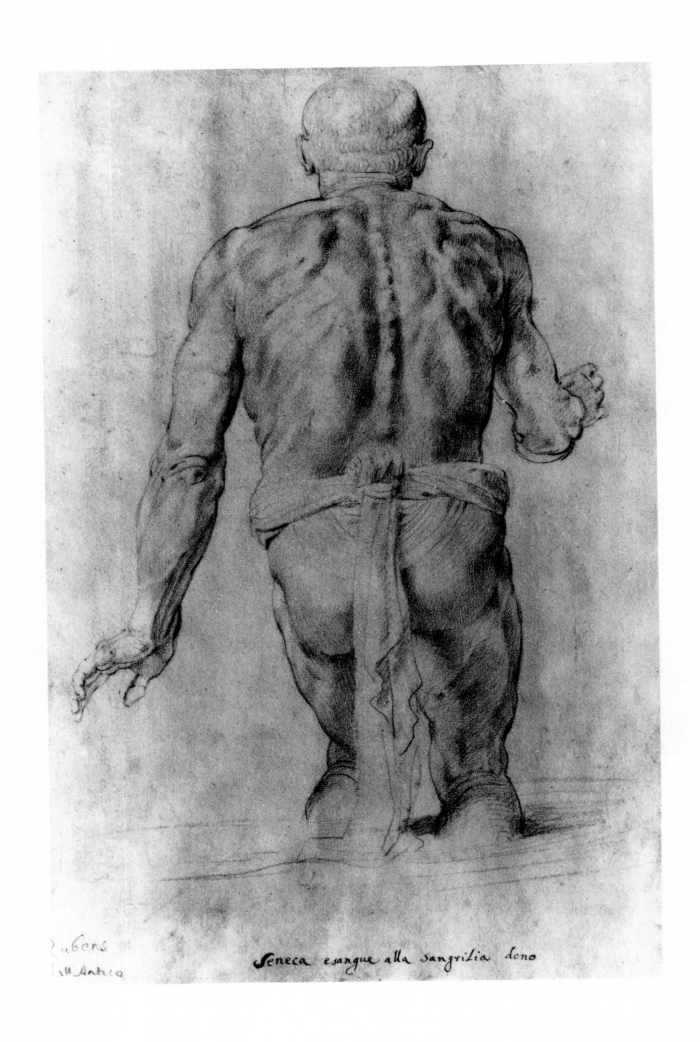

Peter Paul Rubens

THE AFRICAN FISHERMAN SEEN FROM THE BACK (DYING SENECA)

39

Peter Paul Rubens

THE DEATH OF DIDO

40

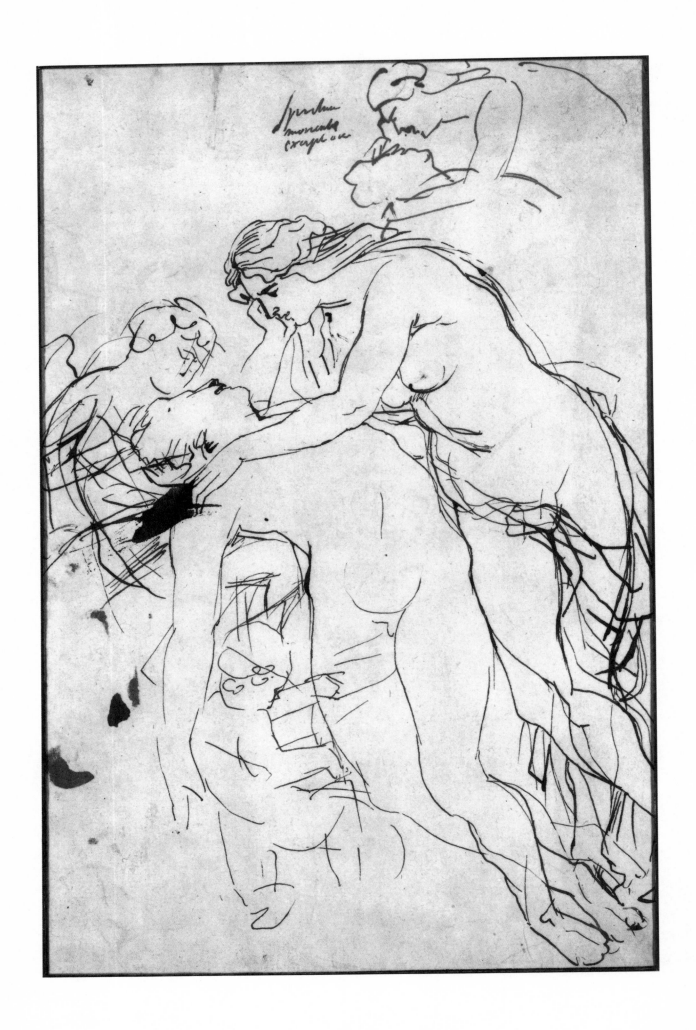

Peter Paul Rubens

VENUS LAMENTING ADONIS

41

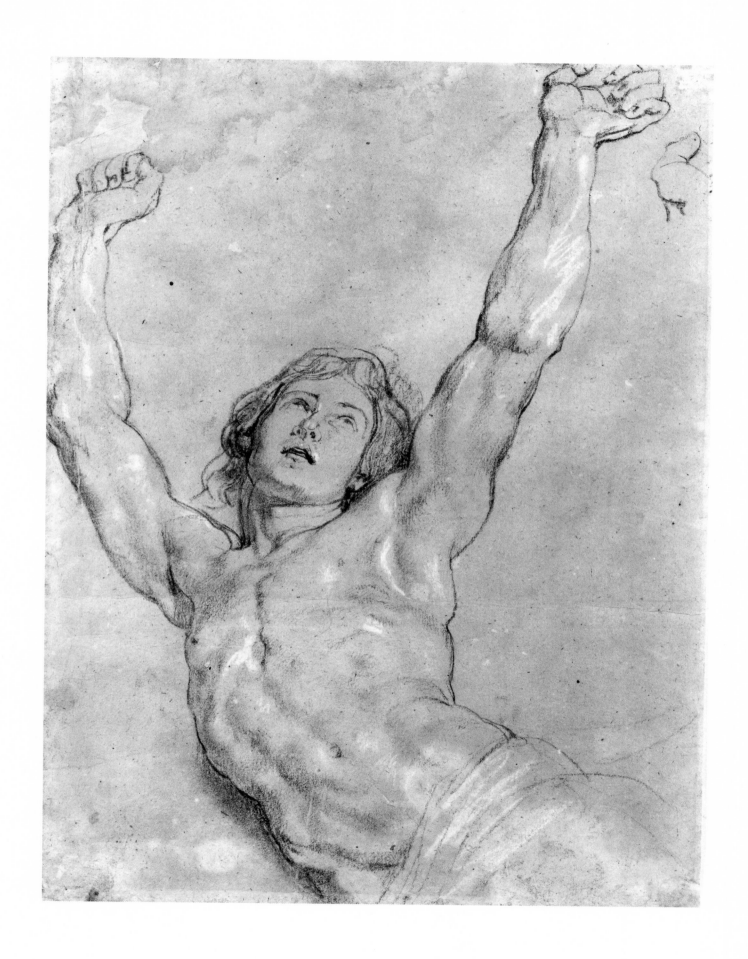

Peter Paul Rubens

STUDY FOR THE FIGURE OF CHRIST IN THE "RAISING OF THE CROSS"

42

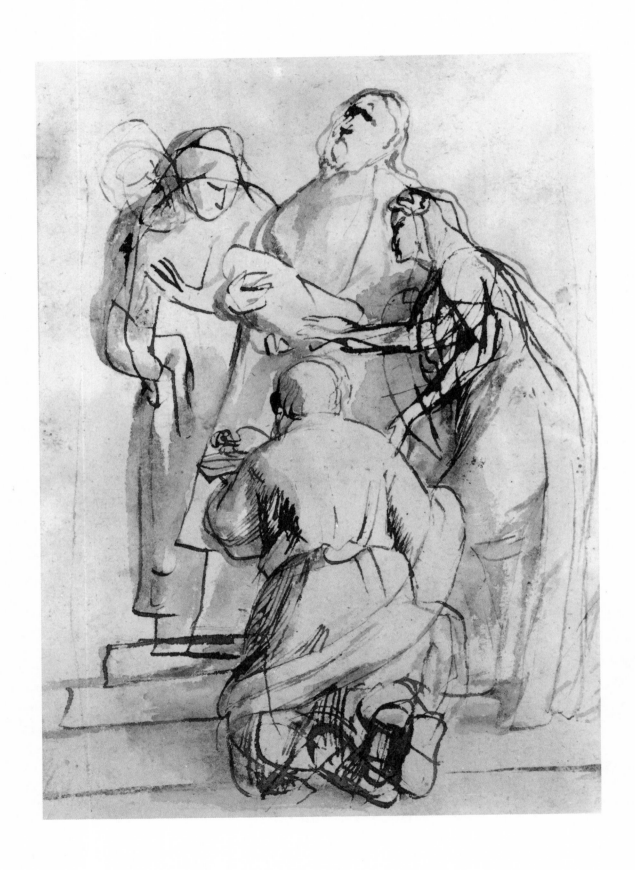

Peter Paul Rubens

STUDIES FOR THE "PRESENTATION IN THE TEMPLE"

43

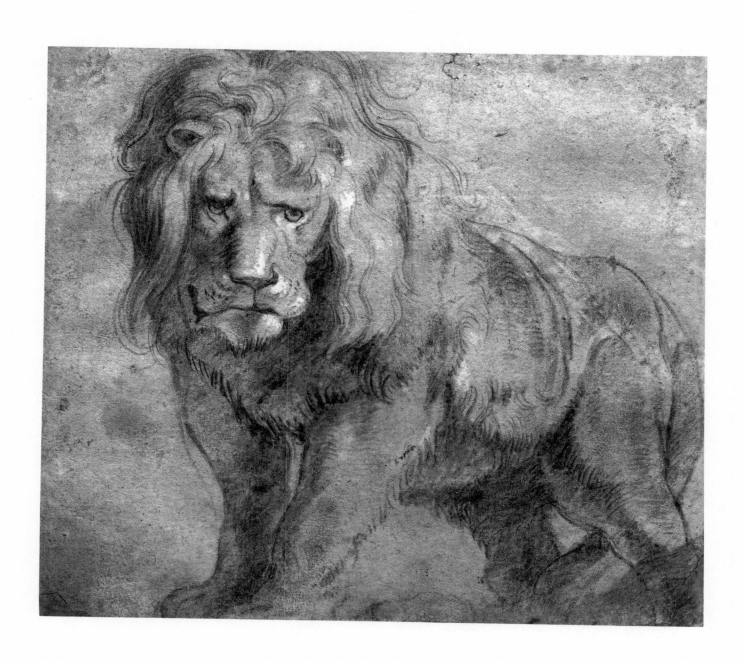

Peter Paul Rubens

STANDING LION

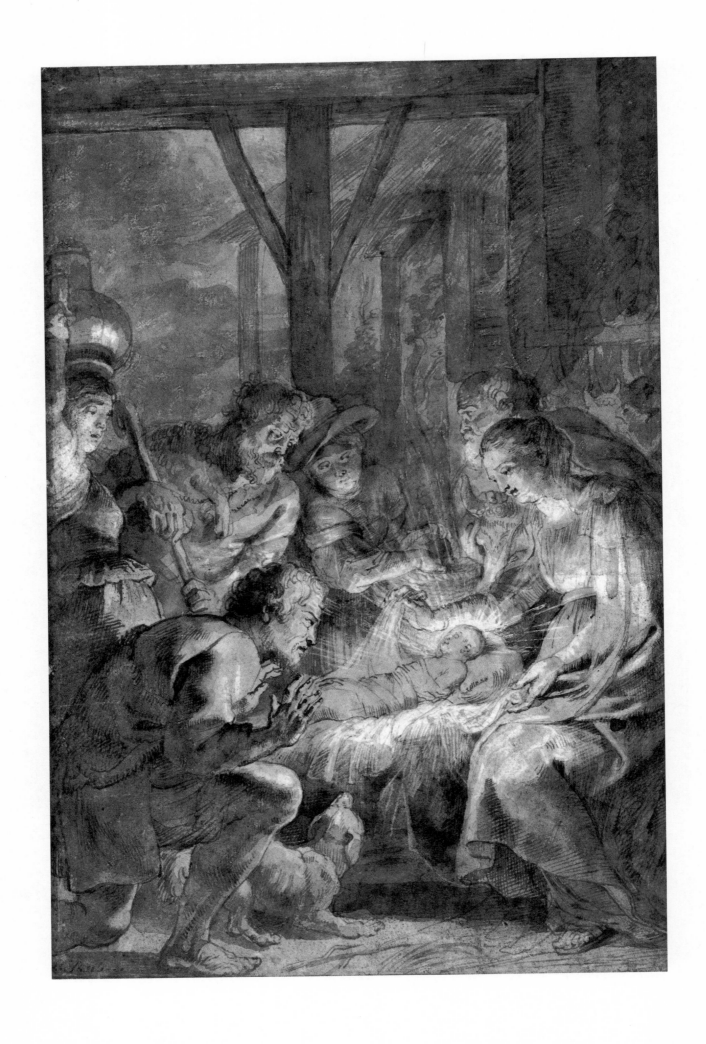

Peter Paul Rubens

ADORATION OF THE SHEPHERDS

45

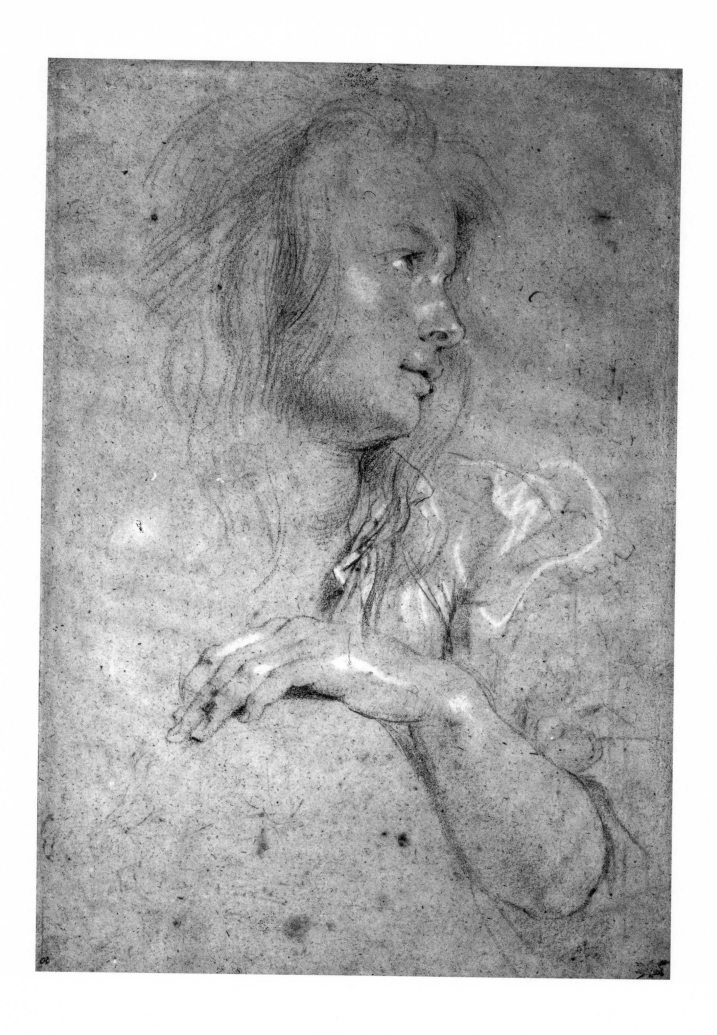

Peter Paul Rubens

YOUNG WOMAN IN PROFILE

© 1992 National Gallery of Art, Washington, D.C.

46

Peter Paul Rubens

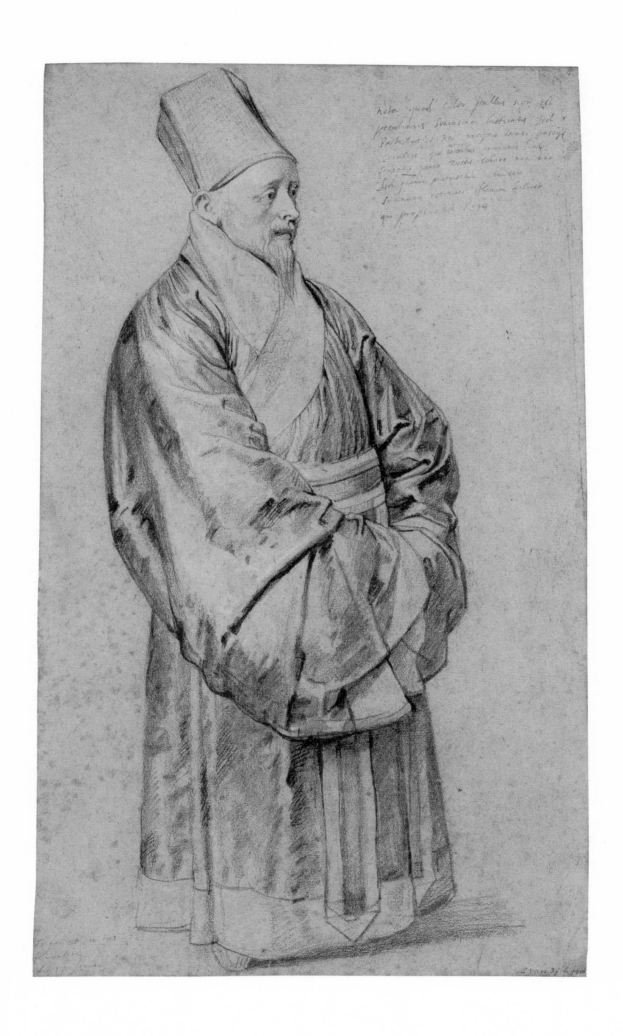

Peter Paul Rubens

MAN IN CHINESE COSTUME (NICOLAS TRIGAULT?)

48

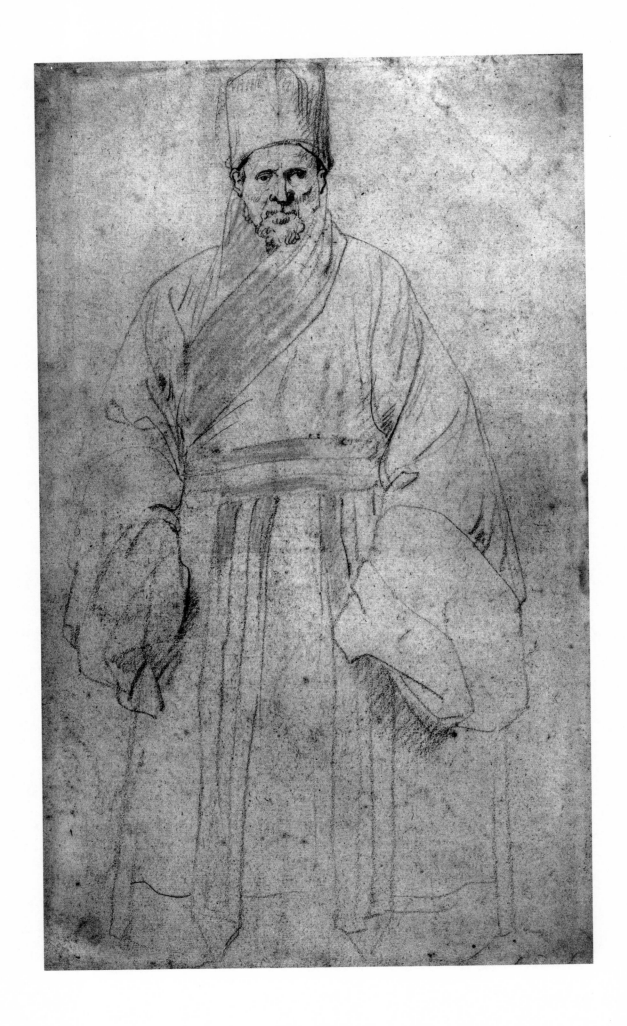

Peter Paul Rubens

JESUIT MISSIONARY IN CHINESE ROBES (JOHANN SCHRECK?)

49

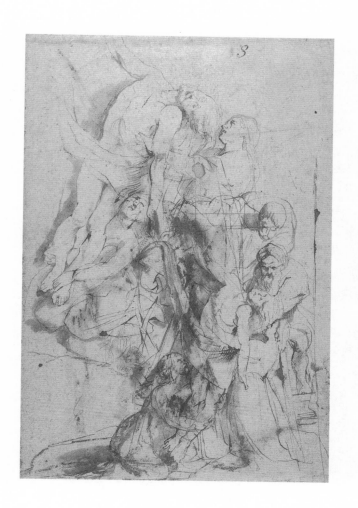

Peter Paul Rubens

50

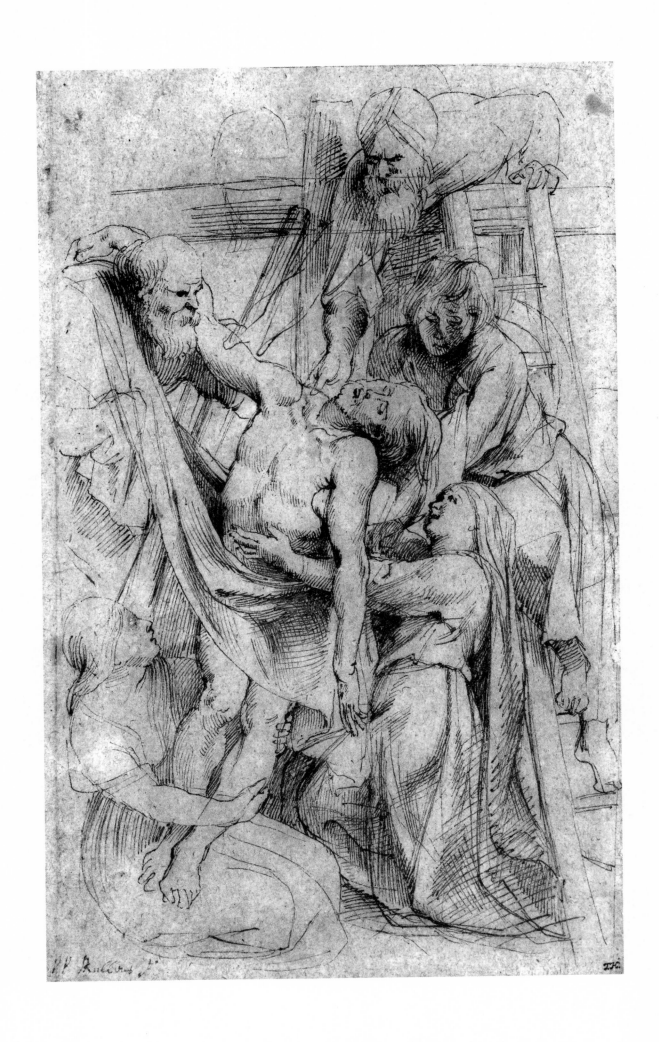

Peter Paul Rubens

STUDY FOR THE "DESCENT FROM THE CROSS"

51

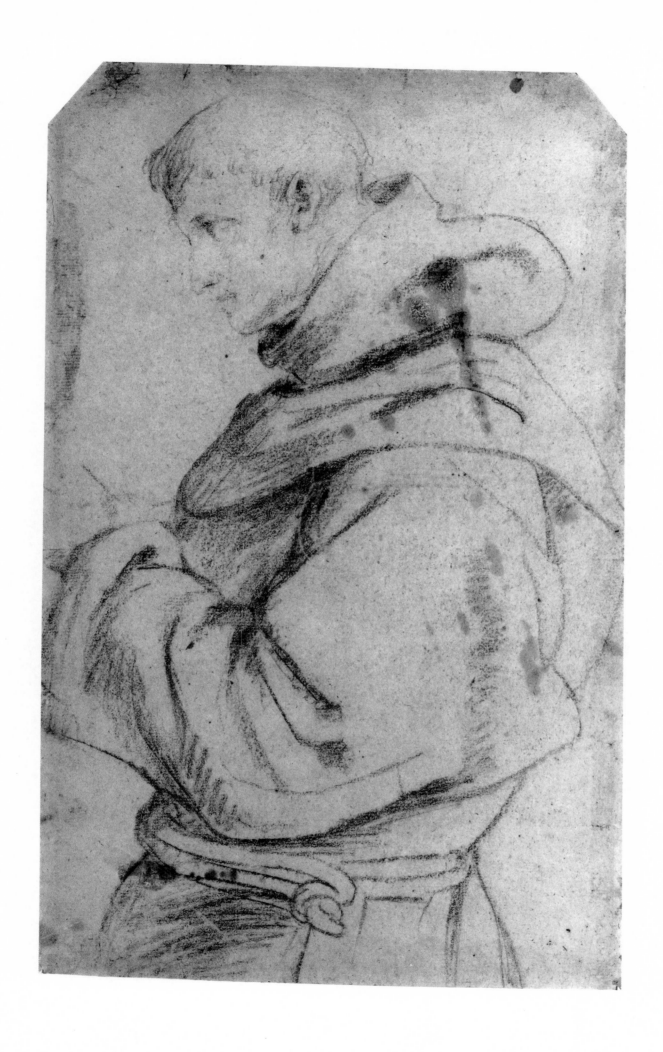

Peter Paul Rubens

A FRANCISCAN FRIAR

52

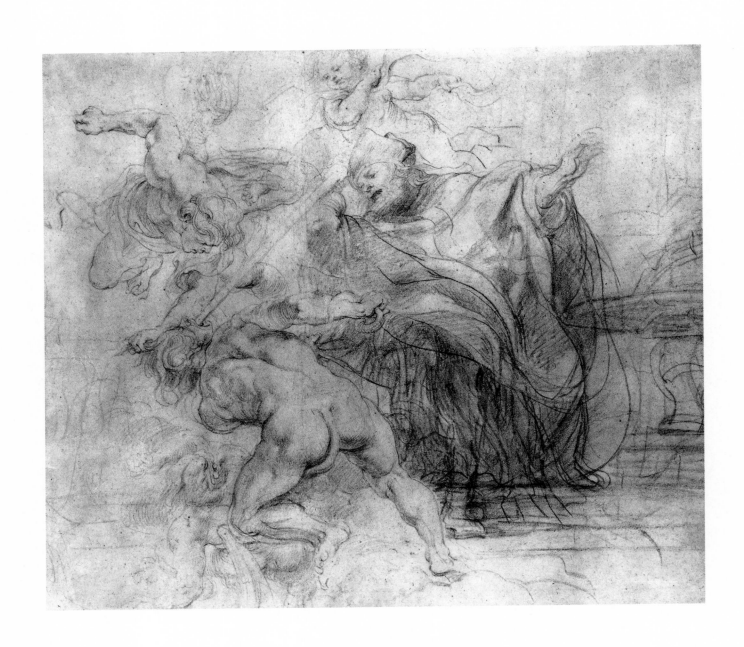

Peter Paul Rubens

ST. GREGORY NAZIANZUS SUBDUING HERESY

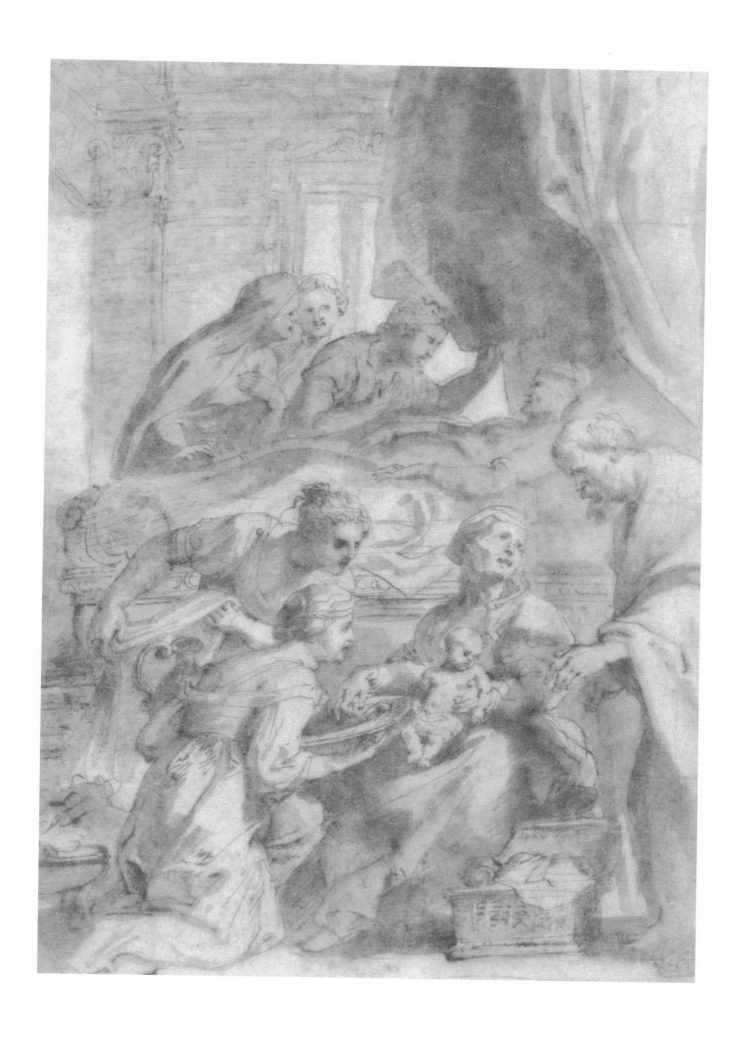

Peter Paul Rubens

THE BIRTH OF THE VIRGIN

54

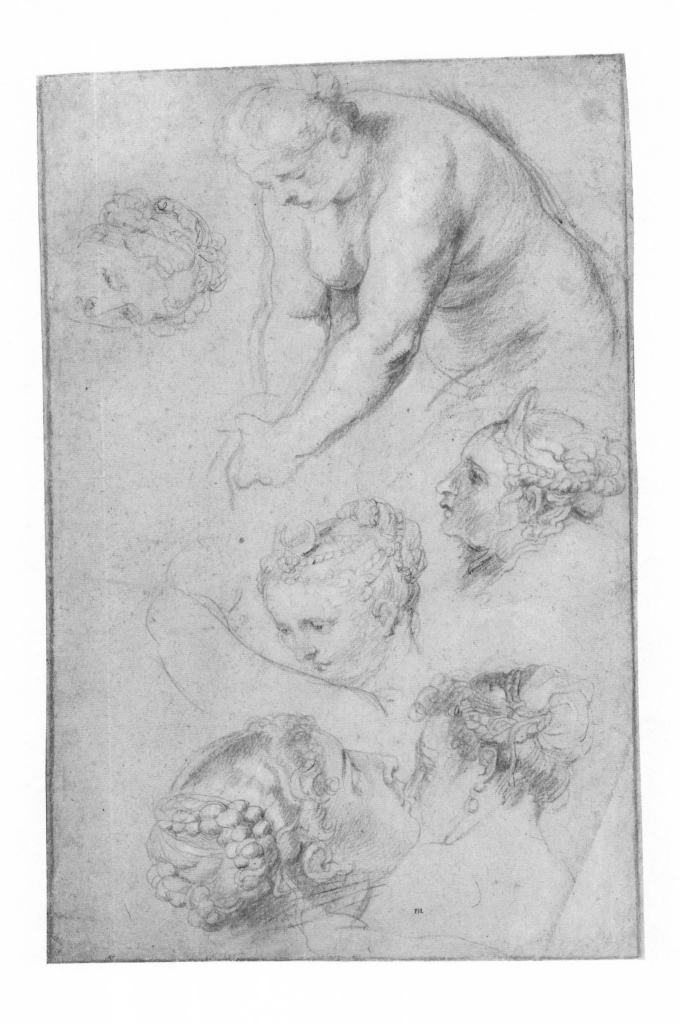

Peter Paul Rubens, after Titian

55

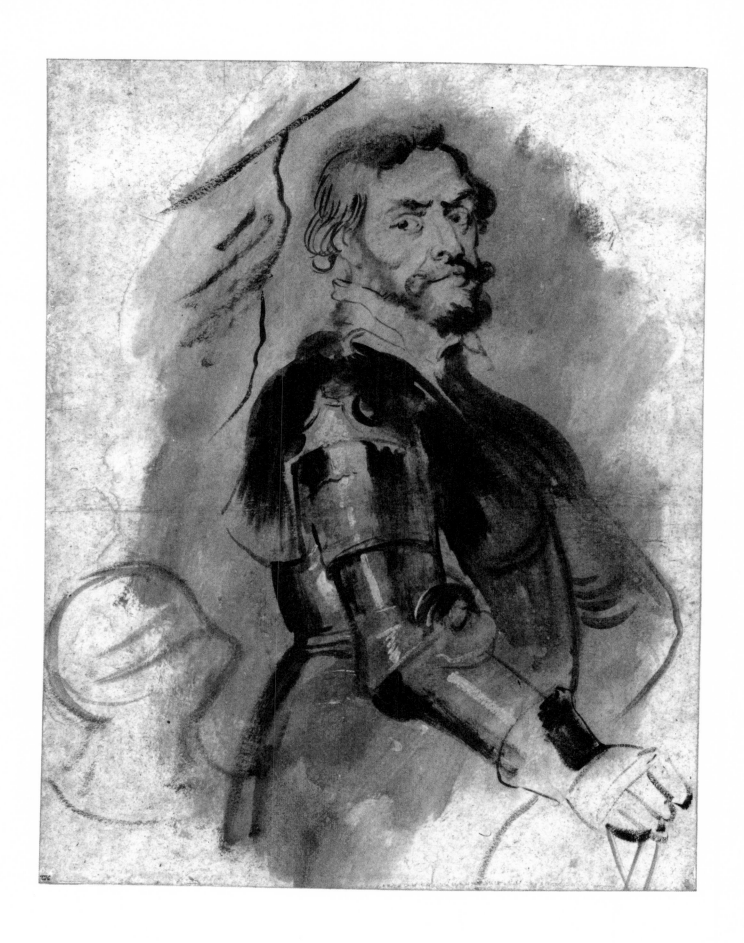

Peter Paul Rubens

THOMAS HOWARD, 2ND EARL OF ARUNDEL (1585–1646)

56

Peter Paul Rubens

ARCHDUKE ALBERT WITH HIS PATRON SAINT, ALBERT OF LOUVAIN

Peter Paul Rubens

THE FEAST OF HEROD *recto*

TOMYRIS AND CYRUS *verso*

58

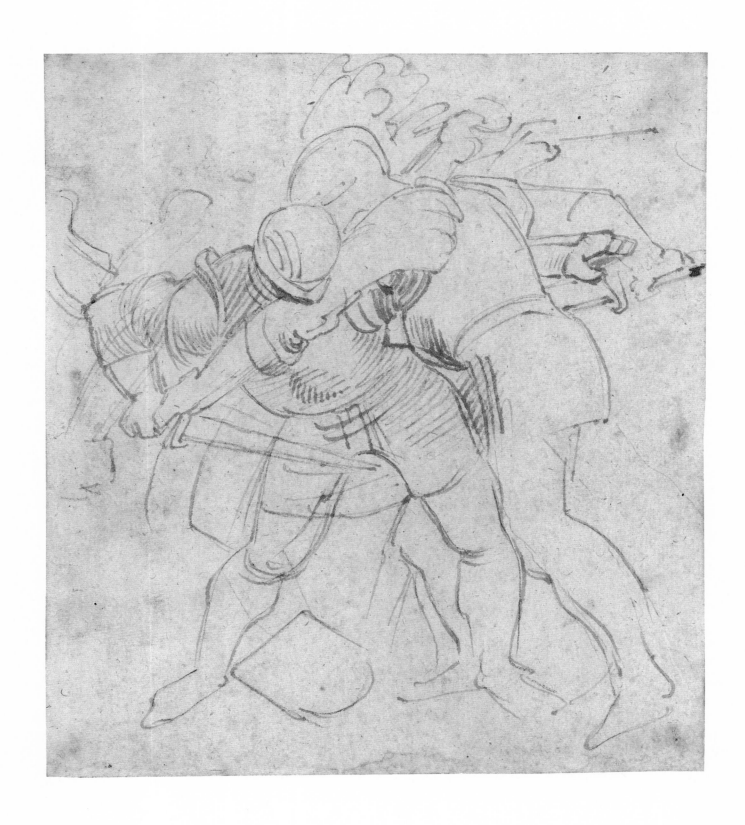

Peter Paul Rubens

TWO ARMED SOLDIERS FIGHTING

59

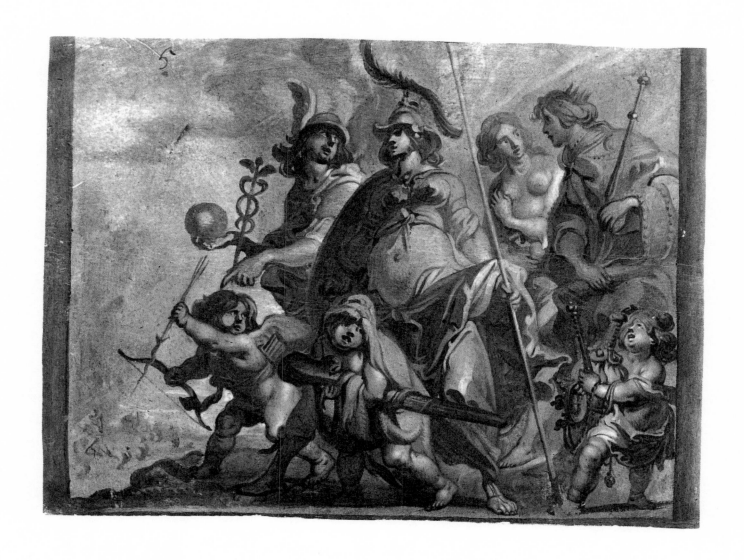

Anthoni Sallarts

MERCURY GUIDING JUNO AND MINERVA TO MEET PARIS

60

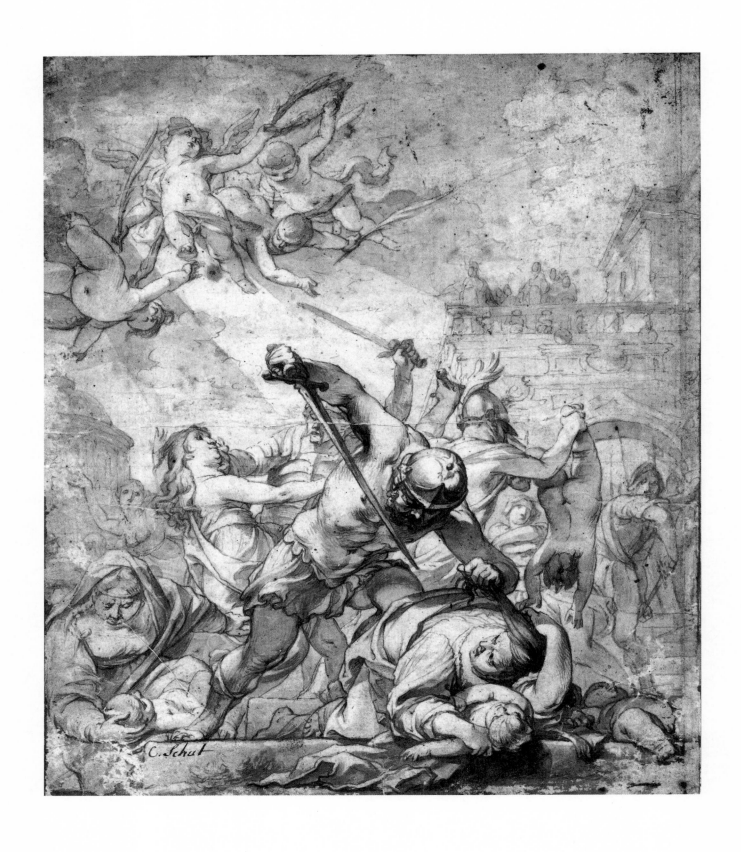

Cornelis Schut

MASSACRE OF THE INNOCENTS

61

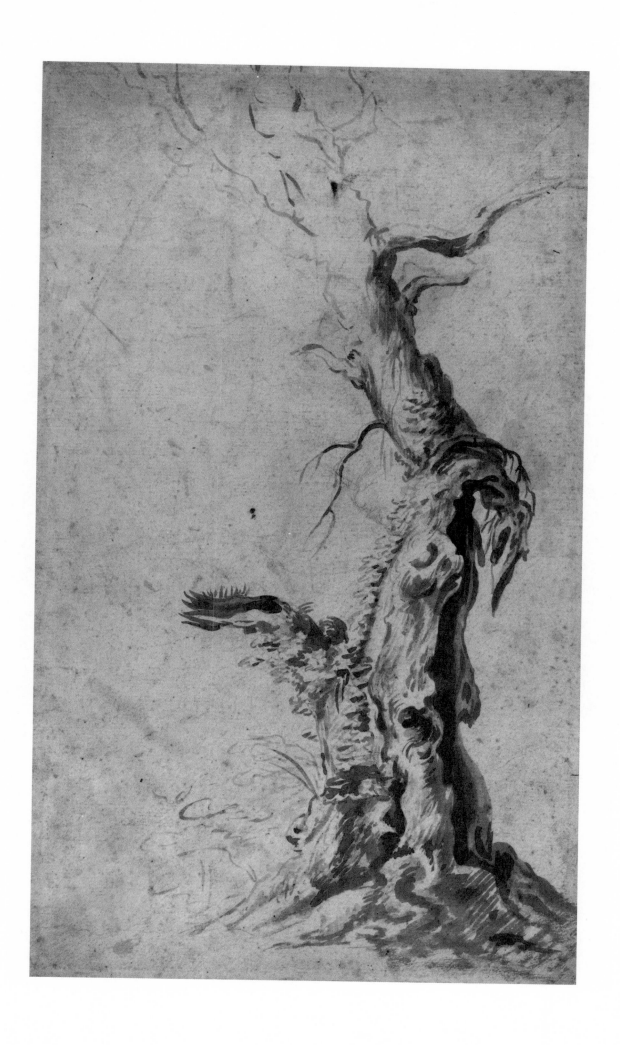

Jan Siberechts

TREE STUMP

62

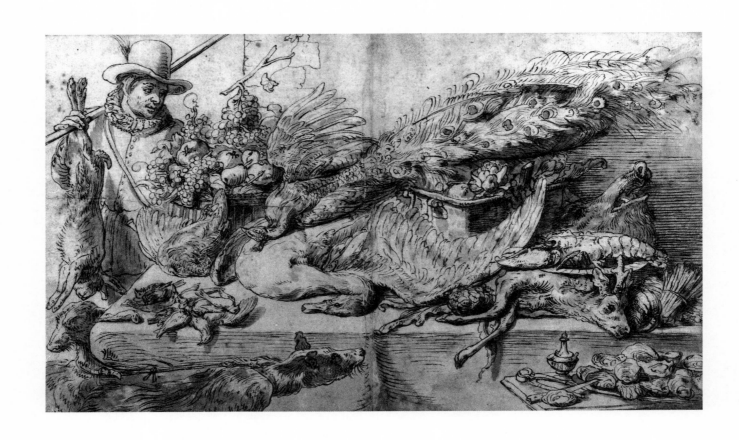

Frans Snyders

A HUNTER WITH STILL LIFE OF GAME AND SHELLFISH

63

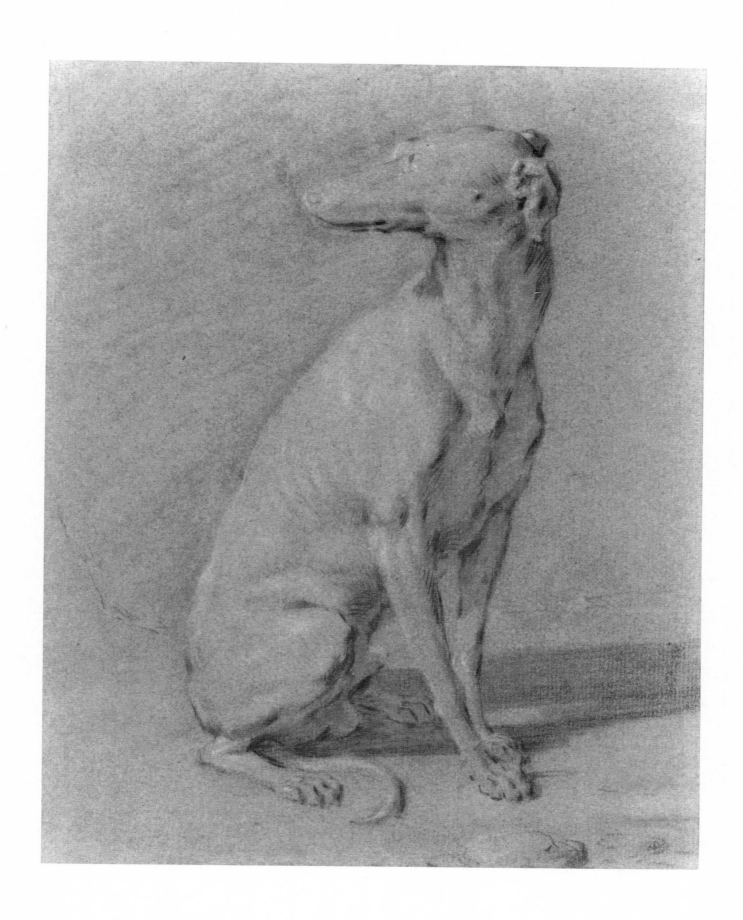

Frans Snyders

WHIPPET, SEATED TO THE RIGHT

Pieter Claesz. Soutman (*attributed to*), after Peter Paul Rubens

LION HUNT

David Teniers the Younger

PEASANTS DANCING, STUDY FOR "VILLAGE HOLIDAY"

66

67

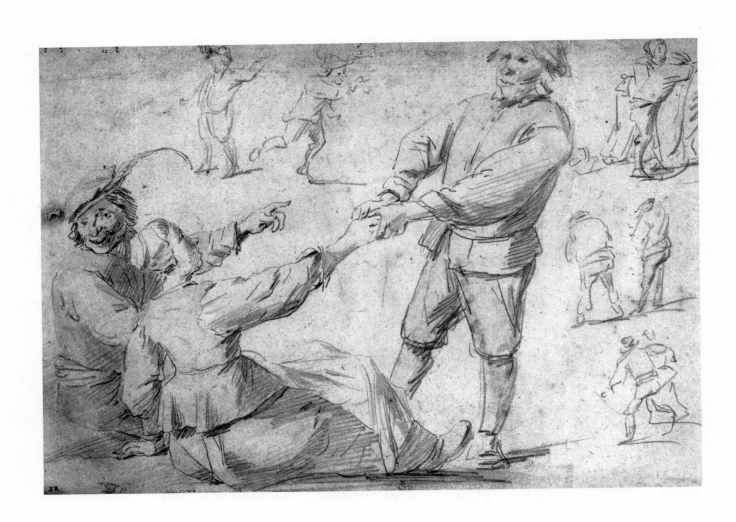

David Teniers the Younger

SHEET OF FIGURE STUDIES

© The Pierpont Morgan Library 1992

67

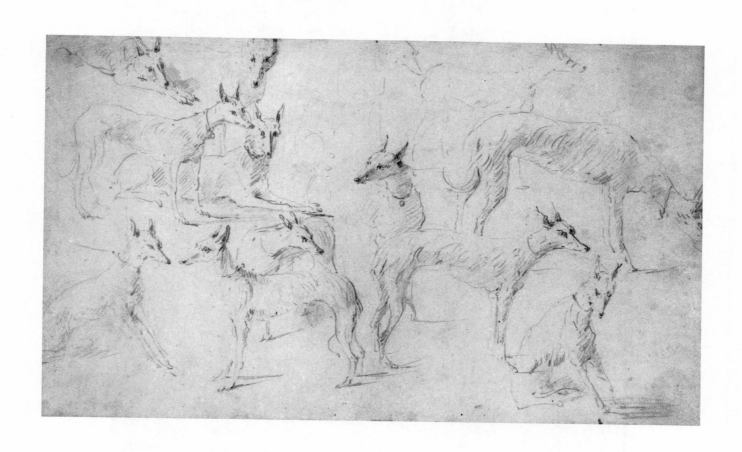

David Teniers the Younger

68

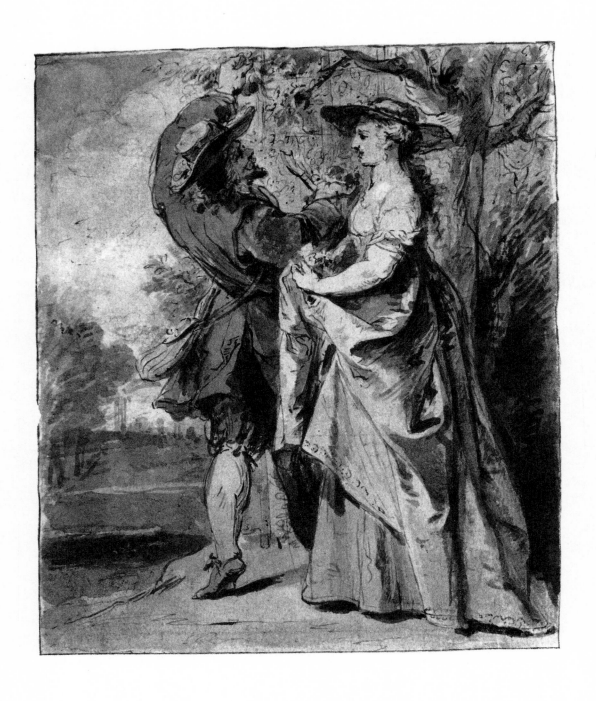

Jan Thomas van Yperen

69

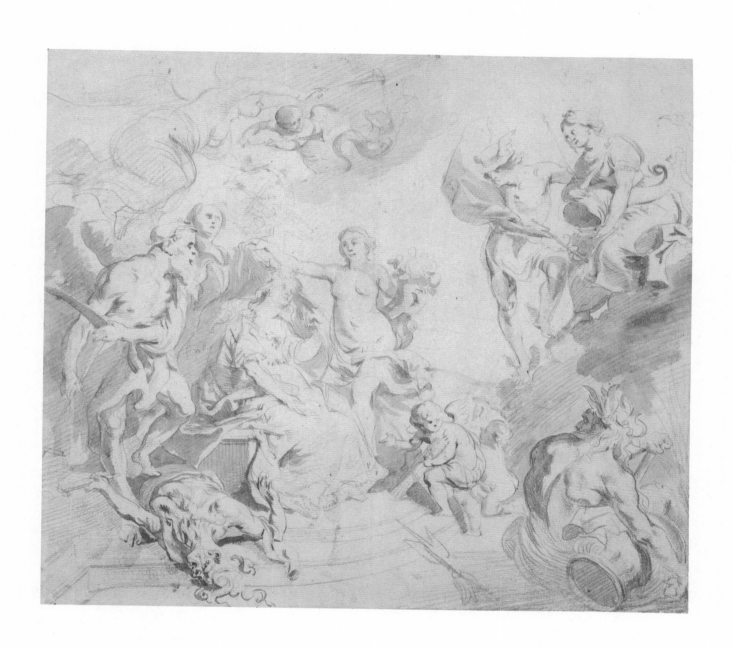

Theodoor van Thulden

ALLEGORY OF THE RETURN OF GOOD FORTUNE TO THE CITY OF ANTWERP

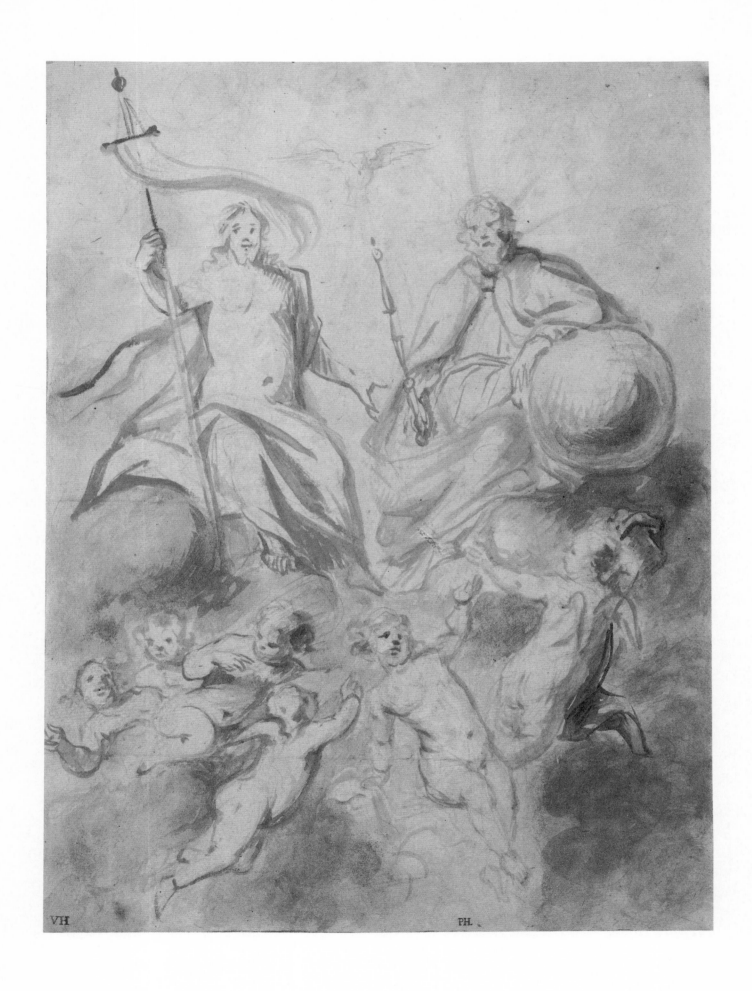

Theodoor van Thulden (*attributed to*)

HOLY TRINITY

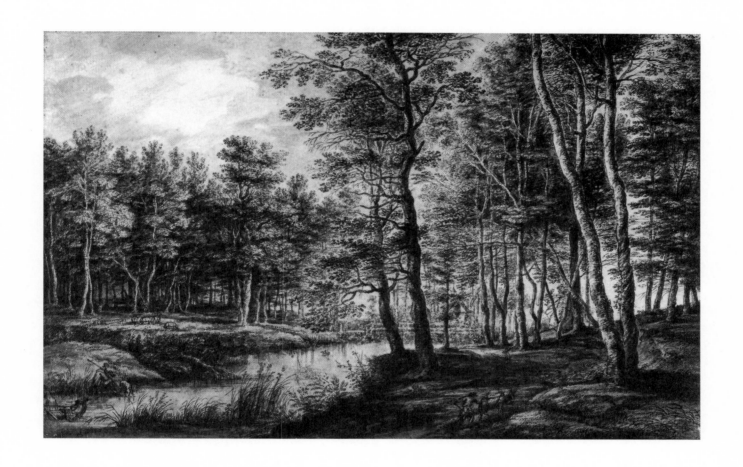

Lucas van Uden

A WOODLAND SCENE WITH A STREAM

72

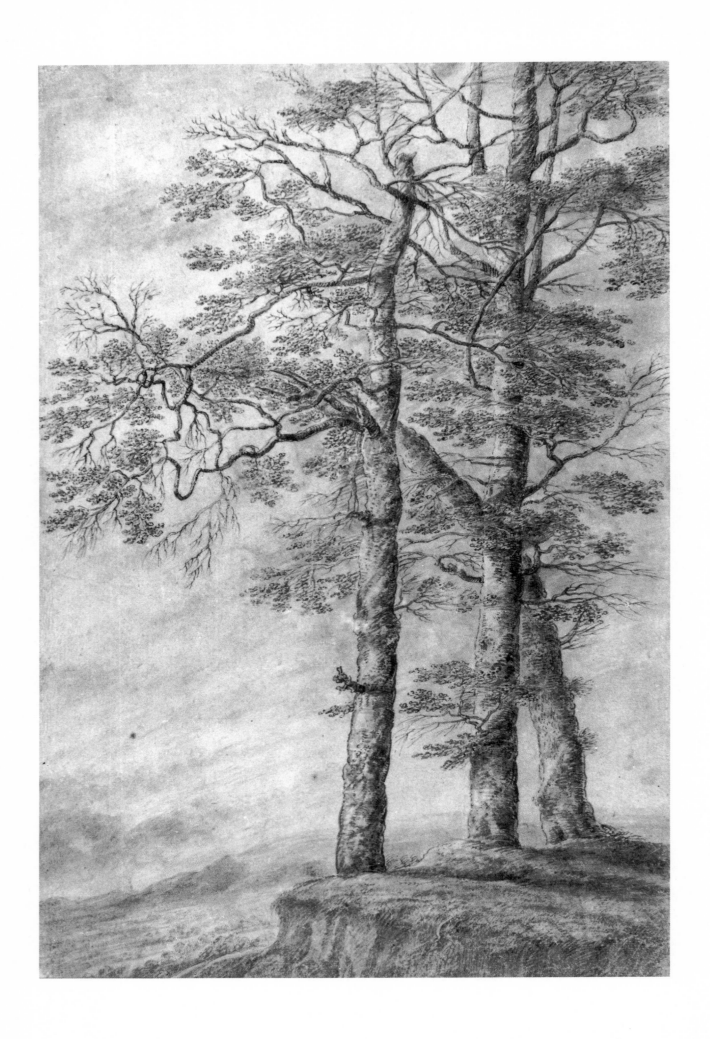

Lucas van Uden

THREE TREES

73

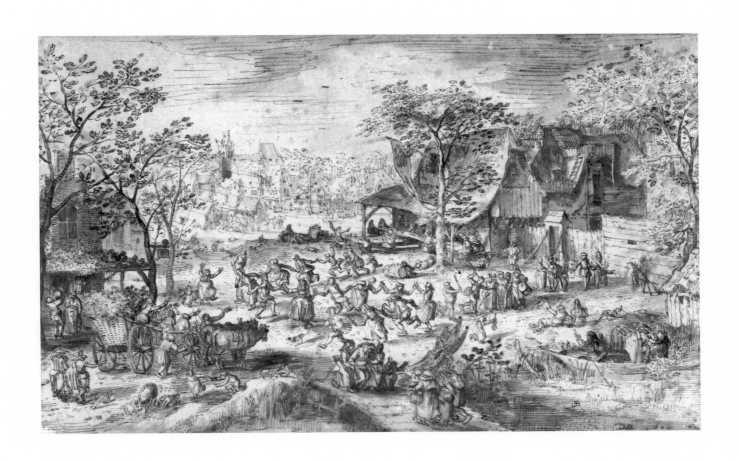

David Vinckboons

PEASANT KERMIS

74

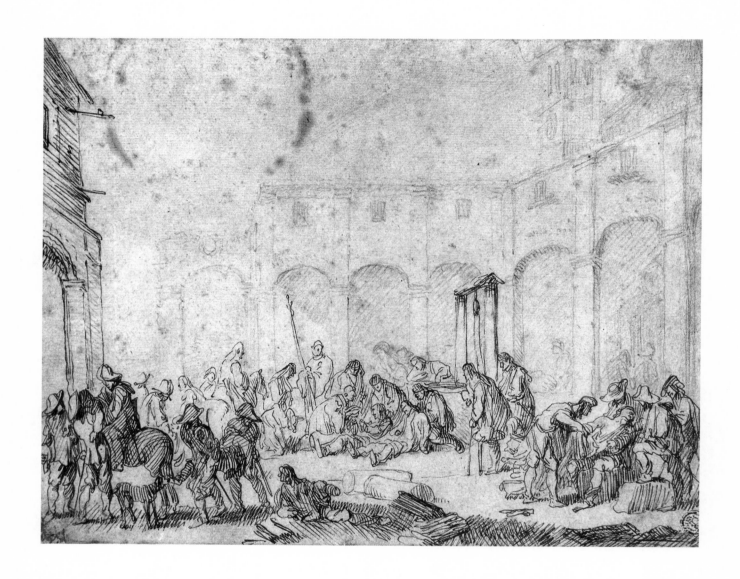

Cornelis de Wael

COURTYARD WITH WOUNDED SOLDIERS

75

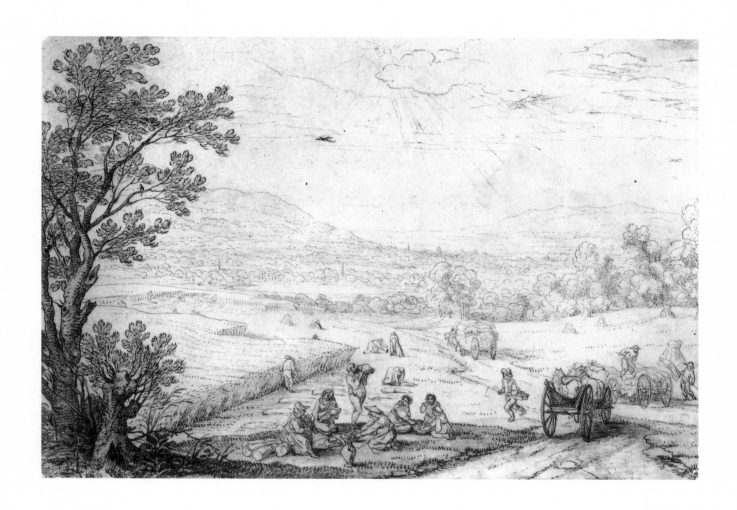

Jan Wildens

THE CATALOGUE

The entries are arranged alphabetically by artist and chronologically within the artist's work. *Attributed to* indicates a certain degree of caution in accepting the drawing as the work of the artist. A *question mark* implies doubt about the authorship. *School of* implies that the drawing was made by an unidentified pupil of the artist named. Regarding manuscript notes on drawings, *signature* and *signed*, *inscription* and *inscribed* indicate that they were written by the artist himself; *annotation* and *annotated* that they were added by someone else. The dimensions are given first in millimeters, then in inches; height precedes width. Bibliographical references are limited to recent publications.

Denijs van Alsloot

Malines ca. 1570–1628 Brussels

Denijs van Alsloot was born in Malines about 1570, the son of a tapestry weaver of the same name. In 1599 he became a master in the Brussels guild of St. Luke and soon thereafter, in 1599–1600, he was appointed painter to the court of the Habsburg regents of the Netherlands, the Archduke Albert and Archduchess Isabella Clara Eugenia in Brussels. In this capacity he painted the official city processions (*ommegang*) as well as views of the castles Tervueren and Mariemont. Together with Lodewijk de Vadder, Jacques d'Arthois, and Lucas Achtschellinck, he belonged to the so-called Brussels landscape painters. Van Alsloot frequently rendered wooded landscapes reminiscent of the large forest of Soignes near Brussels. Between 1611 and 1615 he collaborated on several occasions with Hendrik de Clerck (Brussels 1570–1629), court painter from 1606, who added the figures to his landscapes.

1

FOREST LANDSCAPE WITH A DISTANT CASTLE, 1608

Pen and brown ink, brown and blue-gray wash, 203 x 276 mm (8 x 10⅞ in.)

Signed in pen and brown ink at bottom right, *D. ab Alsloot.S.A. Pic.* and dated at bottom left, *1608.*

Collection of The J. Paul Getty Museum, Malibu, California

Inv. no. 86.GA.9

Provenance: private collection, Paris; art market, London

Reference: Goldner and Hendrix 1992, no. 81, ill.

Exhibited in Wellesley only

In 1961 Wolfgang Wegner published the group of eight drawings he considered to be by Denijs van Alsloot, none of which was annotated with the artist's name, let alone signed or dated (Wegner 1961, pp. 206–07). The inscribed drawing recently acquired by the Getty Museum is therefore of the utmost rarity. Wegner's characterization of common aspects in this group of drawings, such as clumps of trees that divide the composition into two separate parts with a clear spatial progression from foreground to background, is supported by the present drawing. The signature and date on the drawing suggest that Van Alsloot considered it a finished work. His painting of a WOODED LANDSCAPE WITH CEPHALUS AND PROCRIS, to which Hendrik de Clerck added the figures (now in the Kunsthistorisches Museum, Vienna, Inv. no. 1077; Laureyssens 1967, p. 167, fig. 3), is also dated 1608 and signed in the same unusual way—*D. ab Alsloot.S.A. Pic*—which refers to his official position as painter to the archduke and archduchess—*Serenissimorum Archiducum Pictor.*

Jan Boeckhorst

Münster ca. 1604–1668 Antwerp

Jan Boeckhorst, also known in his native Germany as Johann Bockhorst and often referred to in old sources as *Lange Jan* (or "Tall John"), was born ca. 1604 in Münster, Westphalia. According to Jan Erasmus Quellinus, who referred to Boeckhorst as *vir philosophus* (that is, a highly educated man), he began painting only at the age of twenty-two. Around 1626 Boeckhorst arrived in Antwerp where he is said to have studied with Jacob Jordaens. In 1633–34 Jan was registered as a master in the Antwerp painters' guild. The following year he participated in the decorations for the Triumphal Entry of Cardinal-Infante Ferdinand into Antwerp, and in 1637 he contributed one painting to Rubens's commission from Philip IV for the royal hunting lodge, the Torre de la Parada, near Madrid. Boeckhorst visited Italy in 1635–36 and again in 1639, the second time going as far as Rome. Between 1651 and 1665 the artist designed a number of book illustrations for the Plantin-Moretus publishing house. He was a close associate of Rubens, and was asked to retouch or finish some of Rubens's paintings after the latter's death in 1640. Hans Vlieghe recently identified him as the painter of the so-called Cardiff cartoons, also considered to be by Rubens (Vlieghe 1983, pp. 350–56, and 1987 [A], pp. 598–99).

2

DESIGN FOR "KING DAVID, THE PROPHET GAD AND THE ANGEL OF DEATH," 1654

Pen and brown ink with brown wash, heightened and corrected with white bodycolor, yellow bodycolor in the sky, over traces of black chalk, traced for transfer, 339 x 211 mm (13⅜ x 8⁵⁄₁₆ in.)

The Saint Louis Art Museum, Saint Louis, Missouri: Purchase, funds given by Mr. and Mrs. Lansing W. Thoms

Inv. no. 206.1966

References: Saint Louis 1975, p. 102, ill. (as Abraham van Diepenbeeck); Logan 1977, pp. 162–66, pl. 18; Lahrkamp 1982, no. 102a, ill.; Steadman 1982, p. 40; Logan, in exh. cat. Antwerp/Münster 1990, p. 121.

133

In the late 1640s the Plantin-Moretus publishing house in Antwerp commissioned from Abraham van Diepenbeeck ten illustrations for a new edition of the *Breviarium Romanum*, to replace the 1614 edition with designs by Rubens (see catalogue number 45 for one of Rubens's drawings). For some unknown reason Van Diepenbeeck's drawing of the penitent King David, today in the Museum Boymans-van Beuningen, Rotterdam, was not used, even though it is traced for transfer and Van Diepenbeeck was paid for the design in 1651 (Inv. no. Diepenbeeck 5; reproduced in Logan 1977, fig. 2; black chalk, pen and brown ink, heightened and corrected with white, traced for transfer, 158 x 103 mm). Instead, it was replaced with this drawing of King David by Boeckhorst. Not surprisingly, this latter drawing was therefore attributed to Van Diepenbeeck until 1971, when Julius Held recognized it as a work of Jan Boeckhorst.

When King David ordered a census of his people, he incurred the wrath of God and therefore was to be punished. The prophet Gad here informs the repentant king of the three options for punishment God prescribed, namely seven years of famine, a three-months-long flight from his enemies, or three days of pestilence; they are symbolized in the drawing by the sheaf of corn, the sword, and the skull that the angel shows to the king. David chose to endure the three days of pestilence and the death of seventy thousand of his people. However, God intervened before the angels could send the plague to Jerusalem. In gratitude to God for saving his people, King David had an altar erected (II Samuel 24:10–25).

Cornelis Galle the Younger (1615–78) engraved the drawing in reverse without any noticeable changes. The print served as frontispiece to the psalter of the Breviary in a later edition of the *Breviarium Romanum* published in 1655. On 24 February 1654, Boeckhorst received payment for the design of this frontispiece as well as for the RESURRECTION OF CHRIST, now lost. He represented the penitent king twice more in paintings: one nearly contemporaneous with the drawing in St. Louis, and close in composition, which is in the church of St. Michael in Ghent; and another in the Bob Jones University Museum of Sacred Art in Greenville, South Carolina, in which the figural groups are still reminiscent of the composition in the drawing but the space is extended at the sides by a throne at the right and a view into the distance at the left (Lahrkamp 1982, nos. 4 and 4a, ill. and exh. cat. Antwerp/Münster 1990, no. 1).

3

THE MARTYRDOM OF ST. JAMES, 1659

Brush and brown ink, brown wash, over preliminary drawing in black chalk, heightened with white, squared in black chalk and folded once vertically through the center and twice horizontally, 290 x 180 mm (11⁷⁄₁₆ x 7⅛ in.)

Annotated on the verso, *Original Zeichnung zu dem schönen Gemälde des Remigius Lange-Jan. Geb. zu Brüssel. Starb 1670. Marter des heil. Jacobus. Auf dem Hauptaltare der Kirche St. Jacobi zu Gent; Dessin du Tableau du maître autel de la Collegiale de S. Jacques Gand peint par Remy Langhejan.*

Philadelphia Museum of Art, Philadelphia, Pennsylvania: The Muriel and Philip Berman Gift.

Acquired from the John S. Phillips bequest of 1876 to the Pennsylvania Academy of the Fine Arts, with funds contributed by Muriel and Philip Berman and the Edgar Viguers Seeler Fund (by exchange) Inv. no. 1984–056–089

Provenance: J. C. Spengler (L. 1434; sale, Copenhagen, Luno, 8 October 1839, lot 1252, as Remigio Langjan); Barry Delaney (1839; L. 350); the Pennsylvania Academy of the Fine Arts, Philadelphia

Exhibition history: Antwerp/Münster 1990, no. 19, ill.

References: Held 1967, pp. 140–42, fig. 5; Lahrkamp 1982, no. 39a, ill.; Logan, in exh. cat. Antwerp/Münster 1990, p. 122.

The attribution to Lange Jan alias Jan Boeckhorst on the verso, and the annotation identifying the drawing as a study for the main altar in the church of St. James in Ghent, have proven to be reliable as Julius Held established. In this image, St. James is about to be beheaded while another martyr, most likely the scribe Josias who was to undergo the same fate, is pushed onto the scene by a soldier at the right. Christ, standing on clouds above, extends a wreath toward the martyred saint while God the Father is seated nearby.

The drawing, squared for transfer and folded into six parts, clearly served as the preliminary study for the altarpiece in Ghent which—as was discovered during a restoration in 1961—Boeckhorst signed in monogram and dated 1659. As a further step in the preparation for the final altar, Boeckhorst followed the drawing with an oil sketch, which recently entered the collection of the Westfälisches Landesmuseum in Münster (exh. cat. Antwerp/Münster 1990, no. 20, ill. in color). The most obvious changes between drawing and painted *modello* are found in the group of Christ and God the Father in Heaven, which is replaced by two hovering putti, extending two wreaths and a martyr's palm toward St. James. This modification seems to have pleased the donors of the altarpiece, Johann de Jonghe and Maria van der Hagen, since it was taken over in the final painting with the minor modification of adding a second martyr's palm and separating the two putti somewhat from each other (Lahrkamp 1982, no. 39, ill.).

4

THE RISEN CHRIST, SURROUNDED BY SAINTS, ca. 1660

Brush and colored wash, 229 x 162 mm (9 1/16 x 6 3/8 in.)

National Gallery of Art, Washington, D.C.: Julius S. Held Collection, Ailsa Mellon Bruce Fund

Inv. no. 1984.3.3

Provenance: E. Calando (L. 837); Julius S. Held

Exhibition history: Binghamton 1970, no. 36, ill.; Antwerp/Münster 1990, no. 14, ill.

References: Held 1967, p. 144, fig. 8; Lahrkamp 1982, no. 28a, ill.

Exhibited in Cleveland only

Originally attributed to Anthony van Dyck, this drawing was first recognized by Julius Held as a compositional study by Jan Boeckhorst for his painting of the same subject, also attributed to Van Dyck or Rubens, today in The Ackland Art Museum, Chapel Hill, North Carolina (Lahrkamp 1982, no. 28, ill.). The brushwork, entirely in brown and greenish watercolor, emphasizes the fluid outlines of the bodies, characteristic of Boeckhorst but unusual for Van Dyck. The drawing probably served as a *modello* for the painting, with few modifications.

The subject of the risen Christ surrounded by repentant sinners was popular during the Counter-Reformation, which reaffirmed penitence. Kneeling in the foreground is the Good Thief (who was crucified with Christ) with King David standing beside him. At the right is the repentant Magdalene next to the Prodigal Son and possibly St. Peter weeping, or the tax collector Zacchaeus. As Held noted, Boeckhorst here combined the theme of the resurrected Christ, supporting the cross with his left hand, and Christ triumphant over sin and death. In the painting, Christ crushes the serpent of original sin with his right foot, while his left rests on the globe, which is encircled by a snake and placed next to a skull, symbol of death.

Both the drawing and painting are dated to around 1660, or close to Boeckhorst's signed altarpiece representing ST. JAMES, dated 1659 (see catalogue number 3 for Boeckhorst's preliminary drawing for that painting).

Jan Brueghel the Elder

Brussels 1568–1625 Antwerp

Jan Brueghel the Elder was the second son of Pieter Bruegel the Elder and Mayken Coecke, a daughter of Pieter Coecke van Aelst. According to Karel van Mander, Jan learned to use watercolors from his grandmother. As early as 1589 he traveled via Cologne to Italy, where he is recorded in Naples in 1590; he resided in Rome from 1592 until 1594. In 1595–96 Jan lived in Milan and worked for Cardinal Federico Borromeo, his lifelong patron, before returning to Antwerp by October. The following year, 1597, Jan entered the guild of St. Luke in Antwerp (where he served as dean in 1602); in 1601 he became a citizen of Antwerp. In 1599 Jan Brueghel married Elisabeth de Jode (d. 1603) and in 1605, Catharina van Mariënberg. Jan traveled to Prague in 1604 and in 1612 to Spa. A year later he went on an official mission to the northern Netherlands together with Rubens and Hendrik van Balen the Elder. In 1616 he was in Nuremberg.

From 1609 until his death in Antwerp in 1625, Jan Brueghel the Elder had a successful career as court painter to the Archduke Albert and Archduchess Isabella in Brussels. He registered one student, Daniel Seghers, in 1611. Jan Brueghel was especially known for his still lifes and landscapes, and collaborated several times with Rubens, as well as with Hendrik van Balen the Elder, Joos de Momper II, Frans Francken II, Tobias Verhaecht, Pieter van Avont, Hans Rottenhammer, and Sebastiaen Vrancx.

5

VILLAGE MEETING PLACE UNDER TWO OLD TREES, ca. 1612

Pen and brush and brown ink, watercolor, vertical fold through the center,

280 x 409 mm (11¹¹⁄₁₆ x 16⅛ in.)

Signed (?) in pen and brown ink at bottom right, *Breugel* (initial *J.* added later in pen and brown ink, not in the artist's hand); annotated in pencil, *1642*; on the reverse, *35* and *Ja Brugel called Velvet Brugel.*

Yale University Art Gallery, New Haven, Connecticut: Library Transfer

Inv. no. 1961.62.25

Provenance: Prosper Henry Lankrink, London (1628–92; L. 2090); John Percival,
1st Earl of Egmont (1683–1748)

Exhibition history: Brussels 1980, no. 162, ill.

References: Haverkamp-Begemann and Logan 1970, no. 524, pl. 280; Winner 1972, p. 150, fig. 32;
Ertz 1979, under no. 364; exh. cat. Brussels 1980, under no. 136; Winner, in exh. cat. Brussels 1980,
pp. 209–12.

This sheet depicting two old shade trees with spreading branches on a village square, drawn freely with the brush and watercolor, is an early example of a landscape study. Despite a freshness that might suggest it was drawn from nature, the sketch most likely was done in the studio. The tentative attribution to Jan Brueghel the Elder, put forth in the Yale catalogue (1970), was supported by Matthias Winner who identified the drawing as one of Jan's rare studies related to an existing painting. In his view, the spontaneous, broad work with the brush, particularly in the foliage at the right, betrays Jan's hand. Winner believes the version in the Städelsches Kunstinstitut, Frankfurt (Inv. no. 6948), which shows slight modifications, to be a copy drawn with a "hesitating brush." He further proposes that the inscription *Breugel* at the lower right may be a signature, while the *J.* was definitely added by another hand.

Although not a detailed preliminary study in the traditional sense—such drawings are practically nonexistent for Jan Brueghel, who sketched in oil on panel instead—this drawing presents a landscape setting similar to that found in his late large painting in the Prado, Madrid, rendering the Archduke Albert and Archduchess Isabella at a village wedding feast (see Balis et al. 1989, pl. 41, ill. in color). In the painting, the trees are in full leaf but partly cropped at the top. The foreground has been extended and the village square is bustling with people who are either seated around two long tables or looking on at the right.

The painting is generally dated to 1621–23, that is, shortly after the death of Archduke Albert in 1621. Winner nevertheless surmises that the landscape study at Yale may have originated much earlier than the painting, or about 1612, when Jan Brueghel also drew some naturalistic views of Spa, a town to the southeast of Liège in eastern Belgium which he visited repeatedly during that year.

Winner went so far as to propose that, based on this unusually large sheet at Yale, Jan Brueghel the Elder produced more such nature studies executed almost exclusively with the brush, in preparation for paintings now lost. While some of his drawn views of Rome are reflected in his paintings, no such correlations exist for the views of Spa or Heidelberg. In its pronounced use of

brush and various shades of green watercolor, this sheet comes very close in technique to the oil sketch. Anthony van Dyck, as well as other Flemish artists throughout the century, continued creating such naturalistic studies, achieved in large part with the brush (see, for example, catalogue numbers 16 and 17).

Jan Cossiers

Antwerp 1600–1671 Antwerp

Jan was a pupil of his father Antoon Cossiers, a watercolor painter, and of Cornelis de Vos. Between 1623 and 1626 the younger Cossiers traveled to Italy and France, where he was influenced by the art of Caravaggio and his followers. Jan is mentioned repeatedly as residing in Aix-en-Provence, where he painted several portraits for Nicolas-Claude Fabri de Peiresc (1580–1637). In 1626 Peiresc wrote a letter on his behalf, recommending him to Rubens. So impressed was Rubens by him that he asked Jan to accompany him to Spain; the trip was not made, however, due to Cossiers's parents' objections. Jan is recorded back in Antwerp in 1628, when he entered the guild of St. Luke. He served as dean in 1640–41 and registered six students between 1632 and 1667. Jan Cossiers was married twice, first in 1630 to Jean Darragon (d. 1639) and then in 1640 to Maria van der Willigen, with whom he had eleven children. In 1635 he assisted Rubens with the decorations for the Triumphal Entry into Antwerp of Cardinal-Infante Ferdinand, and in 1637 he collaborated on Philip IV's commission for the royal hunting lodge, the Torre de la Parada, near Madrid. Many of Cossiers's works remain in the churches of Malines, especially in the Grand Béguinage.

138

6

PORTRAIT OF THE ARTIST'S SON GUILLIELLEMUS, 1658

Black and red chalk, a few touches of white chalk, some lines strengthened with pen and

brown ink, 268 x 183 mm (10 ⁹⁄₁₆ x 7 ³⁄₁₆ in.)

Numbered in pen and brown ink, probably by the artist, at top left, *21*, and inscribed at top right, *Guilliellemus Cossiers.*

The Pierpont Morgan Library, New York, New York

Inv. no. I,248

Provenance: Henry Temple, 2nd Viscount Palmerston (1739–1802) and by inheritance the Hon. Evelyn Ashley (1836–1907); in his sale, London, Christie's, 24 April 1891, as one of five in lot 129; Sir John Charles Robinson, London (d. 1913); Charles Fairfax Murray, London (d. 1919); J. Pierpont Morgan

Exhibition history: Brussels 1965, no. 313; New York 1979–80, no. 34, ill.

Reference: Stampfle 1991, no. 264, ill.

Guilliellemus (or William) was the youngest of five sons by Jan Cossiers and his second wife, Maria van der Willigen. Five such freely drawn portraits of his sons are known today, all inscribed by the artist and four of them dated 1658. What may have prompted their father to sketch these

sensitive studies in that year remains unknown. Jan Cossiers captured each child in a different mood: cheerful as here, reflective, or observant. The drawings are executed quickly with black and red chalk, at times with additional touches of the pen to accentuate eyes and mouth.

These portrait drawings must at one time have been gathered in a folio, numbered, and arranged in accordance with the children's ages, beginning with the sheet representing the youngest, GUILLIELLEMUS, which bears the number 21, followed by that of JACOBUS, in the British Museum, numbered 25. The portrait of GEERAERT, a drawing that recently came to light, once in the Paignon Dijonval collection, is inscribed 27 (black and red chalk, pen and brown ink, 267 x 187 mm; exh. cat. New York/London 1987, no. 35, ill. in color). A sheet depicting CORNELIS, in the collection of the heirs of J. Q. van Regteren Altena, Amsterdam, bears the number 32 (exh. cat. Paris 1977 (A), no. 43, pl. 106), while that of JAN FRANS in the Institut Néerlandais, Fondation Custodia, Collection Frits Lugt, Paris, is faintly inscribed 31 at top left (exh. cat. Paris 1972, no. 20, pl. 74); another version of the drawing in the Louvre, Paris, is also numbered 31. At age sixteen, Jan Frans was the eldest of the five Cossiers sons.

Another, slightly smaller drawing in red and black chalk of the HEAD OF A YOUNG BOY, very similar in execution, numbered 36 at top left but not inscribed, was recently sold from the collection of the Earl of Leicester (London, Christie's, 2 July 1991, lot 65, ill. in color; black and red chalk, 200 x 154 mm). We may therefore deduce that at one point there existed no fewer than thirty-six such realistic "snapshots," apparently all of young boys, which Jan Cossiers kept together as a group. A similar series of girls is unknown. Only three somewhat related such drawings are known, the HEAD OF A YOUNG GIRL, attributed to Cossiers, formerly in the Hatvany collection (sale, London, Christie's, 24 June 1980, lot 67, ill., with an old annotation attributing the drawing to Rubens) and two studies of girls in Edinburgh and Hamburg respectively, which Michael Jaffé attributed to Jan Cossiers (1971, pp. 11–12, fig. 12).

Gaspar de Crayer

Antwerp 1584–1669 Ghent

Gaspar de Crayer was born in Antwerp in 1584, the son of an art dealer and illuminator. He was a pupil of Michiel Coxcie in Brussels, where he was received as a master in the painters' guild in 1607 (elected dean in 1614–16). De Crayer was known especially for his portraits and religious paintings. The artist was elected painter to the court of Cardinal-Infante Ferdinand in 1636, and later, in 1647, to the court of Archduke Leopold Wilhelm. In 1663 he registered in the guild at Ghent, where he relocated in 1664 and spent his remaining years.

7

Gaspar de Crayer (*attributed to*)

THE LAMENTATION, 1640s

Black chalk, brush and gray ink, heightened with white chalk, on tan paper,

427 x 472 mm (16¾ x 18½ in.)

The Cleveland Museum of Art, Cleveland, Ohio: Fiftieth Anniversary Gift for the

Mr. and Mrs. Charles G. Prasse Collection

Inv. no. 66.174

Provenance: Johannes Noll, Frankfurt a.M. (F. A. C. Prestel, 7–8 October 1912, p. 57, no. 116, pl. 54,

as Van Dyck); Leona E. Prasse

References: *Cleveland Museum of Art Bulletin* LIII, September 1966, p. 282, no. 92, ill. p. 209;

Cleveland 1966, p. 120, ill. (as Van Dyck); Held 1989, p. 62, fig. 10 (as Gaspar de Crayer?).

This exceptionally large LAMENTATION, traditionally attributed to Van Dyck, was first associated with Gaspar de Crayer by Julius Held in 1989; both Ann Percy (1982) and An Zwollo (1984) (information from curatorial files) considered the drawing to be Italian rather than Flemish.

Held's opinion was influenced by a comparison with De Crayer's preliminary study for the MIRACULOUS DRAUGHT OF FISHES in the Institut Néerlandais, Fondation Custodia, Collection Frits Lugt, Paris (Inv. no. 1973-T-69; Vlieghe 1979–80, p. 188, fig. 30) for the altar of the Fishmongers of 1643–44, today in the Musées Royaux des Beaux-Arts, Brussels (Vlieghe 1972, no. A89, fig. 89). This latter drawing was once considered to be by Pordenone, according to an old annotation; Egbert Haverkamp-Begemann reattributed it for the first time to De Crayer. The sheet in Paris exhibits a similarly loose handling of the chalk, as well as short, repeated contour lines drawn with the pen; in the present drawing in Cleveland, the figure of Christ on the Virgin's lap, Mary Magdalene, holding His hand, and another person barely visible at the left, are drawn primarily in black chalk. The draftsman subsequently strengthened the outlines with brush and dark gray ink. None of De Crayer's five extant representations of the Lamentation is similar in composition to this drawing.

In its large size and heavy use of wash, the drawing seems closer to a *modello*.

Abraham van Diepenbeeck

's-Hertogenbosch 1596–1675 Antwerp

When Abraham van Diepenbeeck, son of the glass painter Jan Roelofszoon (d. 1619), was born in 's-Hertogenbosch in 1596, the town was still part of the southern Netherlands (and remained so until 1629, when it was conquered by the Dutch). In 1620 Van Diepenbeeck migrated to Antwerp,

where he worked as a glass painter executing twelve large windows for the Carmelite Cloister in 1622 (now lost). In 1624 the artist was granted citizenship. According to a deposition Van Diepenbeeck made in 1643 (see Hensbroeck-van der Poel 1986, pp. 206–08), he spent some time in France before 1629; thereafter he lived with his brother Gijsbert in 's-Hertogenbosch, later with another brother Jacob in Eindhoven, both in the northern Netherlands. He is documented in Antwerp in the years 1633 to 1636, in 1637 when he married Catherine Heuvick (d. 1648), and in 1652 when he married Anna van der Dort.

Mariette recounted that Van Diepenbeeck was in Paris in 1632, when he made the drawings for the *Tableaux du Temple des Muses* (1851–60, II, p. 107). Not long after Van Diepenbeeck signed a contract for windows in the church of St. Paul in Antwerp in 1633, he virtually stopped working as a glass painter. In 1638 he became a member of the painters' guild instead; three years later he was elected dean but did not take up the office. From the mid-1650s Van Diepenbeeck concentrated increasingly on designing book illustrations, and title and thesis pages; over forty are known today (see Steadman 1982, pp. 33, 55–57, Appendix 2).

8

THE HOLY FAMILY WITH ST. ANNE HOLDING THE CHILD, ca. 1644

Brush and shades of black and gray watercolor, with white bodycolor, over black chalk,

the figures reserved against a gray prepared background; incised with the stylus,

245 x 341 mm (9⅝ x 13⁷⁄₁₆ in.)

The Pierpont Morgan Library, New York, New York

Inv. no. I,246

Provenance: Sir Charles Greville (1763–1832; L. 549); George Guy, 4th Earl of Warwick (1818–93; L. 2600); his sale, London, Christie's, 20–21 May 1896, one of three in lot 106; Charles Fairfax Murray, London (d. 1919); J. Pierpont Morgan

References: Steadman 1982, p. 64; Stampfle 1991, no. 265, ill.

Although Van Diepenbeeck made a great effort to be registered in the Antwerp painters' guild, he is better remembered today as a prolific draftsman. Judging by the engravings credited to him, he made more than 750 drawings, the majority of them for prints.

Van Diepenbeeck drew this HOLY FAMILY WITH ST. ANNE expressly as a model for a print, as the more painterly technique of brush in watercolor and bodycolor indicates. The overall impression is close to a grisaille, a medium that traditionally characterizes a model for an engraver. Pieter de Jode the Younger (Antwerp 1606–74) engraved the *modello* in reverse (Hollstein, V, p. 243, no. 159 and IX, p. 203, no. 3; reproduced in Stampfle 1991, fig. 100). The print includes at the left a view into a garden and buildings in the distance, which shows that the design was cut down at the right and most likely along the top as well. In De Jode's engraving the architecture is extended to include a niche with a prayerbook and the indication of an archway leading onto a terrace. Whereas in its

present state the drawing shows the Holy Family gathered in a small interior, Van Diepenbeeck originally placed the figures in a more spacious indoor setting. The text of the engraving's caption pertains to the Song of Solomon (3:4). Van Diepenbeeck dedicated the print to his kinsman, the Reverend Philip van Hoeswinckel, since 1638 the pastor in charge of the Chapel of Onze-Lieve-Vrouw-van-Goeden-Wil in Duffel, a chapel under the protection of the Praemonstratensians from Tongerloo. The occasion most likely was to congratulate Van Hoeswinckel (Antwerp 1605–1673 Duffel) on his history of the chapel, *Onse L. Vrouwe van Duffel*, published in 1644 by Martinus Binnaert in Antwerp with a title page designed by Erasmus II Quellinus (Hollstein, XVII, p. 283, no. 2; see Dom 1936, ill. p. 65, and Goovaerts 1902, columns 304–05; the drawing was not listed in De Bruyn 1986, since he excluded designs for title pages).

Cornelis Galle the Elder copied De Jode's print in a slightly smaller engraving in reverse, which is preserved in an impression in the British Museum, London (not in Hollstein; reproduced in Stampfle 1991, fig. 101).

9

THE DEATH OF HERCULES, ca. 1650

Black chalk, heightened with white, traces of brown ink, 241 x 180 mm (9½ x 7⅛ in.)

Museum of Art, Rhode Island School of Design, Providence, Rhode Island:

Gift of Mrs. Gustav Radeke

Inv. no. 20.433

Provenance: Willem Isaack Hooft, Amsterdam (1782–1863; L. 2631); Mrs. Gustav Radeke, Providence (1855–1931)

Exhibition history: Providence 1983, no. 80, ill.

References: McAllister Johnson 1968, p. 180, no. 24; Steadman 1982, p. 65, Appendix 3; Van Tatenhove 1989, p. 34.

Exhibited in Wellesley only

This is one of seven extant designs by Van Diepenbeeck for Michel de Marolles's *Tableaux du Temple des Muses*, published in Paris in 1655. These drawings brought Van Diepenbeeck international recognition. The volume was conceived originally by Jacques Favereau under the title *Tableaux des Virtues et des Vices*, to be accompanied by sonnets, but was left incomplete at his death in 1638. The French engraver Pierre Brébiette (d. ca. 1650) had contributed at least twenty-three designs which were later replaced by Van Diepenbeeck's drawings. Michel de Marolles continued the project and published it in a much more elaborate edition in 1655 with the revised title of *Tableaux du Temple des Muses*. The fifty-eight mythological scenes or *tableaux* more often than not were based on Ovid's *Metamorphoses*, with a brief text to which De Marolles added a commentary.

In this drawing, Van Diepenbeeck depicted Hercules in the foreground engulfed by the flames on the funeral pyre, which—following the hero's instructions—was erected on the highest mountain. Above, Hercules rides his chariot to Olympus where he is being welcomed by Jupiter, his father, and Juno, who will adopt him as her son. Cornelis II Bloemaert (Utrecht 1603–1684 Rome) engraved it in reverse as plate 24 in Michel de Marolles's *Tableaux du Temple des Muses*, published in Paris in 1655. The print was included as one of six illustrations in Chapter XXIV, p. 187 of Book III, entitled *La Chasse et les Combats* (The Hunt and Battles) and signed on the plate *A. Diepenbeeck Stet. fig.* The pose of Hercules is strongly reminiscent of Pierre Brébiette's earlier, but discarded, design of Ixion (reproduced in McAllister Johnson 1968, p. 190, fig. 35a). This suggests that the drawing was part of the group of twenty-three that Van Diepenbeeck was commissioned to create as a replacement for Brébiette's earlier designs. Although the drawing is not indented for transfer, there seem to be traces of squaring which would have assisted in transposing the design onto the copper plate. Cornelis Bloemaert followed Van Diepenbeeck's *modello* with minor modifications, such as the inclusion of small figures in the distant landscape.

Of the eight drawings for the *Tableaux du Temple des Muses* that Steadman listed (1982, pp. 62–67), Van Tatenhove (1989, p. 34) accepted only five as specific preliminary designs for illustrations (in reverse) in the *Tableaux*, namely THE FLOOD and PANDORA in Frankfurt, JUPITER AND SEMELE in Leiden, the present drawing with the DEATH OF HERCULES, and PROMETHEUS AND THE EAGLE in a private collection in the United States. (The latter was incorrectly published as an early drawing by Erasmus Quellinus in De Bruyn 1986, pp. 221–23, fig. 7, also pointed out by Van Tatenhove 1989, p. 34 and acknowledged by De Bruyn 1991, p. 198.) To this group Van Tatenhove added two further preliminary designs, DEUCALION AND PYRRHA (sale, Amsterdam, Sotheby/Mak van Waay, 26 November 1984, lot 89) and the FALL OF ICARUS in the Biblioteca Nacional, Madrid (Inv. no. 8767; Van Tatenhove 1989, fig. 5; for the corresponding prints see McAllister Johnson 1968, nos. 3–6, 12, 24 and 34). Van Diepenbeeck prepared at least some of the designs for the *Tableaux* with a more freely executed preliminary sketch in pen and wash, such as THE FLOOD, now in the Rubenshuis, Antwerp (Steadman 1982, p. 67, fig. 17). Van Diepenbeeck's drawings of the FALL OF PHAETON in Frankfurt (with which Wood associated another unpublished version by Van Diepenbeeck in the Victoria and Albert Museum, London; see Wood 1990, p. 14 and note 58), JASON AND THE GOLDEN FLEECE in Valenciennes, and HERCULES AND ACHELOUS in Amsterdam likewise did not serve specifically as designs for the respective prints in the *Tableaux*. (Steadman considered the drawing of MELEAGER in the Albertina, Vienna, to be a copy, whereas in Hollstein [V, p. 242, after A. van Diepenbeeck, s.v. C. Bloemaert, nos. 34–93] it is listed as the only known preliminary drawing for the series.) Mariette thought Van Diepenbeeck made these drawings during his stay in Paris in 1632; the *avvertissement* in the *Tableaux* stated that the artist had begun work on the illustrations before 1638, the year Favereau died. Van Diepenbeeck stayed in Paris

143

again in 1650, as we see from his signed copy after Francesco Primaticcio's ADORATION OF THE KINGS, then in the Chapel of the Duc de Guise in Paris (destroyed), dated 1650 (Frankfurt, Städelsches Kunstinstitut; Wood 1990, fig. 16). His drawing of the DEATH OF HERCULES must therefore have been finished at the latest during that sojourn.

10

DESIGN FOR THE TITLE PAGE TO THE "COSTUMEN VAN HET GRAFSCHAP VAN VLAENDEREN," 1674

Pen and brown ink, black chalk, heightened with white, traced with a stylus for transfer, on two sheets of paper, 343 x 224 mm (13½ x 8¹³⁄₁₆ in.)

Inscribed in pen and brown ink on the cartouche held by two putti at top, *T GEBRVYCK / GHEEFT SEDEN / AEN WET / EN REDEN*; on the ribbon at the center along left edge, *DVYSTER EN SWAER WORD LICHT EN CLAER*; on the tablet held by the female figure at the left, *RAVWE / WET*; on the ribbon held up by the putto at the right, *SPITS RECHT*; on the tablets on the pedestal at the bottom, *T'GEBRVYCK / BESET / EN RECHT EN WET*.

Bowdoin College Museum of Art, Brunswick, Maine: Bequest of the Honorable James Bowdoin III

Inv. no. 1811.135

Provenance: James Bowdoin III

Exhibition history: Brunswick, Maine 1985, no. 20, ill.

References: Steadman 1982, p. 61; Becker, in exh. cat. Brunswick, Maine 1985, no. 20.

The drawing was unattributed until 1966, when Haverkamp-Begemann assigned it for the first time to Abraham van Diepenbeeck. Steadman identified it as the design for the title page of the *Costumen van het Grafschap van Vlaenderen* (The Customs of the County of Flanders) by Laurens van der Hane, published in Antwerp and Ghent in 1674. It was therefore among Van Diepenbeeck's last designs, since he died the following year. Cornelis van Caukercken (Antwerp ca. 1625–ca. 1680 Bruges) engraved the drawing in reverse (not mentioned in Hollstein). Its complex iconography, which stresses the value of customs or common law in the county of Flanders, was explained by A. J. O. van Wassenaer as follows: The venerable elderly woman standing in the center of an elaborate platform personifies *Custom* (*'t gebruyck* or *'t gebruick*), that is Common Law. She is bringing together *Justice*, in the drawing at the right, and *Lex* or Written Law, at the left, who is holding a book of codified law (*RAVWE WET*). *SPITS RECHT*, written on the banner held by the putto floating above Justice refers to sharply reasoned law; the whip (*zweep* or *breidel*) in his left hand signifies both criminal justice and restraint (bridle). The putto at the lower left is using a grindstone honing and polishing the raw law, reflected in the words on the banner: *duyster en swaer word licht en claer* ([that which is] dark and obscure will become light and clear). The motto on the cartouche held aloft by the two putti at the top is to be understood as "Custom humanizes

or tempers both (written) codified law and reason(ing)." The motto on the pedestal at the bottom should be interpreted as "Custom outweighs both law and codified law."

(An impression of the title page only is in the Department of Prints and Photographs in The Metropolitan Museum of Art, New York, Inv. no. 56.515.55; a copy of the *Costumen* is in the Bibliothèque Royale Albert I^{er} in Brussels.)

Anthony van Dyck

Antwerp 1599–1641 London

Van Dyck was the son of a merchant, who was not as wealthy as previously believed. It was thus necessary for Anthony at times to paint in order to survive (see Van der Stighelen 1993). In 1609 he registered in the painters' guild as a pupil of Hendrik van Balen. As early as 1615–16 Van Dyck seems to have worked as an independent artist, although he did not become a master in the guild until 1618. Never properly a pupil of Rubens, he became Rubens's most esteemed collaborator and painted a series of ceiling paintings to Rubens's designs for the Jesuit church in Antwerp.

In 1620 Van Dyck briefly went to London before traveling south to Italy, where in 1621 he visited Venice, Genoa, Rome, and Palermo in Sicily. By the fall of 1627 he was back in Antwerp, having established his reputation as a portrait painter. In 1630 Van Dyck was appointed court painter to the Archduchess Isabella and two years later, in 1632, to the court of Charles I. He spent most of his remaining years in England except for a brief return to the southern Netherlands from early 1634 until mid-1635. By the winter of 1631–32 Van Dyck was working on a project known as the *Iconography*, with which more than fifty of his drawings are associated; left incomplete at his death in 1641, it was published—enlarged to one hundred plates—by Gillis Hendricx in Antwerp in 1645.

145

11

A BEARDED OLD MAN HOLDING A BUNDLE *recto*, ca. 1618

FIGURE STUDIES *verso*

Black, red, and white chalk (recto); pen and brown ink (verso), 380 x 220 mm (14¼ x 9 in.)

Private Collection

Provenance: Lt.-Col. J. C. Dundas, Fochtertyre, Stirling (his sale, London, Sotheby's, 6 March 1946, lot 134); Dr. and Mrs. Francis Springell, Portinscale, Cumberland (sale, London, Sotheby's, 30 June 1986, lot 58); William Acquavella, New York (1990)

Exhibition history: New York/Fort Worth 1991, no. 8, ill. in color.

Reference: Vey 1962, no. 35, pls. 45–46.

Van Dyck drew this figure from life as a study for the lame man in his painting the HEALING OF THE PARALYTIC (St. Matthew, 9:1–8), known in two versions: one in the English royal collection (Larsen 1988, no. 275), the other one exhibited at Schleissheim as part of the Bayerische

Staatsgemäldesammlungen (Larsen 1988, no. 276; New York/Fort Worth 1991, fig. 2). In the latter, the lame man is bearded as well, while in the painting at Buckingham Palace, believed to be Van Dyck's primary version, he is clean shaven. In both compositions the old man is somewhat younger in appearance than in the drawing and carries a blanket over his arm rather than a bundle under it. In the paintings the paralytic raises his left hand in front of his chest in a gesture expressing gratitude for having been chosen to be healed.

Christopher Brown's observation (exh. cat. New York/Fort Worth 1991, no. 8) that the red chalk is by Van Dyck, rather than added by another hand as Vey suggested, is justified. The ear of the old man, for example, would become unintelligible if the red chalk were subtracted. These additions in red chalk form an integral part of the drawing. This is the only known preparatory study for the HEALING OF THE PARALYTIC, whether for individual figures or for the composition as a whole, although there are three entirely different drawings of the same subject that could belong to an early stage of the development. (See Vey 1962, nos. 43–44, 47 and exh. cat. New York/Fort Worth 1991, under no. 8, p. 70, figs. 4–6. In addition, Müller Hofstede published a pen-and-brush drawing in the Museum Boymans-van Beuningen, Rotterdam, of a striding man, carrying his bed on his shoulders, which he considered to be by Van Dyck, made in connection with a full-length version of the subject; see Müller Hofstede 1973, p. 156, pl. 21.) Since the figures of the paralytic in Van Dyck's painted versions in the English royal collection and at Schleissheim are quite similar, we may suppose that he made the drawing late in preparation for the composition. The boldness in handling of the black chalk and the sparse indications of modeling recall Rubens's studies of individual figures in black chalk drawn about 1618 as well as, for example, his black chalk study of the BLIND MAN in the Albertina, Vienna, of ca. 1617–18 (Held 1986, no. 128) for the blind beggar in the altar of the MIRACLES OF ST. FRANCIS XAVIER, painted originally for the Jesuit church in Antwerp and now in Vienna.

The studies in pen and brown ink on the verso of the drawing are difficult to read and seem unrelated to the study for THE HEALING OF THE PARALYTIC on the recto. Instead we find four distinct groups of figures, which, in their abbreviated sketchiness, are very close to Rubens's early compositional drawings. At the top left a man with arms outstretched to the right is facing a group of men looking intently at him; in the center a man in a toga-like garment is seated on a stool; at the top right another group of men, one again with arms raised, is observing something at the right. Christopher Brown pointed out that some of the groups reflected paintings that Rubens was working on during those years, in particular, the DECIUS MUS series (to which Van Dyck contributed), the ASSUMPTION OF THE VIRGIN in Düsseldorf, and the PENTECOST in Munich; Ludwig Burchard interpreted these figural groups as studies for Christ at the Pool of Bethesda (quoted by Vey 1962), and thus related to the recto.

12

STUDY FOR THE FIGURE OF MALCHUS, ca. 1618–21

Black chalk, 273 x 400 mm (10¾ x 15¾ in.)

Annotated in pen and brown ink at bottom right, *ant. Vandijck.*

Museum of Art, Rhode Island School of Design, Providence, Rhode Island:

Gift of Mrs. Gustav Radeke

Inv. no. 20.443

Provenance: Pierre Jean Mariette, Paris (1694–1774); Gabriel Huquier, Paris (1695–1772; his sale, Amsterdam, 14 September 1761, no. 563); Willem Isaack Hooft, Amsterdam (1782–1863; L. 2631); Mrs. Gustav Radeke, Providence (1855–1931)

Exhibition history: Antwerp 1960, no. 45; Princeton 1979, no. 29; Providence 1983, no. 77; New York/Fort Worth 1991, no. 35, ill. in color.

Reference: Vey 1962, no. 87, pl. 117.

Exhibited in Wellesley only

Van Dyck drew this black chalk study from a model in preparation for the figure of Malchus in his painting of the BETRAYAL OF CHRIST, once in the collection of Rubens and now in the Prado, Madrid. Malchus, the servant of the high priest, is struggling with Peter who has grasped his cloak and is about to cut off his ear with a sword. Malchus's discarded lantern is visible in the foreground. This is the last and only detailed figure study in a sequence of ten known drawings (two versos included) that Van Dyck made in preparation for his three extant painted versions. (In addition to the BETRAYAL in the Prado, the other two are in The Minneapolis Institute of Arts and in the collection of the 4th Lord Methuen at Corsham Court, on loan from the City of Bristol Museum and Art Gallery.) The group of Peter attacking Malchus presented the greatest challenge for the artist as is attested by no less than four specific compositional studies (Vey 1962, nos. 80, 82v, 85, 86). These are invariably drawn with pen and brown ink while this last one is the only study in black chalk. (For a discussion of Van Dyck's drawings and painted versions of the BETRAYAL and TAKING OF CHRIST, see Christopher Brown in New York/Fort Worth 1991, pp. 128–42, and Susan J. Barnes in Washington, D.C. 1990–91, pp. 110–16.) Brown did not refer to a small sheet in the Kunstsammlungen, Veste Coburg, of a head drawn in black chalk that Müller Hofstede attributed to Van Dyck (Müller Hofstede 1973, p. 154, no. 2, pl. 18b). According to Müller Hofstede, it represents another study by Van Dyck for the head of Malchus, shown in sharp foreshortening with the mouth distorted in pain; this was followed by the larger drawing here discussed.

The pose of the anguished Malchus in the Prado's BETRAYAL OF CHRIST differs little from the black chalk study in Providence. Van Dyck emulated a familiar practice of Rubens, who would at the very end of the working process draw figures from the model in the exact pose seen in the

final painting. As in this example by Van Dyck, the figure, more often than not, is placed prominently in the foreground and thus was prepared separately in a carefully drawn study. Drawn slightly earlier (ca. 1611), Rubens's example of a study from the model for the figure of Christ in the RAISING OF THE CROSS, from the Fogg Art Museum, is reproduced here for a firsthand comparison (catalogue number 42).

Van Dyck made several such studies in black chalk for specific figures during the relatively short time that he was Rubens's trusted assistant, from about 1618 until the autumn of 1621 when he left for Italy. His drawing not only has the same function as Rubens's, but comes uncomfortably close to Rubens's manner of drawing.

This is by far the most dramatic of Van Dyck's black chalk studies, almost like an *hommage* to Rubens. Malchus appears in this very pose only in the Prado version of the BETRAYAL OF CHRIST, a painting that Van Dyck presented to Rubens before leaving for Italy in 1621.

13

RINALDO AND ARMIDA, ca. 1627
Pen and brown ink on blue paper, 250 x 344 mm (9⅞ x 13½ in.)
The Chrysler Museum, Norfolk, Virginia: Gift of Walter P. Chrysler, Jr.
Inv. no. 71.458
Provenance: Sir Peter Lely, London (1618–80)(?); Sir John Charles Robinson, London (d. 1913); Charles Fairfax Murray, London (d. 1919); R. Ederheimer, New York City (sale, New York, Anderson Galleries, 6–7 November 1924, lot 208); Victor Koch, London; Oskar Klein, New York City (Central Picture Galleries); Walter P. Chrysler, Jr. (1965)
Exhibition history: Antwerp 1899, no. 121; London 1900, no. 183; Norfolk 1979, no. 39, ill.
References: Valentiner 1950, pp. 8–10, ill.; Los Angeles 1954, under no. 19; Vey 1962, no. 119, pl. 136; Larsen 1988, under no. A176.

This is the earliest of the three known versions of RINALDO AND ARMIDA by Van Dyck inspired by Torquato Tasso's epic poem *Gerusalemme Liberata*, first published in 1581, which recounts the siege and capture of Jerusalem by the crusaders. Tasso's *Gerusalemme Liberata* was well known at the English court and inspired the last masque Ben Jonson wrote for King James, "The Fortunate Isles and Their Union," performed in 1625 (see Parry 1981, pp. 55–58). In the drawing, Van Dyck rendered an episode from the love story of Rinaldo and Armida that Tasso wove into the epic poem, described in Canto XIV, verses 57–68. (The quotations below are from Edward Fairfax's translation into English, London, 1600.)

Rinaldo, the Christian knight, fell asleep to the singing of the river nymph on the bank of the river Orontes, where Armida found him. "Swearing Revenge, and threat'ning Torments smart," her hatred was transformed into love at the sight of the sleeping knight. "And with a Vail she wiped now and then From his fair Cheek the Globes of silver Sweat," upon which Rinaldo awakened startled. In Van Dyck's drawing, Armida is about to tie him with garlands of flowers and to abduct him in her chariot to her palace on the Fortunate Isles. The putto in the center with the inverted torch may allude to Rinaldo's dormant love, about to be awakened. Another putto with a book tucked under his arm hovers in the sky, while the inscription on the marble column, which tempted Rinaldo to the island in the first place, is difficult to decipher in the drawing; it is loosely indicated in a rectangular shape in the sky. Later, Rinaldo will be rescued by his friends Ubaldo and Carlo to rejoin the crusaders. Tasso's poem ends with Rinaldo again encountering Armida, who flees in despair from the field of battle; while consoling her he promises to restore her to her father's throne.

Vey believed the drawing to be heavily reworked, an opinion supported by Erik Larsen who rejected it altogether and removed it from Van Dyck's œuvre. The heavier, blotchier pen lines in the putto in the center, the nymph at the left, as well as in the legs of Rinaldo, are so close in hue to the brown ink Van Dyck used for the underlying drawing that it is difficult to separate them from each other. Some of the blotchiness seems to have been caused by the absorbent heavy paper that Van Dyck used. The drawing may still date from his last year in Italy, 1627, or possibly from shortly after his return to Antwerp.

Van Dyck may have made a painting based on this drawing since there exists a version once considered to be an original by Van Dyck, formerly in the Los Angeles County Museum of Art (57 x 79 in.; sale, Los Angeles, Sotheby Parke Bernet, 21–23 June 1982, lot 28, ill., as attributed to Erasmus Quellinus). The most obvious difference is the pose of Rinaldo, who sleeps resting on his right arm, eliminating the rather unsatisfactory parallelism of Armida's and Rinaldo's arms in the drawing. The floating column is anchored to the ground in the painting and placed at the far left of the composition.

Due to Van Dyck's astonishing ability to reverse compositions with great ease—possibly because of his supposed early training in copying paintings after Rubens for prints—the drawing also may have served as a point of reference for his much larger, more dramatic version of RINALDO AND ARMIDA in an upright format in The Baltimore Museum of Art (Inv. no. 1951.103; oil on canvas, 93 x 90 in.), the painting that Endymion Porter acquired from Van Dyck for Charles I in 1629. Here the principal figures are reversed, with Rinaldo slumbering at the left, Armida approaching from the right, and the river nymph surfacing from the water barely visible at bottom right, while the torch-bearing putto and the column are eliminated.

14

PORTRAIT OF CARLOS COLOMA (1573–1637), 1627–35

Natural black chalk, heightened with white chalk on cream antique laid paper,
darkened to light tan, 242 x 187 mm (9½ x 7 1/16 in.)
Annotated in pen and brown ink at bottom left, *1628*, and by another hand (Lambert ten Kate?)
at bottom right, *A. van Dyk*.
Fogg Art Museum, Harvard University Art Museums, Cambridge, Massachusetts:
Gift of Meta and Paul J. Sachs
Inv. no. 1961.150
Provenance: Lambert ten Kate, Amsterdam (1674–1751); Sybrand Feitama, Amsterdam (his sale,
Amsterdam, 1758, lot 50); C. A. C. Ponsonby; F. Flameng, Paris (his sale, Paris, Georges Petit Gallery,
26–27 May 1919, lot 52, ill.); Paul J. Sachs, Cambridge, Massachusetts (1878–1965)
Exhibition history: New York/Fort Worth 1991, no. 62, ill. in color.
References: Mariette 1851–60, IV, p. 201; Mongan and Sachs 1940, no. 466, pl. 238; Vey 1962, no. 259,
pl. 312.

Don Carlos Coloma (Alicante 1573–1637), a Spanish general and statesman whom Philip IV appointed as special ambassador to discuss the terms of the peace with England, most likely sat for Van Dyck between 1627 and 1635. Van Dyck concentrated primarily on the general's face, sketching his pose only summarily. Coloma is rendered in civilian clothes, although he seems to be wearing a military sash; the baton that he holds in the grisaille oil sketch and in Pontius's engraving is indicated by a simple straight line running through his left hand.

The drawing, which is not traced for transfer, served for the engraving in the same sense by Paul Pontius (Antwerp 1603–1658). It is one of sixteen similar studies in black chalk on white paper of princes and military commanders that Van Dyck made in Flanders during the years 1627 to 1635 for a collection of eighty etched and engraved portraits, known as the *Iconography*, printed by Martinus van den Enden (active 1630–54). In 1645 Gillis Hendricx enlarged it to one hundred plates, the so-called *Icones . . . Centum*, or, with its translated title, *One Hundred Portraits of Princes, Men of Letters, Painters, Printmakers, Sculptors as well as Amateurs of the Pictorial Arts Done from Life By Anthony van Dyck, Painter, and Engraved at his Expense In Copper.*

In Pontius's engraving (Mauquoy-Hendrickx 1991, no. 45) Don Carlos is represented in armor holding a commander's baton, standing in front of a patterned curtain with his right hand in a gauntlet resting on a parapet. Since Van Dyck included none of these elements in his preliminary drawing here discussed, Pontius must have based his engraving largely on the grisaille in reddish tones, nearly identical in size, in the collection of the Duke of Buccleuch at Boughton House (figure VI; Inv. no. 194; oil on panel, 9½ x 6¾ in.); this renders Don Carlos very much as we

see him in Pontius's print (see Larsen 1988, pp. 483–84, no. 7 and fig. 509 for the copy in Bayonne; see also Spicer 1993).

According to both Vey and Brown, Van Dyck drew Carlos Coloma from life. In contrast, Joaneath Spicer recently argued that—based on her analysis of the prints, drawings, oil studies, and paintings for the *Iconography*—Van Dyck probably made the black chalk studies after a painted portrait of the subject (Spicer 1993); in this instance the drawing at the Fogg Art Museum most likely would have been based on an oil painting and not drawn from life. This, in her opinion, is explained in the inscription on the engraving, *Van Dyck pinxit*, which she interprets as conveying that the portrait derived from a painting by Van Dyck. Although no such painted portrait of Coloma by Van Dyck is known, the practice is consistent with other drawings in black chalk that we know Van Dyck made after painted portraits in preparation for engravings that were published in the *Icones . . . Centum*. The chalk drawing was subsequently transferred to the copper plate with the help of a tracing paper (Van den Wijngaert 1943, p. 106, called it "décalque"). If Van Dyck's drawing was in black chalk only, as in this portrait of Coloma, a grisaille followed, painted by Van Dyck or an assistant. Spicer concluded that the remark *ad vivum expressae* (studied from life) on the title page of Hendricx's *Icones . . . Centum* of 1645 referred to Van Dyck's painted portraits rather than to his chalk drawings.

15

Anthony van Dyck (*attributed to*)

CHRIST ON THE CROSS

Black chalk and some red chalk, traces of white, some stumping in black chalk of the background, 344 x 288 mm (13⁹⁄₁₆ x 11³⁄₈ in.)

Illegible inscription in faint black chalk at bottom right.

The Pierpont Morgan Library, New York, New York

Inv. no. I,242

Provenance: Sir Charles Greville (1763–1832; L. 549); George Guy, 4th Earl of Warwick (1818–93; L. 2600; his sale, London, Christie's, 20–21 May 1896, lot 126, as Van Dyck); Charles Fairfax Murray, London (d. 1919); J. Pierpont Morgan

Exhibition history: London 1877–78, no. 1124.

Reference: Stampfle 1991, no. 274, ill.

Attributions for this half-length figure of CHRIST ON THE CROSS range from an unknown copyist (Burchard, Van Regteren Altena, D'Hulst, among others) to Van Dyck himself (Jaffé and Held), the latter with the proviso that the extensive shading in the background and possibly some of the repetitious contours were later additions (see Stampfle 1991, no. 274). No corresponding painting is known, although this type of Crucifixion is found in paintings by or attributed to Van Dyck and

his followers, such as examples in Vienna (Larsen 1988, no. 714, fig. 223), Antwerp (Larsen 1988, no. 715, fig. 224), and elsewhere.

There exist relatively few preliminary drawings in black chalk by Van Dyck of individual figures that correspond to his religious paintings. Invariably Van Dyck concentrated on the pose of the human body, omitting most of the surrounding elements. Thus, in a study with a similar function of a Christ on the Cross in the British Museum, London (Vey 1962, no. 126), Van Dyck concentrated solely on Christ's body and outstretched arms, without any indication of the cross, in preparation for the CRUCIFIXION in the church of Our Lady in Dendermonde of about 1628–29 (KdK 4242; Larsen 1988, no. 709, fig. 215). Consequently, adding the beams of the cross, as in this study of Christ, is inconsistent with Van Dyck's practice. They are clumsily drawn and the disappearing vertical shaft to the right of Christ's torso is particularly inept. This is a further argument against attributing the drawing to Van Dyck himself. The few *pentimenti*, primarily in the arms and hands, speak against an outright copy. Christ on the Cross with the arms in an almost vertical position was represented rather often in Flemish art. The drawing therefore may well be by one of the many lesser known Flemish seventeenth-century draftsmen, as Stampfle also concluded.

16

LANDSCAPE WITH A TALL TREE, 1630s
Watercolor, pen and brown ink, 190 x 364 mm (7 ½ x 14 ¹⁵⁄₁₆ in.)
Collection of The J. Paul Getty Museum, Malibu, California
Inv. no. 85.GG.96
Provenance: Nicolaes Anthoni Flinck, Rotterdam (1646–1723; L. 959); William, 2nd Duke of Devonshire, Chatsworth; by descent to the current duke (sale, London, Christie's, 3 July 1984, lot 58); art market, New York
Exhibition history: New York/Fort Worth, 1991, no. 91, ill. in color.
References: Vey 1962, no. 307, pl. 359; Goldner 1988, no. 88, ill.

Exhibited in Wellesley only

An inscription, possibly by Nicolaes Flinck, on the verso of the HILLY LANDSCAPE WITH TREES at Chatsworth (Vey 1962, no. 306) suggests that at one time there existed no less than sixteen such landscapes by Anthony van Dyck, most probably also drawn with the brush and watercolor. This LANDSCAPE WITH A TALL TREE, a watercolor that Van Dyck left unfinished, is one of the five still known today (three more are at Chatsworth, and another is in the Barber Institute of Fine Art, Birmingham University, Birmingham). They are usually dated to Van Dyck's last years in England and interpreted as studies drawn from nature that he would adapt in the landscape backgrounds of his paintings. None corresponds exactly, suggesting that Van Dyck made them for their own sake.

These watercolors were unprecedented in England and had a great influence later on the English school of watercolorists. Netherlandish artists used watercolors in landscapes much earlier, as Jan Brueghel's VILLAGE MEETING PLACE UNDER TWO OLD TREES of ca. 1612 amply demonstrates (catalogue number 5). The difference now is that Van Dyck probably made these watercolors outdoors from nature, that is *naer het leven*.

The landscape study in the Getty Museum, drawn almost exclusively with watercolor, has traditionally been associated with Van Dyck's YOUNG WOMAN AS ERMINIA of about 1637–38 in the collection of the Duke of Marlborough, Blenheim Palace (Larsen 1988, no. 1042, ill.; exh. cat. New York/Fort Worth 1991, no. 91, fig. 1), since the concept of a tall tree standing out in the distance is found similarly in the landscape background. Van Dyck had already used a similarly arranged group of trees earlier, in the background of Van Dyck's family portrait of Sebastiaen Leerse with his second wife Barbara van den Bogaerde and son Johan Baptist (born 1623) in Cassel, dated to about 1630–32 (Larsen 1988, no. 695; Schnackenburg 1985, color pl. 22).

17

Anthony van Dyck (*school of*)

CLEARING IN THE WOODS

Watercolor and bodycolor on blue-gray paper, vertical fold through the center,

252 x 411 mm (9¹⁵⁄₁₆ x 16³⁄₁₆ in.)

Annotated in pen and brown ink at bottom right, *Wouters*. Yale University Art Gallery,

New Haven, Connecticut: Library Transfer

Inv. no. 1961.66.64

Provenance: Prosper Henry Lankrink, London (1628–92; L. 2090); John Percival,

1st Earl of Egmont (1683–1748)

References: Haverkamp-Begemann et al. 1964, under no. 24, fig. 28; Haverkamp-Begemann and Logan 1970, no. 621, pl. 294; exh. cat. London/New Haven 1987, under no. 59; Brown, in exh. cat. New York/Fort Worth 1991, p. 266, n. 14; Stampfle 1991, under no. 275.

This rather large rendering of a clearing in the woods, together with another related drawing, WOODS AT THE EDGE OF A LAKE, also in the Yale University Art Gallery and done entirely with the brush and bodycolor on blue paper, belongs to a group of nine or ten similar studies, five of which have an old annotation to Van Dyck. (Christopher Brown published one of them, the MEADOW BORDERED BY TREES in the British Museum, London, as an original landscape study by Van Dyck of ca. 1635 in his monograph on the artist in 1982, p. 216, fig. 224, ill. in color.) While this traditional attribution is no longer accepted, it nevertheless shows that since at least the early eighteenth century, this unusual technique was associated with Anthony van Dyck. One of the latter's rare surviving landscapes in watercolor, accentuated with pen and brown ink, and

now in The J. Paul Getty Museum, is here discussed as catalogue number 16. In comparing the two landscape drawings, one observes that Van Dyck preferred to apply thin layers of transparent watercolor while in contrast the artist responsible for drawings like CLEARING IN THE WOODS favored opaque bodycolor and extensive heightening in white.

To these two landscapes at Yale with an old annotation to Wouters, Felice Stampfle recently added a third example, HILLY LANDSCAPE WITH TREES, which was sold in 1974 with an attribution to Frans Wouters (London, Sotheby's, 22 November 1974, lot 88, ill. p. 81). As early as 1959, Julius Held had suggested Frans Wouters as the most likely artist for this group of landscape drawings in bodycolor, since the wooded scenery was not unlike the artist's landscape backgrounds in paintings in Vienna, Copenhagen, and London (see Glück 1933, pp. 222–43). Held's opinion, which he reiterated in 1993, seems plausible. Frans Wouters, born in Lier in 1612, became a master in the Antwerp's painters guild in 1634–35 and assisted Rubens with the decorations for the Triumphal Entry of Cardinal-Infante Ferdinand into Antwerp. The following year, in 1636, he traveled in the retinue of Emperor Ferdinand II to England, where he remained until at least 1637. Wouters was recorded as having been painter to the Prince of Wales (Martin 1970, p. 286). Later in 1641 he was back in Antwerp where he died in 1659. As long as no securely attributed landscape drawing by Frans Wouters becomes known, however, studies of wooded scenery in bodycolor similar to the ones discussed here will continue to be classified among the school or circle of Van Dyck.

Justus van Egmont

Leiden 1601–1674 Antwerp

Van Egmont was born in the northern Netherlands; at the age of fourteen, upon his father's death, his mother moved the family back to her native Antwerp. After a three-year apprenticeship with the history painter Jaspar van den Hoecke (Antwerp ca. 1585–after 1648 Antwerp), Van Egmont left for Italy in the spring of 1618. Upon his return he entered the studio of Rubens, who thought so highly of him that he supposedly delegated Van Egmont to paint the LAST SUPPER (now lost) in the chapel of St. Rombouts in Malines based on his—Rubens's—sketch. In 1625, Rubens mentioned in a letter that he left "Justo" (Justus van Egmont) behind in Paris in order to collect the payment due to him for the Medici series of paintings that he had just finished installing in the Luxembourg Palace.

Shortly after Van Egmont became a master in the Antwerp painters' guild in 1627–28, he left for Paris, where he met with considerable success. He was the painter of the Orléans family, executing the decorations in the castle of Balleroy; his portraits of Philip d'Orléans, Louis XIV, and the Grand Condé have been preserved as well. Honored with the title of *peintre du Roy*, Justus van Egmont was one of the founders of the French academy of painting and sculpture in 1648. According to André Félibien (III, p. 311), he assisted Simon Vouet with cartoons for tapestries, destined for the manufactory run by Flemish immigrants such as Coomans and De la Planche (Van der Plancken)

in the Faubourg Saint-Marcel in Paris. This skill brought Van Egmont good fortune later on in Antwerp, enabling him to buy not only the large house of Jan Wildens in 1662, but a sizeable art collection as well.

In 1649 and again in 1655, Justus van Egmont was recorded as being in Brussels; by early 1654 he had moved back to Antwerp. From these later years date his many cartoons for tapestries.

18

FAME CROWNING A VICTORIOUS GENERAL, DESIGN FOR A FRONTISPIECE (?), after mid-1650s
Black chalk, heightened with white, traced, horizontal crease through center,
312 x 210 mm (12¼ x 8¼ in.)
Private Collection
Provenance: William Sharp (L. 2650); Countess Sophy von Hollstein-Rathlow, Copenhagen;
Zeitlin & Verbrugge, Los Angeles; sale, New York, Christie's, 12 January 1988, lot 129, ill.

See the following entry.

19

FAME CROWNING A VICTORIOUS GENERAL, DESIGN FOR A FRONTISPIECE (?), after mid-1650s
Pen and gray-black ink and pencil and gray wash, heightened with white (partly oxidized),
313 x 212 mm (12⁵⁄₁₆ x 8⁵⁄₁₆ in.)
Annotated in pen and brown ink at bottom left, *Iust. Verus V. Eggmond.*
Yale University Art Gallery, New Haven, Connecticut: Library Transfer
Inv. no. 1961.63.46
Provenance: John Percival, 1st Earl of Egmont (1683–1748)
Reference: Haverkamp-Begemann and Logan 1970, no. 560, pl. 309.

Fame, seated on a pedestal, is crowning an unidentified man in armor with a laurel wreath. She is surrounded by allegorical representations of Justice and Wisdom (Minerva) at the left, Fortitude and Strength (Hercules) at the right. Since 1970, when this drawing was attributed to Justus van Egmont, primarily because of the annotation *Iust. Verus V. Eggmond,* two closely related versions have come to light, one in a private collection in the U.S.A. (see previous entry) that bears an old annotation *J. ab Egmont* on the mount, the other in the Victoria and Albert Museum, London, where it was classified as Anonymous, Netherlands school (figure VII; Inv. no. 9275; pen and gray ink and wash on gray paper, 311 x 207 mm). In 1975 J. van Tatenhove associated the latter drawing with the example at Yale in an annotation on the mount of the photograph at the RKD in The Hague. While at least one of the additional drawings supports this earlier attribution to Justus van Egmont, the question of the drawings' chronology needs reassessment.

The study in a private collection (catalogue number 18), which is identical in size to the other two examples mentioned, was probably the first idea for the composition. It is drawn broadly in black chalk and heightened with white, and is close in technique to Van Egmont's two preliminary drawings in Chicago for the ZENOBIA tapestry series (see catalogue number 20). In addition, there are rough tracing lines applied with a stylus that correspond exactly to the pen outlines in the Yale drawing, while the latter—despite the fact that it looks like a design for a print—is not traced. It would therefore seem likely that Justus van Egmont transferred the principal outlines from the looser, early draft in black chalk onto a second sheet that he worked up with the pen in order to facilitate the transfer of the composition onto the copper plate. This drawing, now in the Victoria and Albert Museum, London, was heightened with white (partly oxidized). The design definitely was meant to be reproduced as a print, as the main protagonists in the drawing act with their left hand—for example, Fame holds the wreath in her left. Since the drawing at Yale shows no *pentimenti*, it must have followed last, as a "clean" or "neat" version of the design in London.

The identification of the person being honored remains to be established. According to Jacques Wilhelm there is no resemblance to any French general, as far as he knows (letter of 4 November 1992), and the drawing most likely dates from Van Egmont's years after his return to Antwerp in late 1653 or early 1654.

Later in life, Justus van Egmont apparently succeeded in tracing his ancestry back to the counts of Egmont; accordingly he expanded his signature to read *Justus Verus ab Egmont*, reflected in the annotation on the Yale drawing (see Van der Stighelen 1991, p. 298).

20

THE MARRIAGE OF ZENOBIA AND ODENATUS, ca. 1665

Black chalk with brush and brown wash, on ivory laid paper, laid down on ivory laid paper, 181 x 318 mm (7⅛ x 12½ in.)

Annotated on the reverse in pencil, *Just d'Egmont.*

The Art Institute of Chicago, Chicago, Illinois: Leonora Hall Gurley Memorial Collection

Inv. no. 1922.1918b

Provenance: Leonora Hall Gurley

Reference: Exh. cat. Brussels 1977, under no. 38.

Exhibited in Cleveland only

This is one of two known drawings by Justus van Egmont for a set of eight tapestries portraying the history of Zenobia, Queen of Palmyra (Syria). The hangings were commissioned, most likely on speculation, about 1665 by the tapestry dealer and *tapissier* in Brussels, Gerard Peemans. The tapestries must have been well received, as Peemans was commissioned for a second set in 1676.

In this early sketch, drawn broadly with chalk, Van Egmont established the general layout of the marriage scene between King Odenatus of Palmyra and his second wife, Zenobia. Witnessing the ceremony is Zenobia's mother, standing between the two in the background at the center. The protagonists clasp each other's left hand, which indicates that Van Egmont took the eventual reversal of the design in the final tapestry into account from the beginning. A tapestry derived from Van Egmont's drawing in Chicago, together with three more hangings from the HISTORY OF ZENOBIA, is in the Musées Royaux d'Art et d'Histoire, Brussels (Inv. nos. 6283-86; see exh. cat. Brussels 1977, nos. 38–41, ill.).

After Odenatus's assassination in 267 A.D., Zenobia, Queen of Palmyra, continued expanding the empire as far as Asia Minor and Egypt. What brought her into open conflict with the Roman Empire and Emperor Aurelius was the minting of her own coins. In the ensuing war against the queen, Aurelius defeated her army in Emesa; when Zenobia refused to submit, however, his soldiers destroyed Palmyra and took her prisoner in 272 A.D. This event is recorded in a second preliminary drawing, ZENOBIA SURROUNDED BY MOUNTED SOLDIERS, also in the Gurley collection of The Art Institute of Chicago for the same tapestry series, which however was not used (Inv. no. 1922.1918a). Emperor Aurelius brought Queen Zenobia by force to Rome, where she is said to have died in 274 A.D.

Whereas this early preliminary study is developed horizontally, the format of the final tapestry, measuring 4.05 x 4.80 m, is less so. Omitted are the putti hovering above, as well as the male figures in attendance, while the children in the foreground no longer stand upright but crouch on the ground. This implies that Justus van Egmont must have made further drawings before the composition was woven in the studio of Gerard Peemans. This supposition is confirmed by a reference in a later contract of 23 January 1676 with Peemans regarding a second set of the "historie van den keyser Aurelianus mette coninginne Cenobia" (the History of Emperor Aurelius and Queen Zenobia), to be accomplished in eight months' time. Here we learn that before 1665 Peemans had commissioned from "Justus Verus ab Egmont" a *patroon* (design for a set of hangings) of this subject for which he paid 9,450 Brabant guilders, a sum that forced him to mortgage his "patrimonial goods." Besides the weaving of the first edition, the price included two sets of cartoons, one of equal size and one of reduced size, the so-called *petits patrons*.

Van Egmont seems to have taken his inspiration from Jean Tristan de Saint-Aman, whose *Commentaires historiques contenant l'histoire générale des Empereurs, Impératrices, Césars et Tyrans de l'empire romain*, published in Paris in 1644, included a romanticized biography of Zenobia, Queen of Palmyra. These tapestries of the HISTORY OF QUEEN ZENOBIA are considered to be among the best examples produced in the second half of the seventeenth century in the Brussels studio of Peemans, his son-in-law Gerard van den Strecken, and the latter's partner,

Jan van Leefdael. The subject matter of the series accords well with other tapestry sets dedicated to heroines of antiquity such as ANTHONY AND CLEOPATRA (an even more popular set designed by Van Egmont), TOMYRIS, JUDITH, and the FEMMES ILLUSTRES after cartoons by Jordaens. One complete set of eight hangings of the HISTORY OF ZENOBIA is still in the Spanish royal collection in Madrid, partly on deposit in Segovia and Barcelona (see Junquera de Vega and Diaz Gallegos 1986, pp. 164–72, series 62, ill. in color) and another set of eight is in the Palazzo Mansi in Lucca, Italy (for the background on this set of tapestries, see Crick-Kuntziger 1950, pp. 11–26).

Jacques Foucquier or Foucquières

Antwerp? 1590/91–1659 Paris

A self-portrait in Göttingen, dated 5 January 1604 and signed *jaques foucquier*, establishes that the thirteen-year-old artist was born in 1590–91 (Stechow 1948, p. 420). Nothing is known about his place of birth except that, according to Sandrart, he was from the western part of Flanders. In 1614 Jacques Foucquier was registered as a master in the Antwerp painters' guild and, in 1616, in the painters' guild of Brussels. Soon thereafter, from 1616–18, Foucquier was in the service of the Elector of the Palatine supervising the decoration of the interior of the so-called English House, which was part of the Heidelberg castle. Foucquier is said to have collaborated with Rubens. Later, in 1621, he moved to Paris and painted fourteen large landscapes for Louis XIII (burned in the Tuileries in 1871). Foucquier also was commissioned for a series of "views of all the main cities of France . . . " (Félibien 1688, p. 34). In 1626 he was in Toulon; in 1629, in Marseilles. In 1641 Foucquier got in the way of Poussin, who referred to him derisively as "le baron Foucquières" who came "to speak to me in his usual haughty way" (Félibien). Foucquier also made designs for tapestries now lost. The identification of Jacques Foucquier with Jan Fouceel that Burchard had suggested to Stechow is no longer accepted. (According to Hollstein, VII, nos. 1–5, Fouceel worked in Antwerp in about 1670.)

21

LANDSCAPE WITH TREES AT THE EDGE OF A FOREST
Brush and black ink, gray wash, over black chalk, heightened with white, on light brown paper,
365 x 435 mm (14⅜ x 17⅛ in.)
Private Collection
Provenance: art market, London

Exhibited in Wellesley only

"[Foucquier was] one of the best landscapists that has as yet appeared," wrote Mariette in his *Abécédario* (ed. 1851–60, IV, pp. 258–59), continuing that "today, the artist is all but forgotten and M. de Piles is quite correct in regarding Foucquier as the Titian among the Flemings." This large landscape drawing is especially welcome as little new information has been published

on Foucquier since Wolfgang Stechow's survey of the artist's drawings and etchings in 1948 (see Ember 1978). Mariette, who was very familiar with the twenty-six Foucquier drawings in Crozat's collection (*Description Sommaire des Dessins*, Paris, 1741, nos. 936–39), characterized some of them as follows: "In most of his drawings one finds amazing light effects. His favorite manner of drawing is a wash over an extremely light sketch made in black chalk, used solely for fixing his first idea. But his wash is full of contrasts (*heurté*) and far from being overly soft." This description accords rather well with this large LANDSCAPE WITH TREES. Foucquier is little known as a draftsman and the examples Stechow discussed in 1948 were executed in a variety of techniques. No painting or etching by Foucquier has been identified that reflects this view of a distant hilly countryside.

Lucas Franchoys the Younger

Malines 1616–1681 Malines

Lucas Franchoys the Younger belonged to the school of Malines (Mechelen), which is less well researched than the school of Antwerp or even the schools of Brussels and Ghent. The younger Franchoys was born in 1616 into a family of artists. He received his first training from his father, Lucas Franchoys the Elder (Malines 1574–1643). In the late 1630s, the younger Franchoys moved to Antwerp where he entered Rubens's studio, most likely on the strength of a recommendation from his cousin, Lucas Faydherbe, who at that time made ivory sculptures from Rubens's designs. After the death of the elder Franchoys in 1643, Lucas may have gone to Paris to work at the court of the princes of Condé, according to De Bie in his *Gulden Cabinet* (1661, pp. 374–76); no documentary evidence supports this. Back in Malines, the artist received his first commissions for churches and monasteries in Tournai (Doornik) around 1647; his signed ANNUNCIATION in the cathedral of Tournai is dated 1649. Heidi Colsoul (1989) wondered whether those commissions might possibly have come from the Condé family (their town of origin, Condé, was only about twelve miles outside of Tournai) or possibly from Alphonse de Bergues, the future archbishop of Malines, who had just been elected canon and became Franchoys's patron. In 1655 Lucas Franchoys the Younger registered in the Malines artists' guild and served as its dean in 1663.

Franchoys enjoyed considerable success and esteem in his own time, thanks in part to the many commissions he received through the Archbishop de Bergues and Lucas Faydherbe. Late in life, in 1668, he married Anna Theresa van Wolschaeten, a peasant woman who was his model for a "madonna," according to Van den Branden (1883, pp. 811–12). Lucas and his brother Peeter Franchoys (Malines 1606–1654) were the only painters of renown in Malines in the seventeenth century.

22

SALOME RECEIVING THE HEAD OF ST. JOHN THE BAPTIST, ca. 1654

Pen and brush and brown ink over preliminary drawing in black chalk, heightened and corrected with white, traced for transfer, 167 x 112 mm (6⅝ x 4⅜ in.)

Annotated in pen and brown ink at bottom left, *L. Francois*; and with pencil on mount, *Lucca*.

Yale University Art Gallery, New Haven, Connecticut: Library Transfer

Inv. no. 1961.63.61

Provenance: John Percival, 1st Earl of Egmont (1683–1748)

References: Haverkamp-Begemann and Logan 1970, no. 569, pl. 311; Colsoul 1989, no. 22, pls. 25–26.

The church of St. John in Malines commissioned Lucas Franchoys to produce two prints, one of the Beheading of St. John, the other, the Martyrdom of St. Barbara, for which he was paid 12 guilders. This is Franchoys's preliminary drawing for the engraver Adriaen Lommelin (Amiens 1637; active in Antwerp 1654, where he died ca. 1673), who put it into print in reverse without any major changes (Hollstein, XI, no. 3). It is one of the few extant drawings by the artist that are known, and shares a fluidity in the contour lines with Franchoys's securely attributed chalk studies such as the ST. JEROME in the collection of Julius Held (figure IIIa). The corresponding design by Franchoys for the print with the Martyrdom of St. Barbara, now lost, was engraved by Richard Collin (d. 1687).

Lucas Franchoys based the composition of this drawing at Yale on one of his earliest known commissions, the signed altarpiece of the BEHEADING OF ST. JOHN THE BAPTIST, painted for the church of St. Quinten in Tournai, which he dated 1650. Although the painting was destroyed in 1944, it can be reconstructed from the description by Michiels (1869, p. 237), which matches the composition of the drawing at Yale as well as an oil sketch by Franchoys in the museum in Tournai (Inv. no. 220; oil on canvas, 62 x 43 cm; see Bailly de Tilleghem 1989, p. 63, ill. in color, acquired from the collection Fauquez, Tournai, in 1970). Colsoul observed correctly that the small sketch on canvas served as the preliminary *modello* for the destroyed altar. This sketch and Lommelin's print give a truer idea of Franchoys's lost altar painting than the drawing at Yale, which shows the composition in reverse; Salome is pointing to the head of St. John with her left hand while the executioner clutches the sword with his left. Other variations found in Franchoys's drawing are the omission of the young attendant who in the oil sketch is holding the platter with the severed head, and the introduction of a doorway at the left with a view of a church tower, possibly that of St. John in Malines.

Colsoul suggests a slightly earlier date of 1654 for the Yale drawing—rather than 1669, the year given in the Yale catalogue. As she points out, in 1669 Franchoys was paid by the church of St. John not only for the two designs for prints, but also for the triptych of St. Roch, which he had painted for the same church. The earlier date, 1654, is also cited by E. Neeffs in his *Chronique artistique de l'église de St-Jean à Malines* (s.l., s.a., p. 26). Franchoys was obviously influenced by the BEHEADING OF ST. JOHN THE BAPTIST that Rubens had painted between 1617 and 1619 on the right wing of his triptych, the ADORATION OF THE KINGS, for the same church (KdK 165, right; Jaffé 1989, no. 482C). Rubens had already shown the same intense brutality with the executioner stepping on St. John's dead body and the blood gushing from the corpse's neck.

Frans Francken the Younger

Antwerp 1581–1642 Antwerp

Frans Francken the Younger, also referred to as Frans II, belonged to a family of painters that extended through three generations. Together with his brothers Ambrosius II (ca. 1590–1632) and Hieronymus II (1578–1623), Frans II probably received his early training in the workshop of his father, Frans Francken I or the Elder (Herentals 1542–1616 Antwerp). Ursula A. Härting considers it likely that Frans II also was apprenticed to his uncle Hieronymus Francken I (ca. 1540–1610), either in Paris where the latter was *peintre du Roy*, or during the latter's visits to Antwerp. In 1605 Frans II became master in the Antwerp painters' guild; in 1615 he was elected dean. The younger Frans Francken specialized in cabinet paintings. In 1607 he applied for a passport to travel to the northern Netherlands, to "attend to business." He apparently worked for the art dealer Chrysostom van Immerzeel, for between 1624 and 1635 he delivered twenty-two original paintings and eight copies that were shipped via Calais to Seville.

Frans II married Elisabeth Placquet in 1607, the same year their eldest son Frans III (d. 1667) was born. Three of his seven children would become painters, though he remained the most productive of the Francken family of painters. He painted figures in landscapes of Jan Brueghel the Elder, among others. Only one pupil is recorded, Daniel Hagens (1616–17). When Frans Francken II died in Antwerp in 1642, his workshop more or less ceased as well.

23

SCENE OF A CONSECRATION

Pen and brush in brown ink, brown wash over preliminary drawing in black chalk, vertical fold through the center, 307 x 393 mm (12 1/16 x 15 7/16 in.)

Signed (?) in pen and brown ink at bottom right, *F. FRANCKEN IN[V]*; and inscribed (?) at top, left of center, . . . *tweed* (?; cut off).

Yale University Art Gallery, New Haven, Connecticut: Library Transfer

Inv. no. 1961.63.71

Provenance: John Percival, 1st Earl of Egmont (1683–1748)

References: Haverkamp-Begemann and Logan 1970, no. 571, pl. 274 (as KNIGHTING OF A YOUNG MAN [?]); Härting 1983, no. ZA 411 (as CONSECRATION OF A PRIEST [?]).

Relatively few drawings by Frans Francken II are known; all those that have been attributed to him were executed in pen and brown ink with brown wash. Ursula A. Härting listed three preliminary studies in contrast to almost four hundred paintings with an additional sixteen drawings that are unrelated to finished works. Drawings may not have been required that often, since Frans II's workshop consisted primarily of his sons and possibly sons-in-law, who would repeat compositions that sold well.

161

The identification of the subject matter remains elusive; neither the knighting of a young man nor the consecration of a priest seems to describe the scene adequately. The kneeling young man in court dress, a dagger at his side, is presenting a venerated object to an officiating priest who is standing in front of the altar, assisted by two acolytes in liturgical garments. The people witnessing this event kneel in prayer; some are crossing their hands on their chests in a gesture of deep reverence. Since the congregation is wearing sixteenth-century dress, Francken probably depicted an historic event, possibly the dedication of a precious object. While Härting accepts the drawing at Yale as an authentic study by the younger Francken, she was unable to relate it to a known work or to date it.

Frans Francken must have attached a certain significance to this drawing, which is executed freely in pen with relatively few *pentimenti*, since he seems to have signed it. An association with Francken's painting of a PRINCE PAYING A VISIT TO HIS CHURCH of 1633 in the Louvre, Paris (Härting 1989, no. 414, fig. 54), should perhaps be considered.

Philip Fruytiers

Antwerp 1610–1666 Antwerp

Philip Fruytiers became master in the guild of St. Luke in 1631–32 as a miniaturist (*afsetter*). It is not known whether Fruytiers studied with Rubens, since the latter was not obliged to register his pupils. Fruytiers was acquainted with the artist, however, since there are two miniatures of his, one depicting four of the children of Rubens and Helena Fourment (Windsor Castle), the other showing three of Rubens's children at play (known only from a print by Tassaert), dating from about 1638–39. Fruytiers was closely linked with the order of the Recollects in Antwerp and in 1630 he became a member of the Pious Sodality of Bachelors. In 1640 Fruytiers was commissioned to illustrate the title page of the *Imago primi saeculi Societatis Jesu,* a book celebrating the centennial of the founding of the Jesuit Order. Jan de Tollenaere (1582–1643), known from Fruytiers's drawing in The Pierpont Morgan Library in New York, gave Balthasar Moretus permission to publish it in 1640. Fruytiers registered students in 1649, 1662, and 1663.

24

THE DISTRIBUTION OF FRANCISCAN CORDS, ca. 1647

Black chalk, brush and gray ink, heightened with white (partly oxidized), traced for transfer, 378 x 271 mm (14⅞ x 10¹¹⁄₁₆ in.)

Annotated in pen and brown ink at bottom center, *Phil. Fruitiers.*

Yale University Art Gallery, New Haven, Connecticut: Library Transfer

Inv. no. 1961.63.63

Provenance: John Percival, 1st Earl of Egmont (1683–1748)

References: Haverkamp-Begemann and Logan 1970, no. 573, pl. 303; Van de Velde 1983, pp. 163–64.

This is one of only three drawings known by Philip Fruytiers, who was praised in his own time for his extraordinary miniatures in watercolor on vellum. The somewhat abraded condition of the drawing at Yale is partly due to its double function: besides serving for an engraving, it also represents Fruytiers's preliminary study for his altarpiece, painted in 1647–49 for the chapter house of the Confraternity of the Cord of Saint Francis in the church of the Recollects in Antwerp. In 1659 Sanderus described the altar in his *Chorographia Sacra Brabantiae* as the work of Philip Fruytiers, which allowed Baudouin (1968, pp. 162–68) to return a number of paintings signed *PHF* to Fruytiers. The altar itself was removed at the end of the eighteenth century and is lost.

The traditional attribution to Fruytiers, reflected in the annotation at the bottom center by a generally well-informed eighteenth-century hand, is confirmed through the engraving in reverse by Jacob (Jacques) Neeffs (Antwerp 1610–after 1660; Hollstein, XIV, no. 14). God the Father and the Holy Ghost are hovering above Saint Francis of Assisi, who is distributing Franciscan cords, assisted by the Virgin and Child, who hand one to a Franciscan saint, most likely St. Bonaventure. The major difference between Fruytiers's preliminary design and Neeffs's engraving after it is found in the prominent kneeling figure, who in the drawing wears a miter but in the subsequent print, a papal tiara. This figure has been identified as Pope Sixtus V (1585–90), a Franciscan who founded the Archconfraternity of the Cord of Saint Francis in 1585. Together with saints, crowned dignitaries, and common people he is receiving cords from the saint. On a separate piece of paper attached at the lower right (87 x 104 mm), Fruytiers inserted angels saving souls from the flames of purgatory, an allusion to the power of indulgences that Sixtus V granted to the Archconfraternity in a bull of 29 August 1587. The caption of Neeffs's print, *Vincula Illius Alligatura Salutaris* (Her [doctrine's] fetters will become a saving tie or bond) is taken from Ecclesiastici, Chapter 6.

Jan Fyt

Antwerp 1611–1661 Antwerp

In 1621 Jan Fyt was apprenticed to the little-known painter Hans van den Berch, but soon moved on to the studio of Frans Snyders. Fyt became a master in the painters' guild of St. Luke in Antwerp in 1629–30. During 1633 and 1634 he lived in Paris, then traveled to Italy, where he received a commission for the Sagredo and Contarini palace in Venice and joined the *Schilderbent* in Rome under the nicknames of "Glaucus," "Goudvink," and "Goedhart"; he is also recorded in Naples and Florence. In the fall of 1641 Fyt was back in Antwerp and the following April he applied for a passport to travel to the northern Netherlands. He registered pupils in 1649 and 1659. Jan Fyt collaborated with Erasmus Quellinus and occasionally with Jordaens and Willeboirts Bosschaert.

25

DEAD GAME IN A LANDSCAPE, after ca. 1634

Pen and brown ink, brown wash, 169 x 221 mm (6 11/16 x 8 3/4 in.)

Wadsworth Atheneum, Hartford, Connecticut: Gift of Henry and Walter Keney

Inv. no. 1956.8

Provenance: collection Marmentel (sale, Paris, Hôtel Drouot, 26 January 1883, lot 284);

Colnaghi, London (1956)

References: Greindl 1956, p. 167; Greindl 1983, p. 354, no. 295.

The composition of this drawing—a few animals observed close up—is characteristic of Fyt's work. Several of his paintings show the same general arrangement of a dead hare, its hind legs tied, dead partridges, and a basket of flowers or fruit in a landscape. The drawing is rather finished with few changes, and no painting by Jan Fyt has been connected with it. Of the fourteen drawings Edith Greindl accepted as authentic, she knew of only two studies that corresponded with an extant painting. A handful of these drawings were signed and one dated 1660, the year before the artist died. Because of their rareness, Fyt's drawings are relatively little studied. In a letter to the Wadsworth Atheneum from September 1956, Greindl left the date of the drawing open, placing it between 1634 and 1661.

Pieter de Jode

Antwerp 1570–1634 Antwerp

Pieter de Jode the Elder was the son of the engraver and cartographer Gerard de Jode. He was supposedly a pupil of Hendrick Goltzius in Haarlem and from about 1595 until 1600 he traveled in Italy, the northern Netherlands, and Paris. In 1600 the artist registered in the Antwerp guild of St. Luke as engraver (*plaetsnyder*); in 1608 he served as dean. Nicolaes Ryckmans was his pupil. The elder De Jode was the brother-in-law of Jan Brueghel the Elder, who married his sister Isabella de Jode in 1599. His son, Pieter de Jode the Younger (Antwerp 1601–1674 England?), was an accomplished engraver as well (see catalogue number 8).

26

DESIGN FOR A SALVER WITH THE STORY OF CUPID AND PSYCHE, ca. 1630

Pen and brown ink, brown wash over black chalk, 297 x 394 mm (11 11/16 x 15 1/2 in.);

central oval, 182 x 279 mm (7 1/8 x 10 7/8 in.); width of the border, 59 mm (2 1/4 in.)

Inscribed on the verso at center, probably by the artist, in red chalk, *pieter de jode*; annotated in pen and brown ink at lower left by Ploos van Amstel, *Petrus de Jode f. / hoog 11 1/2 dm / br 15 1/2 dm / f L* (?).

The Pierpont Morgan Library, New York, New York

Inv. no. 1985.51

Provenance: Isaac Walraven, Amsterdam (his sale, Amsterdam, Hendrick de Winter & Jan Yver, 14 October 1765 and days following, Album H, lot 441, "Een Hemelraad de Goden, een Ovaal formaat, om dezelve een randgetekend met de Pen en gewassen met Inkt"); Johan van der Marck Aegzn., Amsterdam (his sale, Amsterdam, Hendrick de Winter & Jan Yver, 29 November 1773, Album R, lot 1597); Cornelis Ploos van Amstel, Amsterdam, together with lot 1598 (his sale, Amsterdam, P. van der Schley, 3 March 1800 and days following, Album G, lot 41); Galerie de Bayser, Paris

Exhibition history: Paris 1985, no. 30, ill.

Reference: Stampfle 1991, no. 78, ill.

The elder Pieter de Jode is best known for his drawings for prints as well as his engravings after paintings by other artists. This design for a platter or salver, which was most likely to be chased in silver—*een model van een gedreven Schotel* as it is described in the catalogue of the Van der Marck sale in 1773—is therefore somewhat unusual in his œuvre. Since De Jode depicted the story of Cupid and Psyche, the salver was probably intended to be used during a marriage ceremony or as a gift. The oval piece of paper, pasted in separately in the center, renders Cupid and Psyche in front of the council of gods. In the border surrounding it, De Jode rendered twelve episodes from the Cupid and Psyche myth in accordance with Apuleius (Books IV and V), progressing clockwise from the top center. Discussed in detail by Felice Stampfle (1991), the sequence begins with the scene showing people paying tribute to the beautiful Psyche, which angered Venus and prompted her to instruct Cupid to make Psyche fall in love with a "most miserable creature." In the next scene, Psyche's father sacrifices to Apollo, followed by Psyche's rescue by Zephyr's winds to a restful valley, where she takes a refreshing bath. The second half of the border continues with Psyche being visited by her unknown and unseen husband, Cupid. Next, her two jealous sisters instigate the painful discovery of Cupid when Psyche drops burning oil from a lamp she carried to look at him, thus awakening him. Cupid flees through the open window with Psyche clinging to his right foot. The following scene shows Cupid admonishing Psyche, while in the background she receives advice from Pan. The border decoration ends with Cupid recovering from his burns in bed, Juno and Ceres at his side.

This drawing, recently acquired by the Morgan Library, is related closely to Pieter de Jode's signed drawing in the Albertina, Vienna (Inv. no. 8200; Stampfle 1991, fig. 62), the MARRIAGE FEAST OF CUPID AND PSYCHE. The size of this latter design is similar to that of the oval centerpiece. As Stampfle surmises, it may actually have been an alternate study or possibly was intended for another salver. If the drawing in Vienna is indeed identical with the "Platfond met Goden en Godinnen" drawing that was also in Van der Marck's, as well as Ploos van Amstel's collection, its

original function would have been forgotten by the eighteenth century since this second design was described as a study for a ceiling decoration ("plafonds" in Van Amstel's inventory) rather than for a salver. Stampfle established that for his compositions De Jode relied heavily on engravings by Agostino Veneziano (active 1490–ca. 1540) and the Master of the Die (active 1530–50), which were based on preliminary drawings by Michiel Coxcie (1499–1592).

The oval shape of the basin is rather unusual, judging from the examples included in 1988–89 in the exhibition at the Rubenshuis, Antwerp, of Antwerp silver from the seventeenth century, where not one similar salver was shown. The closest prototype is found in Rubens's grisaille sketch of the BIRTH OF VENUS in the National Gallery, London (Held 1980, no. 265), painted in 1630–31, presumably as a model for an oval basin, suggesting a date of around 1630 for De Jode's design as well. De Jode's drawing not only is almost identical in shape, but likewise shows the individual episodes arranged in a wide border around the centerpiece. No silver basin based on either Rubens's oil sketch or this drawing by Pieter de Jode the Elder is known to exist. Such richly decorated pieces chased in precious metals were commissioned for certain occasions as showpieces not to be used in everyday life.

Jacob Jordaens

Antwerp 1593–1678 Antwerp

Jordaens was trained by Adam van Noort, who had also been one of Rubens's teachers. In 1615 Jordaens was registered in the Antwerp painters' guild as a *waterschilder*, that is a painter in tempera and watercolor; the following year, he married Catharina van Noort, the eldest daughter of his teacher. In 1637 Jordaens collaborated with Rubens on the Torre de la Parada commission for Philip IV of Spain. After Rubens's death in 1640 and with Van Dyck still residing in England, Jacob Jordaens was the foremost painter in Antwerp with a large studio. In 1648 he received a major commission from Queen Christina of Sweden. Some of the artists who previously had collaborated with Rubens such as Theodoor van Thulden, Pieter Soutman, and Thomas Willeboirts Bosschaert then collaborated between 1648 and 1652 with Jordaens in the decoration of the Oranjezaal in the Huis ten Bosch outside The Hague; Amalia van Solms had commissioned the work to commemorate her late husband Frederick Henry, Prince of Orange. Jordaens contributed, among other paintings, the TRIUMPH OF FREDERICK HENRY. In 1661 he furnished three paintings for the new Amsterdam town hall. Besides these mythological and historical subjects, Jordaens also designed cartoons for tapestries such as the SCENES FROM COUNTRY LIFE and the FLEMISH PROVERBS series.

27

MOTHER AND CHILD, 1630s

Black and red chalk, gray wash, heightened with white, 175 x 205 mm (6 13/16 x 8 1/8 in.)

Illegible inscription in black chalk at the top right.

Collection of Mr. & Mrs. Eugene Victor Thaw

Provenance: Emile Wauters, Paris (1846–1933; sale, Amsterdam, F. Muller, 15–16 June 1926, lot 89, ill.); Paul Cassirer, Berlin; sale, Lucerne, Galerie Fischer, 31 May 1979, lot 452, pl. VIII

Exhibition history: New York 1985, no. 5, ill.

References: D'Hulst 1974, I, no. A130, fig. 143; Nelson 1990, pp. 105–19, especially p. 113.

Jordaens used this study from life of a mother and daughter for the corresponding figures in his painting THE KING DRINKS (Musée du Louvre, Paris), which according to R.-A. d'Hulst dates from about 1638–40 (reproduced in D'Hulst 1982, fig. 139). The inscription is difficult to decipher; neither *dichten* . . . (to fill . . .), *dichter bij* . . . (closer by . . .), nor *de groen bij de rood* . . . (green next to red . . .), as D'Hulst read it, conforms satisfactorily with the few letters that can be made out. If the artist indeed rendered here his wife Catharina van Noort (1589–1659), whom he married in 1616, with their younger daughter Anna Catharina (baptized in 1629), the drawing would have originated earlier, or about 1631. Held pointed out that this identification was unlikely since the mother would have to be in her early forties or even close to fifty in the painting (Held 1940, p. 80). D'Hulst equivocated by calling the sitter "perhaps Catharina van Noort"; Kristi Nelson was more positive about this identification. While it is difficult to accept the notion that Jordaens may have used drawings of family members for the figures of a mother and daughter at the rather boisterous meal in THE KING DRINKS, he did include members of his family in his early paintings. For the figure of the old "king," for example, Jordaens used the likeness of his father-in-law and erstwhile teacher, Adam van Noort (1562–1641), which he drew at least twice (see D'Hulst 1974, nos. 134–35).

28

NUDE OLD MAN SEATED, ca. 1640

Red and black chalk, heightened with white chalk on cream laid paper,

345 x 218 mm (13⅝ x 8⁹⁄₁₆ in.)

Annotated in pen and brown ink at bottom left, *Jacob Jordaens*.

The Art Institute of Chicago, Chicago, Illinois: Restricted gift of Mrs. George B. Young;

Helen Regenstein and H. Karl and Nancy von Maltitz endowments

Inv. no. 1990.139

Provenance: Jean Willems, Brussels (1966); A. De Heuvel, Brussels (1966);

Prof. and Mrs. R.-A. d'Hulst, Dilbeek, Belgium

Exhibition history: New York 1991, no. 12.

References: D'Hulst 1974, no. A148, fig. 161; D'Hulst 1982, p. 312, fig. 148 in color.

Exhibited in Cleveland only

This is one of the rare Flemish seventeenth-century studies that clearly shows the artist sketching from a live model. We may deduce this from the rope visible in the upper left corner which the

seated, corpulent, and elderly model grasped with his right hand to sustain the uncomfortable pose. Jordaens drew the figure first with red chalk and then reworked it in parts with black chalk, above all to render the hair and beard, and to indicate the shadow around the buttocks and left elbow.

Jordaens made additional studies after the same model in various poses, also around 1640 (D'Hulst 1974, nos. A149–53). Although he did not use this particular study from the nude in a painting, Jordaens modified the figure slightly for Argus in MERCURY AND ARGUS in the collection of Gaston Dulière, Brussels, on loan to the Rubenshuis in Antwerp (figure VIII; D'Hulst 1982, fig. 195 and dated ca. 1650).

29

THE SATYR AND THE PEASANT, ca. 1644
Blue, red, green, brown, and yellow watercolor, white bodycolor over black chalk,
squared in black chalk; sheet extended at the left side, top, and bottom by the artist,
303 x 245 mm (11¹⁵⁄₁₆ x 9⅝ in.)
Numbered in pen and brown ink on the verso, 7.
The Pierpont Morgan Library, New York, New York
Inv. no. I,236
Provenance: possibly Henry Temple, 2nd Viscount Palmerston (1739–1802) and by inheritance
the Hon. Evelyn Ashley (1836–1907); possibly in his sale, London, Christie's, 24 April 1891,
as one of three in lot 177; Charles Fairfax Murray, London (d. 1919); J. Pierpont Morgan
Exhibition history: Ottawa 1968–69, no. 220, ill.; New York, 1981, no. 64, ill.
References: D'Hulst 1974, I, no. A200 and III, pl. 215; Schnackenburg 1985, p. 40, fig. 11;
Nelson 1985–86, p. 225, pl. 36; Stampfle 1991, no. 283, ill.

The drawing illustrates one of Aesop's fables in which a satyr refuses a man's friendship because he, the satyr, did not believe that one could blow hot (to warm one's hands) and cold (to cool one's food) at the same time, meaning that men could not be trusted. The subject found much favor with Dutch artists, among them pupils of Rembrandt such as Gerbrand van den Eeckhout, Constantijn van Renesse, and Samuel van Hoogstraten.

Jordaens made the drawing as a preliminary design for one tapestry in a set of eight illustrating Flemish proverbs. On 22 September 1644, he signed an agreement to furnish the three Brussels weavers Frans Cotthen (Cophem), Jean Cardys (Jan Quaradys), and Baldouin van Beveren with designs for such a set of tapestries. Jordaens derived the composition of this watercolor at the Morgan Library from his painting at the Royal Museum of Fine Arts, Brussels (Inv. no. 588; Brussels 1984, p. 157, ill.), which dates from the same period. In this design for the tapestry Jordaens modified the figures, showing them full-length, and placed the entire scene on a feigned tapestry

hanging from an architectural support. Jordaens thus used an idea that Rubens had applied earlier in his own designs for the series the TRIUMPH OF THE EUCHARIST of 1626–28, where he represented a tapestry within a tapestry. Jordaens did not take the reversal of the action in the tapestry into account; accordingly, the woman raising the glass as well as the mother pointing are both left-handed in the tapestry.

At least one other preliminary drawing by Jordaens must have existed, for in the final hanging the figure of the satyr was replaced by two children, one playing with a goat and placing a wreath around its neck, the other eating grapes. The scene was therefore changed to fit the proverb "Nature is content with little" (*De natuur is met weinig tevreden*), with its Latin equivalent *Natura paucis contenta* written in the cartouche at the top of the tapestry. The goat corresponds closely with the individual study of the animal in the drawing at Yale, here included as catalogue number 30, which Jordaens might have drawn especially for this tapestry. Jordaens used the composition once more in his painting from around 1650, the so-called PORRIDGE EATERS at Cassel (see Schnackenburg 1985, pl. 27, ill. in color), in which he again placed a goat prominently in the foreground.

The speculative origin of the commission, hoping to entice Archduke Leopold Wilhelm to purchase a set, paid off in 1647. Later his inventory even listed a second set with gold threads, now lost. The archduke bequeathed both sets of the PROVERB tapestries to his chamberlain Johann-Adolf Schwarzenberg, who inherited them after the archduke's death in 1663. One is still extant in the Czech castle of Hluboká in Bohemia, a former Schwarzenberg palace (figure IX; 3.80 x 4.43 m; see Blazková 1959, pp. 73–80). Another set, increased by an additional ten tapestries after cartoons by Jordaens, is in the Museo Diocesiano in Tarragona, Spain (see D'Hulst 1982, p. 301).

30

GOAT, ca. 1644

Red, black, and yellow chalk, touches of red and brown wash, heightened with white,
254 x 199 mm (9 15/16 x 7 7/8 in.)

Yale University Art Gallery, New Haven, Connecticut: Everett V. Meeks, B.A. 1901 Fund

Inv. no. 1963.9.39

Provenance: Henri Baderou, Paris (1963)

Exhibition history: Ottawa 1968–69, no. 254, ill.

References: Haverkamp-Begemann and Logan 1970, no. 578, pl. 302; D'Hulst 1974, I, no. A321,
fig. 338; D'Hulst 1982, p. 313, fig. 215 in color.

Various paintings by Jordaens in which a goat figures prominently in the foreground are known, among them THE INFANT JUPITER, FED BY THE GOAT AMALTHEA, also known as

THE EDUCATION OF JUPITER (in the Louvre, Paris) of ca. 1630–35 (D'Hulst 1982, fig. 119), and MARSYAS ILL-TREATED BY THE MUSES of about 1640 in the Mauritshuis, The Hague (D'Hulst 1982, fig. 147; on loan from the Rijksmuseum, Amsterdam).

As Michael Jaffé was the first to observe (exh. cat. Ottawa 1968–69, no. 254), this spirited life study of a goat that Jordaens drew in colored chalks was used—with only slight modifications such as the turning of the head to the left—for the animal in the foreground of the signed ADORATION OF THE SHEPHERDS in the North Carolina Museum of Art in Raleigh, dated 1657 (Inv. no. G.55.7.1.; reproduced in D'Hulst 1982, fig. 216). Accordingly, D'Hulst revised the date of about 1628–40, as quoted in the Yale catalogue in 1970, to about 1657, surmising that Jordaens may have drawn the study especially in preparation for this ADORATION OF THE SHEPHERDS. D'Hulst qualified his opinion by noting that Jordaens may nevertheless have drawn the study earlier; this view must now be given added weight since Jordaens introduced an almost identical goat, again with the head turned to the right, in the cartoon for the tapestry NATURA PAUCIS CONTENTA, commissioned in 1644 as part of the PROVERB series.

In the initial preliminary design in watercolor, today in The Pierpont Morgan Library, New York, reproduced here as catalogue number 29, a satyr is depicted instead of a goat and two children. Jordaens introduced the animal only at a later stage, once he had decided to transform the representation of Aesop's fable of "The Satyr and the Peasant" into the proverb "Nature is content with little." The goat in the tapestry is as prominently placed in the foreground as in Jordaens's ADORATION OF THE SHEPHERDS in Raleigh. Thus it is quite possible that Jordaens made this closely observed study of a goat in that earlier context and reused it a decade later.

31

CONVERSION OF ST. PAUL WITH HORSEMAN AND BANNER, ca. 1645–47

Black and red chalk, pen and black ink, brush and colored wash; section added at the top and arched, 328 x 199 mm (12 15/16 x 7 3/4 in.)

Annotated in pen and brown ink at bottom right, *Jordaens.*

The Cleveland Museum of Art, Cleveland, Ohio: Delia E. and L. E. Holder Funds

Inv. no. 54.366

Provenance: Duke Albert of Sachsen-Teschen (1738–1822), Albertina, Vienna; Otto Burchard

Exhibition history: Antwerp 1966, no. 92, ill.; Los Angeles 1976, no. 217, ill.

References: Cleveland 1957, pp. 17–22, ill. on cover; Jaffé 1963, p. 465; Cleveland 1966, p. 120, ill.; D'Hulst 1974, no. A238, fig. 253.

See the following entry.

32

CONVERSION OF ST. PAUL WITH CHRIST AND THE CROSS, ca. 1645–47

Brush and brown and red ink, gray and yellow wash, black and red chalk, pen and black ink; section added at the top and arched, 328 x 199 mm (12¹⁵⁄₁₆ x 7¾ in.)

Annotated in pen and brown ink at bottom right, *Jordaens*.

The Cleveland Museum of Art, Cleveland, Ohio: Delia E. and L. E. Holder Funds

Inv. no. 54.367

Provenance: Duke Albert of Sachsen-Teschen (1738–1822), Albertina, Vienna; Otto Burchard

Exhibition history: Brussels 1965, no. 332, ill.; Ottawa 1968–69, no. 228, ill.

References: Cleveland 1957, pp. 17–22, ill. p. 18; D'Hulst 1974, no. A239, fig. 254 (as ca. 1645–47).

Three drawings by Jordaens portraying the Conversion of St. Paul (Acts 9:1–7) are known, all of the same size and medium but with slight modifications of the subject: two of them, once in the collection of Duke Albert of Sachsen-Teschen, founder of the Albertina in Vienna, are discussed here (see catalogue number 31), while a third is in a private collection in Augsburg. Jordaens used the brush and colored wash almost exclusively to render different ideas for the same theme of the Conversion of St. Paul. The three studies must have served the function of an early preliminary design, akin to that of a small painted *modello*, to submit to the patron for discussion of the final layout. Only one commission for an altarpiece of St. Paul is known, lost today, which Jordaens painted for the abbey church at Tongerloo in the Diocese of Antwerp, for which he was paid 400 Rhenish guilders in October 1647. Unfortunately no description has emerged that would allow the identification of the composition that was selected out of the three submitted. Some twenty years later, about 1665, Jordaens depicted the subject again in a drawing of oblong format, which is now preserved at the Hermitage, St. Petersburg (D'Hulst 1974, no. A406, fig. 426).

33

ANNUNCIATION TO THE VIRGIN, ca. 1645–50

Black and red chalk, graphite, pen and brown ink, red, ocher and some gray-black wash, 216 x 159 mm (8½ x 6¼ in.); sheet enlarged at top (9–10 mm) and bottom (11–13 mm) by the artist.

Collection of Gary and Millicent Adamson, Saint Louis, Missouri

(via The Saint Louis Art Museum)

Provenance: Sir Gilbert Lewis (d. 1883); Sir Henry Duff-Gordon, Hampton Court (sale, London, Sotheby's, 19 February 1936, under lot 102); Geneviève Aymonier, Paris (1946); Mr. and Mrs. Winslow Ames

Exhibition history: Hartford/Hanover/Boston 1973, no. 14, ill.

Reference: D'Hulst 1974, no. A256, fig. 272.

Following one of his characteristic working procedures, Jordaens here enlarged the original compositional study, drawn predominantly in graphite, at the top and bottom with thin strips of paper. He then extended part of the design onto these additions with a blunt pen and brown ink. With the same pen he reinforced the contours of the figures. The clouds under the angel were added with brush and gray-black wash. Jordaens subsequently followed this reworked preliminary design rather closely in a painting formerly in the collection of Duff-Gordon (1936) that Charles R. Eisers presented in 1938 to the Museum at Lodz in Poland. Jordaens's painting was removed by the Germans in 1944–45 and subsequently disappeared (reproduced in D'Hulst 1974, pl. V). D'Hulst discussed the drawing as one of Jordaens's studies from around 1645–50. It would therefore date from shortly after Jordaens's design for a tapestry in The Pierpont Morgan Library, New York, here illustrated as catalogue number 29.

Pieter van Lint

Antwerp 1609–1690 Antwerp

Van Lint was a pupil of Artus Wolffort (Antwerp 1581–1641), with whom he collaborated until 1631. The following year he became a master in the Antwerp painters' guild and shortly thereafter left for Italy. In 1635 at the latest, he was in Rome, where he remained until at least 1641 before returning to Antwerp. From 1665 until 1678 he worked for the Antwerp firms of Forchoudt and Musson, which sold many of his paintings to Spanish collectors. Among his students was Godfried Maes.

34

VENUS DE' MEDICI, SEEN FROM THE FRONT, 1640

Black chalk, heightened with white, brush and gray ink, on blue paper,

419 x 274 mm (16⅜ x 10⁹⁄₁₆ in.)

Signed in black chalk, partly gone over with pen and black ink, at bottom center, *PvL* [in ligature] *D.L. a Roma 1640*; inscribed in pen and brown ink at lower right, *Die hier te veele van mij hiel / verloor gesonthijdt goedt en ziel.*

The Metropolitan Museum of Art, New York, New York: Rogers Fund, 1964

Inv. no. 64.197.8

Provenance: Colnaghi, London

Exhibition history: London 1964, no. 66; New York 1970, no. 15.

Reference: Van Hasselt, in exh. cat. Paris 1972, under no. 49.

The so-called Venus de' Medici, one of the most famous and frequently copied antique statues in Rome, was excavated in the sixteenth century and placed in the Villa Medici, where it is recorded in 1638. The statue is a copy from the first century B.C., perhaps Athenian, of a bronze original

derived from the type of the Cnidian Venus of Praxiteles (see Haskell and Penny 1981, no. 88, fig. 173). Today, the sculpture is in the Uffizi (Tribuna) in Florence. Pieter van Lint copied it at the Villa Medici from three viewpoints in 1640, before leaving Rome sometime in the following year. In a second view, also in The Metropolitan Museum of Art (figure X; Inv. no. 64.197.9), Van Lint drew the statue from the back, while the third study in the Institut Néerlandais (Fondation Custodia, Collection Frits Lugt, Paris; Inv. no. 5830B) shows a frontal pose closer to the drawing discussed here, in which the statue's head is rendered in a lost profile.

All three drawings are the same size, drawn in a somewhat dry manner in black chalk on blue paper. Van Lint's inscription, found in each version in the same location at the lower right, translates as: "Those who loved me too much have lost their health, worldly goods [*goederen*] and salvation." The skull that Van Lint added in brush and gray ink at the lower left, together with this reminder of the transitoriness of human life, give a moral interpretation to this famous statue by alluding to the perseverance of classical antiquity over death.

Van Lint's copies of the Venus de' Medici were exceptionally accurate, to judge from a comparison with François Perrier's three plates (81–83) in his *Segmenta nobilium signorum e statuarum…* (Rome, 1638), an anthology of the most admired statues in Rome and the earliest trustworthy reproduction of the statue. Pieter van Lint continued here a practice also known from Rubens, who likewise copied antique sculpture in Rome from various views, as exemplified by the back view of the so-called AFRICAN FISHERMAN in a private collection (see catalogue number 39).

Jan I Peeters

Antwerp 1624–before 1680 Antwerp

Jan I Peeters belonged to a family boasting many marine painters. He was the younger brother of Gillis I (Antwerp 1612–1653) and Bonaventura I (Antwerp 1614–1652 Hoboken) Peeters and became a master in the Antwerp painters' guild in 1645. Jan lived in Hoboken with his sister Catharina (Antwerp 1615–after 1676), a marine and still-life painter, from 1652 to 1654 when he returned to Antwerp to marry Catharine Buseliers. In 1659 Jan traveled through the northern Netherlands, making drawings along the way, which were etched by Caspar (Gaspar) Bouttats (Antwerp 1625 –1695) and published in Antwerp in 1684 (Hollstein, III, no. 22). His drawings of distant harbors and cities may be based on material supplied by his two well-traveled nephews, Bonaventura II and Gillis II Peeters.

35

VIEW OF MECCA, 1665

Pen and brown ink, brush and gray wash over traces of black chalk, on cream laid paper, laid down on board, 200 x 413 mm (7⅞ x 16¼ in.)

Signed in pen and brown ink at bottom center, *I P* and dated *1665*; inscribed in pen and brown ink, *A / B / C*.

The Art Institute of Chicago, Chicago, Illinois: Leonora Hall Gurley Memorial Collection

Inv. no. 1922.1821

Provenance: John Lord Hampden; Leonora Hall Gurley

Reference: Wegner 1973, under no. 826.

Exhibited in Cleveland only

The monogram *I P* in the center foreground was identified correctly with Jan I Peeters by Wegner (instead of Jan Porcellis, ca. 1584–1632; confirmed independently by Haverkamp-Begemann in an annotation on the drawing's mount in 1989). Wegner undoubtedly recognized the drawing because a similar view, inscribed *Gacha di Maha*, a locale in Arabia, with an almost identical landscape foreground that also included a caravan of camels, is in the Staatliche Graphische Sammlung, Munich (Inv. no. 1910:9; Wegner 1973, no. 826, pl. 141). VIEW OF MECCA in Chicago is close enough to the etching in reverse by Caspar Bouttats from the series VIEWS FROM ARABIA, JUDEA, CHALDEA, SYRIA, JERUSALEM, ANTIOCHIA, ALEPPO, MECCA, ETC. published in 1672 (113 x 252 mm; Hollstein, III, no. 23), to consider it Jan I Peeters's preliminary design for the etching, although it is not traced for transfer. The artist identified several of the buildings of Mecca, which are spread out on a plateau in the distance, with capital letters, to be identified in Bouttats's etching in accompanying legends. The Art Institute preserves another drawing from the same series, again with an erroneous earlier attribution to Porcellis, depicting landscape scenery near Aleppo (Inv. no. 1922.1820).

There is no evidence documenting a journey by Jan I Peeters to the Middle East and we may assume that he availed himself of his nephews' travel records.

Peter Paul Rubens

Siegen 1577–1640 Antwerp

Rubens was born in Siegen (Germany), the sixth child of Jan Rubens and Maria Pypelinckx. In 1589, two years after the death of his father in Cologne, the family returned to Antwerp. Of Rubens's three teachers—Tobias Verhaecht, Adam van Noort, and Otto van Veen—Van Veen made the greatest impression on the young artist. Rubens became a master in the Antwerp painters' guild in 1598. The years 1600 to 1608 he spent in Italy, officially residing in Mantua as painter to the Gonzaga, interspersed with prolonged visits to Rome and Spain (1603). Rubens received commissions for churches in Rome, Genoa, and Fermo. Later in 1609 Rubens was appointed court painter to the Archduke Albert and Archduchess Isabella Clara Eugenia. Soon thereafter he married Isabella Brant (d. 1626). In the following years, Rubens carried out many commissions for churches and public buildings in Antwerp—among them the paintings for

the ceiling of the Jesuit church—as well as other cities in the southern Netherlands. At that time he established his studio which, by 1611, had attracted more pupils than he could accommodate. His two enormous altarpieces, the RAISING OF THE CROSS (1610–11) and the DESCENT FROM THE CROSS (1612–14), which are still in the Antwerp cathedral, were painted in these first years after Rubens's return from Italy. Between 1622 and 1627 Rubens traveled repeatedly to Paris in connection with the Medici cycle. The most important tapestry series, the TRIUMPH OF THE EUCHARIST for the convent of the Descalzas Reales in Madrid (1626–28), was commissioned by the Archduchess Isabella.

Between 1628 and 1630 Rubens made prolonged trips to Spain and England on behalf of the Infanta Isabella, in search of a peace treaty between England and Spain. In 1630 he married the much younger Hélène Fourment, daughter of the tapestry dealer Daniel Fourment. During the last ten years of his life, Rubens continued painting for royal courts: among these projects were the ceiling decoration of the Banqueting House at Whitehall in London (completed in 1634) and numerous paintings for the hunting lodge of Philip IV of Spain, the Torre de la Parada near Madrid (1634–40). In late 1634–early 1635 Rubens designed and supervised the decorations of triumphal arches and stages that were erected by the city of Antwerp in celebration of the Triumphal Entry of Cardinal-Infante Ferdinand, the new Spanish governor. Around that time Rubens purchased the country estate *Het Steen* in Elewijt, situated between Brussels and Malines, where he spent his last summers. Rubens died in Antwerp in 1640. His estate was dispersed at auction soon thereafter, except for the drawings, which were not sold until 1657, after it became clear that none of his children or their descendants would become painters.

36

Anonymous, northern Netherlands (?), retouched by Peter Paul Rubens

THREE STUDIES OF A WOMAN WEARING AN ELABORATE HEADDRESS

Pen and light-brown ink, accentuated with brush and dark-brown ink; partly covered with greenish bodycolor; retouched and partly redrawn by Rubens with brush and dark-brown ink and greenish bodycolor, 127 x 128 mm (5 x 5 1/16 in.)

The Cleveland Museum of Art, Cleveland, Ohio: John L. Severance Fund

Inv. no. 1987.31

Provenance: Robert P. Roupell, London (1798–1886; L. 2234); sale, Amsterdam, F. Muller & Co., 27–29 April 1937, lot 614, pl. 1 (as entirely by Rubens); Mrs. Leo van Bergh, Wassenaar; sale, Amsterdam, Christie's, 19 November 1985, lot 4, pl. 1; art market, London

Exhibition history: London 1986, no. 1, ill. in color (as from the circle of Fouquet, retouched by Rubens).

References: Belkin 1980, p. 119; Logan 1987, p. 71, under no. 66, p. 72, fig. 4.

Rubens's selection of this subject illustrates his interest in costume studies, which found its most vivid expression in the so-called Costume Book, now in the British Museum, London, that Rubens began soon after his return to Antwerp in 1608. The wide, winged headdress, seen from

the front, back, and left side, was likely of French origin and worn in the late fourteenth to the early fifteenth centuries by working-class women as protection from sun and rain. Similar headgear is found, for example, in the illuminations for the months of February and July in the *Très Riches Heures* of the Duc de Berry of about 1416 (Chantilly, Musée Condé; see Porcher n.d.). The large, stiffened piece of cloth is carefully folded under in the front and wrapped into a covering hood at the back, while at either side the starched lappets extend wing-like into the air. By the second half of the fifteenth century, this type of headdress was fashionable with the middle class and possibly was even worn informally on occasion by upper-class women (see Scott 1980, figs. 114, 120). Rather similar is the headdress worn by Jeanne de Montaigu in her portrait of about 1475 painted by the Master of Saint-Jean-de-Luz (Ring 1949, pl. 132; then in the John Rockefeller Collection, New York). According to Aileen Ribeiro (letter of July 1992), this intriguing headgear was widespread across northwestern Europe during the first quarter of the sixteenth century but thereafter went out of fashion. She also noted that the draftsman of the original study seemed to be unfamiliar with the actual construction of this headdress.

Edmund Schilling, apparently, was the first to observe correctly that Rubens only retouched the drawing, an opinion he communicated to Ludwig Burchard (Belkin 1980, p. 119). Schilling attributed the underdrawing to Hans Süss von Kulmbach (Kulmbach? ca. 1480–1522 Nuremberg). An artist from the northern Netherlands would seem more likely for the original drawing in pen and brown ink. Rubens gently retouched and selectively reworked the underlying late fifteenth or early sixteenth-century drawing with brush and dark-brown ink and greenish bodycolor. Thus he redrew the profile of the head at the left, and added strands of hair to the head of the woman seen from the front at the top right, in addition to "correcting" the contour of her chin and retouching her eyes. Furthermore, he "fleshed out" the arms and waist of the woman at the lower right by completing her bodice and indicating a skirt. Rubens's brush stroke can also be detected at the left in the woman's back, which he broadened.

Rubens's retouched drawings are difficult to date. No painting is known in which he made use of this headdress, and the drawing could have come to his attention at any time. With regard to subject matter, the sheet is most closely allied with the group of drawings by Rubens assembled in the *Costume Book* in the British Museum, mentioned earlier, dated to the years 1610–11 (see especially Belkin 1980, nos. 21, 26, 27 and 28) and the ELEVEN HEADS OF WOMEN of about 1608–12 in Braunschweig (Belkin 1980, no. 45, fig. 232; Held 1986, no. 64, fig. 64). Despite these intensive studies, Rubens did not always depict the headgear accurately in his paintings. Ribeiro pointed out that Rubens completely misunderstood the fifteenth-century headdress worn by St. Bega in the double portrait with Ansegisus in Vienna of about 1614 (KdK 106; Jaffé 1989, no. 248).

37

ANATOMICAL STUDIES, ca. 1600–05

Pen and light-brown ink, 280 x 187 mm (11 x 7⅜ in.)

Collection of The J. Paul Getty Museum, Malibu, California

Inv. no. 88.GA.86

Provenance: Sir Roger Newdegate; by descent (sale, London, Christie's, 6 July 1987, lot 61);
art market, London

Exhibition history: New York/London 1987, no. 23, ill. in color.

References: Jaffé 1987, no. 61, ill. in color; Goldner and Hendrix 1992, no. 85, ill.

Exhibited in Wellesley only

This study is one of eleven anatomical drawings by Rubens that came to light as recently as 1987. Seven of them are known also from copies among the drawings in the so-called Rubens *cantoor* in the Royal Museum of Fine Arts, Copenhagen, while five were reproduced in print (in reverse) by Paulus Pontius (Antwerp 1603–1658), including this drawing.

In this sheet of ANATOMICAL STUDIES, Rubens has drawn the same statue from different angles. As we know from Rubens's several drawings after LAOCOÖN, the Hellenistic marble sculpture in the Vatican, or the AFRICAN FISHERMAN (see catalogue number 39), the artist studied a sculpture by walking around it, drawing various views in the process. Here we can observe Rubens examining the muscle structure of the human body in a striding position, most likely drawn from an *écorché* statuette that has not been identified.

The foremost figure is found in a drawn copy attributed to Rubens's pupil Willem Panneels (Antwerp? 1600–ca. 1650 Madrid?) among the *cantoor* group in Copenhagen (Inv. no. VI,44; black and red chalk, pen and brown and black ink, 298 x 163/165 mm; see Garff and Pedersen 1988, no. 217, pl. 219). Half of this cache of about five hundred drawings has been recently attributed outright to Panneels by Garff and Pedersen (1988; see Held 1991, p. 421 and n. 11). Rubens left the younger artist in charge of his house and studio from 1628 until early 1630 while he was away on diplomatic missions in Spain and England. During that time Panneels made a number of copies after Rubens's anatomical drawings, annotating a large number with comments about how well the outline (*omtreck*) was drawn. In the foremost figure striding to the right that Panneels lifted out from Rubens's ANATOMICAL STUDIES at the Getty Museum, he concentrated on the contour lines as well as on the muscular structure, omitting head and arms.

Pontius's print was included as plate 9 (of twenty) in *A Drawing-Book* consisting of anatomical studies, heads, and two vases after drawings by Peter Paul Rubens, published by Alexander Voet in Antwerp after Rubens's death in 1640 and before 1658, when Pontius died. (See Van den Wijngaert

1940, p. 85, no. 557.9; Hollstein, XVII, no. 157; and Bolten 1985, p. 103.) The notation in the center of the title page that Rubens made the preliminary drawings (*PETRVS PAVLVS / RVBBENS / DELINEAVIT*) speaks most strongly against attributing this and the other related anatomical drawings to the engraver Pontius (see Garff and Pedersen 1988, pp. 79–80).

The fact that some of the recently discovered anatomical studies are on a type of paper used in Mantua in the late sixteenth century supports a rather early date during Rubens's stay in Italy, when the artist was also studying anatomy by copying antique sculpture in Rome. Jaffé's earlier explanation, that the publication of *A Drawing-Book* with prints by Paulus Pontius after drawings by Rubens may have been a *ballon d'essai* (trial balloon) on the part of Rubens's heirs to draw attention to material in his estate, is intriguing but cannot be proven (1966, I, pp. 38–39).

At least two of Rubens's anatomical drawings from the Newdegate Settlement were known in English medical circles early on. The surgeon William Cowper (1666–1709) seems to have used Rubens's NUDE STRIDING TO THE RIGHT, HIS HANDS BEHIND HIS BACK (sale, London, Christie's, 6–7 July 1987, lot 59) as a prototype for the print after it (in the same sense) which he included in his anatomical treatise on the muscles of the human body, the *Myotomia reformata*, London, 1694. The Wellcome Institute in London preserves a copy after Rubens's TWO HANDS (pen and brown ink, 303 x 249 mm; annotated bottom right: *P.P.Rubens*), also known in Pontius's print which shows that the drawing formerly in the Newdegate collection was cut rather severely at the left (sale, London, Christie's, 6–7 July 1987, lot 66).

38

Bartolomeo Passarotti (Bologna 1529–1592 Bologna), retouched by Peter Paul Rubens
TWO STUDIES OF AN ARM, retouched 1600–08
Red chalk and red-brown watercolor, 238 x 312 mm (9⅜ x 12⁵⁄₁₆ in.)
Annotated in pen and brown ink on verso, *70 / No 56 / Rm 15*.
Museum of Fine Arts, Boston, Massachusetts: Gift of Henry P. Rossiter
Inv. no. 52.1761
Provenance: Peter Paul Rubens; Prosper Henry Lankrink, London (1628–92; L. 2090);
Sir Joshua Reynolds, London (1723–92; L. 2364); H. F. Sewall; Gift of Henry P. Rossiter
Exhibition history: Cambridge, Massachusetts 1974, no. 18.
References: Held 1974, p. 259, under n. 18; Logan 1976–78, p. 111, fig. 4; Macandrew 1983, no. 3a, ill.;
Byam Shaw 1984, p. 445, fig. 72; Höper 1987, II, p. 117, no. Z33; Jaffé 1987, p. 59.

The traditional attribution of the underlying drawing in red chalk to Bartolomeo Passarotti (Bologna 1529–1592) has recently been upheld by Corinna Höper, who related it to his anatomical studies of arms and legs preserved in Princeton and Berlin. Rubens's reworking of an Italian

sixteenth-century original was first noticed by Konrad Oberhuber and confirmed by Michael Jaffé in an annotation on the mount (1958). According to Macandrew (1983) the red chalk study is by a Central Italian draftsman and dates from the mid-sixteenth century; Byam Shaw (1984) considered it early sixteenth-century Florentine.

Rubens retouched the two arms with the tip of the brush so extensively that it is difficult to separate his work from the sixteenth-century original underneath. His changes are most discernible along the contours of the shoulders, which are given more volume. Rubens further redefined the bony elbow section and the fingers. He seems to have been fascinated by the protruding veins as he highlighted and enhanced them. Rubens's brush was also responsible for the indication of the chest at the top left. With his flowing brush lines, Rubens greatly increased the modeling and thus the plasticity of the two arms, surely more in accordance with his own ideas. The careful rendering of the veins and the underlying musculature reveals the same interest in anatomical detail that can be detected in Rubens's two portrait drawings, which he also reworked with the brush and red ink most likely during his stay in Italy: one is the so-called NICCOLÒ DA UZZANO in The Pierpont Morgan Library, New York (Stampfle 1991, no. 297, ill., as entirely by Rubens), the other, the HEAD OF AN OLD MAN, at Oberlin College (Stechow 1976, no. 289, fig. 148, as entirely by Rubens).

39

THE AFRICAN FISHERMAN SEEN FROM THE BACK (DYING SENECA), ca. 1601–02

Black chalk, 473 x 314 mm (18⅝ x 12⅜ in.)

Annotated in black chalk at bottom left, *Rubens / dall' Antico*; in pen and brown ink at bottom center, *Seneca esangue alla sangrilia dono*.

Private Collection

Provenance: Maximilian Labbé (d. 1675?); Padre Sebastiano Resta (1635–1714); Philip V of Spain (1700–46); Orléans collection?; sale, London, Christie's, 22 November 1966, lot 119, ill. (from an album containing 109 drawings that belonged to Philip V of Spain)

Exhibition history: London, 1967, no. 28.

References: Müller Hofstede 1968, p. 233, fig. 165; Jaffé 1977, pp. 80, 116, n. 17, fig. 275; Müller Hofstede, in exh. cat. Cologne 1977, under no. 52; Garff and Pedersen 1988, under no. 76; Wood 1990, p. 7, fig. 4 and cover; Stampfle 1991, p. 151, under no. 317; Alexey Larionov, in exh. cat. Retretti 1991, p. 134.

Exhibited in Wellesley only

Padre Sebastiano Resta (Milan 1635–1714) specified in the inscription, which he added to the drawing when it was in his possession, that Rubens copied it after the antique, and that the statue at that time was believed to represent Seneca bleeding to death from cutting his veins, standing in a tub of hot water (which was supposed to accelerate death). The statue, a copy from the second century in dark-brown marble with enamel eyes and a belt of antique alabaster after a lost Hellenistic original, was then in the collection of Cardinal Scipio Borghese in Rome. It was much restored (with the arms, belt, and one thigh added) and placed on a marble vase with the top painted red to indicate blood. Rubens drew the statue with these restorations at least seven times from different angles, in a systematic examination of the sculpture. (Today the AFRICAN FISHERMAN is in the Louvre, Paris; see Haskell and Penny 1981, no. 76. The basin, removed around the turn of the century, has been replaced and the statue restored.)

The methodical way in which Rubens copied the AFRICAN FISHERMAN from the front (St. Petersburg), back (private collection, catalogue number 39), left and right sides (St. Petersburg; Milan), and at various angles from the front and back (known only from copies among the *cantoor* group in Copenhagen), indicates that he was trying to absorb every facet of the statue and commit it to memory, since, as he wrote, "in order to attain the highest perfection in painting, it is necessary to understand the antiques, nay, to be so thoroughly possessed of this knowledge, that it may diffuse itself everywhere." Roger de Piles published this passage in the *Cours de peinture par principes*, Paris, 1708 (English translation, 1743, p. 86) from Rubens's unpublished treatise in Latin concerning the "Imitation of the Antique Statues," which then was in De Piles's possession. There can be no doubt that Rubens made these copies in front of the sculpture in the Borghese collection and that he kept them together in a chest (*cantoor*), as we may deduce from the copies Willem Panneels made after a number of them in 1628–30. Similarly, Rubens made no less than fifteen copies after the LAOCOÖN group as if to commit it to his visual memory. For all the copies after the AFRICAN FISHERMAN and LAOCOÖN Rubens used black chalk, the medium he later preferred for his studies from the model.

We know that Rubens believed the sculpture to represent Seneca since Panneels identified one of his copies specifically as "ceneca" (Garff and Pedersen 1988, no. 76, fig. 78). Moreover, in 1604, some years after Justus Lipsius had converted back to the Catholic faith, he published the treatise *Manuductionis ad Stoicam Philosophiam Libri tres*, included in volume V of his collected writings, or "guidelines" to the stoic philosophy of Seneca, where he claimed that the statue of the AFRICAN FISHERMAN rendered the true image of Seneca. Lipsius went further to interpret Seneca in a more Christian sense, endowing him with a martyr-like quality, an idea Rubens must have known (see Von Simson 1990).

Julius Held retains the somewhat later date of ca. 1605–08 for Rubens's copies after antique sculpture in Rome, partly because one of them, the so-called SLEEPING HERMAPHRODITE, once in the Borghese collection as well and likewise now in the Louvre, Paris, was discovered at the earliest in 1608, and possibly as late as 1620 (see Haskell and Penny 1981, no. 48). Neither of the two drawn copies that are attributed to Rubens and have been associated with this sculpture—one in The Metropolitan Museum of Art, New York (from the Walter C. Baker collection; Held 1982, p. 103), the other in the British Museum, London (Held 1986, no. 38, pl. 37)—are unanimously accepted as originals by him, which leaves the date for Rubens's copies after the antique more open-ended. A slightly earlier date during his first visit to Rome in 1601–02 would seem more likely for the present drawing, a date also suggested by Larionov (see exh. cat. Retretti 1991, p. 134).

40

THE DEATH OF DIDO, ca. 1602–05

Pen and brown ink, 95 x 115 mm (3¾ x 4½ in.)

Bowdoin College Museum of Art, Brunswick, Maine: Bequest of Helen Johnson Chase

Inv. no. 1958.67

Provenance: Jonathan Richardson, Sr. (1665–1745; L. 2184); Prof. Henry Johnson;

Helen Johnson (Mrs. Stanley P.) Chase

Exhibition history: Cambridge, Massachusetts/New York 1956, no. 2; Cologne 1977, no. 29, ill.;

Waterville, Maine 1978, no. 9, ill.; Brunswick, Maine 1985, no. 13, ill.

References: Mather 1914, p. 115, no. 635, fig. 8; Lugt 1949, under no. 591; Held 1959, no. 9, pl. 10; Jaffé 1977, pp. 29, 64, pl. 219; Elizabeth McGrath, in exh. cat. London 1981–82, p. 214; Held 1986, no. 25, pl. 25 and under no. 24, pl. 24; Logan 1987, p. 67.

"Nothing is too good for Rubens," wrote Julius Held in 1952 in response to Frank J. Mather's earlier opinion reattributing the present drawing to the young Van Dyck, declaring it "far too good" for Rubens.

This small pen sketch of a woman committing suicide by her sword relates closely to a larger sheet in the Louvre, Paris, where five more studies show this figure in different poses. Although Frits Lugt accepted the attribution of the latter drawing to Van Dyck as well, both drawings are now firmly attributed to Rubens and dated to his early years in Mantua, most likely between 1602 and 1605. While no painting is known for which Rubens used these studies, there are certain similarities to a female figure at the lower left in his oil sketch, the MARTYRDOM OF ST. URSULA, in the Palazzo Ducale, Mantua, where a woman seems to be impaled by a sword or possibly a thick arrow (not in KdK; Jaffé 1989, no. 46).

According to Jaffé, the faint pen sketch of what appears to be a staff on the verso of the drawing at Bowdoin, is a continuation of the staff held by the figure of Paris on the verso of the Louvre drawing, proving, in his opinion, that the two studies were cut from the same sheet (figure XI). This is difficult to ascertain, for not one of the pen lines corresponds precisely with those on the verso of the drawing in the Louvre. It is more likely that the Bowdoin drawing originated independently and was cut down rather severely at the bottom, where a loose pen sketch of a head and a cloud-like shape is still partially visible, in addition to the staff.

While there is now agreement that the drawings at Bowdoin and in the Louvre are by Rubens, there is less consensus about their subject matter. Until recently, the studies were interpreted as rendering the suicide of Thisbe, with Rubens representing her at the dramatic moment when she put the point of the sword under her breast and fell forward, in accordance with a passage in Ovid's *Metamorphoses* (Book IV, verses 162–63). Elizabeth McGrath made an alternate suggestion that identifies the figure with Dido, the Queen of Carthage. She based this proposal in part on the crown worn by the woman in the lower left of the study in the Louvre. Rubens would therefore have represented a scene from Virgil's *Aeneid*, in which Dido falls upon the sword Aeneas had presented to her as a gift (Book IV, verses 663–65). McGrath further recalls a passage in J. Campo Weyerman, who related that Duke Vincenzo Gonzaga surprised the artist reciting aloud verses from the *Aeneid* one day while painting the BATTLE OF AENEAS AND TURNUS (1729, pp. 258–59). Since Rubens seems indeed to have painted an Aeneas cycle in Mantua, the identification of the subject with a figure from Virgil is preferable.

The random arrangement of the figures in varying situations of distress, as well as the quick pen lines with few *pentimenti* defining the differing poses, are not unlike that of another Rubens drawing which Elizabeth McGrath established as a "visual commentary," as she characterized the drawing (Kupferstichkabinett, Berlin) on which Rubens jotted down images of various Roman emperors while reading Suetonius's *Lives of the Caesars* (1991, p. 703, fig. 40). One may ask whether this drawing at Bowdoin and the related sheet in Paris represent an earlier instance of Rubens's practice of formalizing on paper images that came to his mind when reading or reciting from the *Aeneid*.

Rubens's interest in women in distress is reflected in two other early pen studies, executed in Mantua, the THREE SKETCHES FOR MEDEA AND HER CHILDREN in The J. Paul Getty Museum, Malibu (Goldner 1988, no. 90v), and the FLIGHT OF MEDEA in the Museum Boymans-van Beuningen, Rotterdam (Held 1986, no. 16).

41

VENUS LAMENTING ADONIS, ca. 1608–12

Pen and brown ink, 306 x 198 mm (12 x 7¾ in.)

Inscribed in pen and brown ink at top center, *Spiritum / morientis / excipit ore.*

National Gallery of Art, Washington, D.C.: Ailsa Mellon Bruce Fund

Inv. no. 1968.20.1

Provenance: T. J. Bell (sale, London, Sotheby's, 26 November 1929, as Van Dyck);
Ludwig Burchard, London

Exhibition history: Amsterdam 1933, no. 103; London 1950, no. 44; Antwerp 1956, no. 46.

References: Held 1959, no. 23, pl. 22; Held 1986, no. 58, fig. 57 (reproduced in reverse);
Logan 1987, p. 71.

Exhibited in Cleveland only

This is one of three closely related drawings Rubens made of VENUS LAMENTING ADONIS; the other two are in the British Museum, London (Held 1986, no. 57, fig. 56), and in the Antwerp Print Room (exh. cat. Antwerp 1991 [A], no. 75, ill.). This latter version is the most summary of the group, whereas in the London drawing Rubens added some brush lines, best visible in Venus's flowing hair, and used wash extensively in the background. In this version, Adonis's body is limp, with his head fallen backward.

The Washington study is the only one that includes Rubens's brief comment in Latin, written at the top near another pen sketch of the heads of Venus and Adonis only, which expresses what he intended to convey in the drawing: *Spiritum morientis excipit ore*, that is Venus, who "draws out the soul of the dying [Adonis] from his mouth." Held associated these lines with the dirge on the death of Adonis by the Greek poet Bion. Elizabeth McGrath has found an even more likely source in Cicero's *Verrine Orations* (*Cicero against Verres*, II, 45, 118), where "unhappy mothers passed the nights at the prison entrance, cut off from the last sight of their children, begging for nothing but permission to receive with their lips their sons' parting breath" (*matresque miserae pernotabant ad ostium carceris ab extremo conspectu liberum exclusae, quae nihil aliud orabant nisi ut filiorum suorum postremum spiritum ore excipere liceret*). This seems indeed what Rubens intended to show in the separate study, where Venus's face comes so close to Adonis's mouth, as if to "draw out the soul of the dying." A similar image was described earlier by Rubens after his visit to the Pasqualino collection in Rome, where he saw a sarcophagus depicting Venus and Adonis, as E. McGrath established. He wrote of that sarcophagus that "while Cupid was tending to his [Adonis's] wounds with a sponge, Adonis was expiring, with his soul almost passing into the mouth of Venus, who moved up close to receive it." (*Luy expirant & rendant l'ame quasi dans la bouche de Venus qui s'approche p[ou]r la recevoir*; for a transcript, see Van der Meulen 1975, p. 205.)

Despite these detailed compositional studies, no painting is known in which Rubens made use of these ideas. (The DEATH OF ADONIS, published in Baudouin 1972, p. 53, fig. 26, as painted in 1601 [Jaffé 1989, no. 25, 1602], has a different composition.) The drawing probably dates from the first years after his return to Antwerp or about 1608–12.

42

STUDY FOR THE FIGURE OF CHRIST IN THE "RAISING OF THE CROSS," ca. 1610

Black chalk with later outlining in charcoal, heightened with white chalk on buff antique laid paper, 400 x 298 mm (15¾ x 11¾ in.)

Fogg Art Museum, Harvard University Art Museums, Cambridge, Massachusetts:

Gift of Meta and Paul J. Sachs

Inv. no. 1949.3

Provenance: possibly Jacob de Wit, Amsterdam (1695–1754; 1755, Boek C, nos. 21–27: *zes gedeelte van het Groote Kruis* [six studies of the large cross]); J. D. Böhm, Vienna (1794–1865); Werner Weisbach, Berlin; Paul J. Sachs, Cambridge, Massachusetts (1878–1965)

Exhibition history: Buffalo 1935, no. 40, ill.; Detroit 1936, no. 5; San Francisco 1940, no. 91, ill.; Worcester 1948, no. 42; Cambridge, Massachusetts/New York 1956, no. 8, pl. III; Antwerp 1956, no. 34, pl. XI; New York 1959–61, no. 67, ill.; Cambridge, Massachusetts/New York 1966, no. 19, ill.; Princeton 1972, no. 8, ill.; Cambridge, Massachusetts 1974, no. 15; Providence 1975, no. 15, ill.

References: Mongan and Sachs 1940, no. 483, pl. 249; Burchard and D'Hulst 1963, no. 55, pl. 55; Martin 1969, p. 42, ill.; Held 1980, under no. 349; Held 1986, under no. 55.

Rubens made this study from life for the figure of Christ in the RAISING OF THE CROSS, represented in the center panel of the altar painted originally for the church of St. Walburga in Antwerp (destroyed); Rubens's triptych is now in the Antwerp Cathedral (KdK 36; Jaffé 1989, no. 135A). Despite the large dimensions of the sheet, the figure extended beyond the paper surface, which forced Rubens to complete the thumb of the left hand in a second study near the upper right margin. The figure's right hand is clenched as if the model were holding a rope to assist him in sustaining this difficult pose. The shading at the lower left and the youth's faintly outlined loincloth, extending to the right, indicate that Rubens drew the figure from a reclining pose. The youth looks upward, as Christ does in the final altar, reaching toward the figure of God the Father, who in the final triptych was positioned at the top of the center panel surmounted by a pelican.

Rubens apparently made at least six such exceptionally large, detailed studies in black chalk of male nudes in preparation for specific figures in the center panel of the RAISING OF THE CROSS, if this is indeed one of the *zes gedeelte van het Groote Kruis* listed in De Wit's inventory. In addition to the sheet reproduced here, three further studies are known today, one each in the Dutch royal collection, the collection of Chr. P. van Eeghen in The Hague, and the Ashmolean

Museum, Oxford. In drawing from the model, Rubens followed the Italian academy tradition as exemplified by Annibale Carracci, a testimony of his long sojourn in Mantua and Rome. No drawing by Rubens exists for the entire composition of the RAISING OF THE CROSS.

Rubens drew this individual study of a youth in preparation for the figure of Christ only after he had established the general layout of the RAISING OF THE CROSS composition in an oil sketch, today in the Louvre, Paris (Held 1980, no. 349; Jaffé 1989, no. 131), which he submitted to the church authorities of St. Walburga in June of 1610. After receiving the commission for the altarpiece, Rubens painted it during the following months in the cathedral itself (because of its enormous size), shielded from the curious public by a large sail. Whereas in the oil sketch Rubens placed the cross more at a diagonal, in the altarpiece he positioned it more upright, with Christ depicted frontally, as in this drawing. This implies that Rubens drew this study from life after he had painted the oil sketch, that is after June of 1610. By then the central panel must have been well underway, since the pose of the youth corresponds closely to the upper body of Christ in the altar. Rubens now knew exactly what he needed, down to the smallest details, such as the clenched fingers or the thumb of Christ's left hand. Even these elements Rubens followed without any noticeable modification, all the more astounding since the figure of Christ in the altar painting is well over life size.

In this life study Rubens shows how thoroughly he had absorbed anatomy during his years in Italy through copying classical sculpture, in particular the LAOCOÖN and the so-called AFRICAN FISHERMAN (see catalogue number 39). The youthful figure also embodies Rubens's ideal of the muscular human body, well toned through strenuous exercise, as we learn from his unpublished treatise in Latin on the "Imitation of the Antique Statues," which Roger de Piles included in his *Cours de peinture par principes* (Paris, 1708).

43

STUDIES FOR THE "PRESENTATION IN THE TEMPLE," March–September 1611
Pen and lighter and darker brown ink, brown wash, 214 x 142 mm (8⁷⁄₁₆ x 5¾ in.)
The Metropolitan Museum of Art, New York, New York: Gift of Mr. and Mrs. Janos Scholz, 1952.
Inv. no. 52.214.3
Provenance: Mr. and Mrs. Janos Scholz
Exhibition history: Cambridge, Massachusetts/New York 1956, no. 11, pl. VII; New York 1970, no. 30; Princeton 1972, no. 9, ill.; Antwerp 1977, no. 136, ill.
References: (recto) Held 1959, no. 28, pl. 34 and fig. 50; Jaffé 1977, pp. 52, 57, pl. 188; Held 1980, under nos. 320, 358; Held 1986, no. 72, pl. 73.
(verso) Held 1959, under no. 70, ill.; Seilern 1971, under no. 56; Jaffé 1977, p. 52, pl. 189; Held 1986, no. 14, fig. 8.

On 7 September 1611 the guild of the Arquebusiers commissioned Rubens to paint the triptych of the DESCENT FROM THE CROSS in Antwerp Cathedral (KdK 52; Jaffé 1989, no. 189A-E), which included on the inside right wing the PRESENTATION IN THE TEMPLE. This preliminary study for a PRESENTATION belongs to Rubens's earliest drawings for the altar whose overriding theme was associated with the Arquebusiers' saint, Christophorus, whom Rubens painted on the two outer wings, carrying the small Christ Child across the river. Throughout the DESCENT FROM THE CROSS, Rubens alluded to "Christo-phorus" or the "Bearer of Christ"; this idea is expressed in the PRESENTATION IN THE TEMPLE in the figure of Simeon, holding the swaddled Child in his arms.

This drawing in The Metropolitan Museum of Art was cut from a larger sheet that originally measured at least 380 x 507 mm. The remaining two fragments are also known: the adjoining section with two further studies for the same PRESENTATION IN THE TEMPLE is in the Princes Gate Collection, Courtauld Institute Galleries, London (242 x 238 mm; Held 1986, no. 72, pl. 73), and the third fragment, a large sheet with several studies for the VISITATION that Rubens painted on the inner left wing of the same triptych, is in the Musée Bonnat, Bayonne (265 x 360 mm; Held 1986, no. 71, pl. 72). In the fragment illustrated here, Rubens experimented with the group, portraying the prophetess Hannah at the left, and Simeon holding the Christ Child in the center, with the Virgin bending toward the Child. Joseph kneels directly in front. Rubens drew this same group of figures twice more in the fragment now in London. A close study of the reconstructed sheet (figure XII) shows that Rubens progressed with the composition from right to left, from a rather finished compositional layout to a more sketchily outlined second idea, included in the sheet in London at the left. The artist settled on this consolidated and tighter configuration in the drawing in New York. Most problematic for Rubens was the position of St. Joseph kneeling in the foreground: he is now turned further to the left, closer to the corresponding figure in the preceding oil sketch, also in the Princes Gate Collection (Held 1980, no. 358).

Since Rubens here placed the two alternate studies of the PRESENTATION IN THE TEMPLE in a more horizontal format than the narrower composition found in the final wing of the triptych, Held argued convincingly that these must belong to the initial drawings of the DESCENT FROM THE CROSS and that Rubens may possibly have followed them with an oil sketch, now lost. In the subsequent *modello* of the PRESENTATION IN THE TEMPLE, also in the Princes Gate Collection, as well as in the wing of the DESCENT FROM THE CROSS triptych, Rubens kept the Virgin's position more or less the same as in this earlier drawing. Simeon, on the other hand, is turned to the right with Hannah standing at his right, while Joseph kneels below, now seen in profile, with all the figures placed in an elaborate architectural framework.

The Arquebusiers first discussed the new altar in Antwerp Cathedral during a meeting on 13 March 1611. Held placed Rubens's preliminary drawings between this date and the signing of the contract in early September, because they reflect Rubens's earliest ideas for the altar. Rubens began to work on the wings of the DESCENT FROM THE CROSS only in the spring of 1613. The entire altar was in place in early 1614.

The fragment on the verso in black chalk of the leg and elbow of a man is one of three (figure XIII) that can be reassembled with few losses into two separate studies of a man holding the shaft of a thick beam for the cross (see Evers in 1944, p. 137, fig. 10). Evers was the first to realize that these studies in black chalk are earlier than the pen drawings on the recto. He thus identified them correctly with Rubens's preparatory studies for his ELEVATION OF THE CROSS painted a decade earlier, about 1601, in Rome for Sta. Croce in Gerusalemme (now preserved only in a copy in the Cathedral in Grasse, KdK 2, right; Jaffé 1989, no. 19). The verso of the drawing in The Metropolitan Museum of Art, New York, thus dates from about the same time as Rubens's copy after the so-called AFRICAN FISHERMAN, here discussed as catalogue number 39.

44

STANDING LION, ca. 1612–13

Black chalk, heightened with white, yellow chalk in the background, 254 x 282 mm (10 x 11⅛ in.)

National Gallery of Art, Washington, D.C.: Ailsa Mellon Bruce Fund

Inv. no. 1969.7.1

Provenance: sale, London, Sotheby's, 27 March 1969, lot 86, ill.

Exhibition history: Washington, D.C. 1978, no. 63, ill. in color.

Reference: D'Hulst and Vandenven 1989, no. 57h, fig. 151.

Exhibited in Cleveland only

Rubens made this close-up study in black chalk for the large lion facing the viewer, standing calmly to the left of Daniel in Rubens's DANIEL IN THE LIONS' DEN in the National Gallery of Art, Washington, D.C. (not in KdK; Jaffé 1989, no. 289). The entire group of drawings of lions was first discussed by Jaffé (1970, pp. 7–33). In keeping with his working practice, Rubens would have drawn this specific study once he had established the desired pose in the painting. Since Rubens's lions are so lifelike, seeming to move and behave so naturally, it is difficult to imagine that he would have worked only from bronze sculptures or prints. In his letter to Sir Dudley Carleton of 28 April 1618, Rubens referred specifically to this painting as "Daniel among many lions, taken from life" (Magurn 1991, letter 28), which indicates that he made studies from live rather than stuffed lions. Lions were kept at the zoo in Ghent, where Rubens could have observed and drawn them. An anecdote by Campo Weyerman supports this hypothesis. He recounted that Rubens actually had a

lion brought into his studio. When the animal dozed off, Rubens had someone tickle the beast under the chin so that it would throw open its mouth for Rubens to get a better view. This apparently so enraged the lion that it had to be destroyed (Weyerman 1729, pp. 287–89).

DANIEL IN THE LIONS' DEN was one of twelve paintings that Rubens exchanged in 1618 with Sir Dudley Carleton for the latter's collection of antique marble sculptures. The lions were widely copied by other painters, among them Jan Brueghel the Elder, who included the lion and lioness at the lower right in his own painting of NOAH AND HIS FAMILY LEADING THE ANIMALS INTO THE ARK, dated 1613, now in The J. Paul Getty Museum, Malibu (Ertz 1979, no. 273, color plate 307). In a version dated 1615 of the same subject in the Wellington Museum, London, Jan Brueghel included a copy after this standing lion, as Jaffé first noted. This and other black chalk drawings by Rubens of lions must therefore date from about 1612.

45

ADORATION OF THE SHEPHERDS, ca. 1613

Pen and brown ink, brown wash, heightened with white, traced for transfer,

279 x 181 mm (11 x 7⅛ in.)

Annotated in pen and brown ink at bottom left, *P.P. Rub....*

Collection of The J. Paul Getty Museum, Malibu, California

Inv. no. 86.GA.592

Provenance: Henri Tersmitten, Amsterdam (sale, Amsterdam, Jean de Bary and Pierre Yver, 23 September 1754, lot 430); Pieter Testas the Younger, Amsterdam (sale, Amsterdam, Hendrik de Leth, 29 March 1757, lot 49); Gerard Hoet Jr., The Hague (sale, The Hague, Ottho van Thol, 25–28 August 1760, lot 243); Dionis Muilman, Amsterdam (sale, Amsterdam, Jan de Bosch Jr., Cornelis Ploos van Amstel, Hendrik de Winter, 29 March 1773, lot 965); M. Neyman, Amsterdam (sale, Paris, F. Basan, 8–11 July 1776, lot 755); Armand-Frédéric-Ernest Nogaret, Paris (sale, Langlier, Antoine C. D. Thierry, 6 April 1807, lot 457); sale, London, Christie's, 2 April 1947, lot 47; Ludwig Burchard, London; Wolfgang Burchard, Farnham; art market, New York

Exhibition history: London 1953, no. 292; London 1953–54, no. 507; Antwerp, 1954, no. 335; Antwerp 1956, no. 48, pl. XVII.

References: Judson and Van de Velde 1978, no. 21a, fig. 81; Stampfle 1991, under no. 305; Goldner and Hendrix, 1992, no. 86, ill.

Exhibited in Wellesley only

This Nativity is one of eight illustrations and a title page Rubens designed for a new edition of the *Breviarium Romanum*, published by the Plantin Press in Antwerp in 1614. The illustrations for this folio edition of a Roman Breviary as well as of the Roman Missal the previous year were the

largest commissions Rubens received for book designs. The drawing is a detailed compositional study drawn exclusively with the pen to guide Theodoor Galle (Antwerp 1571–1633), who engraved it in reverse with one notable change—he showed the rafters of the stable roof at the top and introduced more space in the foreground at the bottom. Rubens used the Christ Child as the source of light, indicating shadows with transparent brown wash. This chiaroscuro effect seems to have been a strong concern since, in a proof impression of the engraving preserved in the Bibliothèque Nationale in Paris, he deepened some of the shadows with brush and brown ink to stress the effect of a night scene. The drawing must have been finished later in 1613, as Theodoor Galle was paid 65 guilders on 12 April 1614 for the engraving. In execution, this drawing of the Nativity is most similar to Rubens's ADORATION OF THE MAGI in The Pierpont Morgan Library, New York, drawn in 1613 for the Roman Missal, but reused and included the following year in the Roman Breviary (Stampfle 1991, no. 305, ill.).

The Getty Museum preserves Rubens's design for yet another illustration in the same edition of the *Breviarium Romanum*, the ASSUMPTION OF THE VIRGIN, which was discovered relatively recently (Held 1986, no. 84, pl. 79; Goldner 1988, no. 91, ill.). Since the ASSUMPTION OF THE VIRGIN was engraved by Theodoor Galle as well, and included in the same payment in 1614, Rubens must have designed it at about the same time as this Nativity. This raises the total number of extant drawings by Rubens for the Roman Breviary to six (Judson and Van de Velde 1978, cat. nos. 18a, 21a, 23a, 26a, 27a, 28a). The *Breviarium Romanum* of 1614 is the last book with illustrations designed by Rubens to be published during his lifetime. For Jan Boeckhorst's design for an illustration in a later edition of the *Breviarium Romanum* (1655), see catalogue number 2.

46

YOUNG WOMAN IN PROFILE, ca. 1613

Black chalk, heightened with white, 375 x 251 mm (14¾ x 9⅞ in.)

National Gallery of Art, Washington, D.C.: Ailsa Mellon Bruce Fund

Inv. no. 1978.18.1

Provenance: Jonathan Richardson, Sr., London (1665–1745; L. 2184);

F. Flameng, Paris (his sale, Paris, Georges Petit Gallery, 26–27 May 1919, lot 87)

Exhibition history: Washington, D.C. 1978, no. 64, ill. in color on the cover.

References: Burchard and d'Hulst 1963, no. 111, ill.; Logan 1978, p. 449, fig. 12; Logan and Haverkamp-Begemann 1978, p. 92; Freedberg 1984, no. 37f, fig. 94; Balis 1986, p. 257; Held 1986, nos. 78–79, figs. 86, 105.

Exhibited in Cleveland only

This is one of Rubens's most delicately drawn studies of a young woman. It belongs to a group of six detailed drawings, all in black chalk, which he made in preparation for figures in the ASSUMPTION OF THE VIRGIN, the altar now in the Kunsthistorisches Museum, Vienna (KdK 206; Jaffé 1989, no. 241; Freedberg 1984, no. 37; reproduced in color in Balis et al. 1987, p. 141). Rubens drew this study for the young woman in the lower center of the altarpiece. Her profile is silhouetted against the blue sky in the distance. In the preceding *modello* in the Hermitage, St. Petersburg, she is surrounded by apostles crowding in from behind (reproduced in a color detail in Varshavskaya 1989, p. 35). Frans Baudouin first referred to a document that seemed to identify this oil sketch in the Hermitage with one of two *modelli* Rubens submitted to the canons of Antwerp Cathedral on 22 April 1611 for consideration for the painting. While no official commission followed, Rubens nevertheless proceeded to complete the ASSUMPTION OF THE VIRGIN. (For a detailed account, see Freedberg 1984.)

In the altarpiece, Rubens painted the young woman in accordance with this preliminary study with her left hand similarly resting on the shoulder of another woman who is displaying the roses she discovered hidden in the Virgin's shroud. The close correspondence between drawing and altarpiece suggests that this is one of Rubens's last studies for the painting, which Freedberg dated to around 1613. While the drawing, in his opinion, dates from ca. 1611–12, it seems preferable to place the study in the same year as the painting.

On the verso, Rubens's *crabbelinge*, or quick, indistinct black chalk sketches, partly reinforced with the pen and brown ink, are difficult to make out (see Held 1986, fig. 105). They probably date from about the same time as the carefully drawn study in chalk on the recto and seem to include a scene with a bull, which is unrelated to the only known Rubens painting on the subject, his BULL HUNT in Gerona (Balis 1986, no. 26).

47

TITLE PAGE FOR THE "COMMENTARIA IN PENTATEUCHUM MOSIS," ca. 1614–15
Pen and brown ink, brown wash over black chalk, partly heightened with white,
traced for transfer; angel at left and medallions at right on separate pieces of paper,
315 x 210 mm (12⅜ x 8¼ in.)
Annotated in pen and brown ink at center by Peter Lely (?), *A / Collection of Altars / & / Altar-Pieces, Churches / &c by ye famous / Boromene &c / severall of them in / their propper colours. / with severall draw- / ings of Albert / Durer, Correggio / Pordenone / &c.*
Department of Printing and Graphic Arts, The Houghton Library, Harvard University, Cambridge, Massachusetts
Provenance: Sir Peter Lely (1618–80; L. 2092); William H. Schab, New York (1942); Philip Hofer
Exhibition history: Cambridge, Massachusetts/New York 1956, no. 15; Antwerp 1977, no. 7b, fig. 10;

Cambridge, Massachusetts 1980, no. 1, ill.

Reference: Judson and Van de Velde 1978, no. 36a, fig. 119 (as ca. 1614–15).

Exhibited in Wellesley only

The *Commentaria in Pentateuchum Mosis* or commentary on the first five Books of the Old Testament by Cornelis van den Steen (Bocholt 1566–1637 Rome) was published in Antwerp in 1616 by the heirs of Martin Nutius and Jan Meurs. Van den Steen held the chair of Scripture at Louvain University from 1596 and was Professor of Hebrew. In 1617 he was invited to continue teaching at the University of Rome. This learned commentary with over 1,000 pages became the standard text for the Jesuits in the seventeenth century. The Pentateuch of Moses, consisting of the five Books of Genesis, Exodus, Leviticus, Numbers, and Deuteronomy, chronicles the world from the Creation to the death of Moses.

Moses, seated upon a pedestal, displays the two Tablets of the Law, which in the engraving bear the following inscriptions from the Ten Commandments: *Ergo sum Dominus Deus tuus…* (I am the Lord thy God…) and *Honora patrem…* (Honor thy father…) (figure XIV). The inscription *Dedit ille legem vitae et disciplinae* (He gave the law of life and knowledge) was added in the engraving beneath him. Above Moses' head, amid the symbols of the four Evangelists, appear the Hebrew letters for Jehovah, emanating rays of light. The surrounding architectural structure— with Corinthian columns, an architrave, entablature, and pediment—contains five medallions with scenes taken from the Pentateuch of Moses. In the scene at center left, Rubens began with a rendering of "The Lord is dividing light from darkness" (Book I, Genesis 1:1–25), continued at center right by "The Passage through the Red Sea" (Book II, Exodus 14:21–28), followed underneath at lower right by "The High Priest Sacrificing the Fowl" (Book III, Leviticus 1:14–17), and ending at lower left with "The Ark of the Covenant Covered by a Tent" (Book IV, Numbers 4:4–6). At bottom center, surrounded by a cartouche, Rubens represented "Moses Preaching to the People of Israel on the Plain" (Book V, Deuteronomy 1:1–3).

The angel at the top left as well as the two medallions at the right are on separate pieces of paper, added as corrections. The drawing was engraved in reverse with few changes by an unknown engraver. The garland of fruit draped over the front of the pedestal as well as the inscription in the drawing are absent in the engraving, for they were added later, possibly by Sir Peter Lely, who may have used it as a frontispiece for a selection of drawings in his own collection. As Held observed, Rubens drew some of the decorative elements that adorn the base of the pedestal only on the right half of the drawing, knowing that the engraver would provide a mirror image on the opposite side (exh. cat. Williamstown 1977, p. 104, n. 3).

If the handwriting of the inscription should prove to be Sir Peter Lely's, Rubens's drawing would be an interesting document for the study of early collecting of drawings in Britain because it provides an idea of how Lely arranged his drawings collection (a point raised by Jeremy Wood, letter of 10 November 1992).

48

MAN IN CHINESE COSTUME (NICOLAS TRIGAULT?), 1617

Black chalk, touches of red chalk in the face and blue-green chalk in the collar facings and bands of the sleeves and along the bottom of the robe, some pen and brown ink, traces of heightening with white; faint sketch of a man's face in pen and brown ink at upper left, 448 x 260 mm (17⅝ x 10¼ in.)

Inscribed by Rubens in pen and brown ink at top right, *Nota quod color pullus non est / peculiaris Sinensium litteratis sed / Patribus S. Iesu. exceptis tamen fascijs / ceruleis quae ceteris communes sunt. / Sinenses porro vestis colore non uno / sed quovis colore promiscue utantur. / Et unum reserves flavem scilicet / qui proprius est Regis.* Inscribed by Rubens (?) at bottom left, (illegible)... *delineatum / die 17 Januaris*; and annotated at bottom right, *A van Dyck fecit.*

Private Collection

Provenance: Lady Sidmouth; Eliza Hobhouse (1842); Henry Hobhouse; Sir Arthur Hobhouse; Alan Rofe (1971); Agnew, London

Exhibition history: London 1900, no. 191 (as Van Dyck); Bristol 1937, no. 251; London 1938, no. 590; Antwerp 1977, no. 156, ill.

References: Burchard and D'Hulst 1963, no. 147, ill.; Logan and Haverkamp-Begemann 1978, p. 97, ill. (as Van Dyck); Vlieghe 1987, no. 154b, fig. 227.

Rubens's inscription in Latin identifies the subject as a Jesuit and explains the choice of colors for the costume: "Note that the dark color is not peculiar to Chinese scholars but to the Fathers of the Society of Jesus [the Jesuits], except for the blue facings, which are common to all. The Chinese, furthermore, do not use one color only in their clothing, but any color they like, except yellow, which is reserved for the King."

The European in Chinese dress in three of four drawings—namely this drawing, the version in Stockholm, which most likely is copied after it, and a drawing recently on the art market—has been plausibly identified as Nicolas Trigault (Douai 1577–1628 Nanking, China), whose features are known from a full-length portrait painting (Musée de la Chartreuse, Douai; Bernard-Maître 1953, pp. 308–13), attributed to the Rubens workshop. The man not only is wearing the same Chinese mandarin costume in all three drawings, but also has the same physiognomy and an almost identical pointed beard. Trigault was a Jesuit Father from Douai who went to India and China in 1606, returning for a brief stay in Europe from 1614 until 1618. Thanks to the inscription on this

portrait in Douai, we know not only his identity but also that he returned to Belgium in 1616 and was portrayed in 1617 (Vlieghe 1987, no. 154, fig. 224; originally in the former Jesuit college in Douai). This, in turn, allows us to complete the date, part of which is inscribed on the drawing at the lower left, to 17 January 1617. The date is further corroborated in letters published by Bernard-Maître locating Trigault in nearby Ghent and Brussels in December/January 1616–17.

This early date strengthens the attribution of the drawing to Rubens, supported by his comments in Latin and probably also the inscription at the lower left that the study was drawn on 17 January (thus revising the opinion expressed in Logan and Haverkamp-Begemann 1978, p. 97, where the drawing was attributed to Van Dyck). The additions with pen and dark brown ink to accentuate folds in the sleeve and robe are similar to those Rubens introduced in the study of ROBIN, THE DWARF of 1620 (Nationalmuseum, Stockholm; Held 1986, no. 145). Like this slightly later drawing, the MAN IN CHINESE COSTUME is essentially a costume study as well, although in this case Rubens did not use it in a painting, as far as is known.

These studies of men in Chinese or Korean costume resemble Van Dyck's portrait studies in black chalk from the following two decades, the late 1620s and all through the 1630s.

49

JESUIT MISSIONARY IN CHINESE ROBES (JOHANN SCHRECK?), 1617

Black and some green chalk, traces of framing line in black chalk,

424 x 244 mm (16 11/16 x 9 5/8 in.)

Annotated in black chalk at bottom right, *A. Dyck.*

The Pierpont Morgan Library, New York, New York

Inv. no. III,179

Provenance: Charles Fairfax Murray, London (d. 1919); J. Pierpont Morgan

Exhibition history: Cambridge, Massachusetts/New York 1956, no. 23, pl. XIII; New York 1979–80, no. 18, ill.

References: Held 1959, no. 105, pl. 123; Held 1986, no. 131, pl. 134; Vlieghe 1987, no. 154d, fig. 230; Stampfle 1991, no. 310, ill.

This is one of five drawings, all comparatively large in size, rendering three different men in oriental dress. Four of them, including this study in the Morgan Library, portray Europeans wearing a Chinese mandarin costume, while in the fifth drawing, now in The J. Paul Getty Museum, Malibu, an Asiatic man is depicted in formal Korean dress with the characteristic transparent horsehair cap (Goldner 1988, no. 93, ill.). The study in the Morgan Library is the most summarily drawn of the group, executed in black chalk without any red chalk in the face, but with touches of blue-green chalk in the collar and girdle, the same chalk that is found in the

drawings in the Nationalmuseum, Stockholm (Vlieghe 1987, no. 154a, fig. 231), and in the drawing in a private collection (catalogue number 48), but absent in the drawing formerly in the collection of Ludwig Burchard (Vlieghe 1987, no. 154c, fig. 229; sale, London, Christie's, 7 July 1992, lot 258, ill. in color). This blue-green chalk is also present in Rubens's drawing of a MAN THRESHING BESIDE A WAGON in the Getty Museum (Goldner 1988, no. 92).

The European man represented in the Morgan Library study must be a Jesuit missionary other than Nicolas Trigault, the probable subject of the drawing in a private collection (see catalogue number 48), bearing Rubens's Latin inscription. The Jesuit Father here, wearing the same costume, is seen frontally. He fills the entire sheet and looks straight out at the viewer. Felice Stampfle (1991) argued convincingly that Rubens possibly represented the Jesuit scientist and missionary Johann Schreck (1576–1630), who accompanied Trigault on his travels to Europe and who eventually sailed with him from Lisbon for Asia on 16 April 1618. Stampfle even found a possible link to Rubens, since Schreck was a close friend of Johannes Faber, the German doctor who cured Rubens of pleuritis in July of 1606 in Rome.

Of the five related drawings, only the KOREAN MAN at the Getty Museum can be associated directly with a painting; he appears in the center foreground of Rubens's altarpiece of the MIRACLES OF ST. FRANCIS XAVIER in the Kunsthistorisches Museum, Vienna (KdK 205; Jaffé 1989, no. 481). Rubens received the commission for this altar prior to 13 April 1617 and the painting was finished in about 1618. As Goldner reasoned, the drawing was made independently rather than as a direct preliminary study, and later adapted to serve for one of the bystanders witnessing the miraculous healings of St. Francis Xavier. This must hold true for the entire group since no other figure studied in these drawings recurs in a painting by Rubens. (The drawing of a JESUIT MISSIONARY recently on the art market, according to Held, does not represent the presumed Trigault, but a different, somewhat older person; see Held 1993.)

50

STUDY FOR THE "DESCENT FROM THE CROSS" *recto*, ca. 1617–18
STUDY FOR ST. ANDREW *verso*
Pen and brown ink, brown wash, occasional point of brush, on light-brown paper (recto and verso), 345 x 233 mm (13 9/16 x 9 1/16 in.)
Numbered in pen and brown ink at top right, *3*; in pencil at bottom left, *6*; in pencil on verso at bottom left, *J/2*.
Collection of Mr. & Mrs. Eugene Victor Thaw
Provenance: Mrs. G. W. Wrangham; Edward Wrangham; Baskett & Day, London
Exhibition history: New York 1975, no. 11, ill.; Antwerp 1977, no. 146, ill.; New York 1979–80, no. 14, ill.; New York 1981, no. 60, ill.

References: Parker 1928, pp. 1–2, pl. 1; Held 1959, no. 42, pl. 39; Held 1974, pp. 252–53, pl. 28; Held 1986, no. 121, pl. 121.

Exhibited in Wellesley only

The drawing is difficult to read not only because the heavy ink wash Rubens used in the figure of St. Andrew on the verso is bleeding through to the recto, but also because Rubens drew two adjoining compositional studies of the DESCENT FROM THE CROSS that partly overlap. He began with the sheet turned upside down—the head of Christ, turned 180 degrees, can still be deciphered at the lower left. Dissatisfied, he rotated the sheet and started anew at the upper left. The body of the dead Christ is shown being lowered into the outstretched arms of the standing Virgin, and supported by the Magdalene kneeling at His feet. Rubens drew a smaller rendition of the DESCENT FROM THE CROSS at the lower right, which includes three men on ladders: on the ladder at the left is a figure barely indicated, possibly Nicodemus, supporting Christ's right arm on one shoulder, with the shroud draped over the other; on the ladder at the right a youth, possibly St. John, leans over the horizontal beam of the cross; below him, a male figure with a turban, perhaps Joseph of Arimathea, holds Christ below His shoulders, lowering the dead body into the arms of the Virgin. Shortly thereafter, Rubens developed this latter configuration further, giving it final form in the drawing in the Museum of Fine Arts, Boston (see the following entry, catalogue number 51). The careful parallel hatching, to indicate the chin and neck of the Magdalene at the upper left, relates closely to the equally controlled pen strokes in the deposition in Boston that followed. It is rare to see Rubens struggle so intensely in order to arrive at a solution he deemed satisfactory, especially in a well-established theme like the DESCENT FROM THE CROSS. Both the drawing in the Thaw collection and the Boston sheet relate closely to Rubens's DESCENT FROM THE CROSS in the Hermitage, St. Petersburg (KdK 90; Jaffé 1989, no. 435), and consequently should be dated about 1617–18.

The pen drawing of St. Andrew on the verso is similar enough in execution to the DESCENT FROM THE CROSS on the recto to be dated to the same period. Here, in contrast, there are few *pentimenti*, most notably in the left leg of St. Andrew. This may possibly be due to the existence of two related chalk drawings in Copenhagen and Munich (Held 1986, nos. 94–95, pls. 93, 95), which Rubens adapted here with minor modifications. Rubens used this preliminary study for the saint's figure on the outer right wing of the triptych, commissioned by the Fishmongers guild, the MIRACULOUS DRAUGHT OF FISHES of about 1618–19 for the church of Nôtre-Dame-au-delà-de-la-Dyle in Malines (KdK 174, right; Jaffé 1989, no. 505E, reproduced in reverse). The most obvious difference is that in the painting St. Andrew holds a large fish with his left hand.

195

51

STUDY FOR THE "DESCENT FROM THE CROSS," ca. 1617–18

Pen and brown ink, 357 x 216 mm (14¹/₁₆ x 8½ in.)

Annotated in pen and brown ink at bottom left, *P.P. Rubbens Ft.*

Museum of Fine Arts, Boston, Massachusetts: Frances Draper Colburn Fund

Inv. no. 20.809

Provenance: Thomas Hudson, London (1701–79; L. 2432); Sir Thomas Lawrence, London (1769–1830; L. 2445); Henry Adams; Mrs. Henry P. Quincy

Exhibition history: Cambridge, Massachusetts 1974, no. 17.

References: Held 1974, pp. 252–53, pl. 29; Held 1986, no. 122, pl. 122.

Classified for many years as a copy after Rubens, this drawing was reintegrated into Rubens's œuvre by Julius Held who linked it convincingly with the DESCENT FROM THE CROSS now in the collection of Mr. & Mrs. Eugene Victor Thaw, New York (catalogue number 50), stating that Rubens must have drawn it almost immediately afterwards. In the Boston study, Rubens redrew the figural group—found at the lower right in the slightly earlier version in the Thaw collection—more clearly and in greater detail. One noticeable *pentimento* remains in the center, revealing Rubens's dissatisfaction with the position of the right hand of the old man on the ladder. The Virgin standing at Christ's side remained more or less unchanged in Rubens's three drawn versions.

The DESCENT FROM THE CROSS in Boston formed the basis for Rubens's painting of the same subject in the Hermitage, St. Petersburg (KdK 90; Jaffé 1989, no. 435). In the painting, Rubens integrated the five figures still further, reversing the places of the Virgin and Mary Magdalene and rendering Christ's head and body more upright. The Magdalene, finally, rises up toward Christ, touching His hand rather than embracing His legs.

52

A FRANCISCAN FRIAR, ca. 1619

Black chalk on gray paper, canted corners at top, 413 x 248 mm (16¼ x 9¾ in.)

Peck Collection, Boston, Massachusetts

Provenance: Mary van Berg, New York; sale, London, Christie's, 4 July 1978, lot 94, pl. 33

Exhibition history: Cambridge, Massachusetts/New York 1956, no. 17, pl. IX; Antwerp 1956, no. 74, pl. XXXI.

References: Held 1956, p. 123; Rosenberg 1956, p. 142; exh. cat. Antwerp 1956, under nos. 72, 73; Held 1959, under no. 44; Burchard and D'Hulst 1963, under no. 122; exh. cat. Antwerp 1971, under no. 61; exh. cat. Paris 1972, under no. 80.

This detail study of a Franciscan monk is among several preliminary drawings that have been associated with Rubens's altar of the LAST COMMUNION OF ST. FRANCIS, commissioned by Jaspar Charles for the Franciscan church in Antwerp and paid for in 1619. (Today the painting is in the Royal Museum of Fine Arts, Antwerp; KdK 190; Jaffé 1989, no. 501.) Two individual studies by Rubens are known for this same altar: one of two Franciscan monks, at Chatsworth (Held 1986, no. 136, pl. 130); the other, a life study of a kneeling male nude for St. Francis, in the Institut Néerlandais, Fondation Custodia, Collection Frits Lugt, Paris (Held 1959, no. 92 and exh. cat. Paris 1972, no. 80, pl. 43). Although the figure of this Franciscan does not correspond exactly with any of the monks in the painting, it most likely dates from about 1619 as well.

There are illegible traces of another drawing in black chalk on the verso.

53

ST. GREGORY NAZIANZUS SUBDUING HERESY, 1620
Black chalk, heightened with white chalk, on buff antique laid paper,
412 x 475 mm (16³⁄₁₆ x 18¾ in.)
Fogg Art Museum, Harvard University Art Museums, Cambridge, Massachusetts:
Bequest of Clarence L. Hay
Inv. no. 1969.168
Provenance: Sir Thomas Lawrence, London (1769–1830); Samuel Woodburn, London (1786–1835; sale, London, 7 June 1860, lot 804, as "St. Dunstan Repulsing Satan"); Robert P. Roupell, London (1798–1886; sale, London, Christie's, 12–14 July 1887, lot 1119); John Hay, New York (1838–1905); Clarence L. Hay (1969)
Exhibition history: Cambridge, Massachusetts/New York 1956, no. 20; New York 1959, no. 43, pl. XXX; Princeton 1972, no. 16, ill.; Cambridge, Massachusetts 1974, no. 20; Providence 1975, no. 18; London 1977, no. 148, ill.
References: Held 1959, no. 47, pl. 49; Martin 1968, no. 25a, fig. 133; Held 1980, under no. 36 and pp. 33–35; Held 1986, no. 147, pl. 146.

The subject of this drawing, one of the four Greek Fathers, is St. Gregory of Nazianzus (329–389), who is shown attacking an evil demon by jabbing him in the mouth with his crozier and trying to push him off a cloud, thus symbolically defending the doctrine of the church from heresy. An angel assists the saint in overcoming the monster. (In the subsequent oil sketch and painting, flames of heresy issue from the demon's mouth.)

In this spirited drawing, Rubens established with great verve the composition of one of the thirty-nine paintings that decorated the ceiling of the Antwerp Jesuit church. As Held remarked, it combines the imaginativeness of a first study with the precision and clarity of studies from life

(Held 1986, p. 56). The group of the angel manhandling the demon recalls similar figures in Rubens's FALL OF THE DAMNED in Munich (KdK 194; Jaffé 1989, no. 528).

Of the twelve similar studies in black chalk heightened with white, listed in 1797 in the collection of P. Wauters in Brussels, only one other example survives, the ST. ATHANASIUS in the Hermitage, St. Petersburg (Martin 1968, no. 19a). Rubens established the main elements of the composition rather carefully, which indicates that he submitted the drawing to the Jesuit authorities during the negotiations for the contract signed on 29 March 1620. Held (1980, p. 34) first considered such a function likely, especially since no *bozzetto* or grisaille sketch by Rubens of this scene is known.

In the subsequent color oil sketch, today in the Albright-Knox Art Gallery, Buffalo, Rubens concentrated on the figure of St. Gregory and simplified the composition by eliminating the angel descending at the left and repositioning the demon. In the Buffalo sketch, Rubens raised the monster—seen in the drawing below at the left—to the forefront, with St. Gregory stabbing him in the face with his crozier. The architectural setting, which Rubens loosely indicated at the right in the drawing, was replaced by clouds and celestial surroundings.

54

THE BIRTH OF THE VIRGIN, 1620

Pen and brown ink, brown wash, 310 x 207 mm (12 3/16 x 8 1/4 in.)

Inscribed by Rubens in pen and brown ink at top: *La Nativita di Nostra donna.*

Hart Collection

Provenance: sale, Monte Carlo, Sotheby's, 13 June 1982, lot 114, ill.

References: Held 1986, under no. 23, fig. 10; Logan 1987, pp. 15–16; Renger, in exh. cat. Munich 1990, pp. 62–63, fig. 35 in color; McGrath 1991 (A), p. 717, fig. 61.

This drawing, which has come to light only recently, was mentioned by Held in 1986 in the context of Rubens's early study for the BIRTH OF THE VIRGIN of about 1604–07 in the Petit Palais, Paris. Held's tentative attribution to Rubens was further supported by Konrad Renger, who correctly associated the drawing for the first time with the decoration of the church of Our Lady at Neuburg on the Danube, north of Munich near Ingolstadt. This hitherto unknown project of 1620 that involved Rubens was initiated by Duke Wolfgang Wilhelm von Pfalz-Neuburg. In correspondence between Wolfgang Wilhelm and his agent Reyngodt in Brussels, repeated mention is made of a *nativitet* of the Virgin.

A series of documents published for the first time by Renger in 1990 reveal the origin of the drawing. On 8 September 1620, Duke Wolfgang Wilhelm instructed Reyngodt to inquire whether Rubens would furnish a design for a Birth of the Virgin. In his reply of the 25th, Rubens promises to do so within the next five or six days. (*Quant au dessein en papier de la nativité de nostre Dame ce n'est*

pas possible de le faire aujourdhuy mais sans doubte je le vous dévoydray enterme de cinq ou six jours affin quil puisse allier avecq l'aultre ordonné apres cestuy.) On 8 October, Reyngodt informed the duke that he had mailed Rubens's drawing, the BIRTH OF THE VIRGIN. The duke acknowledged receipt on 20 October, adding that he liked it (*wollgefellig*). From this it may be deduced that Rubens made the drawing around the first of October 1620. Moreover, Elizabeth McGrath succeeded in establishing the real purpose of Rubens's drawing: it served as a design for a stucco relief by Pietro Castelli that is found near the entrance to the left side of the nave (figure XV), confirming Renger's earlier tentative association with the decorations of the church of Our Lady in Neuburg. The Castelli, a family of *stuccatori*, were recorded as working in the church between 1616 and 1620 (see Seitz and Lidel 1983, pp. 48–49, 68, pls. 12–13). A related scene of the ASSUMPTION, signed by Pietro Castelli, is in the corresponding position on the right or south nave.

The fact that Rubens made the drawing for someone else's use explains some of its unusual features. For example, the detailed compositional study is covered extensively with brown wash to indicate highlights and shadows, thus taking into account the three-dimensional relief that Castelli was to carve from this design. Held saw that the drawing had a specific function when he wrote in 1986 that the piece recalled Rubens's designs for engravings. Another unusual aspect is that the inscription, *La Nativita di Nostra donna*, is written in Italian, the language Rubens preferred in his letters; for explanatory texts in his drawings he chose Latin almost exclusively (an exception are his comments in Flemish on the FEAST OF HEROD drawing in Cleveland; see catalogue number 58). Rubens's use of Italian is now easily explained, since the drawing was made to assist an Italian-speaking *stuccatore*. Finally, the fact that the sheet was folded horizontally three times leaves little doubt that McGrath's supposition was correct and that we have here the *"dessein en papier de la nativité de nostre Dame"* that Rubens had mailed as a letter to Reyngodt.

55

Peter Paul Rubens, after Titian
STUDIES OF WOMEN, 1628–29
Black, red and white chalk, lower right corner replaced, 449 x 289 mm (17 11/16 x 11⅜ in.)
Collection of The J. Paul Getty Museum, Malibu, California
Inv. no. 82.GB.140
Provenance: Prosper Henry Lankrink, London (1628–92; L. 2090); Dr. Nicolas Beets, Amsterdam; A. S. Drey, Munich; Dr. Gollnow, Stettin; Dr. Anton Schrafl, Zurich (sale, London, Christie's, 9 December 1982, lot 78)
Exhibition history: New York 1988, no. 22, ill. in color.
References: Held 1986, no. 175, color plate 5; Goldner 1988, no. 94, ill.; Pilo 1990, pl. XXIX (as 1628).

Exhibited in Wellesley only

"Here I keep to painting, as I do everywhere," wrote Rubens in December of 1628 from Madrid (Magurn 1991, letter 180), where he stayed in connection with peace negotiations between Spain and England, until the end of April 1629. According to Francisco Pacheco, father-in-law of Velázquez, Rubens copied "all" the pictures by Titian in the Spanish royal collection (1649, p. 153); Rubens's inventory of 1640 listed no fewer than thirty-two paintings after the artist. This is the only known drawing by Rubens with copies after Titian that dates from this sojourn in Madrid.

On this surprisingly large sheet—especially in comparison with his early copies in pen—Rubens drew six heads and the partial figure of a nymph after three of Titian's *poesie*, or mythological paintings, that Philip II had commissioned in the 1550s (Wethey 1975, nos. 9, 10, 40). Rubens most likely began at the top with the bending nymph, which he copied from Titian's DIANA SURPRISED BY ACTAEON of 1559, to the extent she was visible in the painting (collection of the Duke of Sutherland, on loan to the National Gallery of Scotland, Edinburgh). This sketch was possibly followed below by the head and raised arm of Diana, slightly modified to allow a full view of the goddess's face. Next he drew at the bottom center the head of Venus, which is taken from VENUS AND ADONIS, Titian's painting of 1554 still in the Prado, Madrid. The remaining three heads, the two at the lower right predominantly in red and the one at the upper left in black chalk, must have been added last, since they are placed along the edges. Rubens selected them from Diana's attendants in Titian's DISCOVERY OF THE SHAME OF CALLISTO of 1559, also in the collection of the Duke of Sutherland and on loan to the National Gallery of Scotland.

According to testimony given by Cassiano del Pozzo, who served as secretary to Cardinal Francesco Barberini on a visit to Spain in 1626, Titian's paintings were hung at that time in pairs. DIANA SURPRISED BY ACTAEON and DIANA AND CALLISTO were in the first chamber of Philip IV's apartment, with VENUS AND ADONIS and its pendant PERSEUS AND ANDROMEDA hung opposite each other in an adjoining room (Volk 1981, pp. 519–20). The 1636 inventory, on the other hand, mentions all of Titian's *poesie* together in Philip IV's private "withdrawing room" (Wethey 1975, p. 82). This rehanging of the paintings must already have taken place by the time Rubens copied these six heads, since it is difficult to imagine—as Held rightly stated—that Rubens would have walked back and forth to fill the sheet with his drawings.

56

THOMAS HOWARD, 2ND EARL OF ARUNDEL (1585–1646), 1629–30

Brush and brown and black ink, brown and gray wash, heightened with white with touches of red, 460 x 355 mm (18¼ x 14 in.)

Annotated on the reverse by Lord Selsey in pen and brown ink, *Rubens, b: at Antwerp A.D.: 1577. D: 1640 / bought at Hudsons Sale A:D: 1779. / N: 45*; followed by an annotation in pen and gray ink by

Robert P. Roupell, *The above is in the handwriting of Lord Selsey at whose / sale in 1872 at Sothebys this drawing was bought. / The Portrait is that of the Earl of Arundel. / RPR.*

Sterling and Francine Clark Art Institute, Williamstown, Massachusetts

Inv. no. 992

Provenance: Unidentified seventeenth-century collector G. H.; Jonathan Richardson, Sr., London (1665–1745; L. 2184); Thomas Hudson, London (1701–79; L. 2432; sale, London, Langford, 15–16 March 1779, lot 69); Lord Selsey (sale, London, Sotheby's, 20–28 June 1872, probably lot 2637); Robert P. Roupell, London (1798–1886; L. 2234; sale, London, Christie's, 12–14 July 1887, lot 1120); private collection, London

Exhibition history: Williamstown 1960, no. 427; London 1972, no. 44; Providence 1975, no. 10, ill.; Antwerp 1977, no. 161, ill.; London/New Haven, 1987, no. 28, pl. 28.

References: Burchard and D'Hulst 1963, no. 170, pl. 170; Haverkamp-Begemann et al. 1964, I, no. 22; Huemer 1977, no. 5a, fig. 51; Held 1986, no. 180, color plate 4; White 1987, fig. 249; Fehl 1987, pp. 7–23, fig. 9; Liedtke, in Balis et al. 1992, p. 205.

Thomas Howard, 2nd Earl of Arundel, whom Rubens called "one of the Four Evangelists and the Supporter of our Art" (Hervey 1921, p. 174), asked Rubens to paint his portrait probably during the latter's stay in England on a diplomatic mission from early June 1629 until late March 1630. Rubens, who admired the Earl's collection of antique sculpture, visited Arundel House in August 1629 and may have made a drawing from life, now lost, which would have served for the rendering of the Earl's expressive face. (The drawing formerly in the collection of Duchastel-Dancelot in Brussels, now in a private collection in France, may be such an early study; see Huemer 1977, no. 4a, fig. 49.)

According to Howarth (1985, pp. 152–53), Arundel most likely conveyed to Rubens that he wished to be portrayed as a martial hero or *magnifico* who, besides being well-read and versed in the arts, was also skilled in tournaments and chivalrous. Rubens obliged the Earl with the portrait now in the Isabella Stewart Gardner Museum, Boston (KdK 288; Jaffé 1989, no. 975), which he prepared in this forceful portrait study in Williamstown. Drawn exclusively with the brush and thick bodycolor, possibly some oil color, it seems to have served the function of the more traditional oil sketch that Rubens usually used to prepare his paintings. In this sketch on paper, Rubens primarily established the pose of his subject. The drawing, as well as the corresponding painting in Boston, shows the Earl in three-quarters' length dressed in full armor in front of a heavy curtain, holding the gold baton of the Earl Marshal, an office traditionally vested in his family and restored to him in 1621. A closed, plumed helmet is indicated on the table next to him. In this sketch, Rubens captures the confident attitude of Arundel, who was premier earl of the realm. Only in the painting did Rubens add the blue sash of the Knight of the Garter and the "Lesser George" on the gold chain.

The cleaning of the painting in 1975 revealed that Rubens left the portrait unfinished when he departed from England in the spring of 1630. At that time he had completed only the figure of Arundel, while the rest of the portrait—which he had sketched out in accordance with the composition found in this drawing in Williamstown—was finished much later. The "ghost" of the Arundel HEAD OF HOMER that Philip Fehl recently "discovered" in the painting in the opened helmet on the table (1987, fig. 6) is in no way indicated in this preliminary drawing; this antique bust would have been completely out of context with the portrait type of a man in armor.

Most writers have suggested that Rubens emulated a portrait by Titian for this painting. Howarth and Jaffé (1989, no. 975) felt that Rubens was inspired by Titian's series of the twelve Caesars in the collection of Charles I. Held cited Titian's portrait of FRANCESCO DELLA ROVERE, Duke of Urbino, as a possible source (1982, pp. 329–30) while Fehl as well as Liedtke suggest that the Arundel portrait recalled Titian's portrait of Charles V with drawn sword, now lost, but known in a copy by Rubens in the collection of Lord Mountgarret (Muller 1989, no. 52, pl. 15) and in an engraving by Lucas Vorsterman (Wethey 1971, no. L-3, pls. 48–49).

57

ARCHDUKE ALBERT WITH HIS PATRON SAINT, ALBERT OF LOUVAIN, ca. 1630–31

Pen and brown ink, brown wash, over black chalk, 203 x 97 mm (8 x 3 13/16 in.)

Philadelphia Museum of Art, Philadelphia, Pennsylvania: The Charles M. Lea Collection

Inv. no. '28-042-4013

Provenance: John Barnard, London (d. 1784; L. 1419); Charles M. Lea (1853–1927; L. Suppl. 1662a)

References: Held 1974, pp. 254–56, pl. 30; Held 1980, under no. 412; Held 1986, no. 190, pl. 182.

The drawing in Philadelphia and its companion in the Fodor collection, Amsterdam (Schapelhouman 1979, no. 68, ill.), representing Archduchess Isabella Clara Eugenia with her patron saint, Elizabeth of Hungary, are preliminary studies for the inner wings of the triptych dedicated to St. Ildefonso (606–667), archbishop of Toledo. As Baudouin pointed out (Balis et al. 1987, p. 162), the format of the triptych that Rubens chose was outdated by the early 1630s (he had last used it in 1618; by the 1630s an altar consisting of a single, usually upright panel or canvas was much preferred). What we witness in the two drawings in Philadelphia and Amsterdam is Rubens's struggle with a *retardataire* idea, possibly imposed on him by rules established during the third synod in Malines in 1607, which forbade representing living persons on a center panel of an altarpiece. Since this was a commission from the Infanta, Rubens probably had to abide by the ruling and transfer the Archduke Albert and Archduchess Isabella from the center panel onto the wings, as he did in the two drawings separated by a large column. In the oil sketch, by contrast, the Archduke Albert and Archduchess Isabella shared the same space as St. Ildefonso and the Virgin, witnessing the miracle happening before them.

In this posthumous portrait of Archduke Albert (d. 1621), the sovereign is shown kneeling at a prie-dieu with a prayer book in his right hand, while his left touches the order of the Golden Fleece. In the underlying quick draft in black chalk—which Rubens then worked out in a more finished drawing in pen and ink and wash over it—the archduke was holding the book with both hands, as he does in the oil sketch in the Hermitage, St. Petersburg (Held 1980, no. 412), and in the final wing of the Ildefonso altar, today in the Kunsthistorisches Museum, Vienna (KdK 325; Jaffé 1989, no. 998A-D). Standing behind him is his patron saint, St. Albert of Louvain, Bishop of Liège (1166–1192), who presents the archduke to the Virgin, depicted on the center panel of the altar, where she hands St. Ildefonso a chasuble in recognition of his defence of the Immaculate Conception in his treatise *De virginitate S. Mariae.*

Rubens painted the altar originally for the chapel of the Brotherhood of St. Ildefonso in the church of St. James on the Coudenberg in Brussels. He began work on the triptych in April 1630, immediately upon his return from the diplomatic mission in England. The Ildefonso altar was in place by January 1632 and represents Rubens's final tribute to the archducal couple who had been his patrons for some twenty years; it was also his last work for the Archduchess Isabella, who died the following year.

58

THE FEAST OF HEROD *recto*, ca. 1637–38

TOMYRIS AND CYRUS *verso*

Pen and brown ink over preliminary drawing in black chalk, on coarse paper; the two figures at top left in red chalk (recto); pen and brown ink, traces of black and red chalk (verso), 272 x 467 mm (10⁹⁄₁₆ x 18⅜ in.)

Inscribed in pen and brown ink at top center, *De Herodias wat hooger* and *den stoel te cort* (?); on verso, *plus spatij.*

The Cleveland Museum of Art, Cleveland, Ohio: Delia E. and L. E. Holden Funds

Inv. no. 54.2

Provenance: Unidentified collector (L. 622; probably Austrian collection, ca. 1800); English private collection

Exhibition history: Cambridge, Massachusetts/New York 1956, no. 26, pl. XVI; Antwerp 1956, no. 131, pl. LIX; Cleveland 1980, p. 29.

References: Held 1959, no. 67, pl. 77 (recto); Burchard and D'Hulst 1963, no. 196, ill.; Held 1986, no. 230, pl. 205.

In this late compositional drawing executed with a broad quill pen on the coarse paper he preferred in the 1630s, Rubens developed his first ideas for the FEAST OF HEROD, now at the National Gallery of Scotland, Edinburgh (not in KdK; Jaffé 1989, no. 1187). The painting includes twice as many

figures as this drawing in Cleveland, a discrepancy that can be explained in part by the fact that the canvas was probably unfinished at the time Rubens died in 1640 and completed shortly thereafter. At that time a strip was added at the left with the seam running through the face of the black servant. The painting in Edinburgh therefore originally ended at the point corresponding with the left edge of the composition in the Cleveland drawing, which was emphatically indicated by Rubens by means of two vertical lines. (See Edinburgh 1970, pp. 84–85.) A weak copy of this FEAST OF HEROD drawing in Cleveland is in the Rijksprentenkabinet in Amsterdam (Inv. no. 40:633; pen and brown ink over black chalk, 209 x 326 mm).

On both recto and verso of this large sheet, Rubens worked out scenes that centered around the severed head of a saint or king who was mocked after a violent death caused by a powerful, vengeful woman. In the FEAST OF HEROD on the recto, the head of St. John the Baptist resting on a platter in the center serves as the focal point of the composition. Salome, standing in front of the table and misidentified in Rubens's inscription as "Herodias," lifts the lid from the platter to present the head of the Baptist to King Herod, who recoils in horror. Herodias, seated to his right, points gleefully with a fork at the tongue of St. John. As Burchard first established (1953, p. 384, n. 2), Rubens's rather unusual rendering of the subject was based on a passage from St. Jerome's *Apologia adversus libros Rufini*, Book 3, where a comparison was made between Herodias's treatment of the Baptist's severed head and Fulvia piercing the tongue of Cicero's head with a pin she removed from her hair (see Dio Cassius, *Roman History*, Book 46, chapter 8). Two further studies of the head of Salome alone are found at top left, while additional black chalk studies of Herodias and Herod are at top center. A canopy is summarily indicated above the figure of Herod. The faces in pen at the upper right are bleeding through from Rubens's drawing on the verso. Rubens's instructions to himself in Flemish translate as "Herodias somewhat higher," stressed by an arrow; actually it should have read "Salome," who in the painting indeed is much taller and towers over the seated Herodias. The inscription at bottom right is difficult to decipher and might possibly translate as "the chair somewhat shorter."

The sketch on the verso is drawn with a finer pen. Rubens represented Tomyris, Queen of the Messagetae, seated under a canopy, watching the immersion in a vessel filled with human blood of the severed head of Cyrus, King of the Persians, who was killed to avenge the death of her son. Some of the figures from the FEAST OF HEROD on the recto show through on the verso.

Rubens's study incorporates elements from his two earlier renderings of the subject in Paris and Boston. The composition in the Louvre of about 1620–23 (KdK 237; Jaffé 1989, no. 666) has a vertical format with the Queen seated toward the right. The horizontal format in this late drawing and the inclusion of a figure like the man in oriental dress, seen from the front, are closer to Rubens's large painting in Boston, the HEAD OF CYRUS BROUGHT TO QUEEN TOMYRIS of about 1616–18

(KdK 175; Jaffé 1989, no. 510). This oriental man, found in still other paintings by Rubens, echoes a figure from Pintoricchio in his DISPUTATION OF ST. CATHERINE in the Vatican, as Held observed (1956, p. 124, fig. 30).

Although Rubens indicated in the center of the drawing that "more space" (*plus spatij*) should be added between the standing figures at the left and the Queen seated at the right, no painting corresponding to this compositional study is known. Since the handling of the pen is very similar to the FEAST OF HEROD on the recto, we may assume that the TOMYRIS AND CYRUS on the verso also dates from the late 1630s or 1637–38.

59

TWO ARMED SOLDIERS FIGHTING, ca. 1638

Pen and brown ink over black chalk (recto), 233 x 203 mm (9 3/$_{16}$ x 8 in.)

Yale University Art Gallery, New Haven, Connecticut: University Purchase,

Everett V. Meeks, B.A. 1901 Fund

Inv. no. 1968.78

References: Logan 1972, pp. 16–18, figs. 1–2; Held 1980, p. 388, under no. 288;

Held 1986, no. 231, pl. 209.

Rubens must have intended to use the study for a scene in a painting of an historical subject since the two soldiers are wearing sixteenth-century armor. With their swords drawn they are locked in hand-to-hand combat. As the various *pentimenti* indicate, Rubens was trying to establish the most satisfactory position for the right arm of the soldier at the left who thrusts the sword toward his assailant.

The broad, angular pen lines and the coarse paper characterize the drawing as a late, rather simplified study that cannot be associated with a known composition. Held plausibly suggests that Rubens may have made it in connection with the large sketch of the CONQUEST OF TUNIS BY CHARLES V in the Staatliche Museen, Berlin, which he dates to about the same years, around 1638–39. Closest in both execution and subject matter is another late drawing, the LANSQUENETS CAROUSING in the Institut Néerlandais, Fondation Custodia, Collection Frits Lugt, Paris, where he demonstrates a related interest in early sixteenth-century soldiers (exh. cat. Paris 1972, no. 85, pl. 44).

Rubens's quick sketch in black chalk of a small dog on the verso is one of his relatively few animal studies. It may date from the early 1630s since such a dog appears in Rubens's oil sketch of ACHILLES RECOGNIZED AMONG THE DAUGHTERS OF LYCOMEDES in Rotterdam (Haverkamp-Begemann 1975, no. 3a; Held 1980, no. 122). Later in the decade it recurs in the foreground of Rubens's SUSANNAH AND THE ELDERS in Munich (KdK 411; Jaffé 1989, no. 1348).

Anthoni Sallarts

Brussels before 1590–1650 Brussels

Anthoni Sallarts, as he signed his name in a document of 1628, was married to Anna Verbruggen and a daughter of his was baptized in 1606. In the same year, when he became an apprentice to Michel de Bordeaux, he referred to himself as burgher; hence he did not come from a family of painters. In 1613 he became a master in the guild of St. Luke in Brussels; in 1633 and again in 1648, he served as dean. Sallarts registered several pupils, among them his brother Melchior (in 1621) and his son Jean (in 1629). Sallarts's daughter Catherine, who was also a painter, furnished the descriptive texts to accompany her father's paintings for the church of Alsemberg, and completed the cycle after his death.

Sallarts played a significant role in reviving tapestry manufacture in Brussels: in 1646 he stated that twenty-four sets of tapestries had been woven from his designs, which means that he furnished 120 to 150 preliminary cartoons.

60

MERCURY GUIDING JUNO AND MINERVA TO MEET PARIS
Brush and brown ink, brown wash, heightened with white and grayish-white bodycolor,
on brown prepared paper, 196/98 x 259 mm (7¾ x 10¼ in.)
Inscribed in pen and brown ink at top left, 5; annotated on the verso, *Hier treckken de godinnen vergeselschapt met / Mercurius met den ghulden appel naer / Pharis den veltschen rechter om van hem / tvonnis te verwachten. / het 5 Stuck.*
Private Collection, Minneapolis, Minnesota
Provenance: sale, Amsterdam, Sotheby/Mak van Waay, 29 October 1979, lot 263, as by a follower of Rubens
Reference: Van Tatenhove 1983, pp. 243–50, fig. 4.

The reattribution of the drawing from an anonymous follower of the Rubens school to Anthoni Sallarts is due to George Keyes.

The explanatory text on the verso, not by Sallarts, describes the scene depicted on the front as follows: "Here go the goddesses in the company of Mercury with the Golden Apple to Paris the shepherd and judge, to await the outcome of the judgment." A companion piece, the JUDGMENT OF PARIS, with a number 6 at top right, is now in the Print Room in Leiden (Inv. no. PK 7903; sold at the same sale in Amsterdam in 1979, lot 264; reproduced in Van Tatenhove 1983, fig. 5). The text on the verso of this second sheet, added by the same hand, translates as "Here Paris is passing the golden apple on to Venus who is being tickled most sweetly by Cupid" (*Hier schickt Pharis den ghulden appel aen / Venus toe als whesende van Cupido / op syn aldersoetste geketelt. / is het 6 Stuck*). As the numbering suggests, the two drawings originally were part of a series of at least six

compositions. Since the protagonists are acting with their left hands, the representations were meant to be reversed. The dark wide bands along the edges of the sheet at either side may simulate the wide borders found on tapestries. Thus the two drawings probably are small cartoons or *petits patrons*, designs that were eventually enlarged into full-size cartoons to guide the weavers.

No series of tapestries with the judgment of Paris is known after Sallarts. Since neither of the drawings is squared for transfer, as is the case with other *petits patrons* by Sallarts, the project may not have been pursued further. Jacques Foucart, who was of the opinion that Sallarts was one of the most brilliant masters of the oil sketch in Rubens's time, coined the more appropriate term "brunailles" for these monochromes, an adaptation of the better known term "grisaille," since the artist used shades of brown almost exclusively for many of these *petits patrons* (Foucart 1980, pp. 8–16).

Cornelis Schut

Antwerp 1597–1655 Antwerp

At the age of twenty-one, in 1618, Cornelis Schut became a master in the Antwerp painters' guild. After that his name is absent from the archives until September 1631, when he married Catharina Geensins. From 1624 until 1627 Schut lived in Rome where he was one of the founders of the *Schildersbent*, a loose association of Netherlandish artists residing in Rome with the nickname *brootsaken* (bread bag). In 1635 Schut took part in the decorations of the Triumphal Entry of Cardinal-Infante Ferdinand in Ghent, as well as later in Antwerp. He registered at least six pupils between 1633 and 1642. Schut also collaborated with the flower painter Daniel Seghers (Antwerp 1590–1661).

61

MASSACRE OF THE INNOCENTS, ca. 1624

Pen and brush and brown ink, brown wash over preliminary drawing in black chalk,

224 x 187 mm (8 13⁄₁₆ x 7⅜ in.)

Annotated in pen and brown ink at bottom left, *C. Schut.*

Yale University Art Gallery, New Haven, Connecticut: Library Transfer

Inv. no. 1961.65.62

Provenance: John Percival, 1st Earl of Egmont (1683–1748)

References: Haverkamp-Begemann and Logan 1970, no. 616, pl. 298; Vlieghe 1990, p. 33, n. 22; Wilmers 1991, no. E19.

The attribution of this drawing to Cornelis Schut in the Yale catalogue in 1970, prompted primarily by the eighteenth-century annotation *C. Schut*, enabled Pierre Rosenberg to restore to the artist an oil sketch in Princeton (figure XVI), which had been attributed to Nicolas Poussin (Inv. no. y863; oil on canvas, 50 x 33.8 cm), and the final painting, now in the church of the Holy Trinity in Caen (exh. cat. Paris 1977, no. 161). Keith Andrews identified one other preliminary study by Schut

for this same MASSACRE OF THE INNOCENTS, in the National Gallery of Scotland, Edinburgh (figure XVII; Inv. no. D3118; pen and brown ink, brown wash over black chalk, 217 x 182 mm; Andrews 1985, p. 79, fig. 519). In this slightly smaller compositional drawing in Edinburgh, which must have preceded the one at Yale, Schut drew more sketchily and added large areas of wash to model the figures in the foreground.

Once Schut established the general composition, he clarified it more fully in the second study at Yale. While the basic layout remained the same, the architecture in the background is now clearly defined, as are the raised arms of two soldiers to the right of center, one brandishing a sword, the other a knife. Wilmers (1991) interpreted this second version of Schut's drawing as a possible further study for the painting in Caen or, perhaps, a design for a lost etching.

In the subsequent oil sketch in Princeton, whose composition is nearly identical to the painting, the action is concentrated on the group in the center, which is preserved more or less intact, except for the soldier, who lifts the mother's hair to reveal her infant son. Her arm is now lowered and cradles the child instead. The second woman and child, included in the two drawings at the lower left, were omitted as were the two weapon-wielding soldiers right of the center. The architecture remains unchanged but was reversed. The fact that in the painting the soldier is about to kill the infant with a long dagger rather than a stiletto knife, as in the sketch, and that the terrace in the background is void of spectators—among other differences—suggests that the sketch preceded the painting rather than followed it. (In the opinion of Wilmers the oil sketch in Princeton is more likely a copy by an Italian artist; 1991, p. 174.)

Schut's extensive preparation for his MASSACRE OF THE INNOCENTS indicates the importance of the painting to him. The inventory, dated 3 February 1638, reveals that both the MASSACRE OF THE INNOCENTS and THE ADORATION OF THE MAGI—another painting by Schut, believed to be its pendant—were in the collection of the Marchese Vincenzo Giustiniani in Rome, where two paintings by "Cornelio Fiammingo" were described as hanging in the *sala grande dell' appartamento nobile* of the palace. Hans Vlieghe deserves credit for establishing that this "Cornelio Fiammingo," active in Rome between 1624 and 1627, was in fact Cornelis Schut (Vlieghe 1977, pp. 207–18). Together with the Dutch painter Timan Craft (or Tilman Kraft; d. The Hague 1646), Schut painted during 1627 several frescoes in Frascati at the Casino of Pietro Pescatore (Pieter de Visscher or Visschers, 1574–1646), a wealthy merchant of Netherlandish origin, well-known for supporting his fellow countrymen. Craft also worked for Giustiniani, which may explain why the Marchese knew of Schut and owned two of the latter's paintings. Independently, Noëlle de La Blanchardière and Didier Bodart (1974, pp. 179–90) also realized that the "Cornelio Fiammingo" in the Giustiniani inventory was Cornelis Schut, thus correcting Luigi Salerno (1960, pp. 102–03) who had wrongly identified him as the Dutch engraver Cornelis Bloemaert (Utrecht 1603–1684 Rome).

The oil sketch in Princeton therefore was probably the *modello* Schut submitted to Giustiniani for approval before painting the MASSACRE OF THE INNOCENTS. Schut's preliminary drawing at Yale likewise must date from the artist's sojourn in Rome. Another drawing of the MASSACRE OF THE INNOCENTS, in Munich with an old attribution to Gaspar de Crayer that Haverkamp-Begemann first attributed to Cornelis Schut in the discussion of the Yale drawing, is difficult to fit into the evolution of the painting in Caen since its composition is very different from the works just discussed (Inv. no. 7313; Wegner 1973, no. 926, pl. 123). However Vlieghe (1990, pp. 31–34) interpreted the Munich version as Schut's first concept of his MASSACRE OF THE INNOCENTS, which the artist then altered in the drawing in New Haven, here discussed. In his opinion, the MASSACRE OF THE INNOCENTS—and its supposed pendant, THE ADORATION OF THE MAGI—belong to Schut's first works painted after his arrival in Rome.

Jan Siberechts

Antwerp 1627–ca. 1703 London

Little is known about Jan Siberechts except that he was the son of a sculptor and became a member of the Antwerp guild of St. Luke in 1648–49. He may have traveled to Italy in the preceding years, which would explain his being influenced by Dutch-Italianate painters such as Nicolaes Berchem, Jan Asselyn, Karel Dujardin, and Jan Both. Sometime between 1672 and 1674, George Villiers, 2nd Duke of Buckingham, supposedly brought him and his family to England where he emerged as the leading topographical painter of the English countryside.

62

TREE STUMP

Brush, brown ink and wash, 398 x 229 mm (15 ¹¹⁄₁₆ x 9 ⅛ in.)

Private Collection, Minneapolis, Minnesota

Provenance: Sir Bruce Ingram (L. Suppl. 1405a); C. R. Rudolf, London (L. Suppl. 2811b; sale, Amsterdam, Sotheby/Mak van Waay, 6 June 1977, lot 67, ill.)

Although gnarled and blasted trees are often found in the middle distance of Jan Siberechts's paintings, none relates closely enough to be based on the present study. The traditional attribution to Siberechts is based on a comparison with a POLLARD ASH in the Institut Néerlandais (Fondation Custodia, Collection Frits Lugt, Paris; Inv. no. 4542; exh. cat. Paris 1972, no. 91), which is likewise drawn with the brush but with watercolor in addition to brown wash. Another similar drawing is the FELLED TREE in the British Museum (Inv. no. 1909-4-6-8; exh. cat. London/New Haven 1987, no. 118), attributed in the eighteenth century to Jan Siberechts. The drawings of individual trees are generally dated to the artist's later years in Antwerp.

Siberechts's drawings are in need of further study. Some of his signed landscape studies are in black chalk only while his panoramic views, which predominate during his years in England, are done in watercolor and bodycolor. The sheet of TREES AND FOLIAGE at the Smith College Museum of Art, Northampton, Massachusetts, that Frits Lugt attributed to Jan Siberechts (in an annotation on the mount at the RKD, The Hague), would reflect yet another aspect of his landscapes since it is drawn predominantly in pen and brush and gray ink, reinforced with some pen and brown ink to accentuate the foliage in the foreground, over a preliminary drawing in black chalk (figure XVIII; Inv. no. 1944:2-2; 308 x 184 mm).

Frans Snyders

Antwerp 1579–1657 Antwerp

Frans Snyders, the son of the innkeeper Jan Snyders, was apprenticed to Pieter Brueghel the Younger in 1593. In 1602 Frans Snyders became a master in the Antwerp painters' guild, and in 1608 he set off to Italy with letters of recommendation from Jan Brueghel the Elder. After visiting Rome and Milan, he was back in Antwerp by July of 1609. Snyders was sought for his large still lifes of animals and collaborated with Rubens, adding still lifes to the latter's paintings. He also contributed still lifes or animals to paintings by Jan Boeckhorst, Van Dyck, and Abraham Janssens, or had these artists paint figures into his own paintings. Rubens named Snyders one of the executors of his estate. Van Dyck painted Frans Snyders's portrait with his wife, Margaretha de Vos, whom he married in 1611 (The Frick Collection, New York). Margaretha was the sister of the portrait painter Cornelis de Vos and of Paul de Vos, a respected painter of animals and still lifes who was greatly influenced by Snyders. He registered three pupils (in 1609, 1616, and 1633).

In the late 1630s Snyders painted numerous hunting scenes for Philip IV of Spain; toward the end of the following decade, Archduke Leopold Wilhelm became another of his patrons. He also was an art dealer who left a significant collection of paintings that Mattijs Musson purchased in 1659 (for Snyders's import/export passes see Koslow 1992, p. 164).

63

A HUNTER WITH STILL LIFE OF GAME AND SHELLFISH, ca. 1627

Pen and brown ink, brown and gray wash, 241 x 402 mm (9½ x 15⅞ in.)

Private Collection

Provenance: Sir Thomas Lawrence, London (1769–1830; L. 2445); C. R. Rudolf, London (sale, Amsterdam, Sotheby/Mak van Waay, 18 April 1977, lot 121); sale, Amsterdam, Sotheby/Mak van Waay, 6 June 1977, lot 66; sale, Amsterdam, Sotheby/Mak van Waay, 15 November 1983, lot 243; Colnaghi, New York (1990)

Exhibition history: London 1962, no. 140; New York 1990, no. 25, ill. in color.

References: Keyes 1977, p. 311, fig. 121; Greindl 1983, p. 81 and p. 380, no. 284; Robels 1989, no. Z5; Balis, in exh. cat. Antwerp/Münster 1990, p. 102, fig. 68.

This large drawing corresponds closely with Snyders's signed painting in the collection of Count Schönborn in Pommersfelden (Robels 1989, no. 15, ill.). Snyders's invention was admired since it is also known in a number of studio versions. Robels included it among the ninety original drawings by Snyders that she listed in her catalogue raisonné.

The HUNTER WITH STILL LIFE OF GAME AND SHELLFISH belongs to a group of highly finished drawings that render an entire composition, including figures, also known from one or more paintings. Executed in pen with brown and gray wash, the drawing shows few *pentimenti* to reflect a change of mind during the evolution of the composition. The question, therefore, has been raised whether this is a preliminary drawing by Snyders or rather a *ricordo*, drawn as a work in its own right to be sold or possibly reused for future painted versions in his workshop. Perhaps finished drawings (like the one discussed here) could even have fulfilled both functions.

If the drawing is seen as a preparatory study by Snyders for his painting in Pommersfelden, the implication is that Snyders sometimes painted the figures in his own pictures instead of commissioning them to collaborators such as Cornelis de Vos or Jan Boeckhorst. In the opinion of Arnout Balis, however, the physiognomy of the hunter in Snyders's painting in the collection of Count Schönborn is closer to figures painted by Martin Pepyn (Antwerp 1575–1642/43), a little-known contemporary of Rubens's, rather than to Snyders's figures (exh. cat. Antwerp/Münster 1990, p. 101). This interpretation would favor seeing in the present drawing a *ricordo*. Robels observed that the features of the hunter in Snyders's painting are close to those in another, lost version of the painting in Pommersfelden (sale of Janos Pállfy, Bad-Pistyan [Czech Republic], 30–31 June 1924, lot 93; Robels 1989, no. 15a). From this she concluded that Snyders must have made the drawing discussed here in preparation for this second version.

Snyders's pendant to the painting in Pommersfelden, depicting a WOMAN SELLING FRUIT AND VEGETABLES, dated 1627, is in the collection Fritz Frey, Bürgenstock (Switzerland). No related finished drawing that would have been a pendant to this drawing of a HUNTER WITH STILL LIFE has been found. The date of 1627 on Snyders's signed painting in the Swiss collection assists in establishing an approximate date for the drawing presented here.

64

WHIPPET, SEATED TO THE RIGHT

Black chalk, heightened with white, lightly stumped, on blue paper,

257 x 199 mm (10 1/16 x 7 3/4 in.)

The Pierpont Morgan Library, New York, New York: Gift of George Abrams

Inv. no. 1991.31

Provenance: Thomas Le Claire, Hamburg (1985)

Exhibition history: Hamburg 1985, no. 16, ill. in color.

Reference: Robels 1989, no. Z75.

In execution and type—a close-up black chalk study of a single dog—this sheet is totally different from the more traditional compositional drawings in pen and ink that one associates with Frans Snyders. A sizeable number of related studies, whose attribution to Snyders has never been questioned, is known, with the largest group of twelve in the Rijksprentenkabinet in Amsterdam (Inv. nos. 4450–61; Robels 1989, cat. nos. Z64–74); further examples are in Leiden, Lille, Antwerp, Munich, and elsewhere (Robels 1989, cat. nos. Z75–86). The dogs, which are drawn from life and shown in different poses, were not incorporated in Snyders's paintings.

While Robels listed these drawings of whippets among the ninety she accepted and catalogued them for the first time in her monograph of 1989, she nevertheless pointed out how isolated they appeared in Snyders's œuvre, and expressed a certain reservation about the group without discussing it further.

Pieter Claesz. Soutman

Haarlem ca. 1580–1657 Haarlem

Pieter Claesz. Soutman was a pupil of Rubens, according to the latter's nephew, Philip Rubens. He seems to have worked in Rubens's studio around 1615–16. In 1619–20 he registered an apprentice in the guild of St. Luke in Antwerp, and in September 1620 he became a citizen of that city. Soutman was appointed court painter of King Sigismund III of Poland by 1624; four years later he was back in his native Haarlem. Soutman was much renowned as an etcher after Rubens's designs.

65

Pieter Claesz. Soutman (*attributed to*), after Peter Paul Rubens

LION HUNT, ca. 1615–18

Pen and brown ink, brownish-gray wash over black chalk, some red chalk at the lower left and at bottom center, touches of heightening with white, vertical fold through the center, traced for transfer, 441 x 599 mm (17¼ x 23½ in.)

Annotated in pen and brown ink at lower left on the shield, *AV Dyck*.

National Gallery of Art, Washington, D.C.: Ailsa Mellon Bruce Fund

Inv. no. 1984.81.1.

Provenance: sale, London, Sotheby's, 7 July 1966, lot 65; H. Shickman Gallery, New York;

David Tunick, New York (1984)

Reference: Balis 1986, no. 6, copy 6, fig. 55.

Exhibited in Cleveland only

The drawing records Rubens's destroyed LION HUNT that Duke Maximilian I of Bavaria (1573–1651) purchased from the artist before 28 April 1618. The painting was exhibited in the Altes Schloss in Schleissheim (outside Munich) until 30 August 1800, when it was removed to Paris by the French and then transferred to Bordeaux in 1803. It perished there in the fire at the museum in 1870. Jaffé was the first to attribute this drawing to Pieter Soutman when he identified it as the design for the artist's slightly larger etching in reverse (455 x 634 mm; see Rosand 1969, p. 30, n. 8). The signature on the plate at bottom right, *P. Soutman, Inuenit Effigiauit et Excud. Cum Privil.*, supports this attribution of the drawing (Balis 1986, no. 6, copies 9, fig. 56). One of the differences between the drawing in Washington and Soutman's print after it, and the painted copies after Rubens's lost LION HUNT, is the modified pose of the lioness: in neither drawing nor print does her front paw touch the horse's rump.

This drawing of a LION HUNT was traditionally listed among the designs done under Rubens's supervision for prints, in this instance an etching, which was exceptional, since the majority of the reproductive prints were engravings. More recently this supposition has been modified, prompted by the fact that the print bears only the generic privilege, *Cum Privil.*, rather than the tripartite one granted by the King of France, the Archduke Albert and the Archduchess Isabella, and the States General of the United Provinces that Rubens used on the reproductive engravings done under his close supervision. Balis, quoting Ludwig Burchard, pointed to another fact that makes it highly unlikely that the etching could have been done with Rubens's knowledge: Soutman credited himself as well as Rubens with the invention of the LION HUNT. It therefore seems more probable that Soutman made the print later, around the time of his etching of a BOAR HUNT, dated 1642, which copies the central part of Rubens's BOAR HUNT in Dresden. Soutman made etchings close in time to each other after two further hunts by Rubens, the WOLF HUNT and the HIPPOPOTAMUS HUNT. (The preliminary design for the latter, also attributed to Soutman, is in the British Museum, London; see Balis 1986, cat. nos. 2, 4, 5.) Curiously, Pieter Soutman—as Balis noted—owned a number of drawings that must have been intended as designs for prints and that probably originated when he was closely associated with Rubens around 1615–18; however, they were etched much later, after Soutman had returned to Haarlem and was active as a publisher (see Balis 1986, p. 48, n. 59). The preliminary design in Washington may therefore date from around 1615–18, corresponding to Soutman's first years in Antwerp, but the print after it must have been executed only after Rubens's death in 1640, around the time of Soutman's etching of the BOAR HUNT, dated 1642.

David Teniers the Younger

Antwerp 1610–1690 Brussels

After an apprenticeship with his father, David Teniers the Elder (1582–1649), the younger Teniers was greatly influenced by the work of Adriaen Brouwer, especially from about 1631 on when the latter moved to Antwerp (d. 1638). In 1632–33 David Teniers the Younger was received as a master in the Antwerp painters' guild; in 1644 he served as its dean. In 1637 he married Anna Brueghel, the daughter of Jan Brueghel the Elder; Rubens, her guardian, was one of the witnesses. Teniers was appointed painter to the court of Archduke Leopold Wilhelm in Brussels in 1651 and at the same time became keeper of the latter's art collection. About ten paintings by Teniers are known representing the archduke among his (primarily Italian) paintings.

As early as 1651, after the death of Jan van den Hoecke, Leopold Wilhelm may have conferred the official title of *ayuda da camera* on David Teniers and the artist may have moved to Brussels, where he built a house with a garden and studio near the palace. (According to Vlieghe 1966, p. 128, Teniers did not move to Brussels until 1656.) In 1656 the archduke left Brussels for Vienna, taking his vast art collection with him. In the meantime, Teniers had begun to work on an illustrated inventory of these paintings, which was first published in Antwerp in Latin in 1658 as the *Theatrum Pictorium*, with a larger edition in 1660. The new governor, Don Juan d'Austria (1656–59), retained Teniers as court painter and the artist continued to prosper, purchasing an estate in 1662: the *Drij Toren* (Three Towers) in Perk, outside Antwerp. Teniers was granted permission to found an art academy in Antwerp in 1663 and students were first accepted in 1665.

66

PEASANTS DANCING, STUDY FOR "VILLAGE HOLIDAY," ca. 1650

Graphite, traces of red chalk at right, 153 x 198 mm (6 1/16 x 7 13/16 in.)

Wadsworth Atheneum, Hartford, Connecticut: Gift of Henry and Walter Keney

Inv. no. 1956.13

Provenance: Colnaghi, London (1956)

References: Klinge, in exh. cat. New York/Maastricht 1982, under no. 36;

Klinge, in exh. cat. Antwerp 1991, under no. 67, fig. 67b; Vlieghe, in Balis et al. 1992, p. 284.

According to Margret Klinge, David Teniers was almost as prolific a draftsman as he was a painter—over 2,000 paintings are attributed to him—due to the fact that he habitually prepared his paintings with preliminary studies drawn almost exclusively in graphite (pencil). Only occasionally did he use the pen and then primarily to accentuate certain forms in a pencil study. Since Teniers's style changed very little over the years, these studies remain difficult to date. The majority probably originated between the early 1630s and about 1660, when his interest in preparing paintings with detailed preliminary drawings diminished.

The drawing in Hartford is a meticulously detailed study, drawn with a sharp pencil, of a group of fourteen dancing peasants that corresponds exactly to dancing peasants in the center of Teniers's signed painting of a VILLAGE HOLIDAY in the Virginia Museum of Fine Arts, Richmond (figure XIX; Inv. no. 56.23; oil on canvas, 53 x 91.1 cm). The study begins with the peasant who rests his right arm on his lower back, grabbing with his left the hand of the peasant next to him, thus directing the group of merry people toward the right into the middle distance. The composition ends with the four women before the break in the human chain at the center, punctuated in the background by the church on the horizon.

Another, very large study of sixteen men and fifteen women corresponding to the group of figures beginning at the extreme left in the same painting is in the Louvre, Paris (Inv. no. 20.529; pencil, 244 x 510 mm; Lugt 1949, no. 1312). A third preliminary drawing for the remaining figures at the extreme right probably existed as well but is now lost.

The care with which Teniers prepared this elaborate composition of about seventy figures, which are rather small in scale and thread their way through an extensive landscape setting under a wide open sky, attests to the importance he attached to the painting. The unusually varied arrangement of the group sets it apart from the many paintings of village festivals the artist produced during his lifetime. According to an early inventory, Archduke Leopold Wilhelm sent the painting in 1651 directly from Brussels to his brother, Emperor Ferdinand III, at the imperial court in Vienna. In that very year Teniers received the coveted title of *ayuda da camera* and this VILLAGE HOLIDAY may therefore reflect the artist's special effort to prove himself worthy of the new post. The two extant drawings of this subject, in the Louvre and this one in Hartford, date from about 1650–51 as well.

67

SHEET OF FIGURE STUDIES, ca. 1650

Graphite, light-brown and some gray wash, traces of a framing line gone over in black,
202 x 288 mm (7 15/16 x 11 3/8 in.)

Numbered in pen and brown ink at bottom left corner, *22*.

The Pierpont Morgan Library, New York, New York

Inv. no. I,124a

Provenance: possibly sale, London, Sotheby's, 20 June 1891, one of five in lot 228;

Charles Fairfax Murray, London (d. 1919); J. Pierpont Morgan

Reference: Stampfle 1991, no. 333, ill.

This is Teniers's preliminary drawing for the frolicking peasants he painted in the center foreground of Lucas van Uden's PEASANTS MERRYMAKING BEFORE A COUNTRY HOUSE in the National Gallery, London (see Martin 1970, p. 284, no. 5866 and Stampfle 1991, fig. 147). The additional pencil sketches of smaller figures at top center and along the right margin also correspond with figures that Teniers added to Van Uden's painting in the middle distance. As was the case in the drawing at Hartford of peasants dancing (see catalogue number 66), Teniers prepared each individual figure carefully, this time, however, with a bolder, freer stroke of the soft pencil. The drawing must date from the same time as the painting or about 1650.

The man at right pulls the woman up to dance to the tune of a bagpiper, who in the painting is playing in front of the country inn, while others are already dancing. The bagpipe was the instrument of the country people used primarily for dances and weddings. In contrast to Teniers's own paintings with dancing peasants, who are always shown in front of a country cottage or an inn, Van Uden painted a large country estate with formal gardens as a backdrop for Teniers's figures.

68

STUDIES OF HOUNDS, ca. 1660
Graphite, 190 x 320 mm (7 ½ x 12 ⅝ in.)
Private Collection
Provenance: unidentified collector (L. 2697); Sir Francis Mackenzie;
Madame Mackenzie of Gairloch; sale, London, Christie's, 19 March 1975, lot 81, pl. 13
Exhibition history: Cambridge, Massachusetts 1977, no. 57, ill.; Vienna 1988–89, no. 64, ill.

Greyhounds such as the ones Teniers studied here in twelve different poses are shown in his paintings either on a leash with well-to-do city people visiting the country or accompanying hunters, as is the case in a sheet in the Nationalmuseum, Stockholm (Inv. no. 2121/1863; exh. cat. Antwerp 1991, no. 122, ill.; dated in the late 1640s). The perked ears and alertness of the hounds here associate them most readily with hunters. Although no painting has been identified with a corresponding group of greyhounds, a similar array—interspersed with some other breeds—is found in Teniers's signed painting representing RESTING HUNTERS in the Royal Museum of Fine Arts, Antwerp (Inv. no. 764). This painting is dated to about 1660 because of the French *trompe* or hunting horn the huntsman is sounding to call back the remaining hunters and dogs (see Leppert 1978, pp. 144–45, fig. 62).

Jan Thomas van Yperen

Ypres 1617–1678 Vienna

Jan Thomas was one of Rubens's last pupils. Sometime after his arrival in Antwerp, he became master in the guild of St. Luke in 1640, the year Rubens died. The following year Jan Thomas married; a year later, in 1642, he obtained citizenship. For the next ten years Jan Thomas maintained a workshop in Antwerp. He registered a pupil in 1641 and again in 1643. Around 1654 he left to become court painter of the Bishop of Mainz. Jan Thomas was recorded in Vienna in 1658 and within another two years he was in Frankfurt where, following his appointment as court painter, he attended the coronation of Emperor Leopold I. Beginning in the late 1650s he also produced a sizeable number of mezzotints. From 1661 on he lived in Vienna.

69

A COUPLE, 1640s

Pen and brown ink, brown and gray wash over black chalk, partly squared in black chalk, 167 x 150 mm (6⁹⁄₁₆ x 5⅞ in.)

Annotated in pen and ink on the verso: *P.P. Rubbens en syn … Door…*.

The Minneapolis Institute of Arts, Minneapolis, Minnesota: The Ethel Morrison Van Derlip Fund Inv. no. 74.45

Provenance: C. G. Boerner, Düsseldorf (*Neue Lagerliste*, 57, 1971, no. 44, ill.); anonymous sale, Hamburg, Hauswedell & Nolte, 14 June 1973, lot 115, ill.

Reference: Foucart, in exh. cat. Paris 1977, under no. 189.

Although referred to in the literature as a "dancing couple," the man actually is picking flowers (roses?) from a trellis. He presents them to the woman standing beside him who gathers them in her skirt. Jan Thomas van Yperen is little known as a draftsman. His drawings are often associated with Rubens as is the case with this study in Minneapolis, where the couple is identified erroneously (in an old annotation on the verso) as Rubens and his wife. Faint traces of squaring in black chalk suggest that the drawing might have served as a design for a painting or print. While no such work by Jan Thomas is known, there nevertheless exist enough similarities between this joyful couple and dancing couples in his PEASANT DANCE in the Louvre, Paris (exh. cat. Paris 1977, no. 189) to consider the attribution viable. The shepherdess in an elegant dress with a straw hat adorned with flowers is also found in a closely related pose in a painting that Ludwig Burchard first attributed to Jan Thomas when he saw it in Berlin in 1927 (last recorded with the art dealer Fritz Rothmann; oil on panel, 41 x 63.5 cm; photograph in the Ludwig Burchard files at the Rubenianum, Antwerp). Here the shepherdess is meeting a shepherd with his flock of goats and sheep in the countryside, in a setting more reminiscent of bucolic scenes popular in the northern Netherlands at that time (see Vlieghe 1976, pp. 297–303 and Kettering 1983).

Theodoor van Thulden

's-Hertogenbosch 1606–1669 's-Hertogenbosch

When Theodoor van Thulden was born in 's-Hertogenbosch in 1606, the town was still part of the southern Netherlands and remained so until 1629, when Prince Frederick Henry of Orange conquered it. In 1621–22 Van Thulden became a pupil of the little known painter Abraham van Blijenberch in Antwerp; by 1626–27 he was a master in the Antwerp painters' guild and served as its dean in 1639–40. Between 1631 and 1633 Van Thulden is recorded in Paris, where Louis Petit, the general of the order of the Trinitarians, commissioned him to paint a series with scenes from the lives of the order's two founders, St. Jean of Matha and St. Felix of Valois. In addition, he published in 1633 two series of prints, the LIFE OF ST. JEAN OF MATHA and the TRAVAUX D'ULYSSE, the latter with fifty-eight plates after frescoes by Primaticcio and Nicolò dell' Abate in Fontainebleau. It has recently been questioned whether Van Thulden made the many chalk copies after frescoes in Fontainebleau (Wood 1990).

Shortly after his return to Antwerp, Van Thulden collaborated on the decorations for the Triumphal Entry of Cardinal-Infante Ferdinand into Antwerp in 1635. He was also commissioned for the commemorative volume of the *Pompa Introitus Ferdinandi*, a publication that appeared only in 1642, after the death of both Rubens and the Cardinal-Infante. In 1635 Van Thulden married Maria van Balen, daughter of Hendrik van Balen the Elder and godchild of Rubens. The following year he became a citizen of Antwerp. In 1637 he contributed two paintings to the Torre de la Parada commission. In the same year he registered a pupil.

Van Thulden left Antwerp for Oirschot in the northern Netherlands in 1644; from there he moved to his native 's-Hertogenbosch. Three large altar paintings for the Trinitarians in Paris date from 1646. Between 1648 and 1651 Van Thulden collaborated with other painters from Antwerp, among them Jacob Jordaens, Thomas Willeboirts Bosschaert, and Gonzales Coques on the decoration of the Oranjezaal in the Huis ten Bosch in The Hague, commissioned by Amalia van Solms to commemorate her late husband, Prince Frederick Henry. Van Thulden was appointed the official painter of the city of 's-Hertogenbosch in 1655. Among his last commissions were the stained glass windows for the church of St. Gudule in Brussels (1656–63).

70

ALLEGORY OF THE RETURN OF GOOD FORTUNE TO THE CITY OF ANTWERP, ca. 1648

Red chalk and brush and black ink with brown and gray wash, 342 x 384 mm (13⁹⁄₁₆ x 15³⁄₁₆ in.)

National Gallery of Art, Washington, D.C.: Julius S. Held Collection

Inv. no. 1985.1.57

Provenance: E. J. Otto, Celle (L. 873b): Julius S. Held

Exhibition history: New York 1966–67, no. 9, ill.

Reference: Roy, in exh. cat. 's-Hertogenbosch/Strasbourg 1991–92, p. 258, no. 38, fig. 54.

Exhibited in Cleveland only

Van Thulden based the subject matter and composition of this drawing on Rubens's STAGE OF MERCURY, one of the decorations for the Triumphal Entry of Cardinal-Infante Ferdinand into Antwerp on 17 April 1635. The artist knew the STAGE well, since he, together with Jan de Labarre, Jan and Gaspar van Balen, the brothers of his wife, as well as Erasmus Quellinus, had painted that very decoration from Rubens's preliminary oil sketch. In Rubens's design, however, Mercury was leaving Antwerp, whose wealth declined due to the closing of the river Scheldt in 1585 and with it, access to the sea. In contrast, Van Thulden here chose to show Mercury returning to Antwerp. This idea must have been especially popular around 1648, when the peace treaty was signed at Münster in conclusion of the Eighty-Year War and the citizens hoped that, once again, the river would bustle with maritime traffic—a hope that was not fulfilled.

Van Thulden depicted the personification of the city of Antwerp seated on a throne at the left, situated on the bank of the river Scheldt (*Scaldis*). She is wearing a turreted crown that in the painting, now in the museum of La Valletta, Malta, will be embellished with roses (exh. cat. 's-Hertogenbosch/Strasbourg 1991–92, fig. 46). Father Time stands at her side, overcoming a figure representing evil and discord at the lower left. The allegorical figure of Abundance, with a cornucopia, partly removes a veil from *Antverpia* with her right hand (in the painting she carries a caduceus). The figure standing behind and slightly higher has been identified as Hope, while in the sky above a putto chases away an evil spirit. Juno, accompanied by her peacock at the upper right, is pouring gold coins from a cornucopia into the river Scheldt below, symbolized by the river god at the lower right. Mercury with his caduceus acts as a witness, watching over Antwerp's commercial fortunes. The drawing may have been trimmed somewhat at the right, since Juno's peacock is barely indicated.

This is the only drawing done primarily in chalk that can be securely attributed to Theodoor van Thulden, since it served as the preliminary study for his painting now in Malta. While Roy dated the latter to around 1640, near Van Thulden's work on the *Pompa Introitus* publication, it is possible that Van Thulden painted it slightly later, closer to his two political allegories of 1647 and 1650 respectively, for the Town Hall of 's-Hertogenbosch (exh. cat. 's-Hertogenbosch/Strasbourg 1991–92, nos. 77, 95 and figs. 56–57, in color).

71

Theodoor van Thulden (*attributed to*)

HOLY TRINITY

Brush and red, purplish-red, yellow-ocher, and gray-brown wash over red chalk;
paper folded into eight squares for transfer, 273 x 202 mm (10¾ x 8 in.)
The Cleveland Museum of Art, Cleveland, Ohio: Purchase from the J. H. Wade Fund
Inv. no. 61.169

Provenance: Prosper Henry Lankrink, London (1628–92; L. 2090); Joseph van Haecken, London (1699?–1749; L. 2516); Duc de Trevise; Dr. W. Hugelshofer, Zurich (sale, Bern, Gutekunst and Klipstein, 28 April 1955, lot 333, pl. 41, as Van Dyck); Schaeffer Galleries, New York
References: Jaffé 1963, p. 465 (as Van Dyck); Roy, in exh. cat. 's-Hertogenbosch/Strasbourg 1991–92, pp. 263–64, no. 80, ill. (as Van Thulden).

Drawn entirely with the brush and colored wash, this study is totally different from the securely attributed preliminary drawings that Alain Roy assembled in 1991 for the Van Thulden exhibition in 's-Hertogenbosch and Strasbourg. Roy has long accepted the Cleveland drawing as Van Thulden's design for the HOLY TRINITY on the main altar of the church of the Trinitarians in Paris, commissioned in 1647 by Louis Petit. There are major differences, however, between the drawing and the altar, now in the Musée de Peinture et de Sculpture in Grenoble (Inv. no. 105; exh. cat. 's-Hertogenbosch/Strasbourg 1991–92, p. 264, no. 81 and p. 71, fig. 50), notably in the figure of Christ, who in the painting does not carry the banner of the Resurrection but rather points to His wounds, with the globe placed beneath Him and God the Father.

Van Thulden's altar is indebted to Rubens's GOD THE FATHER AND CHRIST WITH SAINTS PAUL AND JOHN THE EVANGELIST of ca. 1616–17 in Weimar (KdK 119; Jaffé 1989, no. 414), as Jeremy Wood rightly stressed. This is most obvious in the central placing of the globe, with Christ and God the Father resting their feet upon it (letter of 10 November 1992). This representation differs greatly from the Cleveland drawing, where the globe is found beside God the Father who rests His left arm on it. If indeed by Van Thulden, the artist must therefore have abandoned his ideas formulated in this preliminary drawing and reverted back to a composition closely associated with Rubens's prototype.

Since the subject of the Holy Trinity is rather common in Flemish art, a closer correspondence between painting and drawing would be expected, all the more so since the drawing was folded vertically in the center and three times horizontally, thereby probably providing a rudimentary squaring for transfer to a painted *modello* or altar. As mentioned above, this drawing differs in execution from other preparatory studies by Van Thulden that Roy assembled in 1991, which are drawn on a small scale in pen and brown ink, with careful annotations of the personifications or brief descriptions of the subjects represented. Van Thulden's preparatory studies resembled records of the painted compositions rather than preliminary drawings for them. On the basis of these reservations, this study for a Holy Trinity is included here with a tentative attribution to Van Thulden.

220

Lucas van Uden

Antwerp 1595–1672 Antwerp

Lucas van Uden was probably an apprentice to his father, the painter Artus van Uden (Antwerp 1544–1627/28). He registered in the guild of St. Luke as a *wijnmeester*, or son of a master, in 1627, the same year he married Anna van Woelput. The assertion that he was an assistant to Rubens and painted landscape backgrounds in the latter's paintings is unfounded. Around 1644 he traveled along the Rhine, returning to Antwerp in 1646. Jacob Jordaens and David Teniers the Younger painted the figures into some of his landscapes (see, for example, the Teniers drawing in New York, discussed here as catalogue number 67). Van Uden also collaborated with Hendrik van Balen and Gonzales Coques. In 1640 and 1642 he registered a pupil.

72

A WOODLAND SCENE WITH A STREAM, ca. 1640

Pen and brown ink, gray wash, blue bodycolor and watercolor in the sky,

223 x 345 mm (8¾ x 13¾ in.)

Private Collection

Provenance: B. Tiffin, E.R. (with his typewritten note on the back of the frame: "The finest drawing by L. van Uden I have not [sic] seen, nothing equal to it in the B Msm. [British Museum] bought from Mr. B. Tiffin/E.R."); Colnaghi, London; H. L. Bradfer-Lawrence; Lt. Col. P. Bradfer-Lawrence; art market, London (1987)

Exhibition history: London 1953 (A), no. 59.

Exhibited in Wellesley only

Van Uden favored wooded landscape settings with rows of slender ash trees lining a brook or stream. They resemble the scenery found in the Forest of Soignes near the Capuchin convent of Tervueren, which Van Uden rendered in other known watercolors, some of which are dated 1640, such as his WOODED LANDSCAPE WITH MONASTERY in the Witt Collection, Courtauld Institute of Art Galleries, London (exh. cat. New York/London 1986, no. 23, ill. in color). The artist depicted similar woodland settings not only in watercolors but also in paintings and etchings. Since there are no visible *pentimenti*, he probably composed the drawing as a finished work of art in his studio, possibly based on quick sketches made outdoors. Only a few of Van Uden's drawings have been identified as specific preparatory studies for a painting, among them the THREE TREES from another private collection (see catalogue number 73).

This WOODLAND SCENE is very close in execution to Van Uden's WOODED LANDSCAPE WITH MONASTERY of 1640 in the Witt Collection, mentioned earlier, and may therefore date from the 1640s as well.

73

THREE TREES

Pen and brown ink, gray wash, and watercolor, over graphite; four corners made up,

347 x 225 mm (13¹¹⁄₁₆ x 8⅞ in.)

Private Collection

Provenance: Schaeffer Galleries, New York

Exhibition history: Cambridge, Massachusetts 1977, no. 58, ill.; Vienna 1988–89, no. 59, ill.;

Santa Barbara 1986–87, no. 89, ill.

Reference: Bailey 1981, pp. 441–42, pl. 23.

Besides the more numerous views of the Flemish countryside, Van Uden also made drawings of a few individual trees such as this one, enhanced with watercolor in the sky. Van Uden used the drawing for his painting LANDSCAPE WITH PIPER AND VILLAGERS BEFORE COTTAGES, formerly in the collection of T. Cottrell-Dormer, Rousham House (Oxon), as Stephen M. Bailey established (1981, fig. 1; sale, London, Christie's, 5 July 1985, lot 90). A closely related drawing of three birch trees, also in a vertical format, is in the Institut Néerlandais, Fondation Custodia, Collection Frits Lugt, Paris (exh. cat. Paris 1972, no. 111, pl. 99).

Bailey argued that because of slight variations between the birches in the drawing and the related painting, Van Uden drew this study outdoors and reused it for the trees when painting this landscape. However, the fact that there are hardly any *pentimenti* on the sheet suggests that it was developed in the studio rather than drawn from nature.

David Vinckboons

Malines 1576–1632 Amsterdam

In 1579, Philips Vinckboons moved his family, including his three-year-old son David, from Malines (Mechelen) to Antwerp. After the fall of Antwerp in 1585 the family fled to the northern Netherlands, first to Middelburg (1586), then to Amsterdam in 1591. His father instructed David in watercolor technique, as Karel van Mander—another immigrant from the southern Netherlands— reported in his *Schilder-Boeck*, published in 1604 in Haarlem. David Vinckboons was one of the youngest artists that Van Mander included. Once he had settled in the northern Netherlands, Vinckboons studied with Gillis van Coninxloo, who had fled from Flanders to Frankenthal before moving to Amsterdam in 1595. Vinckboons married Agnieta van Loon in 1602.

74

PEASANT KERMIS, 1604

Pen and brown ink, brown and gray wash, 213 x 339 mm (8⅜ x 13⁵⁄₁₆ in.)

Signed in monogram in pen and brown ink at bottom right, *DVB* (in ligature) and dated, *1604*.

Collection of The J. Paul Getty Museum, Malibu, California

Inv. no. 88.GA.129

Provenance: private collection (sale, London, Sotheby's, 22 November 1974, lot 28, ill. p. 78);

J. Theodor Cremer, New York; art market, London

References: Wegner and Pée 1980, no. 19, fig. 19 and under nos. 16 and 27; exh. cat.

Washington, D.C., 1986, p. 300, under no. 118 (n. 4); Briels 1987, p. 122, fig. 140;

Goldner and Hendrix, 1992, no. 89, ill.

Exhibited in Wellesley only

David Vinckboons drew all four extant representations of a *kermis* or peasant festival scene within three years, from 1602 to 1605, each one different in composition as well as technique (Wegner and Pée 1980, nos. 16, 18, 19, 27). These variations in style may be explained by the fact that a third of his known drawings originated during these same years. The earliest and most elaborate of the four, the so-called LARGE KERMIS of 1602 in Copenhagen, was reproduced in print and copied often in paintings, thus attesting to the attraction of this basically Flemish subject in the northern Netherlands. In the VILLAGE KERMIS from the following year, 1603, in The Pierpont Morgan Library, New York, Vinckboons used watercolor and bodycolor extensively—a technique he learned from his father. This he must have considered an independent work. In contrast, the PEASANT KERMIS in the Getty Museum, signed in monogram and dated *1604*, is drawn in ink and wash only. Vinckboons concentrated here more on the figures, which he arranged into several groups milling around the village square. They are rather small in scale, a reminder of Vinckboons's training under Gillis van Coninxloo. A painting, known in 1954 in a Paris private collection and dated by Goossens around 1604 (1977, fig. 34), is closely related to the Getty drawing, while a copy after the latter is in the Herzog Anton Ulrich-Museum in Braunschweig (Flechsig 1923, no. 68).

Cornelis de Wael

Antwerp 1592–1667 Rome

Cornelis de Wael was trained by his father Jan de Wael. In 1642 the city of Genoa granted him citizenship after he had lived there for about twenty years, which implies that he and his older brother Lucas de Wael (Antwerp 1591–1661) settled in Genoa around 1620 (Donati 1988, p. 9). Soon thereafter, their childhood friend Anthony van Dyck paid a visit and made their home his base

during the years he spent in Italy. As a gesture of appreciation, Van Dyck painted their double portrait, today in the Capitoline Museum in Rome (exh. cat. Washington, D.C. 1990–91, no. 42). Cornelis de Wael's reports on Van Dyck's travels in Italy in letters to a fellow Fleming and art dealer Lucas van Uffel in Venice—lost but known from an anonymous eighteenth-century manuscript in the Louvre, Paris—are an indispensable resource for any biography of Van Dyck (published in Larsen 1975). In 1656 De Wael moved to Rome where he was joined by the sons of his brother Lucas de Wael, Jan Baptist and Antoon de Wael, who both painted in the same style.

75

COURTYARD WITH WOUNDED SOLDIERS

Graphite, pen and brown ink, on tan laid paper, laid down on card, 205 x 262 mm (8⅛ x 10¼ in.)

The Art Institute of Chicago, Chicago, Illinois: Leonora Hall Gurley Memorial Collection

Inv. no. 1922.1947

Provenance: Leonora Hall Gurley

Exhibited in Cleveland only

Cornelis de Wael is noted for small battle scenes on sea and land, but particularly those depicting military life and soldiers, as Cornelis de Bie wrote in his *Gulden Cabinet* (1661, p. 229). This study is similar to military scenes assembled in Cornelis de Wael's book of fifty-three drawings in the British Museum, London. These drawings were done in Rome between 1656 and 1667, according to his inscription on the title page (Hind 1923, p. 151, no. 2, from the collection of John Percival, 1st Earl of Egmont). No painting or print is known that corresponds to the drawing, but its small figures sketched in outline with the pen and modeled with parallel hatching are rather characteristic of his studies; the attribution to Cornelis de Wael was confirmed by Egbert Haverkamp-Begemann (in annotation on mount, 1989).

Jan Wildens

Antwerp 1586–1653 Antwerp

In 1596 the ten-year-old Jan was apprenticed to Pieter Verhulst, a painter from Malines, who became a master in the Antwerp painters' guild in 1589. In 1604 Wildens himself became a master and registered one pupil in each of the years 1610, 1628, and 1629. He resided in Italy from 1613 until 1616. Upon his return to Antwerp, Wildens entered Rubens's studio where he assisted in painting landscape backgrounds until 1620. Wildens also collaborated with Frans Snyders, Paul de Vos, and Jacob Jordaens. In 1619 he married Maria Stappaerts. Her niece, Helena Fourment, became Rubens's second wife in 1630, with Jan Wildens a witness at the marriage. These close family ties with Rubens are also evident from the fact that Wildens was one of the executors of Rubens's will in 1640. In addition to being a painter, Wildens was also an art dealer. Both of his sons, Jan Baptist (1620–1637) and Jeremias (1621–1653), became painters.

224

76

HARVEST SCENE, 1614

Pen and brown ink, gray, brown, and light-blue wash, point of brush and gray wash in foliage,
over traces of black chalk; partly traced for transfer, 262 x 377 mm (10 5/16 x 14 13/16 in.)

The Pierpont Morgan Library, New York, New York

Inv. no. 1975.20

Provenance: private collection (sale, London, Sotheby's, 22 November 1974, lot 124, ill. p. 70);
Yvonne Tan Bunzl, London

Exhibition history: New York 1979–80, no. 21, ill.

References: Adler 1980, no. Z11, fig. 181; Stampfle 1991, no. 339, ill.

Jan Wildens used this HARVEST SCENE as a representation of AUGUST in his series of the Twelve
Months, which he had engraved in 1614 by Andries Jacobsz. Stock (Antwerp ca. 1580–ca. 1648 The
Hague; Hollstein, XXVIII, no. 13). In his engraving in reverse, Stock followed Wildens's pen drawing
accurately. The drawing may actually have been trimmed at the right, since in the print the fields
extend further at the left. Wildens also made a series of paintings of the Twelve Months, preserved
in the Galleria di Palazzo Bianco in Genoa, that correspond to the known drawings except for the
representation of August, which differs in composition (Adler 1980, no. G4, fig. 20). According to
Wolfgang Adler, a related painting was last recorded in the Flor Burton sale in Antwerp (14 March
1927, lot 29; reproduced in Stampfle 1991, fig. 154, and Adler 1980, fig. 33).

Adler knew all the drawings in the series except for JANUARY, SEPTEMBER, OCTOBER, and NOVEMBER
(1980, cat. nos. Z2–12). Wildens's preliminary study for OCTOBER, engraved in reverse by Stock
(Hollstein, XXVIII, no. 14), was recently sold from the collection of John C. Witt, London (pen and
brown ink, brown and blue wash, 266 x 344 mm; sale, Amsterdam, Sotheby's, 12–13 November 1991,
lot 247, ill.). When the drawing was exhibited in 1963 in the Courtauld Institute Galleries, it was
attributed to Joos de Momper, an attribution made by William Esdaile at the time he owned it.

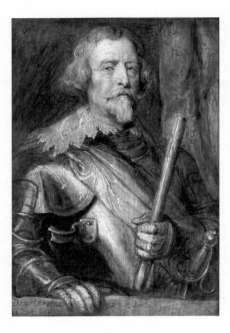

figure VI
Anthony van Dyck, CARLOS COLOMA,
Duke of Buccleugh, Boughton House
(oil on panel, 241 x 171 mm)

figure VII
Justus van Egmont, DESIGN FOR A
FRONTISPIECE (?), ca. 1650s, Victoria and
Albert Museum, London (Inv. no. 9275;
pen and gray ink and wash on gray paper,
311 x 207 mm)

226

figure VIII

figure IX

Jacob Jordaens, MERCURY AND ARGUS,
Rubenshuis, Antwerp (Inv. no. S199;
oil on canvas, 1.162 x 1.967 m)

Baldouin van Beveren, after Jacob Jordaens,
THE SATYR AND THE PEASANT, ca. 1644,
Hluboká Castle, Czech Republic (tapestry,
3.80 x 4.43 m)

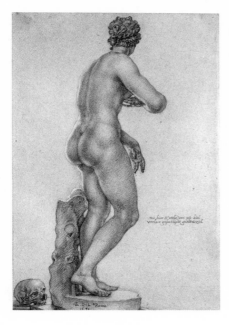

figure X

Pieter van Lint, VENUS DE' MEDICI, VIEW
FROM THE BACK, 1640, all rights reserved,
The Metropolitan Museum of Art, New York,
New York (Inv. no. 64.197.9; black chalk,
heightened with white, and pen and gray
wash on blue paper, 419 x 274 mm)

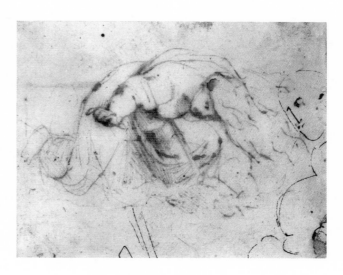

figure XI

Peter Paul Rubens, SKETCHES OF A HEAD
AND PART OF A STAFF (?), verso of cat. no. 40

227

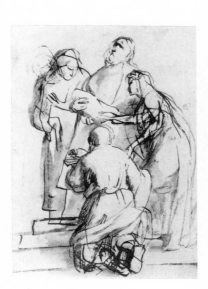

figure XIIa

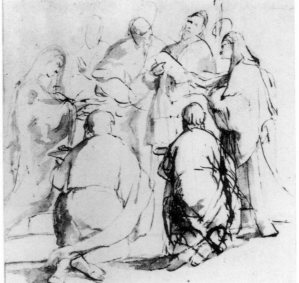

figure XIIb

Peter Paul Rubens, reconstruction of THE PRESENTATION IN THE TEMPLE, The Metropolitan
Museum of Art, New York, New York (cat. no. 43) and The Princes Gate Collection, Courtauld
Institute Galleries, London (Inv. no. 56; pen and brown ink, brown wash, 242 x 380 mm)

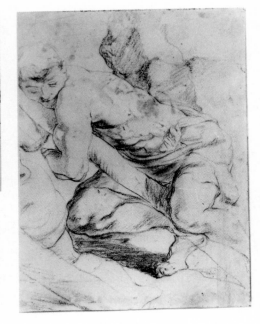

figure XIII

Peter Paul Rubens, reconstruction of
STUDIES OF A MAN HOLDING THE SHAFT OF
A THICK BEAM FOR THE CROSS, verso of
figure XII with the addition of a fragment
from the Musée Bonnat, Bayonne
(black chalk, entire sheet 380 x 507 mm)

228

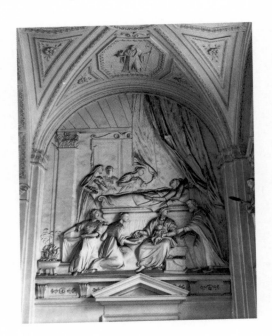

figure XIV

Unknown engraver, after Peter Paul Rubens,
TITLE PAGE FOR THE "COMMENTARIA IN
PENTATEUCHUM MOSIS," ca. 1614–15, Library
of Congress, Washington, D.C. (Inv. no. BS 1225
L. 35; engraving)

figure XV

Pietro Castelli, after Peter Paul Rubens,
THE BIRTH OF THE VIRGIN, 1620, Church of
Our Lady, Neuburg, Germany (stucco relief)

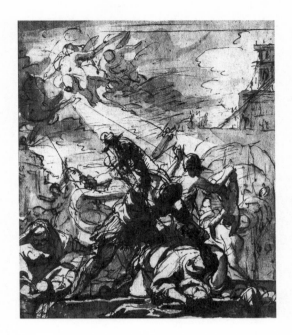

figure XVI
Cornelis Schut, MASSACRE OF THE
INNOCENTS, ca. 1627, The Art Museum,
Princeton University, Princeton, New Jersey:
Museum purchase (Inv. no. y863;
oil on canvas, 50 x 33.8 cm)

figure XVII
Cornelis Schut, MASSACRE OF THE
INNOCENTS, ca. 1627, National Gallery of
Scotland, Edinburgh (Inv. no. D3118; pen and
brown ink, brown wash over black chalk,
217 x 182 mm)

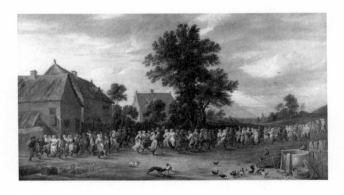

figure XIX

figure XVIII
Jan Siberechts, TREES AND FILAGE,
Smith College Museum of Art, Northampton,
Massachusetts: Purchased (Inv. no. 1944:2–2;
pen and brown ink over gray wash and black
chalk, 308 x 184 mm)

David Teniers, VILLAGE HOLIDAY, ca. 1650,
Virginia Museum of Fine Arts, Richmond,
Virginia: Museum purchase, The Adolph D.
and Wilkins C. Williams Fund (Inv. no. 56.23;
oil on canvas, 53 x 91.1 cm)

BOOKS AND ARTICLES

Adler 1980
Wolfgang Adler. *Jan Wildens.*
Der Landschaftsmitarbeiter des Rubens.
Fridingen, 1980.

Aesop
Fabulae Aesopea. Translated by Ben Edwin
Perry. Loeb Classical Library, Cambridge,
Massachusetts, 1965.

Andrews 1985
Keith Andrews. *Catalogue of Netherlandish*
Drawings in the National Gallery of Scotland.
2 vols. Edinburgh, 1985.

Bailey 1981
Stephen M. Bailey. "A Preparatory Drawing by
Lucas van Uden." *Master Drawings* XIX, 1981,
pp. 441–42.

Bailly de Tilleghem 1989
Serge Le Bailly de Tilleghem. *Catalogue,*
Musée des Beaux-Arts, Tournai. Brussels, 1989.

Balis 1986
Arnout Balis. *Landscape and Hunting Scenes, II.*
Corpus Rubenianum Ludwig Burchard.
Part XVIII. Oxford, 1986.

Balis et al. 1987
Arnout Balis, Frans Baudouin, Klaus Demus,
Nora De Poorter, Hans Devisscher,
Dirk De Vos, Wolfgang Prohaska, Karl Schütz,
Marc Vandenven, Carl Van de Velde, Paul
Verbraeken and Hans Vlieghe, eds. *Flandria*
extra muros. De vlaamse Schilderkunst in het
Kunsthistorisches Museum te Wenen.
Antwerp, 1987.

Balis et al. 1989
Arnout Balis, Matías Díaz Padrón, Carl Van de
Velde, Hans Vlieghe, eds. *Flandria extra muros.*
De vlaamse Schilderkunst in het Prado.
Antwerp, 1989.

Balis et al. 1992
Arnout Balis, Carl Van de Velde, Hans Vlieghe,
eds.; selected by Guy C. Bauman and Walter
A. Liedtke. *Flandria extra muros. Flemish*
Paintings in America. A Survey of Early
Netherlandish and Flemish Paintings in the
Public Collections of North America.
Antwerp, 1992.

Baudouin 1968
Frans Baudouin. "Nog een toeschrijving aan
Philips Fruytiers, en Antwerps schilder uit
Rubens' omgeving." *Bulletin der Koninklijke*
Musea voor Schone Kunsten van België XVII,
1968, pp. 161–69.

Baudouin 1977
Frans Baudouin. *Pietro Pauolo Rubens.*
New York, 1977.

Belkin 1980
Kristin Lohse Belkin. *The Costume Book.*
Corpus Rubenianum Ludwig Burchard.
Part XXIV. Brussels, 1980.

Bernard-Maître 1953
Henri Bernard-Maître, S. J. "Un Portrait de
Nicolas Trigault dessiné par Rubens?"
Archivum Historicum Societatis Jesu XXII, 1953,
pp. 308–13.

Bie 1661
Cornelis de Bie. *Het gulden Cabinet van de*
edel vry schilderconst. Antwerp, 1661 (reprint
Soest, 1971).

Bieneck 1992
Dorothea Bieneck. *Gerard Seghers (1591–1651).*
Lingen, 1992.

Blanchardière and Bodart 1974
Noëlle de La Blanchardière and Didier Bodart.
"Pietro Pescatore e gli affreschi di Cornelis
Schut e di Timan Craft al Casino Pescatore di
Frascati." *Arte Illustrata*, 1974, pp. 179–90.

Blazková 1959
Jarmila Blazková. "Les tapisseries de Jacob
Jordaens dans les châteaux tchéchoslovaques."
In *Het Herfstij van de vlaamse tapijtkunst
[Koninklijke Vlaamse Academie voor
Wetenschappen, Letteren en schone Kunsten
van België, Klasse der schone Kunsten].*
Brussels, 1959, pp. 73–80.

Bolten 1985
Jaap Bolten. *Method and Practice. Dutch and
Flemish Drawing Books 1600–1700.* London, 1985.

Van den Branden 1883
F. Jos. van den Branden. *Geschiedenis der
Antwerpsche schilderschool.* Antwerp, 1883.

Briels 1987
Jan Briels. *Peintres flamands en Hollande au
début du Siècle d'Or 1585–1630.* Antwerp, 1987.

Brussels 1984
Brussels, Musées Royaux des Beaux-Arts de
Belgique. *Catalogue inventaire de la peinture
ancienne.* Brussels, 1984.

De Bruyn 1986
Jean-Pierre De Bruyn. "Erasmus II Quellinus
(1607–1678) als tekenaar." *Jaarboek van
het Koninklijk Museum voor schone Kunsten,
Antwerpen*, 1986, pp. 213–71.

De Bruyn 1991
Jean-Pierre De Bruyn. "Erasmus II Quellinus
(1607–1678) addenda en corrigenda II."
*Jaarboek van het Koninklijk Museum voor
schone Kunsten, Antwerpen*, 1991, pp. 157–98.

Burchard 1953
Ludwig Burchard. "Rubens' 'Feast of Herod' at
Port Sunlight," *Burlington Magazine* XCV, 1953,
pp. 383–87.

Burchard and d'Hulst 1963
Ludwig Burchard and Roger-A. d'Hulst.
Rubens Drawings. 2 vols. Brussels, 1963.

Byam Shaw 1984
James Byam Shaw. Review of Hugh
Macandrew, *Italian Drawings in the Museum
of Fine Arts, Boston*, 1983. *Burlington Magazine*
CXXVI, 1984, pp. 445–46.

Cleveland 1957
Henry S. Francis in *The Bulletin of the
Cleveland Museum of Art* XLIV, 1957, pp. 17–22.

Cleveland 1966
The Cleveland Museum of Art, Handbook.
Cleveland, 1966.

Colsoul 1989
Heidi Colsoul. "Lucas Franchoys de Jonge
(1616–1681). Oeuvrecatalogus, I." *Handelingen
van de Koninklijke Kring voor Oudheidkunde,
Letteren en Kunst van Mechelen* XCII (1988),
1989, pp. 117–283.

Crick-Kuntziger 1950
Marthe Crick-Kuntziger. "La tenture de
l'histoire de Zénobie, reine de Palmyre."
Bulletin des Musées Royaux d'art et d'histoire 22,
1950, pp. 11–26.

Dom 1936
E. Dom. *De geschiedenis van O. L. Vrouw van
Goeden Wil te Duffel.* Tongerlo, 1936.

232

Donati 1988
Piero Donati. *Le sette opere di misericordia di Cornelio de Wael.* Genoa, 1988.

Duverger 1977
Erik Duverger. "J. B. Van Caukercken S. J. (1675–1755), auteur van de Beschrijving van de Zolderstukken van Rubens in de Jezuïetenkerk te Antwerpen." *Jaarboek van het Koninklijk Museum voor schone Kunsten, Antwerpen*, 1977, pp. 281–90.

Duverger 1984
Erik Duverger. *Antwerpse kunstinventarissen uit de zeventiende eeuw (Fontes Historiae Artis Neerlandicae).* 6 vols. Brussels, 1984 ff.

Edinburgh 1970
Colin Thompson and Hugh Brigstocke. *National Gallery of Scotland. Shorter Catalogue.* Edinburgh, 1970.

Ember 1978
Ildiko Ember. "Un Paysage de Jacques Foucquier au musée des Beaux Arts." *Bulletin du musée hongrois des Beaux-Arts* 50, 1978, pp. 63–72.

Ertz 1979
Klaus Ertz. *Jan Brueghel der Ältere (1568–1628). Die Gemälde mit kritischem Oeuvrekatalog.* Cologne, 1979.

Evers 1944
Hans Gerhard Evers. *Rubens und sein Werk. Neue Forschungen.* Brussels, 1944.

Fehl 1987
Philipp P. Fehl. "The Ghost of Homer. Observations on Rubens's *Portrait of the Earl of Arundel.*" *Fenway Court, Isabella Stewart Gardner Museum*, 1987 (1988), pp. 7–23.

Félibien 1688
André Félibien. *Entretiens sur les vies et les ouvrages des plus excellens peintres anciens et modernes.* Paris, 1688.

Flechsig 1923
E. Flechsig. *Zeichnungen alter Meister im Landesmuseum in Braunschweig.* Frankfurt, 1923.

Foucart 1980
Jacques Foucart. "Alexandre et Diogène, une grisaille d'Anthoni Sallarts." *Bulletin des amis du Musée de Rennes* 4, 1980, pp. 8–16.

Freedberg 1984
David Freedberg. *Rubens. The Life of Christ after the Passion.* Corpus Rubenianum Ludwig Burchard. Part VII. New York, 1984.

Garff and Pedersen 1988
Jan Garff and Eva de la Fuente Pedersen. *Rubens Cantoor. The Drawings of Willem Panneels. A Critical Catalogue.* 2 vols. Copenhagen (Royal Museum of Fine Arts, Department of Prints and Drawings), 1988.

Glück 1933
Gustav Glück. *Rubens, Van Dyck und ihr Kreis.* Vienna, 1933.

Goldner 1988
George R. Goldner with the assistance of Lee Hendrix and Gloria Williams. *European Drawings, 1. Catalogue of the Collections.* Malibu, 1988.

Goldner and Hendrix 1992
George R. Goldner and Lee Hendrix with the assistance of Kelly Pask. *European Drawings, 2. Catalogue of the Collections.* Malibu, 1992.

Goossens 1977
Korneel Goossens. *David Vinckboons.* Soest, 1977 (reprint of ed. 1954).

Goovaerts 1902
Léon Goovaerts. *Ecrivains, artistes et savants de l'ordre de Prémontré*. Brussels, 1902.

Greindl 1956
Edith Greindl. *Les peintres flamands de nature morte au XVIIe siècle*. Brussels, 1956.

Greindl 1983
Edith Greindl. *Les peintres flamands de nature morte au XVIIe siècle*. Paris, 1983.

Härting 1983
Ursula Alice Härting. *Studien zur Kabinettbildmalerei des Frans Francken II (1581–1642)*. Hildesheim/Zurich/New York, 1983.

Härting 1989
Ursula Härting. *Frans Francken der Jüngere (1581–1642). Die Gemälde mit kritischem Oeuvrekatalog*. Flämische Maler im Umkreis der grossen Meister, 2. Freren, 1989.

Haskell and Penny 1981
Francis Haskell and Nicholas Penny. *Taste and the Antique. The Lure of Classical Sculpture 1500–1900*. New Haven, 1981.

Haverkamp-Begemann et al. 1964
Egbert Haverkamp-Begemann, Standish D. Lawder, and Charles E. Talbot Jr. *Drawings from the Clark Art Institute*. New Haven, 1964.

Haverkamp-Begemann and Logan 1970
Egbert Haverkamp-Begemann and Anne-Marie S. Logan. *European Drawings and Watercolors in the Yale University Art Gallery, 1500–1900*. New Haven, 1970.

Haverkamp-Begemann 1975
Egbert Haverkamp-Begemann. *The Achilles Series*. Corpus Rubenianum Ludwig Burchard. Part X. Brussels, 1975.

Held 1940
Julius S. Held. "Jordaens' Portraits of his Family." *Art Bulletin* XXII, 1940, pp. 7–82.

Held 1956
Julius S. Held. Review of exhibition, Cambridge, Massachusetts/New York, 1956. *Drawings and Oil Sketches by Rubens from American Collections. Burlington Magazine* XCVIII, 1956, pp. 123–24.

Held 1959
Julius S. Held. *Rubens. Selected Drawings, with an Introduction and a Critical Catalogue*. 2 vols. London, 1959. See Held 1986.

Held 1967
Julius S. Held. "Jan van Boeckhorst as Draughtsman." *Bulletin, Musées Royaux des Beaux-Arts de Belgique* XVI, 1967, pp. 137–54.

Held 1974
Julius S. Held. "Some Rubens Drawings— Unknown or Neglected." *Master Drawings* XII, 1974, pp. 249–60.

Held 1980
Julius S. Held. *The Oil Sketches of Peter Paul Rubens. A Critical Catalogue*. 2 vols. Princeton, 1980.

Held 1982
Julius S. Held. "Padre Resta's Rubens Drawings after Ancient Sculpture." In *Rubens and his Circle. Studies by Julius S. Held*. Edited by Anne W. Lowenthal, David Rosand, and John Walsh, Jr. Princeton, 1982, pp. 94–105 (reprinted from *Master Drawings* II, 1964, pp. 123–141).

Held 1986
Julius S. Held. *Rubens. Selected Drawings*. Mt. Kisco, New York, 1986. See Held 1959.

Held 1989
Julius S. Held. "More on Gaspar de Crayer." *Master Drawings* XXVII, 1989, pp. 53–63.

Held 1991
Julius S. Held. Review of Jan Garff and Eva
de la Fuente Pedersen. *Rubens Cantoor.*
The Drawings of Willem Panneels. A Critical
Catalogue, 1988. *Master Drawings* XXIX,
1991, pp. 416–30.

Held 1993
Julius S. Held. Review of Felice Stampfle, with
the assistance of Ruth S. Kraemer and Jane
Shoaf Turner, *Netherlandish Drawings of the*
Fifteenth and Sixteenth Centuries and Flemish
Drawings of the Seventeenth and Eighteenth
Centuries in the Pierpont Morgan Library, 1991.
Master Drawings XXXI, 1993.

Hensbroeck-van der Poel 1986
D. B. Hensbroeck-van der Poel. Review of
David W. Steadman, *Abraham van Diepenbeeck*,
1982. *Oud-Holland* C, 1986, pp. 206–08.

Hervey 1921
M. F. S. Hervey. *The Life, Correspondence and*
Collections of Thomas Howard Earl of Arundel.
Cambridge, 1921.

Hind 1923
Arthur M. Hind. *Catalogue of Drawings*
by Dutch and Flemish Artists Preserved in the
Department of Prints and Drawings in the
British Museum. Vol. II. Drawings by Rubens,
Van Dyck and Other Artists of the Flemish
School of the XVII Century. London, 1923.

Höper 1987
Corinna Höper. *Bartolomeo Passarotti*
(1529–1592). Worms, 1987.

Hollstein
F. W. H. Hollstein. *Dutch and Flemish Etchings,*
Engravings and Woodcuts ca. 1450–1700. vol. I–.
Amsterdam, 1949–.

Howarth 1985
David Howarth. *Lord Arundel and his Circle.*
New Haven, 1985.

Huemer 1977
Frances Huemer. *Portraits.* Corpus
Rubenianum Ludwig Burchard. Part XIX, vol. I.
Brussels, 1977.

d'Hulst 1974
Roger-A. d'Hulst. *Jordaens Drawings.* 4 vols.
London, 1974.

d'Hulst 1982
Roger-A. d'Hulst. *Jacob Jordaens.* Ithaca,
New York, 1982.

d'Hulst and Vandenven 1989
Roger-A. d'Hulst and M. Vandenven.
Rubens. The Old Testament. Corpus
Rubenianum Ludwig Burchard. Part III.
Oxford, 1989.

Jaffé 1963
Michael Jaffé. "Cleveland Museum of Art.
The Figurative Arts of the West c. 1400–1800."
Apollo LXXVIII, 1963, p. 457–67.

Jaffé 1966
Michael Jaffé. *Van Dyck's Antwerp Sketchbook.*
2 vols. London, 1966.

Jaffé 1970
Michael Jaffé. "Some Recent Acquisitions
of Seventeenth-Century Flemish Painting."
National Gallery of Art. Report and Studies
in the History of Art, 1969. Washington, D.C.,
1970, pp. 7–33.

Jaffé 1971
Michael Jaffé. "Figure Drawings Attributed
to Rubens, Jordaens, and Cossiers in
the Hamburg Kunsthalle." *Jahrbuch der*
Hamburger Kunstsammlungen XVI, 1971,
pp. 39–50.

Jaffé 1977
Michael Jaffé. *Rubens and Italy.* Oxford, 1977.

Jaffé 1987
Michael Jaffé. "Rubens's Anatomy Book."
In sales catalogue *Old Master Drawings,*
Christie's, London, 6 July 1987, pp. 58–83.

Jaffé 1989
Michael Jaffé. *Rubens. Catalogo Completo.*
Rome, 1989.

Judson and Van de Velde 1978
J. Richard Judson and Carl Van de Velde.
Book Illustrations and Title-Pages. Corpus
Rubenianum Ludwig Burchard. Part XXI.
2 vols. London, 1978.

Junquera de Vega and Diaz Gallegos 1986
Paulina Junquera de Vega and Carmen Diaz
Gallegos. *Catálogo de tapices del Patrimonio
nacional, II, Siglo XVII.* Madrid, 1986.

KdK
Rudolf Oldenbourg. *P.P. Rubens. Des Meisters
Gemälde. Klassiker der Kunst, V.* Stuttgart, 1921.

Kettering 1983
Alison McNeil Kettering. *The Dutch Arcadia.
Pastoral Art and Its Audience in the Golden Age.*
Montclair, New Jersey, 1983.

Keyes 1977
George Keyes. "Still Life Drawings by Fyt
and Snyders." *Burlington Magazine* CXIX, 1977,
pp. 311–12.

Koslow 1992
Susan Koslow. Review of Hella Robels, *Frans
Snyders,* 1989. *Kunstchronik* 45, 1992, pp. 163–69.

L.
Frits Lugt. *Les marques de collections de dessins
et d'estampes.* Amsterdam, 1921. *Supplément.*
The Hague, 1956.

Lahrkamp 1982
Helmut Lahrkamp. "Der 'Lange Jan'. Leben
und Werk des Barockmalers Johann Bockhorst
1604–1668." *Zeitschrift Westfalen* LX, 1982,
pp. 3–184.

Larsen 1975
Erik Larsen. "La vie, les ouvrages, et les élèves
de Van Dyck." *Académie royale de Belgique,
Mémoires de la classe des beaux-arts* 14,
Brussels, 1975, pp. 7–19.

Larsen 1988
Erik Larsen. *The Paintings of Anthony van Dyck.*
Freren, 1988.

Laureyssens 1967
Willy Laureyssens. "De samenwerking van
Hendrik De Clerck met Denijs van Alsloot."
*Bulletin Musées Royaux des Beaux-Arts de
Belgique* 16, 1967, pp. 163–77.

Leppert 1978
Richard D. Leppert. "David Teniers the
Younger and the Image of Music." *Jaarboek van
het Koninklijk Museum voor schone Kunsten,
Antwerpen,* 1978, pp. 63–155.

Logan 1972
Anne-Marie Logan. "Two Armored Soldiers
Fighting, a late drawing by Peter Paul Rubens."
Yale University Art Gallery Bulletin XXXIV,
1972, pp. 16–18.

Logan 1976–78
Anne-Marie Logan. "Some Early Drawings
by Rubens." *Gentse Bijdragen* XXIV, 1976–78,
pp. 104–12.

Logan 1977
Anne-Marie Logan. "Three Drawings by
Johann Boeckhorst." *Master Drawings* XV, 1977,
pp. 162–66.

235

Logan 1978
Anne-Marie Logan. "Rubens Exhibitions, 1977–1978." *Master Drawings* XVI, 1978, pp. 419–50.

Logan and Haverkamp-Begemann 1978
Anne-Marie Logan and Egbert Haverkamp-Begemann. "Dessins de Rubens." *Revue de l'art* XLII, 1978, pp. 89–99.

Logan 1987
Anne-Marie Logan. Review of Julius S. Held, *Rubens. Selected Drawings*, 1986. *Master Drawings* XXV, 1987, pp. 63–82.

Los Angeles 1954
Los Angeles County Museum. *A Catalogue of Flemish, German, Dutch and English Paintings, XV–XVIII Century.* Los Angeles, 1954.

Lugt 1949
Frits Lugt. *Musée du Louvre. Inventaire général des dessins des écoles du nord. École flamande.* 2 vols. Paris, 1949.

Macandrew 1983
Hugh Macandrew. *Italian Drawings in the Museum of Fine Arts, Boston.* Boston, 1983.

Magurn 1991
Ruth Saunders Magurn, ed. and trans. *The Letters of Peter Paul Rubens.* Evanston, Illinois, 1991 (reprint of ed. 1955).

Mariette 1851–60
P. J. Mariette. *Abécédario de P. J. Mariette, et autres notes inédites de cet amateur sur les arts et les artistes, publié d'après les manuscrits autographes....* Compiled 1740–70. Edited and published by Philippe de Chennevières and Anatole de Montaiglon. 6 vols. In *Archives de l'art français*, vols. II, IV, VI, VIII, X, XII. Paris, 1851–60.

Martin 1968
John R. Martin. *The Ceiling Paintings for the Jesuit Church in Antwerp.* Corpus Rubenianum Ludwig Burchard. Part I. Brussels, 1968.

Martin 1969
John R. Martin. *Rubens, The Antwerp Altarpieces. The Raising of the Cross and The Descent from the Cross.* New York, 1969.

Martin 1970
Gregory Martin. *National Gallery Catalogues. The Flemish School, circa 1600–circa 1900.* London, 1970 (reprint London, 1986).

Martin 1972
John R. Martin. *The Decoration for the Pompa Introitus Ferdinandi.* Corpus Rubenianum Ludwig Burchard. Part XVI. Brussels, 1972.

Mather 1914
Frank Jewett Mather, Jr. "Drawings by Old Masters at Bowdoin College Ascribed to Northern Schools. II." *Art in America* II, 1913–14, pp. 108–15.

Mauquoy-Hendrickx 1991
Marie Mauquoy-Hendrickx. *L'Iconographie d'Antoine van Dyck. Catalogue raisonné.* 2 vols. Brussels (Bibliothèque royale Albert I), 1991.

McAllister Johnson 1968
W. McAllister Johnson. "From Favereau's *Tableaux des Vertus et des Vices* to Marolle's *Tableaux du Temple des Muses.* A Conflict between the Franco-Flemish Schools in the Second Quarter of the Seventeenth Century." *Gazette des Beaux-Arts* LXXII, 1968, pp. 171–90.

McGrath 1991
Elizabeth McGrath. "'Not even a fly'. Rubens and the mad emperors." *Burlington Magazine* CXXXIII, 1991, pp. 699–703.

McGrath 1991 (A)
Elizabeth McGrath. Review of Konrad Renger, *Peter Paul Rubens. Altäre für Bayern*, 1990. *Burlington Magazine* CXXXIII, 1991, pp. 717–19.

Van der Meulen 1975
Marjon Van der Meulen. *Petrvs Pavlvs Antiqvarivs. Collector and Copyist of Antiqve Gems.* Alphen aan den Rijn, 1975.

Michiels 1869
Alfred Michiels. *Histoire de la Peinture Flamande.* Paris, 1869.

Mongan and Sachs 1940
Agnes Mongan and Paul J. Sachs. *Drawings in the Fogg Museum of Art.* 2 vols. Cambridge, 1940.

Muller 1989
Jeffery M. Muller. *Rubens. The Artist as Collector.* Princeton, 1989.

Müller Hofstede 1968
Justus Müller Hofstede. "Zur Kopfstudie im Werk von Rubens." *Wallraf-Richartz Jahrbuch* XXX, 1968, pp. 223–52.

Müller Hofstede 1973
Justus Müller Hofstede. "New Drawings by Van Dyck." *Master Drawings* XI, 1973, pp. 154–59.

Nelson 1985–86
Kristi Nelson. "Jacob Jordaens' Drawings for Tapestry." *Master Drawings* XXIII–XXIV, 1985–86, pp. 435–54.

Nelson 1990
Kristi Nelson. "Jacob Jordaens. Family Portraits." *Leids Kunsthistorisch Jaarboek* VIII, 1990, pp. 105–119.

Ovid
Ovid. *Metamorphoses.* Translated by Frank Justus Miller. 2 vols. Loeb Classical Library. Cambridge, Massachusetts, 1946.

Pacheco 1649
Francisco Pacheco. *Arte de la pintura.* Madrid, 1649. (Edition by F. J. Sánchez Cantón, Madrid, 1956, based on original manuscript completed in 1638.)

Parker 1928
Karl T. Parker. "Some Drawings by Rubens and His School in the Collection of Mrs. G. W. Wrangham." *Old Master Drawings* III, 1928, pp. 1–2.

Parry 1981
Graham Parry. *The Golden Age restor'd. The culture of the Stuart Court, 1603–42.* New York, 1981.

Pilo 1990
Giuseppe M. Pilo. *Rubens e l'eredità veneta.* Rome, 1990.

Porcher n.d.
Jean Porcher. *Les Très Riches Heures du Duc de Berry.* Paris, n.d.

RKD
Rijksbureau voor Kunsthistorische Documentatie (Netherlands Institute for Art History). The Hague, The Netherlands.

Ring 1949
Grete Ring. *A Century of French Painting 1400–1500.* New York, 1949.

Robels 1989
Hella Robels. *Frans Snyders. Stilleben-und Tiermaler 1579–1657.* Munich, 1989.

Rosand 1969
David Rosand. "Rubens's Munich Lion Hunt. Its Sources and Significance." *Art Bulletin* LI, 1969, pp. 29–40.

Rosenberg 1956
Jakob Rosenberg. Review of exhibition,
Cambridge, Massachusetts/New York, 1956.
*Drawings and Oil Sketches by Rubens from
American Collections. Art Quarterly* XIX,
1956, pp. 139–42.

Rubenianum
Kunsthistorische Musea, Rubenianum.
Antwerp, Belgium.

Saint Louis 1975
*The Saint Louis Art Museum. Handbook of
Collections.* Saint Louis, Missouri, 1975.

Salerno 1960
Luigi Salerno. "The Picture Gallery
of Vincenzo Giustiniani. II. The Inventory."
Burlington Magazine CII, 1960, pp. 102–03.

Schapelhouman 1979
Marijn Schapelhouman. *Oude tekeningen in het
bezit van de Gemeentemusea van Amsterdam
waaronder de collectie Fodor. Vol. II. Tekeningen
van Noord-en Zuidnederlandse kunstenaars
geboren voor 1600.* Amsterdam, 1979.

Schnackenburg 1985
Bernhard Schnackenburg. *Flämische Meister in
der Kasseler Gemäldegalerie.* Cassel, 1985.

Scott 1980
Margaret Scott. *Late Gothic Europe, 1400–1500.*
The History of Dress Series.
London/Sydney/Toronto, 1980.

Seilern 1971
Count Antoine Seilern. *Corrigenda & Addenda
to the Catalogue of Paintings & Drawings
at 56 Princes Gate London SW7.* London, 1971.

Seitz and Lidel 1983
Reinhard H. Seitz and Albert Lidel.
*Die Hofkirche Unserer Lieben Frau zu Neuburg
an der Donau.* Weissenhorn, 1983.

von Simson 1990
Otto von Simson. "Der christliche Seneca."
Frankfurter Allgemeine Zeitung, no. 149,
30 June 1990.

Spicer 1993
Joaneath A. Spicer. "Anthony van Dyck's
Iconography. An Overview of Its Preparation."
In *Van Dyck 350*, Susan J. Barnes and Arthur K.
Wheelock, Jr., eds. *Studies in the History
of Art* 47, National Gallery of Art, Washington,
D.C., 1993.

Stampfle 1991
Felice Stampfle with the assistance of Ruth
S. Kraemer and Jane Shoaf Turner.
*Netherlandish Drawings of the Fifteenth and
Sixteenth Centuries and Flemish Drawings
of the Seventeenth and Eighteenth Centuries
in the Pierpont Morgan Library.*
New York/Princeton, 1991.

Steadman 1982
David W. Steadman. *Abraham van Diepenbeeck,
Seventeenth-Century Painter.* Ann Arbor, 1982.

Stechow 1948
Wolfgang Stechow. "Drawings and Etchings
by Jacques Foucquier." *Gazette des Beaux-Arts*
XXXIV, 1948, pp. 419–34.

Stechow 1976
Wolfgang Stechow. *Catalogue of Drawings and
Watercolors in the Allen Memorial Art Museum,
Oberlin College.* Oberlin, Ohio, 1976.

Van der Stighelen 1989
Katlijne Van der Stighelen. "Cornelis de Vos as
a Draughtsman." *Master Drawings* XXVII, 1989,
pp. 322–40.

Van der Stighelen 1991
Katlijne Van der Stighelen. Review of Zirka
Zaremba Filipczak, *Picturing art in Antwerp,*
1987. Simiolus 20, 1991, pp. 293–98.

Van der Stighelen 1993
Katlijne Van der Stighelen. "Young Anthony.
Archival Evidence on Van Dyck's Early Years."
In *Van Dyck 350*, Susan J. Barnes and
Arthur K. Wheelock, Jr., eds. *Studies in the
History of Art* 47, National Gallery of Art,
Washington, D.C., 1993.

Van Tatenhove 1983
J. van Tatenhove. "Enkele tekeningen en
monotypieën van Anthonis Sallaert
(ca. 1590–1650)." *Leids Kunsthistorisch Jaarboek,
(Art in Denmark 1600–1650)* 2, 1983, pp. 243–50.

Van Tatenhove 1989
J. van Tatenhove. "Abraham van Diepenbeeck
(1596–1675)." *Delineavit et Sculpsit* 2,
1989, p. 34.

Valentiner 1950
W. R. Valentiner. "Rinaldo and Armida by Van
Dyck." *Quarterly Los Angeles County Museum*
8, no. 1, 1950, pp. 8–10.

Van de Velde 1983
Carl Van de Velde. "Een tekening van Filips
Fruytiers voor het Stedelijk Prentenkabinet."
Cultureel Jaarboek Stad Antwerpen I, 1983, p. 33.

Van den Wijngaert 1940
Frank Van den Wijngaert. *Inventaris der
rubeniaansche prentkunst.* Antwerp, 1940.

Van den Wijngaert 1943
Frank Van den Wijngaert. *Antoon van Dyck.*
Antwerp, 1943.

Varshavskaya 1989
Maria Varshavskaya (updated by Natalia
Gritsai), Xenia Yegorova and Yelena Roslavets.
*Peter Paul Rubens. Paintings from Soviet
Museums.* Leningrad, 1989.

Vey 1962
Horst Vey. *Die Zeichnungen Anton van Dycks.*
2 vols. Brussels, 1962.

Vlieghe 1966
Hans Vlieghe. "David II Teniers (1610–1690)
en het hof van aartshertog Leopold-Wilhelm
en Don Juan van Oostenrijk—1647–1659."
Gentse Bijdragen XIX, 1961–66, pp. 123–48.

Vlieghe 1972
Hans Vlieghe. *Gaspar de Crayer. Sa vie et ses
œuvres.* Brussels, 1972.

Vlieghe 1976
Hans Vlieghe. "Een Pastorale door Gerard
Seghers." *Jaarboek van het Koninklijk Museum
voor schone Kunsten, Antwerpen,* 1976,
pp. 297–304.

Vlieghe 1977
Hans Vlieghe. "Zu den römischen Jahren des
Malers Cornelis Schut." *Mitteilungen des
kunsthistorischen Institutes in Florenz* XV, 1977,
pp. 207–18.

Vlieghe 1979–80
Hans Vlieghe. "Gaspar de Crayer, Addenda
et Corrigenda." *Gentse Bijdragen tot de
Kunstgeschiedenis* XXV, 1979–80, pp. 158–207.

Vlieghe 1983
Hans Vlieghe. "The Identity of the Painter of
the Cardiff Cartoons. A Proposal." *Burlington
Magazine* CXXV, 1983, pp. 350–56.

Vlieghe 1987
Hans Vlieghe. *Rubens Portraits of Identified
Sitters Painted in Antwerp.* Corpus Rubenianum
Ludwig Burchard. Part XIX, vol. II.
London, 1987.

Vlieghe 1987 (A)
Hans Vlieghe. "The Cardiff cartoons.
Boeckhorst, after all." *Burlington Magazine*
CXXIX, 1987, pp. 598–99.

Vlieghe 1990
Hans Vlieghe. "Cornelis Schut in Italy."
Mercury 11, 1990, pp. 28–41.

Volk 1981
Mary Crawford Volk. "Rubens in Madrid and
the Decoration of the King's Summer
Apartments." *Burlington Magazine* CXXIII,
1981, pp. 513–29.

Wegner 1961
Wolfgang Wegner. "Zeichnungen von Denis
van Alsloot." *Oud-Holland* LXXVI, 1961,
pp. 206–07.

Wegner 1973
Wolfgang Wegner. *Kataloge der Staatlichen
Graphischen Sammlung, München. Die
niederländischen Handzeichnungen des 15.–18.
Jahrhunderts.* 2 vols. Berlin, 1973.

Wegner and Pée 1980
Wolfgang Wegner and Herbert Pée. "Die
Zeichnungen des David Vinckboons."
Münchner Jahrbuch der bildenden Kunst XXXI,
3. Folge, 1980, pp. 35–128.

Wethey 1971
Harold E. Wethey. *The Paintings of Titian,*
vol. II, *The Portraits.* London, 1971.

Wethey 1975
Harold E. Wethey. *The Paintings of Titian,*
vol. III, *The Mythological and Historical
Paintings.* London, 1975.

Weyerman 1729
J. Campo Weyerman. *De levens-beschrijvingen
der Nederlandsche konst-schilders en
konst-schilderessen.* 's-Gravenhage, 1729.

White 1987
Christopher White. *Peter Paul Rubens. Man
and Artist.* New Haven, 1987.

Wilmers 1991
Ida Gertrude Wilmers. *The Paintings of
Cornelis Schut The Elder (1597–1655).* Ph.D. diss.,
Columbia University, 1991.

Winner 1972
Matthias Winner. "Neubestimmtes und
Unbestimmtes im zeichnerischen Werk von Jan
Brueghel d.Ä." *Jahrbuch der Berliner Museen*
N.F. XIV, 1972, pp. 122–60.

Wood 1990
Jeremy Wood. "Padre Resta's Flemish
Drawings. Van Diepenbeeck, Van Thulden,
Rubens, and the School of Fontainebleau."
Master Drawings XXVIII, 1990, pp. 3–53.

EXHIBITION CATALOGUES

Amsterdam 1933
Amsterdam, Kunsthandel J. Goudstikker.
Rubens-Tentoonstelling, 1933.

Antwerp 1899
Antwerp, Museum van Schoone Kunsten.
Van Dyck Tentoonstelling, 1899.

Antwerp 1954
Antwerp, Koninklijk Museum voor Schone
Kunsten. *De Madonna in de Kunst*, 1954.

Antwerp 1956
Antwerp, Rubenshuis. *Tekeningen van P. P.
Rubens*, cat. by Ludwig Burchard and Roger-A.
d'Hulst, 1956.

Antwerp 1960
Antwerp, Rubenshuis; Rotterdam, Museum
Boymans-van Beuningen. *Antoon van Dyck.
Tekeningen en oliverfschetsen*, cat. by R.-A.
d'Hulst and Horst Vey, 1960.

Antwerp 1966
Antwerp, Rubenshuis; Rotterdam, Museum
Boymans-van Beuningen. *Tekeningen van Jacob
Jordaens 1593–1678*, cat. by R.-A. d'Hulst, 1966.

Antwerp 1971
Antwerp, Rubenshuis. *Rubens en zijn tijd*, 1971.

Antwerp 1977
Antwerp, Museum of Fine Arts. *P. P. Rubens.
Paintings-Oil Sketches-Drawings*, 1977.

Antwerp 1988–89
Antwerp, Rubenshuis and Rockoxhuis.
*Antwerps huiszilver uit de 17ᵉ en 18ᵉ eeuw; Zilver
uit de gouden eeuw van Antwerpen*, cat. by Piet
Baudouin and Godelieve Van Hemeldonck,
1988–89.

Antwerp/Münster 1990
Antwerp, Rubenshuis; Münster, Westfälisches
Landesmuseum für Kunst und
Kulturgeschichte. *Jan Boeckhorst 1604–1668*, 1990.

Antwerp 1991
Antwerp, Koninklijk Museum voor Schone
Kunsten. *David Teniers the Younger. Paintings,
Drawings*, cat. by Margret Klinge, 1991.

Antwerp 1991 (A)
Antwerp, Museum Plantin-Moretus and
Stedelijk Prentenkabinet. *Antoon van Dyck
(1599–1641) & Antwerpen*, cat. by Alfred Moir,
Francine de Nave and Carl Depauw, 1991.

Binghamton 1970
Binghamton, New York, University Art Gallery,
State University of New York, and elsewhere.
*Selections from the Drawing Collection of
Mr. and Mrs. Julius S. Held*, 1970.

Bristol 1937
Art Treasures of the West Country, Royal West
of England Academy, Bristol, 1937.

Brunswick, Maine 1985
Brunswick, Maine, Bowdoin College Museum
of Art. *Old Master Drawings at Bowdoin
College*, cat. by David P. Becker, 1985.

Brussels 1965
Brussels, Musées Royaux des Beaux-Arts de
Belgique. *Le siècle de Rubens*, 1965.

Brussels 1977
Brussels, Musées Royaux d'Art et d'Histoire.
Tapisseries bruxelloises au siècle de Rubens, 1977.

Brussels 1980
Brussels, Palais des Beaux-Arts.
Bruegel. Une dynastie de peintres, 1980.

Buffalo 1935
Buffalo, New York, Albright Art Gallery.
*Master Drawings Selected from the Museums
and Private Collections of America*, 1935.

Cambridge, Massachusetts/New York 1956
Cambridge, Massachusetts, Fogg Art Museum;
New York, The Pierpont Morgan Library.
*Drawings & Oil Sketches by P. P. Rubens from
American Collections*, cat. by Agnes Mongan
and Felice Stampfle, 1956.

Cambridge, Massachusetts/New York 1966
Cambridge, Massachusetts, Fogg Art Museum;
New York, Museum of Modern Art.
*Memorial Exhibition. Works of Art from the
Collection of Paul J. Sachs [1878–1965]*, cat. by
Agnes Mongan, 1965–66.

Cambridge, Massachusetts 1974
Cambridge, Massachusetts, Fogg Art Museum.
Flemish Drawings, 1974.

Cambridge, Massachusetts 1977
Cambridge, Massachusetts, Fogg Art Museum.
*Renaissance and Baroque Drawings from
the Collections of John and Alice Steiner*, ed. by
Konrad Oberhuber, 1977.

Cambridge, Massachusetts 1980
Cambridge, Massachusetts, Department of
Printing and Graphic Arts, Houghton Library,
Harvard University. *Drawings for Book
Illustration. The Hofer Collection*, cat. by
David P. Becker, 1980.

Cleveland 1980
Cleveland, Cleveland Museum of Art. *Idea to
Image*, cat. by Mark M. Johnson, 1980.

Cologne 1977
Cologne, Wallraf-Richartz-Museum. *Peter Paul
Rubens*, 1977. Cologne/Antwerp/Vienna 1992–93.

Cologne 1992–93
Cologne, Wallraf-Richartz-Museum; Antwerp,
Koninklijk Museum voor Schone Kunsten;
Vienna, Kunsthistorisches Museum. *Von
Bruegel bis Rubens*, cat. edited by Ekkehard
Mai and Hans Vlieghe, 1992–93.

Detroit 1936
Detroit, The Detroit Institute of Arts.
Peter Paul Rubens, cat. by W. R. Valentiner, 1936.

Hamburg 1985
Hamburg, Thomas Le Claire.
*Handzeichnungen alter Meister 1500–1800,
III*, 1985.

Hartford/Hanover/Boston 1973
Hartford, Wadsworth Atheneum; Hanover,
Dartmouth College, Hopkins Center Art
Galleries; Boston, Museum of Fine Arts.
*One Hundred Master Drawings from
New England Private Collections*, cat. by
Franklin W. Robinson, 1973.

's-Hertogenbosch/Strasbourg 1991–92
's-Hertogenbosch, Noordbrabants Museum;
Strasbourg, Musées des Beaux-Arts.
*Theodoor van Thulden. Een Zuidnederlandse
barokschilder 1606–1669*, cat. by Alain Roy,
1991–92.

London 1877–78
London, Grosvenor Gallery. *Drawings by the
Old Masters, and Water Colour Drawings by
Deceased Artists of the British School*, 1877–78.

London 1900
London, Royal Academy of Arts. *Exhibition of
Works by Van Dyck*, 1900.

London 1938
London, Royal Academy of Arts. *17th Century
Art in Europe*, 1938.

London 1950
London, Wildenstein and Co. *A Loan Exhibition of Works by Peter Paul Rubens*, cat. by Ludwig Burchard, 1950.

London 1953
London, Royal Academy of Arts. *Drawings by Old Masters*, cat. by K. T. Parker and J. Byam Shaw, 1953.

London 1953 (A)
London, Arts Council. *Watercolours and Drawings from the Bradfer-Lawrence Collection*, 1953.

London 1953–54
London, Royal Academy of Arts. *Flemish Art, 1300–1700*, 1953–54.

London 1962
London, Arts Council. *Old Master Drawings from the Collection of Mr. C. R. Rudolf*, 1962.

London 1964
London, Colnaghi. *Old Master Drawings*, 1964.

London 1972
London, Tate Gallery. *The Age of Charles I*, cat. by Oliver Millar, 1972.

London 1973
London, Victoria and Albert Museum. *Old Master Drawings from Chatsworth*, 1973.

London 1977
London, British Museum. *Rubens. Drawings and Sketches*, cat. by John Rowlands, 1977.

London 1981–82
London, Victoria and Albert Museum. *Splendours of the Gonzaga*, cat. edited by David Chambers & Jane Martineau, 1981–82.

London 1986
London, Baskett and Day. *Old Master Drawings of the French School 1480–1880*, 1986.

London/New Haven 1987
London, The British Museum; New Haven, Yale Center for British Art. *Drawing in England from Hilliard to Hogarth*, cat. by Lindsay Stainton and Christopher White, 1987.

Los Angeles 1976
Los Angeles, Los Angeles County Museum of Art. *Old Master Drawings from American Collections*, cat. by Ebria Feinblatt, 1976.

Munich 1990
Munich, Bayerische Staatsgemäldesammlungen. *Peter Paul Rubens. Altäre für Bayern*, cat. by Konrad Renger, 1990.

New York 1959
New York, Knoedler & Co. *Great Masters of Seven Centuries*, 1959.

New York 1959–61
New York, The Cooper Union Museum (circulated by The American Federation of Arts). *Five Centuries of Drawing. The Cooper Union Centennial Exhibition*, 1959–61.

New York 1966–67
New York, American Federation of Arts. *17th & 18th Century European Drawings*, cat. by Richard Wunder, 1966–67.

New York 1970
New York, The Metropolitan Museum of Art. *Flemish Drawings & Prints of the 17th Century*, 1970.

New York 1975
New York, The Pierpont Morgan Library. *Drawings from the Collection of Mr. and Mrs. Eugene V. Thaw*, cat. by Felice Stampfle and Cara D. Denison, 1975.

New York 1979
New York, The Metropolitan Museum of Art, The Robert Lehman Collection. *Seventeenth-Century Dutch and Flemish Drawings from the Robert Lehman Collection*, cat. by G. Szabo, 1979.

New York 1979–80
New York, The Pierpont Morgan Library.
Rubens and Rembrandt in Their Century.
Flemish and Dutch Drawings of the 17th
Century from The Pierpont Morgan Library,
cat. by Felice Stampfle, 1979–80.

New York 1981
New York, The Pierpont Morgan Library.
European Drawings, 1375–1825, cat. by
Cara D. Denison and Helen B. Mules with the
assistance of Jane V. Shoaf, 1981.

New York/Maastricht 1982
New York/Maastricht, Noortman & Brod.
Adriaen Brouwer and David Teniers the
Younger, cat. by Margret Klinge, 1982.

New York 1985
New York, The Pierpont Morgan Library.
Drawings from the Collection of Mr. and Mrs.
Eugene Victor and Clare Thaw, cat. by Cara
D. Denison, William W. Robinson, Julia Herd
and Stephanie Wiles, 1985.

New York/London 1986
New York, The Drawing Center; London, The
Courtauld Institute Galleries. *The Northern*
Landscape. Flemish, Dutch, and British
Drawings from the Courtauld Collections, cat.
by Dennis Farr and William Bradford, 1986.

New York/London 1987
New York and London, Richard Day, Ltd.
An Exhibition of Old Master Drawings, 1987.

New York 1988
New York, The Drawing Center. *Creative*
Copies. Interpretive Drawings from
Michelangelo to Picasso, cat. by Egbert
Haverkamp-Begemann with Carolyn
Logan, 1988.

New York 1990
New York, Colnaghi. *Master Drawings*, 1990.

New York 1991
New York, The Frick Collection.
From Pontormo to Seurat. Drawings Recently
Acquired by The Art Institute of Chicago, 1991.

New York/Fort Worth 1991
New York, The Pierpont Morgan Library;
Fort Worth, The Kimbell Art Museum.
The Drawings of Anthony van Dyck, cat. by
Christopher Brown, 1991.

Norfolk 1979
Norfolk, Chrysler Museum. *One Hundred*
Drawings in the Chrysler Museum at Norfolk,
cat. by Eric M. Zafran, 1979.

Ottawa 1968–69
Ottawa, National Gallery of Canada.
Jacob Jordaens, 1593–1678, cat. by Michael Jaffé,
1968–69.

Paris 1972
Paris, Institut Néerlandais and elsewhere.
Flemish Drawings of the Seventeenth Century
from the Collection of Frits Lugt, cat. by
Carlos van Hasselt, 1972.

Paris 1977
Paris, Grand Palais. *Le siècle de Rubens*, cat. by
Jacques Foucart, 1977.

Paris 1977 (A)
Paris, Institut Néerlandais, Collection Frits
Lugt. *Le Cabinet d'un Amateur. Dessins*
flamands et hollandais des XVIᵉ et XVIIᵉ siècles
d'une collection privée d'Amsterdam, cat. by
M. J. Giltay, 1977.

Paris 1985
Paris, Galerie de Bayser. *Dessins de maîtres*
anciens, 1985.

Princeton 1972
Princeton, The Art Museum, Princeton
University. *Rubens Before 1620*, cat. edited by
John Rupert Martin, 1972.

Princeton 1979
Princeton, The Art Museum, Princeton
University. *Van Dyck as Religious Artist*,
cat. by John Rupert Martin and Gail
Feigenbaum, 1979.

Providence 1975
Providence, Brown University, Bell Gallery, List
Art Building. *Rubenism*, cat. by Mary Crawford
Volk et al., 1975.

Providence 1983
Providence, Rhode Island, Museum of Art,
Rhode Island School of Design et al.
*Old Master Drawings from the Museum of Art,
Rhode Island School of Design*, 1983.

Retretti 1991
Retretti, Finland, Retretti Art Center
(Retretin hallituksen puheenjohtaja).
Rubens, 1991.

San Francisco 1940
San Francisco, Fine Arts Palace. *Golden Gate
International Exposition. Master Drawings*, 1940.

Santa Barbara 1986–87
Santa Barbara, Museum of Art and elsewhere.
*Old Master Drawings from the Collection
of John and Alice Steiner*, cat. by Alfred Moir,
1986–87.

Tokyo 1979
Tokyo, National Museum of Western Art.
*European Master Drawings in the Fogg Art
Museum*, 1979.

Vienna 1988–89
Vienna, Albertina. *Meisterzeichnungen aus
New York. Vier emigrierte Altösterreicher als
Sammler*, edited by Konrad Oberhuber and
Sabine Kehl-Baierle, 1988–89.

Washington, D.C. 1978
Washington, National Gallery of Art.
*Master Drawings from the Collection of the
National Gallery of Art and Promised Gifts*,
cat. by Andrew Robison, 1978.

Washington, D.C. 1986
Washington, National Gallery of Art; Fort
Worth, Kimbell Art Museum; San Francisco,
Fine Arts Museums of San Francisco.
*Dürer to Delacroix. Great Master Drawings
from Stockholm*, 1986.

Washington, D.C. /New York 1986–87
Washington, National Gallery of Art;
New York, The Pierpont Morgan Library.
*The Age of Bruegel. Netherlandish Drawings in
the Sixteenth Century*, 1986–87.

Washington, D.C. 1990–91
Washington, National Gallery of Art.
Anthony van Dyck, cat. by Arthur K. Wheelock,
Jr., Susan J. Barnes, and Julius S. Held, 1990–91.

Waterville, Maine 1978
Waterville, Maine, Colby College Art Museum.
Drawings from Maine Collections, 1978.

Williamstown 1960
Williamstown, Massachusetts, Clark Art
Institute. *Dutch and Flemish Masters
(Exhibit Twelve)*, 1960.

Williamstown 1977
Williamstown, Massachusetts, Chapin Library
of Rare Books, Williams College. *Rubens and
the Book. Title Pages By Peter Paul Rubens*, cat.
edited and introduced by Julius S. Held, 1977.

Worcester 1948
Worcester, Massachusetts, Worcester Art
Museum. *Art of Europe during the Sixteenth
and Seventeenth Centuries*, 1948.

PHOTOGRAPHY CREDITS

The Art Institute of Chicago, Chicago, Illinois: plates 20, 28, 35, 75

The Art Museum, Princeton University, Princeton, New Jersey: figure 16

Borum Photographics, Nashville, Tennessee: plate 54

Bowdoin College Museum of Art, Brunswick, Maine: figure 11; plates 10, 40

The Chrysler Museum, Norfolk, Virginia, photograph by Scott Wolff: plate 13

The Cleveland Museum of Art, Cleveland, Ohio: plates 7, 31, 32, 36, 58 recto and verso, 71

Colnaghi, London: plate 63

Courtauld Institute Galleries, London: figure 12 (right portion), 13 (upper left portion)

Department of Printing and Graphic Arts, The Houghton Library, Harvard University, Cambridge, Massachusetts: plate 47

Fogg Art Museum, Harvard University Art Museums, Cambridge, Massachusetts: plates 14, 42, 53

The J. Paul Getty Museum, Malibu, California: plates 1, 16, 37, 45, 55, 74

Hluboká Castle, Czech Republic: figure 9

The Huntington Library, Art Collections, and Botanical Gardens, San Marino, California: figure 4

Tom Jenkins, Dallas, Texas: plate 11

Kunsthistorische Musea, Fotodienst, Antwerp: figure 8

Library of Congress, Washington, D.C.: figure 14

Photograph Services, The Metropolitan Museum of Art, New York, New York: figures 2, 10, 12 (left portion), 13 (lower left portion); plates 34, 43

The Minneapolis Institute of Arts, Minneapolis, Minnesota: plate 69

Museum of Art, Rhode Island School of Design, Providence, Rhode Island: plates 9, 12

Museum of Fine Arts, Boston, Massachusetts: plates 38, 51

National Gallery of Art, Photographic Services, Washington, D.C.: plates 4, 41, 44, 46, 65, 70

National Gallery of Scotland, Edinburgh, photograph by Tom Scott: figure 17

Sidney W. Newberry, London: plate 48

Peck Collection, Boston, Massachusetts: plate 52

Philadelphia Museum of Art, Philadelphia, Pennsylvania: plates 3, 57

The Pierpont Morgan Library, New York, New York: figure 1; plates 6, 8, 15, 26, 29, 49, 64, 67, 76

The Saint Louis Art Museum, Saint Louis, Missouri: plates 2, 33

Smith College Museum of Art, Northampton, Massachusetts, photograph by David Stansbury: figure 18

Stanford University Museum of Art, Stanford University, Stanford, California: figure 5

Sterling and Francine Clark Art Institute, Williamstown, Massachusetts: plate 56

Mr. & Mrs. Eugene Victor Thaw: plates 27, 50 recto and verso

Victoria and Albert Museum, London: figure 7

Virginia Museum of Fine Arts, Richmond, Virginia: figure 19

Wadsworth Atheneum, Hartford, Connecticut: plates 25, 66

Yale University Art Gallery, New Haven, Connecticut: plates 5, 17, 19, 22, 23, 24, 30, 59, 61

This publication was designed by
plus design inc., Boston,
production coordinated by Susan McNally,
typeset in Berthold Walbaum
and Monotype Walbaum by
Moveable Type Inc., Toronto
and edited by Elizabeth Allen,
Robin Hazard Ray, Nancy DuVergne Smith
and Moveable Type Inc.
2500 books were printed on
Mellotex Cartridge 137 gsm text
and binding board covers in
Ghent by Snoeck-Ducaju & Zoon.